# 陳澄波全集
## CHEN CHENG-PO CORPUS

第十五卷・修復報告（I）
Volume 15・Selected Treatment Reports（I）

策劃／財團法人陳澄波文化基金會

發行／財團法人陳澄波文化基金會
中央研究院臺灣史研究所

出版／藝術家出版社

# 感 謝
## APPRECIATE

文化部 Ministry of Culture

嘉義市政府 Chiayi City Government

臺北市立美術館 Taipei Fine Arts Museum

高雄市立美術館 Kaohsiung Museum of Fine Arts

台灣創價學會 Taiwan Soka Association

尊彩藝術中心 Liang Gallery

吳慧姬女士 Ms. WU HUI-CHI

# 陳澄波全集
## CHEN CHENG-PO CORPUS

第十五卷・修復報告（Ⅰ）
Volume 15・Selected Treatment Reports（Ⅰ）

藝術家

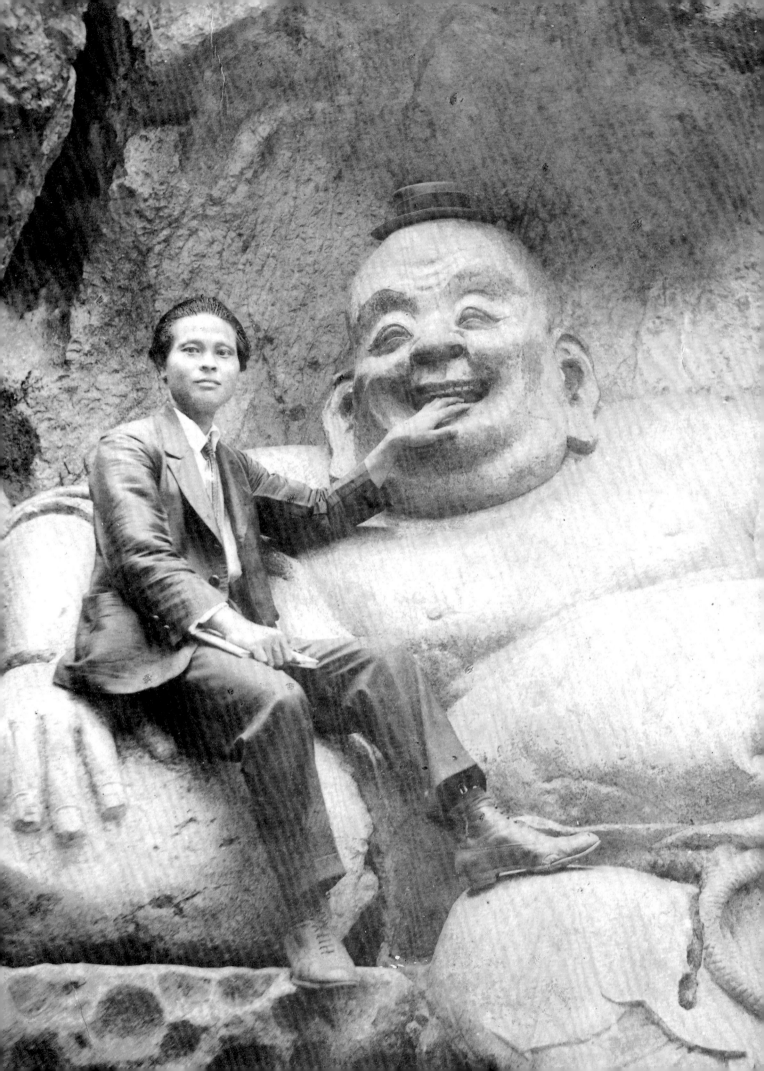

# 目　錄

# Contents

# 榮譽董事長 序

家父陳澄波先生生於臺灣割讓給日本的乙未（1895）之年，罹難於戰後動亂的二二八事件（1947）之際。可以說：家父的生和死，都和歷史的事件有關；他本人也成了歷史的人物。

家父的不幸罹難，或許是一樁歷史的悲劇；但家父的一生，熱烈而精采，應該是一齣藝術的大戲。他是臺灣日治時期第一個油畫作品入選「帝展」的重要藝術家；他的一生，足跡跨越臺灣、日本、中國等地，居留上海期間，也榮膺多項要職與榮譽，可說是一位生活得極其精彩的成功藝術家。

個人幼年時期，曾和家母、家姊共赴上海，與父親團聚，度過一段相當愉快、難忘的時光。父親的榮光，對當時尚屬童稚的我，雖不能完全理解，但隨著年歲的增長，即使家父辭世多年，每每思及，仍覺益發同感驕傲。

父親的不幸罹難，伴隨而來的是政治的戒嚴與社會疑慮的眼光，但母親以她超凡的意志與勇氣，完好地保存了父親所有的文件、史料與畫作。即使隻紙片字，今日看來，都是如此地珍貴、難得。

感謝中央研究院翁啟惠院長和臺灣史研究所謝國興所長的應允共同出版，讓這些珍貴的史料、畫作，能夠從家族的手中，交付給社會，成為全民共有共享的資產；也感謝基金會所有董事的支持，尤其是總主編蕭瓊瑞教授和所有參與編輯撰文的學者們辛勞的付出。

期待家父的努力和家母的守成，都能夠透過這套《全集》的出版，讓社會大眾看到，給予他們應有的定位，也讓家父的成果成為下一代持續努力精進的基石。

我が父陳澄波は、台湾が日本に割譲された乙未（1895）の年に生まれ、戦後の騒乱の228事件（1947）の際に、乱に遭われて不審判で処刑されました。父の生と死は謂わば、歴史事件と関ったことだけではなく、その本人も歴史的な人物に成りました。

父の不幸な遭難は、一つの歴史の悲劇であるに違いません。だが、彼の生涯は、激しくて素晴らしいもので、一つの芸術の偉大なドラマであることとも言えよう。彼は、台湾の殖民時代に、初めで日本の「帝国美術展覧会」に入選した重要な芸術家です。彼の生涯のうちに、台湾は勿論、日本、中国各地を踏みました。上海に滞在していたうちに、要職と名誉が与えられました。それらの面から見れば、彼は、極めて成功した芸術家であるに違いません。

幼い時期、私は、家父との団欒のために、母と姉と一緒に上海に行き、すごく楽しくて忘れられない歳月を過ごしました。その時、尚幼い私にとって、父の輝き仕事が、完全に理解できなっかものです。だが、歳月の経つに連れて、父が亡くなった長い歳月を経たさえも、それらのことを思い出すと、彼の仕事が益々感心するようになりました。

父の政治上の不幸な非命の死のせいで、その後の戒厳令による厳しい状況と社会からの疑わしい眼差しの下で、母は非凡な意志と勇気をもって、父に関するあらゆる文献、資料と作品を完璧に保存しました。その中での僅かな資料であるさえも、今から見れば、貴重且大切なものになれるでしょう。

この度は、中央研究院長翁啟恵と台湾史研究所所長謝国興のお合意の上で、これらの貴重な文献、作品を共同に出版させました。終に、それらが家族の手から社会に渡され、我が文化の共同的な資源になりました。基金会の理事全員の支持を得ることを感謝するとともに、特に総編集者である蕭瓊瑞教授とあらゆる編輯作者たちのご苦労に心より謝意を申し上げます。

この《全集》の出版を通して、父の努力と母による父の遺物の守りということを皆さんに見せ、評価が下させられることを期待します。また、父の成果がその後の世代の精力的に努力し続ける基盤になれるものを深く望んでおります。

<div align="right">

財團法人陳澄波文化基金會
榮譽董事長　陳重光

</div>

# Foreword from the Honorary Chairman

My father was born in the year Taiwan was ceded to Japan (1895) and died in the turbulent post-war period when the 228 Incident took place (1947). His life and death were closely related to historical events, and today, he himself has become a historical figure.

The death of my father may have been a part of a tragic event in history, but his life was a great repertoire in the world of art. One of his many oil paintings was the first by a Taiwanese artist featured in the Imperial Fine Arts Academy Exhibition. His life spanned Taiwan, Japan and China and during his residency in Shanghai, he held important positions in the art scene and obtained numerous honors. It can be said that he was a truly successful artist who lived an extremely colorful life.

When I was a child, I joined my father in Shanghai with my mother and elder sister where we spent some of the most pleasant and unforgettable days of our lives. Although I could not fully appreciate how venerated my father was at the time, as years passed and even after he left this world a long time ago, whenever I think of him, I am proud of him.

The unfortunate death of my father was followed by a period of martial law in Taiwan which led to suspicion and distrust by others towards our family. But with unrelenting will and courage, my mother managed to preserve my father's paintings, personal documents, and related historical references. Today, even a small piece of information has become a precious resource.

I would like to express gratitude to Wong Chi-huey, president of Academia Sinica, and Hsieh Kuo-hsing, director of the Institute of Taiwan History, for agreeing to publish the *Chen Cheng-po Corpus* together. It is through their effort that all the precious historical references and paintings are delivered from our hands to society and shared by all. I am also grateful for the generous support given by the Board of Directors of our foundation. Finally, I would like to give special thanks to Professor Hsiao Chong-ruy, our editor-in-chief, and all the scholars who participated in the editing and writing of the *Chen Cheng-po Corpus*.

Through the publication of the *Chen Cheng-po Corpus*, I hope the public will see how my father dedicated himself to painting, and how my mother protected his achievements. They deserve recognition from the society of Taiwan, and I believe my father's works can lay a solid foundation for the next generation of Taiwan artists.

Honorary Chairman, Chen Cheng-po Cultural Foundation
Chen Tsung-kuang

# 院長 序

　　嘉義鄉賢陳澄波先生，是日治時期臺灣最具代表性的本土畫家之一，1926年他以西洋畫作〔嘉義街外〕入選日本畫壇最高榮譽的「日本帝國美術展覽會」，是當時臺灣籍畫家中的第一人；翌年再度以〔夏日街景〕入選「帝展」，奠定他在臺灣畫壇的先驅地位。1929年陳澄波完成在日本的專業繪畫教育，隨即應聘前往上海擔任新華藝術專校西畫教席，當時也是臺灣畫家第一人。然而陳澄波先生不僅僅是一位傑出的畫家而已，更重要的是他作為一個臺灣知識份子與文化人，在當時臺灣人面對中國、臺灣、日本之間複雜的民族、國家意識與文化認同問題上，反映在他的工作、經歷、思想等各方面的代表性，包括對傳統中華文化的繼承、臺灣地方文化與生活價值的重視（以及對臺灣土地與人民的熱愛）、日本近代性文化（以及透過日本而來的西方近代化）之吸收，加上戰後特殊時局下的不幸遭遇等，已使陳澄波先生成為近代臺灣史上的重要人物，我們今天要研究陳澄波，應該從臺灣歷史的整體宏觀角度切入，才能深入理解。

　　中央研究院臺灣史研究所此次受邀參與《陳澄波全集》的資料整輯與出版事宜，十分榮幸。臺史所近幾年在收集整理臺灣民間資料方面累積了不少成果，臺史所檔案館所收藏的臺灣各種官方與民間文書資料，包括實物與數位檔案，也相當具有特色，與各界合作將資料數位化整理保存的專業經驗十分豐富，在這個領域可說居於領導地位。我們相信臺灣歷史研究的深化需要多元的觀點與重層的探討，這一次臺史所有機會與財團法人陳澄波文化基金會合作共同出版陳澄波全集，以及後續協助建立數位資料庫，一方面有助於將陳澄波先生的相關資料以多元方式整體呈現，另一方面也代表在研究與建構臺灣歷史發展的主體性目標上，多了一項有力的材料與工具，值得大家珍惜善用。

臺北南港／中央研究院
院長
2012.3　翁啟惠

# Foreword from the President of the Academia Sinica

Mr. Chen Cheng-po, a notable citizen of Chiayi, was among the most representative painters of Taiwan during Japanese rule. In 1926, his oil painting *Outside Chiayi Street* was featured in Imperial Fine Arts Academy Exhibition. This made him the first Taiwanese painter to ever attend the top-honor painting event. In the next year, his work *Summer Street Scene* was selected again to the Imperial Exhibition, which secured a pioneering status for him in the local painting scene. In 1929, as soon as Chen completed his painting education in Japan, he headed for Shanghai under invitation to be an instructor of Western painting at Xinhua Art College. Such cordial treatment was unprecedented for Taiwanese painters. Chen was not just an excellent painter. As an intellectual his work, experience and thoughts in the face of the political turmoil in China, Taiwan and Japan, reflected the pivotal issues of national consciousness and cultural identification of all Taiwanese people. The issues included the passing on of Chinese cultural traditions, the respect for the local culture and values (and the love for the island and its people), and the acceptance of modern Japanese culture. Together with these elements and his unfortunate death in the post-war era, Chen became an important figure in the modern history of Taiwan. If we are to study the artist, we would definitely have to take a macroscopic view to fully understand him.

It is an honor for the Institute of Taiwan History of the Academia Sinica to participate in the editing and publishing of the *Chen Cheng-po Corpus*. The institute has achieved substantial results in collecting and archiving folk materials of Taiwan in recent years, the result an impressive archive of various official and folk documents, including objects and digital files. The institute has taken a pivotal role in digital archiving while working with professionals in different fields. We believe that varied views and multi-faceted discussion are needed to further the study of Taiwan history. By publishing the corpus with the Chen Cheng-po Cultural Foundation and providing assistance in building a digital database, the institute is given a wonderful chance to present the artist's literature in a diversified yet comprehensive way. In terms of developing and studying the subjectivity of Taiwan history, such a strong reference should always be cherished and utilized by all.

President of the Academia Sinica
Nangang, Taipei
Wong Chi-huey
2012.3

# 總主編 序

作為臺灣第一代西畫家，陳澄波幾乎可以和「臺灣美術」劃上等號。這原因，不僅僅因為他是臺灣畫家中入選「帝國美術展覽會」（簡稱「帝展」）的第一人，更由於他對藝術創作的投入與堅持，以及對臺灣美術運動的推進與貢獻。

出生於乙未割臺之年（1895）的陳澄波，父親陳守愚先生是一位精通漢學的清末秀才；儘管童年的生活，主要是由祖母照顧，但陳澄波仍從父親身上傳承了深厚的漢學基礎與強烈的祖國意識。這些養分，日後都成為他藝術生命重要的動力。

1917年臺灣總督府國語學校畢業，1918年陳澄波便與同鄉的張捷女士結縭，並分發母校嘉義公學校服務，後調往郊區的水崛頭公學校。未久，便因對藝術創作的強烈慾望，在夫人的全力支持下，於1924年，服完六年義務教學後，毅然辭去人人稱羨的安定教職，前往日本留學，考入東京美術學校圖畫師範科。

1926年，東京美校三年級，便以〔嘉義街外〕一作，入選第七回「帝展」，為臺灣油畫家入選之第一人，震動全島。1927年，又以〔夏日街景〕再度入選。同年，本科結業，再入研究科深造。

1928年，作品〔龍山寺〕也獲第二屆「臺灣美術展覽會」（簡稱「臺展」）「特選」。隔年，東美畢業，即前往上海任教，先後擔任「新華藝專」西畫科主任教授，及「昌明藝專」、「藝苑研究所」等校西畫教授及主任等職。此外，亦代表中華民國參加芝加哥世界博覽會，同時入選全國十二代表畫家。其間，作品持續多次入選「帝展」及「臺展」，並於1929年獲「臺展」無鑑查展出資格。

居滬期間，陳澄波教學相長、奮力創作，留下許多大幅力作，均呈現特殊的現代主義思維。同時，他也積極參與新派畫家活動，如「決瀾社」的多次籌備會議。他生性活潑、熱力四射，與傳統國畫家和新派畫家均有深厚交誼。

唯1932年，爆發「一二八」上海事件，中日衝突，這位熱愛祖國的臺灣畫家，竟被以「日僑」身份，遭受排擠，險遭不測，並被迫於1933年離滬返臺。

返臺後的陳澄波，將全生命奉獻給故鄉，邀集同好，組成「臺陽美術協會」，每年舉辦年展及全島巡迴展，全力推動美術提升及普及的工作，影響深遠。個人創作亦於此時邁入高峰，色彩濃郁活潑，充份展現臺灣林木翁鬱、地貌豐美、人群和善的特色。

1945年，二次大戰終了，臺灣重回中國統治，他以興奮的心情，號召眾人學說「國語」，並加入「三民主義青年團」，同時膺任第一屆嘉義市參議會議員。1947年年初，爆發「二二八事件」，他代表市民前往水上機場協商、慰問，卻遭扣留羈押；並於3月25日上午，被押往嘉義火車站前廣場，槍決示眾，熱血流入他日夜描繪的故鄉黃泥土地，留給後人無限懷思。

陳澄波的遇難，成為戰後臺灣歷史中的一項禁忌，有關他的生平、作品，也在許多後輩的心中逐漸模糊淡忘。儘管隨著政治的逐漸解嚴，部分作品開始重新出土，並在國際拍賣場上屢創新高；但學界對他的生平、創作之理解，仍停留在有限的資料及作品上，對其獨特的思維與風格，也難以一窺全貌，更遑論一般社會大眾。

以「政治受難者」的角色來認識陳澄波，對這位一生奉獻給藝術的畫家而言，顯然是不公平的。歷經三代人的含冤、忍辱、保存，陳澄波大量的資料、畫作，首次披露在社會大眾的面前，這當中還不包括那些因白蟻蛀蝕

而毀壞的許多作品。

　　個人有幸在1994年，陳澄波百年誕辰的「陳澄波‧嘉義人學術研討會」中，首次以「視覺恆常性」的角度，試圖詮釋陳氏那種極具個人獨特風格的作品；也得識陳澄波的長公子陳重光老師，得悉陳澄波的作品、資料，如何一路從夫人張捷女士的手中，交到重光老師的手上，那是一段滄桑而艱辛的歷史。大約兩年前（2010），重光老師的長子立栢先生，從職場退休，在東南亞成功的企業經營經驗，讓他面對祖父的這批文件、史料及作品時，迅速地知覺這是一批不僅屬於家族，也是臺灣社會，乃至近代歷史的珍貴文化資產，必須要有一些積極的作為，進行永久性的保存與安置。於是大規模作品修復的工作迅速展開；2011年至2012年之際，兩個大型的紀念展：「切切故鄉情」與「行過江南」，也在高雄市立美術館、臺北市立美術館先後且重疊地推出。眾人才驚訝這位生命不幸中斷的藝術家，竟然留下如此大批精采的畫作，顯然真正的「陳澄波研究」才剛要展開。

　　基於為藝術家留下儘可能完整的生命記錄，也基於為臺灣歷史文化保留一份長久被壓縮、忽略的珍貴資產，《陳澄波全集》在眾人的努力下，正式啟動。這套全集，合計十八卷，前十卷為大八開的巨型精裝圖版畫冊，分別為：第一卷的油畫，搜羅包括僅存黑白圖版的作品，約近300餘幅；第二卷為炭筆素描、水彩畫、膠彩畫、水墨畫及書法等，合計約241件；第三卷為淡彩速寫，約400餘件，其中淡彩裸女占最大部分，也是最具特色的精采力作；第四卷為速寫（I），包括單張速寫約1103件；第5卷為速寫（II），分別出自38本素描簿中約1200餘幅作品；第六、七卷為個人史料（I）、（II），分別包括陳氏家族照片、個人照片、書信、文書、史料等；第八、九卷為陳氏收藏，包括相當完整的「帝展」明信片，以及各式畫冊、圖書；第十卷為相關文獻資料，即他人對陳氏的研究、介紹、展覽及相關周邊產品。

　　至於第十一至十八卷，為十六開本的軟精裝，以文字為主，分別包括：第十一卷的陳氏文稿及筆記；第十二、十三卷的評論集，即歷來對陳氏作品研究的文章彙集；第十四卷的二二八相關史料，以和陳氏相關者為主；第十五至十七卷，為陳氏作品歷年來的修復報告及材料分析；第十八卷則為陳氏年譜，試圖立體化地呈現藝術家生命史。

　　對臺灣歷史而言，陳澄波不只是個傑出且重要的畫家，同時他也是一個影響臺灣深遠（不論他的生或他的死）的歷史人物。《陳澄波全集》由財團法人陳澄波文化基金會和中央研究院臺灣史研究所共同發行出版，正是名實合一地呈現了這樣的意義。

　　感謝為《全集》各冊盡心分勞的學界朋友們，也感謝執行編輯賴鈴如、何冠儀兩位小姐的辛勞；同時要謝謝藝術家出版社何政廣社長，尤其他的得力助手美編柯美麗小姐不厭其煩的付出。當然《全集》的出版，背後最重要的推手，還是陳重光老師和他的長公子立栢夫婦，以及整個家族的支持。這件歷史性的工程，將為臺灣歷史增添無限光采與榮耀。

<div align="right">
《陳澄波全集》總主編<br>
國立成功大學歷史系所教授　蕭瓊瑞
</div>

# Foreword from the Editor-in-Chief

As an important first-generation painter, the name Chen Cheng-po is virtually synonymous with Taiwan fine arts. Not only was Chen the first Taiwanese artist featured in the Imperial Fine Arts Academy Exhibition (called "Imperial Exhibition" hereafter), but he also dedicated his life toward artistic creation and the advocacy of art in Taiwan.

Chen Cheng-po was born in 1895, the year Qing Dynasty China ceded Taiwan to Imperial Japan. His father, Chen Shou-yu, was a Chinese imperial scholar proficient in Sinology. Although Chen's childhood years were spent mostly with his grandmother, a solid foundation of Sinology and a strong sense of patriotism were fostered by his father. Both became Chen's Office impetus for pursuing an artistic career later on.

In 1917, Chen Cheng-po graduated from the Taiwan Governor-General's Office National Language School. In 1918, he married his hometown sweetheart Chang Jie. He was assigned a teaching post at his alma mater, the Chiayi Public School and later transferred to the suburban Shuikutou Public School. Chen resigned from the much envied post in 1924 after six years of compulsory teaching service. With the full support of his wife, he began to explore his strong desire for artistic creation. He then travelled to Japan and was admitted into the Teacher Training Department of the Tokyo School of Fine Arts.

In 1926, during his junior year, Chen's oil painting *Outside Chiayi Street* was featured in the 7th Imperial Exhibition. His selection caused a sensation in Taiwan as it was the first time a local oil painter was included in the exhibition. Chen was featured at the exhibition again in 1927 with *Summer Street Scene*. That same year, he completed his undergraduate studies and entered the graduate program at Tokyo School of Fine Arts.

In 1928, Chen's painting *Longshan Temple* was awarded the Special Selection prize at the second Taiwan Fine Arts Exhibition (called "Taiwan Exhibition" hereafter). After he graduated the next year, Chen went straight to Shanghai to take up a teaching post. There, Chen taught as a Professor and Dean of the Western Painting Departments of the Xinhua Art College, Changming Art School, and Yiyuan Painting Research Institute. During this period, his painting represented the Republic of China at the Chicago World Fair, and he was selected to the list of Top Twelve National Painters. Chen's works also featured in the Imperial Exhibition and the Taiwan Exhibition many more times, and in 1929 he gained audit exemption from the Taiwan Exhibition.

During his residency in Shanghai, Chen Cheng-po spared no effort toward the creation of art, completing several large-sized paintings that manifested distinct modernist thinking of the time. He also actively participated in modernist painting events, such as the many preparatory meetings of the Dike-breaking Club. Chen's outgoing and enthusiastic personality helped him form deep bonds with both traditional and modernist Chinese painters.

Yet in 1932, with the outbreak of the 128 Incident in Shanghai, the local Chinese and Japanese communities clashed. Chen was outcast by locals because of his Japanese expatriate status and nearly lost his life amidst the chaos. Ultimately, he was forced to return to Taiwan in 1933.

On his return, Chen devoted himself to his homeland. He invited like-minded enthusiasts to found the Tai Yang Art Society, which held annual exhibitions and tours to promote art to the general public. The association was immensely successful and had a profound influence on the development and advocacy for fine arts in Taiwan. It was during this period that Chen's creative expression climaxed — his use of strong and lively colors fully expressed the verdant forests, breathtaking landscape and friendly people of Taiwan.

When the Second World War ended in 1945, Taiwan returned to Chinese control. Chen eagerly called on everyone around him to adopt the new national language, Mandarin. He also joined the Three Principles of the People Youth Corps, and served as a councilor of the Chiayi City Council in its first term. Not long after, the 228 Incident broke out in early 1947. On behalf of the Chiayi citizens, he went to the Shueishang Airport to negotiate with and appease Kuomintang troops, but instead was detained and imprisoned without trial. On the morning of March 25, he was publicly executed at the Chiayi Train Station Plaza. His warm blood flowed down onto the land which he had painted day and night, leaving only his works and memories for future generations.

The unjust execution of Chen Cheng-po became a taboo topic in postwar Taiwan's history. His life and works were gradually lost to the minds of the younger generation. It was not until martial law was lifted that some of Chen's works re-emerged and were sold at record-breaking prices at international auctions. Even so, the academia had little to go on about his life and works due to scarce resources. It was

a difficult task for most scholars to research and develop a comprehensive view of Chen's unique philosophy and style given the limited resources available, let alone for the general public.

Clearly, it is unjust to perceive Chen, a painter who dedicated his whole life to art, as a mere political victim. After three generations of suffering from injustice and humiliation, along with difficulties in the preservation of his works, the time has come for his descendants to finally reveal a large quantity of Chen's paintings and related materials to the public. Many other works have been damaged by termites.

I was honored to have participated in the "A Soul of Chiayi: A Centennial Exhibition of Chen Cheng-po" symposium in celebration of the artist's hundredth birthday in 1994. At that time, I analyzed Chen's unique style using the concept of visual constancy. It was also at the seminar that I met Chen Tsung-kuang, Chen Cheng-po's eldest son. I learned how the artist's works and documents had been painstakingly preserved by his wife Chang Jie before they were passed down to their son. About two years ago, in 2010, Chen Tsung-kuang's eldest son, Chen Li-po, retired. As a successful entrepreneur in Southeast Asia, he quickly realized that the paintings and documents were precious cultural assets not only to his own family, but also to Taiwan society and its modern history. Actions were soon taken for the permanent preservation of Chen Cheng-po's works, beginning with a massive restoration project. At the turn of 2011 and 2012, two large-scale commemorative exhibitions that featured Chen Cheng-po's works launched with overlapping exhibition periods — "Nostalgia in the Vast Universe" at the Kaohsiung Museum of Fine Arts and "Journey through Jiangnan" at the Taipei Fine Arts Museum. Both exhibits surprised the general public with the sheer number of his works that had never seen the light of day. From the warm reception of viewers, it is fair to say that the Chen Cheng-po research effort has truly begun.

In order to keep a complete record of the artist's life, and to preserve these long-repressed cultural assets of Taiwan, we publish the *Chen Cheng-po Corpus* in joint effort with coworkers and friends. The works are presented in 18 volumes, the first 10 of which come in hardcover octavo deluxe form. The first volume features nearly 300 oil paintings, including those for which only black-and-white images exist. The second volume consists of 241 calligraphy, ink wash painting, glue color painting, charcoal sketch, watercolor, and other works. The third volume contains more than 400 watercolor sketches most powerfully delivered works that feature female nudes. The fourth volume includes 1,103 sketches. The fifth volume comprises 1,200 sketches selected from Chen's 38 sketchbooks. The artist's personal historic materials are included in the sixth and seventh volumes. The materials include his family photos, individual photo shots, letters, and paper documents. The eighth and ninth volumes contain a complete collection of Empire Art Exhibition postcards, relevant collections, literature, and resources. The tenth volume consists of research done on Chen Cheng-po, exhibition material, and other related information.

Volumes eleven to eighteen are paperback decimo-sexto copies mainly consisting of Chen's writings and notes. The eleventh volume comprises articles and notes written by Chen. The twelfth and thirteenth volumes contain studies on Chen. The historical materials on the 228 Incident included in the fourteenth volumes are mostly focused on Chen. The fifteen to seventeen volumes focus on restoration reports and materials analysis of Chen's artworks. The eighteenth volume features Chen's chronology, so as to more vividly present the artist's life.

Chen Cheng-po was more than a painting master to Taiwan — his life and death cast lasting influence on the Island's history. The *Chen Cheng-po Corpus*, jointly published by the Chen Cheng-po Cultural Foundation and the Institute of Taiwan History of Academia Sinica, manifests Chen's importance both in form and in content.

I am grateful to the scholar friends who went out of their way to share the burden of compiling the corpus; to executive editors Lai Ling-ju and Ho Kuan-yi for their great support; and Ho Cheng-kuang, president of Artist Publishing co. and his capable art editor Ke Mei-li for their patience and support. For sure, I owe the most gratitude to Chen Tsung-kuang; his eldest son Li-po and his wife Hui-ling; and the entire Chen family for their support and encouragement in the course of publication. This historic project will bring unlimited glamour and glory to the history of Taiwan.

Editor-in-Chief, *Chen Cheng-po Corpus*
Professor, Department of History, National Cheng Kung University
Hsiao Chong-ray

*Chong-ray Hsiao*

# 澄波重現──簡論陳澄波作品的保存與維護

## 一、前言

　　陳澄波是臺灣接受西方繪畫黎明期的代表，也是臺灣接收現代藝術教育的先驅者。在學院派的教育下，他跳脫出群體化的藝術教育系統，強烈而執著的特質展現了獨特的風格與情操，被稱為「學院中的素人畫家」。

　　2010年在大眾殷切的期盼下，陳澄波文化基金會（以下簡稱基金會）著手開始規畫2014年「陳澄波百二誕辰東亞巡迴大展」的一系列活動，目的是希望以陳澄波的各式作品來帶出他對於藝術的熱情與躍動的生命力，將這位自期如「油彩的化身」的藝術家創作的本質與態度如實呈現。規畫在此展中的作品也因為這個要素，包含了多種樣式的作品，跨含多類媒材，如西方的油畫、水彩、鉛筆、炭筆、鋼筆、粉彩、設計等，東方的膠彩、水墨、書法、底稿等。《陳澄波全集》第15-17卷都是以介紹修復為主的專文或作業內容集結而成，作品分別由三個修復單位主持，在15和16卷的前段是介紹國立臺灣師範大學藝術學院文物保存維護研究發展中心（以下簡稱師大文保中心）完成的修復作品內容，15卷是紙質類作品、16卷的前段則是介紹東京藝術大學與師大文保中心結盟合作修復的油畫作品和文物。16卷後段是由另一位修復師林煥盛先生的「臺北文化財保存研究所」所負責修復的相關生活史料與東方繪畫，第17卷則是由「私立正修科技大學文物修護中心」負責執筆。本文以下將逐一介紹第15-16卷各類型作品在各修復單位的作業過程紀錄與修復對策的專文，藉由這些作品、史料在展前的修復過程與展示中的呈現方式結合為一個完整、透明化的保存過程，將當時在藝術、教育、藝壇風潮與陳澄波心中的創作訊息等，更完整的從各角度詮釋他傳奇而短暫的一生。

## 二、師大文保中心

　　師大文保中心在此案中所負責的項目幾乎概括全部的類型，從油畫、東方繪畫（膠彩、水墨、書法）、水彩、鉛筆、炭筆、鋼筆、粉彩、設計等，以及底稿、遺書（共計1,012件、素描簿29本）面對如此完整、龐大的數量與緊迫的展示目標，保存修復的任務已不僅是單純修復技術的介入，而是必須在有限的時間內快速整合修復方針與研發適合的安全配套系統。修復目標除了著手修復各類文物長久以來的老化損弱狀況之外，亦需確保在日後與接下來的一連串展示、移動中保持最安全的狀況。除此之外，為了在多樣的作品中確保修復作業的完整性，並使修復效果能充分發揮作品價值（研究價值、展示價值、市場價值），師大文保中心將此案劃分為下述三種不同意義的修復方針：

1. 「既定藝術形式」作品的修復方針：共計37件：油畫36件，膠彩1件。

2. 「兼具史料意義」作品的修復方針：共計素描簿29本、963件作品（水彩71件、炭筆素描71件、鉛筆單頁速寫763件、素描簿附件6件、水墨7件、書法23件、設計底稿4件、剪紙4件、插畫4件、裸女淡彩9件、粉彩1件）。

3. 「史料文物類」的修復方針：共計12件：遺書9件、受難著服2件、相片1件。

（一）修復專案設立

　　國立臺灣師範大學文保中心成立於 2009 年，是一個綜合教育、研究與執行修復任務的專業領域，成立之初是以維護師大的校藏品[1]為主要任務，同時也承接校外修復委託案。2011 年中心承接基金會的託付，成立陳澄波作品修復團隊負責此案，團員中最大的特色就是歌田真介、木島隆康二位教授與他們的高徒鈴鴨富士子博士的加入，這三位來自於東京藝術大學也就是從前的東京美術學校、陳澄波的母校，主導此案中油畫作品的調查研究與修復。

　　日本東京藝術大學是一個非常重視校友情誼的學校，各種不同分野的學生常會在不同的課程、古美術研究旅行或是藝祭、各種競賽、展覽活動中交流。校內有一個奇怪的風氣，就是大家都很喜歡逗留在學校，窩在研究室裡不停的創作、摸索，休息的時候也喜歡到別人的研究室串串門子，甚至深夜也偷偷躲著校警繼續作業。這種彼此之間互相切磋、打氣、競爭的風氣，加上古老的校區也不是很大，所以師生之間也都不陌生，畢業後校友之間仍互相關心或是透過各種管道保持聯繫。此次修復計劃最早也是由於校友的串聯與母校的支持，如基金會董事長陳立栢先生在〈轉身，擁抱驕陽——陳立栢與阿公心底的約定〉中所述：「直到 1997 年，時任北美館館長林曼麗館長引介東京藝術大學修復師歌田真介，將作品送到東京修復。歌田真介為表達對校友的愛護，將〔岡〕與〔嘉義街景〕的修復轉作教學案，支付四成修復費，剩餘六成再由陳重光籌款。」[2]

　　歌田教授是日本西畫修復的先驅者，除了修復的技法與經驗一流之外，對於明治時期當時日本接收西方影響的歷史、傳承與繪畫材料技法等相關研究可謂是第一人，他自藝大「技法材料科」畢業之後致力於油畫保存修復技術，曾擔任創形美術學校修復研究所的所長、東京藝術大學教授，在校任職期開創油畫保存修復科兼任第一任藝大美術館長。他的重要著作《解剖油畫——從修復家的立場看日本西畫史》[3]一書，將幕府晚期到明治時期這一段受西方繪畫影響的「激動期」中的先驅者高橋由一、黑田清輝、岸田劉生等代表作家的特色，從修復現場、油畫創作技法、顏料畫布等材料技法開始，深入探討日本在接受西方思想影響後，對於繪畫空間、光線、描寫方式、畫面的切入手法等問題，是一部全面性探討繪畫材料技法與繪畫歷史變遷的重要書籍。歌田教授退休之後轉任榮譽教授，並薦舉他的得意門生木島教授接任藝大的研究室，持續進行多項重要的研究與修復計劃，是日本結合修復實務、教學研究、國際修復派遣隊的重要修復研究室。

　　木島教授繼 1998 年臺北市立美術館的七件（其中陳澄波二幅）重要藏品委託修復[4]之後，2007 年又繼續承接基金會委託修復三幅，先後共完成五幅陳澄波的重要代表作品。2011 年師大文保中心成立「陳澄波作品修復專案」之後，鈴鴨博士也隨後加入團隊，修復的陣地正式轉移地點至師大文保中心。這個決定除了作品得以在現地修復，隨時可以掌握與家屬們的訊息與意見之外，更直接地因為國外師資、技術的導入而培養了一批新生代的修復師。只是老師們三年間的辛勞幾乎每月一次的往返，其中甚至二次在中心度過他們的正月新年，走筆至此不禁再次要對他們的付出表達衷心的感激之意。藉由陳立栢先生所述：「師大的文保中心邀請歌田真介的學生木島隆康擔任基金會師大修復案的主持人，這兩年多來，他的行為令我非常感動：幾乎每個月都帶助手鈴鴨富士子來台，且依國科會計價標準，住師大宿舍、吃小吃，至今將近三年。這（收價）大概差了三到五倍。後來，木島把修復所有收入通通捐給文保中心，等於一塊錢都沒拿。我真的被感動了。是他推廣我，是他讓我知道『再不好好正確地健

17

康修復，那麼將失去所有日後要推廣的媒介』」[5]。

　　鈴鴨博士是木島教授的得意門生，秀外慧中的她在專業上的精優當然也毋庸置疑，是日本學院派新生代修復家的代表。特別的是鈴鴨博士原以優異的成績畢業於日本醫科大學之後又毅然決定轉入木島教授的研究室，投身於最愛的文物保存修復專業。除了精研一般修復技術之外，她之前的醫學專業也使得她不同於一般來自於藝術分野的修復師，對理化、科技、材料分析方面更是得心應手。在團隊中除了修復作業之外，鈴鴨老師還要負責日台雙方的聯繫、修復的進度規畫與整合。個性沈穩而待人誠懇親切的她，不論旅途多麼勞累，永遠面帶微笑的處理每一項繁雜瑣事，耐心的對年輕學子們不厭其煩地解說、細心確認每一步驟。看著文靜的她穿著白袍在充滿「患者」的修復室中穿梭，讓人不禁聯想到小時候常聽到南丁格爾的故事幾乎是一樣的情節，對「真誠的付出是一種幸福」是最好的詮釋。修復家是文物的醫療人員，能夠有這樣的人格修養與文保專業，同時又有熱愛藝術的情操，實在是不可多得的人才。

（二）師大專文簡介

　　此書是綜合此次修復專案的思維、技法、研究加以說明分類為 11 篇專文集結成冊，內容是以串聯、說明作品特色與修復技術為前提，然因排版編輯的原因，將專文分為紙質類修復（第 15 卷）與油畫修復（第 16 卷前段）二個區塊，雖然各文章之執筆者不同，但是實際操作時許多作業細節與分工都是經過討論後制定規範的修復方針再經整個團隊相互配合完成的，紙質方面的專文如下：

（1）紙質類修復專文

　　修復方針是為了輔助修復倫理原則[6]的方向性，它的作用是為了在龐大而繁複的修復作業中，建立一個共同指標，達到整合性的效果。除此之外，一件作品、文物的價值可分為研究價值、展示價值與市場價值，方針的制定也是為了防止在修復過程中忽略或扭曲作品、文物所涵蘊的價值性。接下來的論述是針對此案對象物（共計 1,012 件、素描簿 29 本）中扣除油畫 36 件之後的紙質類作品的修復作業，對象物如水墨、書法、水彩、素描（鉛筆、炭筆）、素描簿、遺書等各式修復技法的分類與運用介紹。

　　紙質文物類的修復作業在亞洲一直與傳統裝裱、東方書畫有著密切的關係，裝裱的技法從古代中國開始傳達至鄰近的韓、日、東南亞等地區影響深遠，近代在西方國家也開始認識、認同裝裱技術有助於修護專業的提升，並開始研究、應用。但是當文化上的習慣性處理變成過度依賴的手段時，有時需重新對「適切性」的拿捏再度評估。例如書籍、西方繪畫（水彩、版畫、素描、檔案等）、染織品、唐卡、拓片、照片等，常發生「西畫中裱」或是厚度重量改變過大、凹凸版被過度攤平、破壞質感等問題。

　　陳澄波的紙質作品對時代意義而言，代表著臺灣跳脫出傳統中國藝術樣式第一批接收西方美術教育洗禮的歷史背景，因此在大量的作品中看到素描、寫生、靜物等隨著他的生活腳步紀錄的作品。媒材與構圖形式上也受到西方的影響像炭筆、水彩、鉛筆、寫生簿、素描簿等，基底材亦有大量西方輸入或受西方影響而製作的紙張，因此在保留歷史特徵的思維上，西方紙質作品應該以西方修復的技法為主。然而受到當時世界潮流機械化大量造紙

的影響，即便如陳澄波這樣注重材料的藝術家也無法未卜先知的避開「酸性紙」[7]的後遺症——紙張因為製造、處理的流程造成酸性體質，日後容易出現黃化與脆化的問題。這不僅是陳澄波作品的問題，全世界的藝術作品、重要書籍、檔案、照片等幾乎都面臨著同樣的危機，甚至至今仍然持續製造、發生。如何將此類酸性紙張以適當的方式維護是後段逐篇探討的重點，先根據作業內容分類出以下 5 篇相關文章：

1. 張元鳳著〈技術、美學與文化性的探討——以陳澄波作品保存修復為例〉
2. 彭元興、徐建國著〈探微觀紙——紙張纖維玻片製作及種類判定〉
3. 丁婉仟著〈陳澄波書法及水墨作品修復〉
4. 陳詩薇著〈多樣性：中國、臺灣、日本紙張用於填補和補強的修復應用與思維〉
5. 李季衡著〈陳澄波紙質作品修復——多面向探討保存修復材料之應用〉

〈技術、美學與文化性的探討——以陳澄波作品保存修復為例〉此文的重點為如何設定修復方針與整合修復作業，內容中探討「托裱」技法的置入問題。雖然大家都認同作品經過中式小托的強化與攤平後，有利於後續管理的便利與安定性，但基於文化因素與文物的本質應該被尊重的原則，筆者將作業的步驟與處理重新調整與整合，特別是針對西式紙質作品的強化、保存、展示等規畫引用了一些新的理念，如材質上導入有「蜉蝣羽翅」之稱的「典具帖」[8]的應用設計、無酸裝框、夾裱與展示系統等以尊重作品的文化特色。分別針對「強化作品—典具帖的應用」與「保護作品—無酸夾裱應用」二個方向論述。

另外，修復師除了致力於科學、技術的進階之外，有鑑於此次修復計畫中已經有不久之前甫修復，但竟在短時間又面臨「重修」的案例出現，重修過程中除了警惕、告誡文物修復師的修復倫理原則之外，筆者基於教育者的立場，在文保的專業發展中初探「修復美學」的重要性，將藝術與技術之間、主觀與客觀之間保留適度的、可對話性的空間，以供未來規畫的可協調性。

〈探微觀紙——紙張纖維玻片製作及種類判定〉為彭元興老師與徐建國老師擔任紙張纖維鑑識的心得報告。兩位老師都是國內造紙業界的知名學者，而徐老師任職的林業試驗所更是人才濟濟，如之前的王國財先生與夏滄琪教授等，都是熱心致力於紙張研究與文保研發的名家。徐老師是臺灣手工紙研究先驅張豐吉教授與十餘年前活躍於國內的松雲山房岑德麟大師的門生，除了熟習各種紙質類文物的修復技法之外，對於紙張鑑識與製造不但累積了多年的實務經驗，更對於古代紙張的技術再現與客觀的科學辨識方法，分辨出各式各樣的纖維與紙張特質，在此也藉此文感謝兩位老師於百忙之中鼎力相助。陳澄波的紙質作品跨越東、西，有中式、日式與各種當時日本進口的西方紙張，這些紙張中所混合的纖維除了可代表當時藝術界常用紙張，也是修復作業開始的基本判斷，對於修復作業的進行是重要的明燈。

看過陳澄波的書法與水墨字跡嗎？如何在驚喜與戒慎恐懼的心情下完成陳澄波青春時期罕見的習作。丁婉仟這篇〈陳澄波書法及水墨作品修復〉雖然平靜地在有限的字數內介紹了書法與水墨的修復過程，但是對本人而言從接觸作品的瞬間震撼到點收、檢測、紀錄、規畫、執行、驗收、資料收集、運輸、掃描、點交，在一連串的緊湊節拍下結束，事後在報告撰寫時不由想起許多嘔心瀝血的夜晚，與許多意猶未盡、卻只能眼睜睜地看著作品被

專車運回基金會的不捨。「如果再給我多一點時間、請再讓我多看一眼！」這種感覺相信不僅是丁助理，接下來的二篇文章，甚至團隊的每一個成員都有相同的感覺。這樣大量的重要作品與資料在正常的情形下應該是一、二件，頂多也是以個位數的狀況下進入修復室，耗時數月以上的時間細細修復。此次的緊鑼密鼓之下，即便每位修復師都善盡心力、竭盡畢生所學使作品如其所願地安全交回基金會。但是即便驗收作業依序完成（數度提出延後交件的終於成果），三年間的朝夕相處仍然覺得時間太短（平均算起來一件作品只有一天左右），所以深怕有遺漏的地方卻來不及再多看一眼的心情至今依然難以平復。書法的字跡上看出陳澄波認真的學子之心，旁邊的朱批雖然已經由艷朱轉為暗赭，依然感受到指導老師諄諄教誨的愛惜與用心，也不禁聯想當時從日本全國各地精選入學的菁英份子皆被視為明日之星（将来の芸術家の玉子）的授課風景。因此這類典型的「兼具史料意義」作品，因為身兼歷史與作者風格，常會因為觀者的立場不同而對修復結果產生不同的見解。文中介紹陳澄波先生 1924 至 1927 年間未經托裱的 23 件書法與 7 件水墨共計 30 件紙本，並將變色與未變色朱墨以 X 射線螢光分析儀（XRF）非破壞檢測後與傳統鉛丹墨及朱砂墨比對後探討變色的原因，再將此類修復方針以東方裝裱的文化特質完成，包含使用修復專用的漿糊、小托命紙、加托強化、填補缺損、全色、鑲貼綾絹等步驟介紹。

與上篇論調接近但完全以西方文化元素為重點的是陳詩薇的〈多樣性：中國、臺灣、日本紙張用於填補和補強的修復應用與思維〉，此文敘述陳澄波的紙質作品中以素描、水彩、素描簿等西方形式的紙張的劣化處理過程。詩薇是受西方修復教育的碩士，畢業後來臺專攻跨東、西文化的修復策略與技術，此次修復重點是發揮西方強項的除酸作業，以確保作品脫離酸性體質，日後趨向穩定的中性體質。「除酸」─將作品的酸性體質在安全的範圍之內改變近趨中性，並且以中性的保護材質設計出防止作品繼續酸化的環境，是保存事項中最主要的安全重點。此技法在西方專業中已發展多年，但在處理不同對象物時如何適度調整則是各修復室的特色。除酸以外的技法策畫，例如紙板水彩是使用乾、濕式紙漿纖維兩階段式的填補破損技法，素描簿是綜合純紙纖維、宣紙、臺灣楮皮紙、典具帖、細川紙的廣泛應用，以及保護單線圈裝訂型式的素描簿而製作的複合式裝幀與加寬書背的介紹等，在材料技法使用上雖然涵括多樣式，但盡量將西方特質帶出的呈現方式是此文的特殊與有趣之處。

李季衡在團隊中是資歷較淺的修復助理，但是他對修復的熱忱與用心是大家公認的超級助理，此篇〈陳澄波紙質作品修復──多面向探討保存修復材料之應用〉便是以介紹基礎材料為主，分別說明修復專用材料的特質與使用方法。文章內用心撰寫此次紙質作品的保存修復材料的選擇及其特性，從無酸材料之化學性層面到文物修復倫理原則之哲學性層面探討材料選擇的重要性。作品從修復完成離開修復室開始，這些文物將持續經過運輸、展示、典藏、甚至百年之後的再次維修，強調文物保護材料的選擇與用心更是一門學問。結束此案後季衡亦負笈千里遠赴德國深造，謹藉此祝福將來立志要成為修復師一員的他一帆風順、學業有成。

（2）油畫修復專文

第 16 卷前半部是東京藝術大學的三位專家來臺與師大文保中心結盟合作修復的油畫作品專文，內容是以日本修復家的三篇專文、國內鑑識專家一篇與文保中心修復師二篇，共計六篇如下：

1. 歌田眞介著〈關於陳澄波的作品〉

2. 木島隆康著〈從修復作品看陳澄波的繪畫技法與作品再修復〉

3. 鈴鴨富士子著〈陳澄波的油畫──透過修復作品看繪畫材料〉

4. 黃曉雯、張維敦著〈陳澄波油畫打底材料與現代油畫材料中元素組成之比較〉

5. 王瓊霞著〈陳澄波的木板油畫調查研究與修復〉

6. 葉濱翰著〈文保中心油畫修復材料介紹與案例〉

　　前三篇分別針對歷史、風格、以及此案之修復技法、繪畫材料技法等詳述說明，是根據實務修復作業與研究而累積的經驗之談。三位日本專家將這些寶貴的經驗及技術無私地公開分享，不但是國內首次將日系油畫保存修復技術完整介紹的初例，更重要的是也藉由教學與實作，更縮短、加速了技術交流的腳步。

　　歌田教授的〈關於陳澄波的作品〉文中論及日本受到西方思想影響後繪畫的轉變過程，包含早期藝術家的源流、特徵、畫風、材料技法、日後發展脈絡等，從黎明期的西畫探討到學院派產生，最後站在一個制高點來探討日本畫壇以及以陳澄波為主的臺、日脈絡。這些早期的重要資料經過歌田教授言簡意賅的敘述下，清楚地看到早期日本在近代西化發展下的大環境中，針對亞洲油畫材料技法特別關出的精彩評論。尤其文中花了相當的篇幅探討日本油畫變遷的過程，關於油畫的材料與體質方面，他認為「明治早期作品（脂派／紫派）的結構非常堅實且質感緻膩，到了明治後半期之後，隨著時代的潮流趨勢，油畫顏料層的耐溶性能也跟著逐漸低下，顏料層易溶解於水的作品也隨之增加」[9]。他與好友森田恒之[10]共同認為早期油畫之所以稱為「油」畫，就是因為混合在顏料中的油呈現出的油性光澤與黏稠感的特徵而命名，因此文中強調「然而在油畫東傳的演變過程中，亞洲的畫家所重視的是新潮流下自由放任的創作表現，畫家們無時無刻不專注、快速地捕捉歐洲藝壇傳來的新趨勢，相對之下反而將支持表現新手法的材料技法這麼重要的基礎忽略……在這樣的風氣下，畫家開始添加了不適切的揮發性溶劑作為稀釋劑或混合使用以求快速，這就是『亞洲化』油畫的材質特徵」。

　　然而，相較於上述日本在一味追求新趣的環境下，陳澄波卻依然專注於油畫的基本特質，加上素樸的風格與充滿熱情的作畫方式，當視點從材料技法回歸到論及陳澄波個人風格時他認為「這位畫家（的作品）是具有油畫體質的，他讓油畫顏料的特質充分地發揮，並以此貼切的描繪出臺灣故鄉的風土。以當時的社會氛圍下的東洋人而言，他的存在是非常特異的、是能夠符合我心目中理想的藝術家條件的少數者之一」[11]。歌田教授描述陳澄波並非一味追求梵谷、塞尚、雷諾瓦等人，而是自然釋放他心中既有的模式與理想，在當時就是一位獨特、自我風格獨特的畫家，是「有國際性、可以代表亞洲的畫家」。因此「陳澄波在日的學習過程中，到底內心真正的想法是什麼呢？」綜合歌田教授在文中對他作品的高度評價，不難看出這位學者從陳澄波身上影射出他對日本西畫發展過程的偏失與不足之外，也包含著檢討的深層意涵。這些建言相對地也警惕著現代藝術家，什麼樣的藝術作品是可以被國際認同甚至永恆流世。

　　其次是木島教授的〈從修復作品看陳澄波的繪畫技法與作品再修復〉，他與歌田教授一樣，都是可以同時以藝術家、修復家二者兼具的立場直接論述的學者。如同木島教授穩重而直爽的個性一樣，此文的一開始便單刀直入地點出陳澄波繪畫的風格與技法特徵，這是綜合了繪畫材料技法發展、修復材料技法發展以及科技檢測驗證等依據集結的經驗下，再以簡明客觀的方式說明。木島教授最擅長使用這種從結構解剖的方式將作品特質一一敘述：

眼光銳利如鷹的他，一眼便可以排除後加修復或是老化的因素，直接洞察作品的本質。因此這篇來自一位熱愛藝術、拯救過無數名作的專家所撰寫的文章，將此次修復現場的實務記錄與觀察集結、濃縮而成的心得以不同的角度切入，絕對兼具了高度的準確性與權威性。不論是在藝術、修復、鑑賞上，都讓人感受到他的修為之所以如此讓人敬服，原因不外乎在他敏銳的洞察力與細膩的表現功力這些專業能力之外，我個人認為最重要的關鍵是他「同理心」善良懇切的態度與不牽強、不做作與坦然面對的特質，不單在待人接物上同時也表現在修復專業上，難怪許多複雜的作品到了他手中後便在不知不覺中順利完成，不愧是一位成功而讓人尊敬的「大師級」修復家。

從 1998 年受臺北市立美術館的委託，對〔嘉義街景〕（1934）、〔夏日街景〕（1927）二幅油畫作品進行修復後，2007 年木島教授再次受到家族的委託，修復〔嘉義街中心〕（1934）、〔岡〕（1936）、〔女人〕（1931）三幅重要作品。此案從 2011 年開始修復 36 幅作品，技法承續先前的技法，一改國內傳統油畫的「直接托黏式」[12] 強化技法為「非黏合式加襯 loose lining」[13] 之外，更發現作者細心、謙和的說明比較二種技法的理念與步驟上的差異性。文中以近年被蠟托裱過的陳澄波作品進行再次修復為例展開說明，該作品的問題並非僅因蠟托裱處理的技術選擇問題，而絕大部分是因為人為處理不當與態度錯誤，造成畫布基底材空鼓、顏料層因加壓加熱過度變形、補彩覆蓋原彩等問題，也是因為修復家的職業道德的鬆弛。其實此文論述的這些想法與實際的做法，一直是國內文保界在授業時不斷重申的倫理原則，因此文中除了讓修復家們再次了解國際性共識之外，藝術愛好者與文資相關者也可以藉此理解修復家自我約束的重要性。歷史與事實顯示在修復專業裡，眾多的材料與技法隨著不同時代與理念輾轉演變或是進化，材料技法本身沒有對錯是非之分，修復成敗其實決定在「態度」，一個明睿的修復家遵循國際公認的原則，適時選擇適當的材料技法並且忠於原創者的理念完成現階段的任務，目的是安全的移轉給下一個世代。面對老化脆弱的文物，修復是不得已的手段，無法「點石成金、一勞永逸」，正確的修復規畫與長遠的保存維護策略，才是與文物恆久共處之道。

與保存修復專業相輔相成的另一個重點是─材料技法發展史，這是理解當下社會人文、科技發展與國際間交流的重要輔助資料，它需要大量研究成果的累積，配合科技化、系統化的記錄管理才能建立成為實用的資料庫。建立一個確實的資料庫可以幫助客觀的比對記錄，從單一作品發展到地域、甚至文化 DNA 的特質。日本對於繪畫材料技法的調查配合修復案的推動，相關的資料累積已經有相當的成果，國內在近十年也由於非破壞科技的進步，資料收集的制度與績效亦持續成長。然而關於日臺之間的銜接卻付之闕如。鈴鴨博士的〈陳澄波的油畫──透過修復作品看繪畫材料〉因可算是首篇將兩國銜接的發表，針對陳澄波在東京美術學校圖畫師範科的最重要指導教授─田邊至，從他的教學、繪畫材料技法的特徵開始說明他在校時的影響。而受老師影響很大的陳澄波從學習期的東美時期、畢業後的上海風格轉換時期與返臺後，各時期作品經過比對、修復與精細科技檢測推算，規畫出其作品的材料特徵，從顏料、畫布、木板、紙板等均在此文中說明。現今非破壞檢測的頻繁使用情形下，大量資料雖可以方便檢出，但若無精確的判斷，反而造成一些似是而非的錯誤資訊。此文給我們一條非常清晰的指引─非破壞檢測在推敲出結論前需要熟習繪畫媒材、技法、程序與材料史，才能從大量的檢測物質中精準的挑出可能性物質並排除干擾物質，經過交叉比對篩選出最有可能的訊息，而非將訊息全部接收造成誤判。

〈陳澄波油畫打底材料與現代油畫材料中元素組成之比較〉是由張維敦教授所指導的博士生黃曉雯所撰寫。張教授是中央警察大學的鑑識科學專業的著名教授、著名刑事鑑識專家李昌鈺博士的傳人，除了教職之外更身兼「臺灣鑑識科學學會」理事長要職，是深具學術與辦案實務經驗的資深學者。張教授在參與此計畫之前便多次協助文保中心從事微物鑑識的專業技術，完成數次文物修復檢測的任務。此文是針對畫布打底用的展色劑所做的分析，使用掃描式電子顯微鏡／X射線能譜分析儀（SEM/EDS）的串聯系統，除了可得知樣品的表面形貌影像外，又可得到化學成分或是微細組織之相關資訊，具有非破壞性檢測、樣品前處理簡單等優點，因此十分適合在微量檢體檢測上之應用，對陳澄波的繪畫資料中無機材質的分析是國內第一次的嘗試，也是對於非破壞檢視的系統之外的另一種驗證技法，日後對於此類研究進路與培育保存科學年輕學者的加入，都會是一個重要的訊息與資料。

文保中心的修復師王瓊霞、葉濱翰二位雖然之前一直是以東方繪畫、紙質文物為第一專長，二人以既備的專業知識與教養在師大文保中心成立之後，在木島、鈴鴨二位教授的指導下，執行師大典藏品油畫的修復案行之餘年。此次除了共同加入油畫修復作業之外，王瓊霞提出〈陳澄波的木板油畫調查研究與修復〉而葉濱翰則提出〈文保中心油畫修復材料介紹與案例〉，這二篇文章除了介紹一般畫布為基底的作品修復之外，還有木板、紙板等不同基底材的油畫作品。除了修復技法之外，亦針對特質、纖維鑑定、材料運用等，成為國內首次介紹日本東京藝術大學油畫修復技法，將日本的論述、授課、實際執行等內容，鉅細靡遺地完整紀錄。修復內容彼此交流與公開的事項，是一開始便在最早1931年的《雅典憲章》中被特別提出要求的世界公約，此案具體的透明化實務記載與成果發表成為成功的國際交流案例，必可以成為業界參考與認同的重要資料。

六篇專文之後接著是油畫的修復報告書，除了將不同基底材區分並過程記錄之外，最重要的是將油畫作品依照「初次修復」與「再修復」二種類型處理。修復作業主要的任務是解除因自然老化、環境因素造成的損傷加以整理、維護、強化以延長作品壽命是最大目標，通常在適當的修復後都希望作品能在百年之內平安度過（適宜的保存環境與制度規畫下）。但是此案中再修復的作品僅不過歷經三、四年左右便需重修，主因是前次修復技法措施應用不當，因此修復者對作品狀況錯誤的判斷與粗劣行為對作品所造成的二次傷害之大是難以想像的。

### 三、林煥盛「臺北文化財保存研究所」

第16卷後段是「臺北文化財保存研究所」的林煥盛先生所負責修復的作品修復過程介紹，林先生是一位傑出而自我要求甚高的修復師，在日本京都著名的宇佐美松鶴堂學習書畫修復開始，數十年來他對東方書畫的保存修復始終抱持著相當的熱忱與挑戰，除了設立「臺北文化財保存研究所」的工作室之外，現在亦擔任雲林科技大學文資所的教師。在此次修復案中，負責處理膠彩畫、淡彩、書畫掛軸類以及藏書、手稿、明信片、東京美術學校圖畫師範科畢業證書、美術圖片等生活資料等多項品目。從2010開始到2013年，三年中完成修復如此數量的效率與成績，南北的奔波勞累亦可想而知。一個有使命感的修復家如林煥盛先生所言「希望保存上能提供出最適宜的處置之外，也能透過修復，詮釋陳澄波的『再現』」，故特於16卷的後段集結了他精彩的努力與成果。

## 四、結語

　　此次修復的陳澄波作品除了配合大展的參展作品之外，修復計畫幾乎包含了基金會所有已知的作品與文獻類，參與的修復單位更網羅國內、外各大重要修復團隊。文保專業教育在國內已推動十數年，但是一個非政府單位的民間基金會能夠在臺灣的文化界刮起如此颶風，回想當時實在是從一個讓人又怕又期待的事件開始。如今此案得到圓滿的成果，甚至讓海外參與的人士、專業團隊也領會到臺灣社會人文如此高水準的表現，深感師大文保中心能參與此案實在是莫大的榮幸。三年的經歷中，上千件需要修復的龐大工作量與修復期間作品安全管理的壓力，雖曾經令人感覺沈重、焦慮與忐忑，但是如今回想起來，欣慰與肯定卻是記憶中的絕大部分。

　　修復計畫執行中，由於同時必須與其他項目緊密配合，負責聯繫與整合的基金會總是不辭辛勞地穿梭奔波在各單位之間，將必須同時進行的展覽規畫、出版文宣、佈展、運輸、典藏、學術研討、國際交流、教育推廣……等一一到位，並力求完善的如期完成。基金會對於每一個狀況、細節、整合都事必躬親、不辭辛苦的嘗試、挑戰、積極的態度，更是此項國際巡迴大展能夠圓滿達成的最主要因素。雖然執行中許多思維、做法、行程曾遇到過困難或不順利，但是最後總是能看見主事者能與時俱進的研擬出一個成熟、適切的模式，並且一直推動著整個團隊朝著一個不曾動搖的目標前進。

　　特別感謝東京藝術大學的三位教授在日本、臺灣間忙碌的奔波與細心的指導，三年緊湊的作業下，師大文保中心面對了極大的挑戰，但是全體修復人員因此得到寶貴的實務經驗，珍貴的國際交流機會教育更促成了在現今教育課程中最難能可貴的人才培育資源。感謝陳澄波文化基金會與策展團隊對修復團隊的信任與配合，此修復案可謂是國內民間委託案中規模最大、最完整的案例，從保存修復、記錄、管理、參展到教育推廣，許多修復相關的想法與規畫都是從策展團隊與基金會的建言下，才得到修正、反省與學習的機會。

*

【註釋】

* 張元鳳為國立臺灣師範大學藝術學院文物保存維護研究發展中心主任。

1. 師大美術系成立於1945年，是國內歷史最悠久的美術教育單位，歷屆優秀師生留校校藏作品計約三千餘件，是臺灣近代藝術創作發展過程中重要的代表系列。

2. 陳芳玲〈轉身，擁抱驕陽──陳立栢與阿公心底的約定〉《典藏投資》第87期，p.164-167，2015.1，臺北：典藏雜誌社。

3. 原日文書名《油絵を解剖する─修復から見た日本洋画史》。

4. 1930年代都曾留學日本的作家們如陳澄波、廖繼春、李石樵、劉啟祥、洪瑞麟、張義雄等作家的作品。

5. 同註2。

6. 國際公認規範概略：1.三大倫理：安全性（環境、技術材料、人員安全）、歷史性（原創性、歷史紀念性）、完整性（現狀完整、原狀真相完整）；2.四項原則：預防性原則 Principle of Prevention、適宜性原則 Principle of Compatibility、相似性原則 Principle of Similarity、可逆性原則 Principle of Reversibility。

7. 參考本卷專文〈技術、美學與文化性的探討──以陳澄波作品保存修復為例〉，p.42-63。

8. 同上註。

9. 日文原文：明治前期の作品は堅牢で緻密な絵肌を持っている。明治後半期以降、時代が降るに従って絵の具層の耐溶剤性能が落ちる。水に溶解する作品も多い。

10. 國立民族學博物館名譽教授、著名材料技法專家。

11. 日文原文：この画家は油絵の体質を持っている。油絵の具の性質を十分に生かしている。その上で故郷台湾の風土に寄り添って描いている。東洋人としては極めてと特異な存在である。ぼくが探し求めていた条件を満たす数少ない画家だ。

12. 國內又稱為「畫布移植」，泛指直接以各式黏著劑將新畫布以托或襯的方式在貼黏作品背面，用以強化作品基底材的修復技法。一般以「蠟托裱」、「大麵糊托裱」、「高分子黏著劑托裱」為代表。

13. 非黏合式加襯：詳見木島隆康著〈從修復作品看陳澄波的繪畫技法與作品再修復〉。

# Chen Cheng-po Rediscovered: An Introduction to the Preservation and Conservation of His Works

## I. Foreword

Chen Cheng-po was representative of Taiwan people when Western painting first gained acceptance in the island. As well, he was a pioneer in receiving education in Western painting in Taiwan. Though he was educated in academicism, he managed to free himself from an art education system that tended to produce people from the same mold. Because the intense and willful nature of his works fully displayed his unique style as well as his noble thoughts and feelings, he has been dubbed "a naive painter from academia".

In 2010, amid much earnest expectation, Chen Cheng-po Foundation ("the Foundation") embarked on planning a series of events for staging in 2014 under the theme "Chen Cheng-po's 120th Birthday Anniversary Touring Exhibition in East Asia" (the "Touring Exhibition"). The aim was to bring out through the artist's various works his passion towards art and his dynamic vitality so that the nature and attitude of the creation of an artist who aspired to be "oil paint incarnate" could be truthfully revealed. For this reason, curated in this exhibition were works spanning different media including Western oil paintings, watercolors, pencil sketches, charcoal sketches, ink pen sketches, pastel drawing, and designs; oriental artworks including glue color, ink-wash, and calligraphy; as well as daily correspondence and manuscripts. Volumes 15-17 of *Chen Cheng-po Corpus* are compilations of essays mainly on the conservation of the artist's works and details of the treatment procedures. The conservation work was carried out separately by three institutions: Volume 15 and the first part of Volume 16 are concerned with conservation works carried out by the Research Center for Conservation of Cultural Relics (RCCCR), National Taiwan Normal University. While Volume 15 deals with paper-based works, the first part of Volume 16 deals with conservation of oil paintings and cultural objects jointly carried out by RCCCR and the Tokyo University of the Arts. The second part of Volume 16 concerns with the conservation of daily life related historical materials and oriental paintings carried out by conservation expert Lin Huan-sheng's Taipei Conservation Center. Volume 17 is the responsibility of Cheng Shiu University Conservation Center. In this essay, we will introduce one by one the essays on treatment procedures and conservation approaches undertaken by the above conservation institutions in dealing with various types of artworks. Through the processes of treating artworks and historical materials as well as the presentation after treatment, a complete and transparent conservation process is formed. As a result, a comprehensive and multi-angle interpretation of the legendary but short life of Chen Cheng-po is given in terms of his art and his education, as well as the trends of the art world in his time and the messages of creation in his mind.

## II. RCCCR

In the current project, the items treated by the RCCCR comprised almost all types of artworks attempted by Chen Cheng-po, ranging from oil paintings, oriental artworks (glue color, ink-wash, and calligraphy), watercolors, pencil sketches, charcoal sketches, ink pen sketches, pastel drawings and design drafts as well as the artist's daily correspondence, original of manuscripts, and his wills. In total, there were 1,012 items and 29 sketchbooks to be treated. In dealing with such a complete range and large

of items as well as a tight exhibition target date, the task of conservation was no longer limited to the application of techniques, but had also required the quick consolidation of conservation guidelines and the development of a suitable safety support system in the limited time available. Apart from repairing the aging damages of the cultural objects, the goals of the conservation also included ensuring that these objects were in the safest conditions when being moved around from one exhibition to another later. In addition, in order to ensure the completeness of the conservation operations for the various types of artworks and that the values (study value, display value, and market value) of the artworks were fully revealed through the treatment process, RCCCR had laid down three conservation principles of different significances for this project:

1. Conservation principles for works of "established art forms":

   Total 37 items: including 36 oil paintings and one glue color painting

2. Conservation principles for works which "works of historic significance":

   Total 29 sketchbooks and 963 artworks: including 71 watercolors, 71 charcoal sketches, 763 single-sheet pencil sketches, 6 sketchbook enclosures, 7 ink paintings, 23 calligraphies, 4 design drafts, 4 paper cuts, 4 illustrations, 9 watercolor nude sketches, and 1 pastel.

3. Conservation principles for "historical materials and cultural relics":

   Total 12 items: including 9 wills, 2 final garments, and 1 photograph.

**a. Establishment of conservation project**

The RCCCR was founded in 2009 as a specialized domain for carrying out education and research in and execution of cultural object conservation. Initially, its mandate was mainly to treat the in-house collection[1] of the National Taiwan Normal University (NTNU) but it could also take on outside conservation projects. In 2011, on accepting a project from the Foundation, a team designated to treating Chen Cheng-po's work was established. The most distinctive feature of this team was the participation of Professors Utada Shinsuke and Kijima Takayasu and their favorite student Suzukamo Fujiko. They all came from Tokyo University of the Arts (TUA), which was formerly Tokyo School of Fine Arts or the alma mater of Chen Cheng-po, and led the investigation, research, and the conservation of oil paintings in the project.

TUA is a school where friendship among fellow students is given a high priority. There are frequent exchanges among students from different fields when they attend together various courses and ancient art studying trips, or when they participate in art festivals, competitions, and exhibitions. One unusual custom in the school is that students like to stay behind on campus. They may take refuge in study rooms to make artworks or explorations in art incessantly. In their break times, they like to go to the study rooms of other students to make small talks. In the middle of the night, some may dodge the campus police to continue producing artwork. This custom of carrying out discussions, cheering up and competing with each other, coupled with the facts that the age-old campus is not very large and that teachers and students are familiar with each other, has resulted in alumni continuing to take care of each other and staying in touch through various channels. Initially, this conservation project was also born out of

connections among alumni and support from the alma mater. Just as Chen Li-po, chairman of the Foundation said in the article "Turn Around and Embrace the Scorching Sun—The Unwritten Understanding between Chen Li-po and His Grandpa", "It was not until 1997 that the then director of Taipei Fine Arts Museum Dr. Lin Mun-lee introduced us to TUA master conservator Utada Shinsuke and asked us to send the works [of Grandpa] to Tokyo for treatment. To show his support toward an alumnus, Prof. Utada made the conservation of the paintings *Hill* and *Chiayi Street Scene* into lesson case studies so as to absorb 40% of the conservation fees. The remaining 60% of the fees would then be raised by Chen Tsung-kuang." [2]

Prof. Utada is a pioneer of Western painting conservation in Japan. Aside from his excellent skills and experience in conservation, he has unparalleled knowledge in Japan's history and legacy of receiving Western influence in the Meiji era and in related studies of painting materials and techniques. Upon his graduation from TUA's oil painting techniques and materials course, he has been dedicating to the conservation and treatment technologies in oil paintings. He has successively been director of the Institute of Conservation at the Sokei Academy of Fine Art & Design and professor of TUA. In the latter capacity, he has founded a course in oil painting conservation and treatment and has been concurrently the first director of the University Art Museum. His book *The Anatomy of Oil Paintings—The History of Western Painting in Japan from the Standpoint of a conservator* [3] is an important work in which he comprehensively discusses painting materials and techniques in relation to historical changes in painting. In the book, he cites the characteristics of the works of Japanese pioneers such as Takahashi Yuichi, Kuroda Seiki, and Kishida Ryusei who had been influenced by Western painting in the "agitated period" from the late shogunate period to the Meiji era. Starting with the places where conservation is carried out and the materials and techniques employed in painting such as the techniques in making oil paintings, pigments and painting canvas, he analyzes in depth the changes after Japan has been influenced by Western ideas in terms of the space, light, and methods of depiction in painting and approaches in introducing picture images. Upon his retirement, Prof. Utada has become a professor emeritus and recommended his favorite student Kijima Takayasu to succeed the directorship of the research laboratory at TUA. As it continuously conducts a number of important research and conservation projects, this research laboratory has become a prime conservation research laboratory in Japan in which work, teaching, and research related to conservation take place and from which international conservation teams are deployed.

In 2007, after he had finished treating seven important curated works [4] (two of which were paintings by Chen Cheng-po) commissioned by Taipei Fine Arts Museum in 1998, Prof. Kijima continued to take on the conservation of three paintings commissioned by the Foundation, so in all, he had treated five representative paintings by Chen. When the "Project for the Conservation of Chen Cheng-po's Works" was established by RCCCR of NTNU in 2011, Dr. Suzukamo also joined the conservation team and the base for carrying out conservation was formerly moved to RCCCR. This decision not only allowed the on-site conservation of the works and convenient access to information and opinions of Chen's family members, but also made it possible to directly nurture a batch of new-generation conservators through the bringing in of foreign teaching staff and techniques. The only drawback was that in the three years' time, the foreign teachers had to endure the hardship of traveling back and forth almost every month, and some of them even had to pass their New Year Days twice in RCCCR. At this juncture,

techniques. The only drawback was that in the three years' time, the foreign teachers had to endure the hardship of traveling back and forth almost every month, and some of them even had to pass their New Year Days twice in RCCCR. At this juncture, I cannot help but once again convey my heartfelt gratitude to their dedication. In the words of Chen Li-po, "NTNU's RCCCR had the fortune of inviting Utada Shinsuke's student Kijima Takayasu to head the Chen Cheng-po Foundation-NTNU conservation project. In the last two years, I was deeply moved by the way he conducted himself: almost every month he would come to Taiwan along with his assistant Suzukamo Fujiko. By sticking to the reckoning standards of NTNU, they put themselves up in one of NTNU's dormitories and always ate casual food for almost three years as of now. As a result, the room and board expenses they incurred were three to five times cheaper than would have been otherwise possible. Afterward, Kijima even donated all of his fees from the project to RCCCR, meaning that he had not taken even one dollar away. I was truly moved. Moreover, it was him who persuaded me and let me realize that 'if correct conservation work was still not properly carried out, all media for future promotion would have been lost.'"[5]

Clear-eyed and intelligent, Dr. Suzukamo is a favorite student of Prof. Kijima. As a representative of Japan's new generation of academia-trained conservators, her professional prowess has never been questioned. What is unusual is that she has graduated with honors from Nippon Medical School before courageously deciding to join Prof. Kijima's research laboratory and dedicate herself to the profession of conserving and treating cultural objects which she likes best. Not only is she knowledgeable in general conservation technologies, her former medical training has also set her apart from conservators with an arts background and makes her conversant with aspects of physical and chemical sciences, technology, and material analysis. In the conservation team, Dr. Suzukamo's duty was not confined to carrying out conservation; she was also responsible for communications between the Taiwan and Japan parties as well as the planning of the conservation schedule and the consolidation of conservation efforts. She has a stable and poised disposition, and she treats people with sincerity and cordiality. No matter how tired she is from traveling, she always wears a smile when dealing with complicated trivialities and would always be patient in explaining to young students and in meticulously confirming every step in a process. When one sees her in her white lab coat working ever so quietly around the conservation laboratory that is full of "patients", one cannot help associate her with the very similar story about Florence Nightingale one often heard about as a kid and conclude that she is the best demonstration of the saying that "earnest dedication is a blessing". Conservators are medical personnel for cultural objects; a person endowed with such a personality upbringing and professionalism in conservation while also having a passion for arts is truly a rare talent.

## b. Synopses of NTNU essays

This volume brings together and explains the concepts, methods, and studies involved in the current conservation project. As a compilation of 11 essays, its contents are all based on the linking up and explanation of the features of the artworks and conservation technologies. Due to typesetting and editorial reasons, the essays are divided into sections, viz. conservation of paper-based works (Volume 15) and conservation of oil paintings (first part of Volume 16). Though the authors of these

essays are different, in actual practice, the detailed conservation procedures and division of labor were carried out through the collaboration of all team members after standardized conservation principles were determined through discussions.

(i) Essays on the conservation of paper-based works

The conservation principles provide direction to the setting of ethical concerns[6] in conservation. Their roles are to establish a common benchmark and to achieve consolidation for the large number of complicated conservation procedures involved. Furthermore, as the value of an artwork or a cultural object can be broken down into study value, display value, and market value, the setting up of principles is also meant to prevent the ignoring or distortion of the value inherent in an artwork or cultural object during the conservation process. In the following discussion, the focus is on the conservation operations on the paper-based works of the current project (total 1,012 items and 29 sketchbooks minus 36 oil paintings). The paper-based items include ink paintings, calligraphies, watercolors, sketches (pencil and charcoal), sketchbooks, wills, etc. The categorization and use of various conservation methods will be discussed.

In Asia, the conservation procedures of paper-based cultural objects have always been closely related to traditional mounting methods and oriental painting and calligraphy. Since ancient times, the methods of mounting have been passed on from China to neighboring areas such as Korea, Japan, and Southeast Asia with profound effects. In modern times, Western countries have also begun to realize and agree that mounting technologies could help raise professionalism in conservation. Subsequently they have started studying and applying such technologies. But when a culturally habitual treatment becomes an over-relied-upon measure, sometimes it is necessary to re-assess how the line of "appropriateness" should be drawn. For example, when it comes to items such as books, Western paintings (including watercolors, engravings, drawings, and files), yarn-dyed fabrics, tankas, rubbings, and photos, various problems would often arise, including "using Chinese mounting on Western paintings", causing too much changes in thickness and weight, over-flattening of depressed and raised areas, damaging of textures, etc.

The epochal significance of Chen Cheng-po's paper-based works lies in the historical background that they are testimonies to Taiwan's liberation from traditional Chinese art forms to reception of Western art education for the first time. Consequently, among the large number of works, there are sketches, paintings from life, still lifes, etc—works that recorded his footprints in life. There is evidence of Western influence in Chen's choices of media and composition. For example, he employed the use of charcoal, watercolor, pencils, and sketchbooks among others. Among the substrate materials he used there were also a large quantity of paper imported from the West or produced under Western influence. For this reason, in terms of the logic in retaining historical characteristics, works using Western paper should be treated mainly by Western conservation methods. Yet, as a consequence of the then world trend of mechanical mass production of paper, even artists such as Chen Cheng-po who were particular about the materials they used could not foretell the after-effects of using "acidic paper"[7]—as paper was rendered acidic during production and treatment processes, problems of yellowing and brittleness tended to crop up later. This is not just a problem confined to Chen's works, but is a crisis affecting many of the world's artworks, great books, files, and photos. In

fact, this type of paper is still being produced and the problem is still arising. What is the most appropriate method to conserve this type of acidic paper is a key discussion point for each paper in the following sections. The five related essays below are categorized according to the substance of the procedures:

1. Chang Yuan-feng, "Technique, Aesthetics, and Culture: Perspectives from the Conservation of Chen Cheng-po's Works of Art"

2. Perng Yuan-shing and Hsu Chien-kuo, "Microscopic Study of Paper: Preparation of Slides and Species Determination of Paper Fibers"

3. Ding Wen-chian, "Conservation Treatment of Chen Cheng-po's Calligraphy and Ink Paintings"

4. Melody Chen, "Versatility of Paper: Considerations and Applications of Chinese, Taiwanese, and Japanese Paper for Loss Infilling and Reinforcement"

5. Lee Chi-heng, "Conservation of Chen Cheng-po's Works on Paper: A Multi-perspective Study on the Use of Conservation Materials"

The focus of the essay "Technique, Aesthetics, and Culture: Perspectives from the Conservation of Chen Cheng-po's Works of Art" is on how to set conservation principles and integrate conservation operations. The question of when best to use the "lining" method is also discussed. It is commonly agreed that the use of Chinese style first lining on a piece of artwork for reinforcement and smoothing out will result in convenience in subsequent management and stabilization. But out of cultural considerations and a respect for the nature of cultural objects, the author has readjusted and integrated operational procedures and treatments. In particular, out of respect for the cultural characteristics of the works, he has introduced some new concepts in dealing with the reinforcement, preservation, and display of paper-based Western works. For example, he has introduced the application of tengujo[8], a kind of very thin and light-weight handmade Japanese paper; as well as the use of acid-free mounting frames, matting, and display systems. There are two main areas of discussion in this essay, namely, "Reinforcement of Artworks—Application of Tengujo" and "Protection of Artworks—Application of Acid-free Mattings".

The author has not limited himself to the advancement of science and technology because, in the current project, there are cases in which artworks that have undergone conservation just a short time ago are requiring conservation again. So during conservation, in addition to admonishing that conservators of cultural objects should bear in mind the ethical concerns of conservation, the author, from the standpoint of an educator, brings up the importance of "conservation aesthetics" in the professional development of conservators. He suggests leaving suitable space for carrying out dialogues between art and technology as well as between subjectivity and objectivity so that there will be flexibility in future planning.

The essay "Microscopic Study of Paper: Preparation of Slides and Species Determination of Paper Fibers" is a report by Perng Yuan-shing and Hsu Chien-kuo on their findings after carrying out identification of paper fibers. Both Mr. Perng and Mr. Hsu are famous scholars in the paper industry in Taiwan. Moreover, there is an abundance of talents in the (Taiwan)

Forestry Research Institute where Mr. Hsu works, including, for instance, former staff Wang Kuo-tsai and Prof. Chia Tsang-chi, who are both passionate in studying paper and in R&D related to conservation of cultural objects. Mr. Hsu himself is a student of both Prof. Chang Feng-chi, a forerunner in the research of handmade paper in Taiwan; and Master Tsen Te-lin of Songyun Lodge fame, who had been active in Taiwan more than a decade ago. Other than being well versed in conservation techniques for various types of paper-based cultural objects, Mr. Hsu also has considerable practical experience in the identification and production of paper and in reviving ancient paper-making technologies. By employing scientific methods, he can identify all types of paper fibers and paper characteristics. Here we would like to convey our gratitude for their sparing time in their busy schedules to lend us their expertise. Chen Cheng-po's paper-based works include both Western and oriental art forms drawn on Chinese paper, Japanese paper, or Western paper imported into Japan at that time. The fibers found in these types of paper are not only characteristics of paper often used in the art circle in his time, but are also a fundamental judgment before one embarks on treating his works. As such they are indispensable in guiding the conservation work.

Have you ever seen Chen Cheng-po's calligraphy and his handwritings in ink painting? It is hard to imagine how, under excitement and trepidation, one can treat those rare coursework he produced in his youth days. In her essay "Conservation Treatment of Chen Cheng-po's Calligraphy and Ink Paintings", Ding Wen-chian serenely describes in minimal words the processes of treating calligraphy and ink-wash paintings. To Ms. Ding herself, it was an experience in which she was momentarily stunned when she first came into contact with the works, followed by a quick succession of procedures including acknowledging receipt after checking, inspecting and testing, keeping records, planning, executing conservation, obtaining approval, collecting information, transporting, scanning, and submitting treated works. Afterward, when she was writing her paper, she could not help but think of the many nights in which she strained her heart and mind in the conservation, as well as her reluctance in seeing the treated works being sent back to the Foundation. "If I were given more time, I would like to take one more look!" she said. This is a sentiment shared also by the authors of the next two essays, and even by every member of the conservation team. Under normal circumstances, artworks and material of such importance would only be sent to the conservation lab one or two pieces, or at most in single digit quantities at any one time and meticulous conservation would take several months. Under the tight schedule of the current project, all conservators have done their best and contributed what they have learned in life in turning in the treated artworks to the Foundation on time. Though all treated works were completed and granted approval successively (after postponement in turning in has been requested and granted several times), a period of three years in dealing with all the items day and night is still considered too short (on average, only one day for each item), so until now, Ms. Ding is still wary that she has no time to give each item one last look to check for omitted areas. From Chen Cheng-po's handwriting in his calligraphy classwork, she discerns that he was a serious student. Though the teachers' comments in red ink on the edge of the pages have already turned from vermilion to sepia, the advising teachers' care and intent in providing untiring guidance can still be felt today. From this, one cannot help to have in mind a picture of the classroom [in the Tokyo School of Fine Art] where top students from all over Japan selected into attending were considered brilliant artists of the future. These are typical artworks which "also have significance

as historical materials". Because they exhibit both a historical style and an artist's personal style, viewers with different standpoints may have very different opinions on what should be the results of conservation efforts. Discussed in Ms. Ding's essay are a total of 30 paper-based items, including 23 calligraphies and 7 ink-wash paintings. These are works made in the period from 1924 to 1927 and have not seen any lining. Red ink which have changed color and those that have not are subjected to non-destructive examination by an X-ray fluorescence analyzer (XRF). The results have been compared with standard red lead and vermilion samples to find out the cause of color change. The conservation principles for these types of artwork are then complemented with the cultural characteristics of oriental mounting techniques. Therefore, in this essay, there are descriptions on the use of specific paste for conservation, applying first lining, applying second lining, infilling losses, inpainting, silk mounting, etc.

Having a similar line of thought is the essay "Versatility of Paper: Considerations and Applications of Chinese, Taiwanese, and Japanese Paper for Loss Infilling and Reinforcement" by Melody Chen. In this essay, the processes for treating deterioration of the type of paper used by Chen Cheng-po for various Western art forms including sketches, watercolors, and sketchbooks are described. Ms. Chen is trained in Western conservation methods and holds a Master's degree. Upon her graduation, she came to Taiwan to focus on conservation strategies and techniques that span across Eastern and Western cultures. In the current conservation project, the key is to make full use of a strong suit of Western conservation techniques—de-acidification—to ensure that the artworks in question will no longer be acidic and will gradually turn neutral and thus become more stable. As the most important safety issue in conservation, de-acidification consists of turning the acidity of an artwork into close to neutrality and using neutral protective materials to provide an environment that prevents further acidification. Though the technique of de-acidification has been developed long ago in the Western world, different conservation labs have different ways of adapting it for different treatment objects. Apart from de-acidification, other techniques have also been mentioned in this essay. For example, for watercolors on paperboards, a two-stage filling up of damages using dry and wet pulp fibers respectively can be applied. In the conservation of sketchbooks, a combination of pure pulp fibers, Xuan paper, Taiwan kozo paper, tengujo, and Hosokawa paper have been extensively used. For the protection of spiral binding sketchbooks, a compound binding and an increase in the width of the spine have been devised. In all, though a multitude of materials and methods are used, presentation methods that bring out Western characteristics as far as possible are a unique and interesting part of this essay.

Though Lee Chi-heng is a project technician with the least qualifications in the team, he is recognized by all as a super assistant because of his passion towards conservation and the concentrated efforts he has applied. In the essay "Conservation of Chen Cheng-po's Works on Paper: A Multi-perspective Study on the Use of Conservation Materials", he mainly talks about substrate materials and explains the characteristics and application methods of materials used specifically for conservation. In describing the details of the choices and properties of conservation materials used in the conservation of paper-based works in this project, he illustrates the importance of choosing the right materials by discussing the chemical properties of non-acidic materials and the ethical concerns in the conservation of cultural objects. He emphasizes that the choice of materials and the intents of their use is special knowledge by itself because, from the moment a piece of treated artwork leaves a conservation lab,

it will constantly subject to transportation, exhibition, curation, and even conservation again after decades or centuries. Upon finishing the current conservation project, Mr. Lee has gone abroad to Germany to further his studies. I would like to take this opportunity to wish him good luck and every success in his pursuit to be a professional conservator.

(ii) Essays on the conservation of oil paintings

The first half of Volume 16 contains essays related to the three TUA experts who have come to Taiwan to cooperate with RCCCR in treating Chen Cheng-po's oil paintings. There are a total of six essays: one essay from each of the Japanese conservators, one from a domestic appraisal expert and two from in-house conservators from RCCCR. These are:

1. Utada Shinsuke, "A Discussion on Chen Cheng-po's Works of Art"

2. Kijima Takayasu, "On Chen Cheng-po's Painting Techniques and the Re-conservation of Artworks"

3. Suzukamo Fujiko, "The Oil Paintings of Chen Cheng-po: An Examination of Painting Materials through Treated Artworks"

4. Huang Hsiao-wen and Chang Wei-tun, "A Comparison between the Elemental Composition of Chen Cheng-po's Oil Paintings and Modern Oil Painting Materials"

5. Wang Chiung-hsia, "Analysis and Treatment of Chen Cheng-po's Oil Paintings on Wood Panel"

6. Yeh Pin-han, "Oil Paintings Conservation Materials at the Research Center for Conservation of Cultural Relics: An Introduction and Case Study"

The first three essays are detailed discussions borne out of much research and conservation practice and deal with aspects of history, style, the conservation methods used in this project as well as materials and techniques used in painting. The open sharing of invaluable experience and technology by the three Japanese experts is not only the first instance of a comprehensive explanation of Japanese oil painting conservation technology. What is more important is that it has stepped up the pace of technical exchange through tutoring and practical demonstrations.

In his essay "A Discussion on Chen Cheng-po's Works of Art", Professor Utada discusses the course of change in Japanese painting after the country had undergone Western influence. His discussions have touched on the origin and development of early period artists as well as their characteristics, painting styles, the materials and techniques they employed, and the thread of future development. After examining [Japan's] Western paintings at the nascent stage all the way to the rise of academicism, he discusses the Japanese painting circle from a commanding height and traces the thread of relationship between the Japan and Taiwan art circles by focusing on Chen Cheng-po. From Prof. Utada's concise and germane description of the key early stage information, we can clearly see the brilliant comments on the materials and techniques of Asian oil paintings at the early stage when Japan was under modern Westernization development. In particular, the essay has dealt at length with the course of changes in trend in Japanese painting. As regard the material and constitution of oil painting, he thinks "Artworks from the early Meiji era (Bitumen School/Violet School) are robust in structure and refined in texture. When it comes to the second

half of the Meiji period, along with the trends of the time, the solvent resistibility of oil paint layers saw a gradual decrease and there was an increase in the number of works in which the paint layers dissolved easily in water."[9] He and his friend Morita Tsuneyuki[10] both agree that the reason why early oil paintings were called "oils" because the oil mixed in the paint displayed an oily luster and stickiness, so in the essay, Prof. Utada stresses that "As the concept of oil painting was passed to the East, what caught the attention of Asian painters was the unrestrictive creative spirit under the then new movements, so much so that painters were always focused on quickly capturing the new trends passed on from European art circles. In contrast, they had ignored materials and techniques which were such important basics to support the new approach of presentation...Under such an ambiance, painters started to add inappropriate volatile solvents as thinner or simply used them in combination so that paints could be applied quicker. And this was a characteristic of 'Asianized' oil paintings."

Yet, at a time when Japan was engrossed solely in going after novelty, Chen Cheng-po was still focused on the basic nature of oil painting while maintaining an unembellished style and a passionate painting method. So when the spotlight returns from materials and techniques back to Chen's personal style, Prof. Utada thinks that "the works of this painter are replete with the constitution of oil paintings; he had allowed a full display of oil paint properties and used that to aptly depict the lands and customs of his Taiwan homeland. Among Japanese under the then prevailing ambiance, his existence was very special and he was one of the few people who can meet my standard of an ideal artist."[11]. In Prof. Utada's description, Chen Cheng-po was not unthinkingly imitating Western artists such as Van Gogh, Cézanne, and Renoir. Instead, he was naturally letting out his pre-existing pattern and ideal. As such he was at that time already an uncommon painter with his own unique style and an "international painter who can represent Asia". So "when Chen Cheng-po was studying abroad in Japan, what was he really thinking about?" Summing up Prof. Utada's high regards on Chen Cheng-po's works, it is not difficult to see that, through Chen, the scholar is expressing his view on the missteps and shortcomings in the course of development of Western painting in Japan, and this view may also include a deep sense of rethink. These suggestions serve also to forewarn modern artists what kind of artwork would be recognized internationally and be passed on to later generations.

The next essay is "On Chen Cheng-po's Painting Techniques and the Re-conservation of Artworks" by Prof. Kijima. Like Prof. Utada, he is also a scholar who is qualified to make direct comments from the standpoint of an artist and that of a conservator. Just like Prof. Kijima's steady and straightforward personality, right from the beginning, this essay points out Chen Cheng-po's painting style and technique characteristics. These are concisely and objectively expressed conclusions he draws from the combined knowledge of the development of painting materials and techniques, the development of conservation materials and methods, and scientific testing and verification methods. Prof. Kijima excels at using this type of deconstruction method in successively describing the characteristics of an artwork. With his keen perception, he can eliminate at a glance factors due to conservation or aging and directly discern the essential characters of an artwork. This essay is undoubtedly highly accurate and authoritative because it is written from a multitude of angles by an expert who is passionate about art and has treated countless masterpieces, and is a condensed summary of the operation records and observations at the conservation site. To me

personally, the main reasons why Prof. Kijima's attainments in art, conservation, and appreciation have commanded so much respect are, besides his keen insight and refined presentation skills, his empathy, his kind and sincere attitude, and his unforced and uncontrived nature that deals with everything with calmness. This nature is demonstrated not only in the way he deals with people but also in his conservation practices. No wonder that when many complicated artworks land on his desk, they would be treated without causing a fuss. That is why he is deservedly a successful and respected "conservator extraordinaire".

In 1998, Prof. Kijima was commissioned by Taipei Fine Arts Museum to treat the two oil paintings *Chiayi Street Scene* (1934) and *Summer Street Scene* (1927). On completion of the assignment, he was once again commissioned in 2007, this time by Chen's family members, to treat three important works, namely, *Downtown Chiayi* (1934), *Hill* (1936), and *Woman* (1931). In the current project in which he began treating 36 pieces of works in 2011, he has continued to use the conservation methods he used previously: instead of the "adhesive lining"[12] method of reinforcement traditionally used for oil paintings in Taiwan, he has switched to the use of a "loose lining"[13] method. In this essay, Prof. Kijima painstakingly and plainly lays out the conceptual and procedural differences between the two methods. An example given is a work which has undergone wax lining treatment in recent years but has to be treated again. Prof. Kijima points out that the problem in the previous conservation is not simply the choice of using wax lining. Rather, much of the problem concerns improper handling and misguided attitude. As a result, the canvas substrate material was separating, the paint layer was distorted from over-application of heat, and the paints applied during retouching were covering up the original paints. All these point to a lax in professional ethics on the part of the conservators concerned. In fact, the ideas and actual practice laid out in the essay have all along been the ethical concerns reiterated constantly by conservationists in cultural objects when they are teaching. Thus this essay once again allows conservators a chance to understand the international consensus involved. Furthermore, through this essay, art lovers and stakeholders in cultural assets can also understand the importance of self-restraint on the part of conservators. History and facts have shown that the myriad of materials and methods will change or evolve with time and prevailing concepts, so there are no definite rights and wrongs in the materials and methods themselves. Rather, what determines the success or failure of conservation is "attitude". An astute conservator will comply with internationally recognized principles, appropriately choose suitable conservation materials and methods, and accomplish his task at the present stage by remaining faithful to the ideas of the originating artist. His objective is to transfer the cultural object safely to the next generation. Given that a cultural object is aging and fragile, conservation is only a measure of last resort and there is no permanent or magical solution. Correct conservation planning and long-term conservation strategy are the only way to maintain everlasting co-existence with cultural objects.

Another key area that complements the conservation profession is the development history of conservation materials and methods, which can provide supplementary information on prevailing social and humanistic circumstances, technological development, and international exchanges. Knowledge on the development history of materials and methods requires the accumulation of a lot of research results and the support of scientific and systemic archive management before a database of

practical value can be established. A well-established database can help the objective comparison of data so that records from a single piece of artwork to that of a region or even to the characteristics of cultural DNA. In Japan, as a result of surveys on painting materials and techniques and the driving needs of conservation projects, there is already a considerable cumulation of information. In Taiwan, due to advancement in non-destructive technologies in the last decade, the system and performance of information gathering are already quite mature. Yet there is still a lack of connection between Japan and Taiwan. Dr. Suzukamo's essay "The Oil Paintings of Chen Cheng-po: An Examination of Painting Materials through Treated Artworks" is the first that links up the two places. It focuses on Tanabe Itaru, the most important advising professor of Chen Cheng-po when he was attending a course in art teaching at the Tokyo School of Fine Arts. Dr. Suzukamo begins by explaining Mr. Tanabe's influence in the school by examining his teaching and the characteristics of the painting materials and techniques he used. Then she summarizes the characteristics of the painting materials used by Chen Cheng-po from his studying period at the Tokyo School of Fine Arts to the period in which his style changed when he was in Shanghai upon graduation and the period after he returned to Taiwan. These characteristics are deduced from a comparison of his works, from various conservation operations, and from precise scientific examination. The materials described in this essay include paints, canvas, wooden boards and paperboards. Today, with the frequent use of non-destructive inspection technologies, a large quantity of information can be easily gleaned. Yet without accurate judgment, specious information may be obtained. This essay provides us with a very clear guideline: before conclusions can be drawn from results of non-destructive inspection, we have to be familiar with the media, techniques, and procedures of painting and also with the history of materials before we can pick out probable matters out from the large quantities of results from the inspection and eliminate interfering ones. We should sieve out the most probable messages through cross-comparisons instead of accepting all messages and make the wrong deduction.

The essay "A Comparison between the Elemental Composition of Chen Cheng-po's Oil Paintings and Modern Oil Painting Materials" is written by Prof. Chang Wei-tun's doctoral student Huang Hsiao-wen. Prof. Chang is a famous professor of forensic science at the Central Police University and a successor of renowned forensic scientist Dr. Henry Lee. Prof. Chang is a leading scholar with eminent academic credentials and abundant case handling experiences who is chairman of Taiwan Academy of Forensic Sciences in addition to his teaching post. Before participating in the current project, Prof. Chang has on numerous occasions helped the RCCCR in carrying out microscopic identification and has completed several assignments in the examination of treated cultural objects. This essay describes the analysis of material used in priming canvases. By using a serial system of a scanning electron microscope and an energy dispersion spectrometer (SEM/EDS), not only can we know the surface topographic image of a sample, but we can also get information related its chemical composition or microscopic structure. Such a system has the advantages of being non-destructive and requiring only simple pre-treatment of samples. As such, it is very suitable for use in trace specimen examination purposes. This is the first attempt in Taiwan at analyzing the inorganic materials in Chen Cheng-po's paintings. It also represents another verification technique outside of the non-destructive examination system. The analysis provides important messages and information to researchers who wants to adopt

such an approach and to the nurture young conservation scientists.

For conservators Wang Chiung-hsia and Yeh Pin-han, the conservation of oriental paintings and paper-based cultural objects used to be their primary specialty before they joined RCCCR. After the establishment of RCCCR, with the professional knowledge and education they already possess and the guidance given by professors Kijima and Suzukamo, they have been carrying out conservation of NTNU's oil paintings for more than a year. In the current project, in addition to participating in the conservation of oil paintings, Ms. Wang has proposed carrying out "Analysis and Treatment of Chen Cheng-po's Oil Paintings on Wood Panel" while Mr. Yeh has come up with "Oil Paintings Conservation Materials at the Research Center for Conservation of Cultural Relics: An Introduction and Case Study". The discussions of these two essays are not limited to conservation of artworks that have canvas as base material, but also ones drawn on wooden boards, paperboards, and other base materials. In addition to describing their conservation methods, they have also focused on the characteristics [of conservation materials], identification of fibers, and the use of materials. As such, these two essays are the first time that TUA's oil painting conservation methods are ever presented in Taiwan; they are also comprehensive records in which the discussions, lectures, and actual implementation of methods by the Japanese experts are all included without fail. It is noted that items arising from exchanges related to conservation projects should be disclosed has already been mentioned in the Athens Charter in 1931. The transparent recording of operations and the publishing of results of the current project are a successful case of international exchange and will definitely serve as important information for reference and for identifying with for the sectors involved.

Following the above six essays are the reports on the conservation of oil paintings. Apart from differentiating artworks based on different base materials and keeping records of the respective conservation processes, the most important approach is to divide the oil paintings into "first-time conservation" and "re-conservation" lots and deal with them accordingly. The main task of a conservation operation is to eliminate damages due to aging and environmental factors and to lengthen the life of the item concerned through tidying up, maintenance, and reinforcement. In general, the objective of appropriate conservation is to allow a piece of work to last for 100 years (under suitable preservation environment, system, and planning). In the current project, the works requiring re-conservation have only undergone conservation for three to four years. The main reason is that the methods and actions taken in the previous conservation are inappropriate. This shows that the wrong judgment of an item and poor actions on the part of a conservator would impart incalculable secondary damages to the item.

## III. Lin Huan-sheng's Taipei Conservation Center

The second part of Volume 16 describes the processes of conservation of artworks under the responsibility of Lin Huan-sheng of Taipei Conservation Center. Mr. Lin is an outstanding and very self-demanding conservator. Since learning conservation of paintings and calligraphies at the renowned Usami Shokakudo in Kyoto, over the decades his zeal in the conservation of oriental paintings and calligraphies has remained high. In addition to the setting up of a studio at Taipei

Training Department of the Tokyo School of Fine Arts and art pictures. From the large number of items he has treated within the three years from 2010 to 2013, we can imagine the heavy traveling schedule and workload he has gone through. Since a conservator with a sense of mission like Mr. Lin has said that his "wish is to provide the best treatment in conservation and to be instrumental in the 'reemerging' of Chen Cheng-po through the conservation," we summarize his brilliant efforts and achievements in the second part of Volume 16.

## IV. Conclusion

Apart from artworks meant for the Touring Exhibition, the current conservation project encompasses almost all artworks and documents known to the Foundation. Moreover, the institutions involved in the project include a number of major conservation teams both at home and abroad. Education in the conservation of cultural relics has been promoted in Taiwan for more than 10 years, but it is hard to imagine that a non-government, private foundation can create such an impact in Taiwan's cultural sector. Thinking back, this was then an incident that had people frightened and yet expectant. Now the project is so successful that even foreign participants and professional teams have come to appreciate the high social and humanistic performance of Taiwan, RCCCR is much honored to be involved. In the course of three years, the huge workload of having to treat over 1,000 items and the pressure from managing the safety of the artworks have invariably led to anxiety and apprehension, but now in hindsight, most of the memory is that of satisfaction and being recognized.

When the project was underway, because of the need to coordinate closely and simultaneously with other projects, the Foundation, which was responsible for liaison and consolidation, had to take up the trouble of going back and forth among different institutions for details in exhibition planning, publication and publicity, exhibition set up, shipping, curating, arranging seminars, fostering international exchanges, and carrying out education promotion so that every activity is completed successfully on time. The key to the success of running this international touring exhibition is the Foundation's hands-on handling of each situation, detail, and coordination while dealing with all sorts of challenges actively. Though difficulties and stumbling blocks were encountered in executing some concepts, practices, and itineraries, the persons-in-charge could always keep pace with the times and come up with well thought-out and appropriate solutions and led the whole team towards a goal that has never deviated.

We convey our special thanks to the three professors from TUA for their enduring the hardship of traveling back and forth between Japan and Taiwan throughout the project and for their giving us advice in matters large and small. Throughout the three years of tightly packed operations, the RCCCR has dealt with a lot of challenges. Nevertheless, all of its conservators have gained valuable practical experience, not least because the precious education opportunities arising from the international exchange have constituted exceptional personnel nurturing resources. We also thank Chen Cheng-po Cultural Foundation and their curatorial team for their confidence in and support given to the conservation team. This conservation project is one of the largest and

the three years of tightly packed operations, the RCCCR has dealt with a lot of challenges. Nevertheless, all of its conservators have gained valuable practical experience, not least because the precious education opportunities arising from the international exchange have constituted exceptional personnel nurturing resources. We also thank Chen Cheng-po Cultural Foundation and their curatorial team for their confidence in and support given to the conservation team. This conservation project is one of the

* Chang Yuan-feng: Director, Research Center for Conservation of Cultural Relics, College of Arts, National Taiwan Normal University.

1. Founded in 1945, the NTNU Department of Fine Arts was the oldest institution of art education in Taiwan. Its collection of more than 3,000 pieces of artworks left by outstanding teaching staff and students over the years is representative of the development of modern art in Taiwan.

2. Chen Fang-ling, "Turn Around and Embrace the Scorching Sun—The Unwritten Understanding between Chen Li-po and His Grandpa" in Volume 87, *ART INVESTMENT*, p.164-167, ART INVESTMENT Magazine, Taipei, January 2015.

3. The original name of the book in Japanese is 油絵を解剖する―修復から見た日本洋画史.

4. Works of artists who had studied abroad in Japan in the 1930s, including Chen Cheng-po, Liao Chi-chun, Li Shi-qiao, Liu Chi-hsiang, Hong Rui-lin, and Chang Yi-hsiung.

5. *Ibid*, footnote 2.

6. Summary of internationally recognized standards: 1. Three main ethical concerns: safety (environmental, technical material, personnel), history (originality, historical commemorative value), and completeness (completeness in current form, completeness in truth behind original form); 2. Four principles: principle of prevention, principle of compatibility, principle of similarity, and principle of reversibility.

7. Please refer to the essay titled "Technique, Aesthetics, and Culture: Perspectives from the Conservation of Chen Cheng-po's Works of Art" in this volume, p.42-63.

8. *Ibid*, footnote 7.

9. The original Japanese is "明治前期の作品は堅牢で緻密な絵肌を持っている。明治後半期以降、時代が降るに従って絵の具層の耐溶剤性能が落ちる。水に溶解する作品も多い。"

10. Renowned expert in [painting] materials and techniques and emeritus professor of the National Museum of Ethnology, Japan.

11. The original Japanese is "この画家は油絵の体質を持っている。油絵の具の性質を十分に生かしている。その上で故郷台湾の風土に寄り添って描いている。東洋人としては極めてと特異な存在である。ぼくが探し求めていた条件を満たす数少ない画家だ。"

12. IIn Taiwan, this method is also called the "canvas transplanting" method. It generally refers to the conservation method of reinforcing primary support of an artwork by using various types of adhesives to stick a new piece of canvas as a lining or backing to the back of the artwork. The most common forms of direct adhesive lining are "wax lining", "barley paste lining", and "polymer adhesive lining".

13. For details of loose lining, please refer Kijima Takayasu's essay "On Chen Cheng-po's Painting Techniques and the Re-conservation of Artworks"

# 紙質作品
## Works on Paper

---

# 專文
## Essays

國立臺灣師範大學文物保存維護研究發展中心
National Taiwan Normal University Research Center for Conservation of Cultural Relics

# 技術、美學與文化性的探討
## ——以陳澄波作品保存修復為例

張元鳳[1]

## 前言

陳澄波的繪畫學習生涯中，石川欽一郎的啟蒙時期與東京美術學校的學院派教育，是影響他的二個重大因素，他強烈而執著的筆觸與大膽豐富的用色展現了獨特的個人畫風，因而被稱為「學院中的素人畫家」。此次修復計畫中，一件件作品經過了詳密的檢測與觀察後，讓人發現到隱藏在狂熱的顏料層背後的，果然是學院派嚴格而扎實的材料技法與有條不紊的創作程序。因此，站在一個修復家的立場而言，陳澄波的作品不僅是代表臺灣，他對創作熱情卻不狂亂，秉持扎實而熟練的材料技法將情感躍升於畫面的修為，更是藝術創作者的典範。

2011年，國立臺灣師範大學藝術學院文物保存維護研究發展中心（以下簡稱文保中心）開始展開為期三年的「陳澄波作品修復計劃」。此案是由文保中心六位修復師再加上欣然投入油畫修復的日本東京藝術大學油畫修復權威歌田真介教授、木島隆康教授、鈴鴨富士子博士等三位專家，組成了跨越學界與國界的修復團隊。除此之外，陸續又邀請了臺、美、日等國內外菁英專業人士，加入照片、染織品、科學分析等方面的多元化研究。如此由多位經驗豐富的專業修復家組成的團隊所達成的目標與效率，不僅是單一領域的修復技術，而是跨領域的研究開發與「修復美學」的倡導。

首次接觸到這批大量而井然有序的作品時，驚訝的發現到這些作品在繪畫材料、技法上的豐富性，光是作品的基底材便包含多種，如各式紙張、絹本、畫布、木板、紙板等，媒材則跨含東、西方繪畫各種，如油畫、水彩、膠彩、水墨、鉛筆、炭筆、鋼筆、粉彩等，將當時在學院派教育、在藝壇、在陳澄波心中的創作訊息表達無遺……。因作品種類多項，依媒材屬性與形式，區分為油畫、東方書畫、西方紙質、文物（遺書、受難著服、相片）四項，此篇文章是將此次保存修復方針設定的思維加以說明，在修復過程中尊重歷史、文化的特性。並根據方針導入此案導入的技法：典具帖與無酸保護材的應用為重點加以簡介說明。

## 一、保存修復目標與方針

文化紀念物保存維護的本質是會在一種「永久之基礎上」被加以維持。就陳澄波的作品與他的存在是否具有歷史代表性的觀點而言，他在藝術創作上的獨特風格與對家鄉的情感描繪手法，早已是臺灣近代藝術的重要代表。在日治時期的西方藝術沖擊下，位處新時代藝術潮流中的陳澄波積極匯合了當時東西藝壇的訊息與活動，熱心推動美術教育，這位早逝的菁英藝術家，目前雖無絕對性的指定或認定[2]，但是他對臺灣藝壇的影響與歷史定義早已獲得廣泛認同。

因此，此案對象物（共計1012件，素描簿29本）的保存維護方針經過商議之後，決定在朝向「永久之基礎上」的共識下執行，根據物件特質將其規畫為不同意義的修復目標與方針。

### （一）保存修復目標

在當時東西交流繁盛的時代下，材料技法大多是受到經由日本傳入的西方藝術與傳統東方藝術的影響，表現技法已跳脫單一媒材或古典技法。尤其是陳澄波所就讀的圖畫師範科的課程訓練更是兼具各種樣式。除此之外，參考藝術史學家的分類法，將其活動期分為四個時期，分別是：1913在臺灣接受石川欽一郎[3]的啟蒙時期、1924-1929年考取東京美術學校[4]的留日時期、畢業後1929-1933中國時期、1934-1947返臺時期。因此這些作品中，若將上述二種因素—材料技法與時期交互比對，更可看出不同時期的思維與信念。有些充滿了學習的熱情與勤奮或是初學者的謹慎、有的則散發強烈的創作理念與激情。不論是習作、資料、書信甚至他在獄中倉促留下的遺書等，皆成為反映作者心態與時空背景的證例。

由於作品數量龐大且展期迫切，修復團隊除了修復作業之外，必需同時考量複製、典藏、展示、研究的協調性。為了完整保存這一批重要作品，從過去「束之高閣」的狀態達到公開活用、展示、教育目的與兼具保存典藏功能是修復計畫的目標，並設計一套符合展示與典藏需求的系統式功能。首先根據物件材質將其劃分四種類別與不同時期，如表1（作品分類表）、表2（作品年代與數量）。

| 油畫 | 畫布 | 28 |
|---|---|---|
| | 木板 | 7 |
| | 紙板 | 1 |
| 東方書畫 | 膠彩 | 1 |
| | 水墨 | 7 |
| | 書法 | 23 |
| 西方紙質類 | 素描簿 | 29 |
| | 水彩 | 71 |
| | 炭筆素描 | 71 |
| | 粉彩 | 1 |
| | 裸女淡彩 | 9 |
| | 單頁速寫 | 763 |
| | 插畫 | 4 |
| | 其他 素描簿附件 | 6 |
| | 設計 | 4 |
| | 剪紙 | 4 |
| 文物類 | 受難著服 | 2 |
| | 遺書 | 9 |
| | 相片 | 1 |
| 總計 | 1012件+素描簿29本 | |

表1、作品分類表

| | 種類／年代 | 1924前 | 1924-1929.3 | 1929.4-1933 | 1934-1947 | 製作年不詳 | 總數 |
|---|---|---|---|---|---|---|---|
| 1 | 油畫 | 0 | 4 | 14 | 4 | 14 | 36 |
| 2 | 膠彩 | 0 | 0 | 0 | 0 | 1 | 1 |
| 3 | 水彩 | 35 | 2 | 2 | 3 | 29 | 71 |
| 4 | 炭筆素描 | 0 | 69 | 0 | 0 | 2 | 71 |
| 5 | 粉彩 | 0 | 0 | 0 | 0 | 1 | 1 |
| 6 | 水墨 | 0 | 2 | 0 | 0 | 5 | 7 |
| 7 | 書法 | 0 | 21 | 0 | 0 | 2 | 23 |
| 8 | 單頁速寫 | 1 | 471 | 152 | 1 | 138 | 763 |
| 9 | 裸女淡彩 | 0 | 0 | 5 | 0 | 4 | 9 |
| 10 | 插畫 | 0 | 0 | 0 | 0 | 4 | 4 |
| 11 | 素描簿 | 0 | 6 | 4 | 17 | 2 | 29（本） |
| 12 | 遺書 | 0 | 0 | 0 | 9 | 0 | 9 |
| 13 | 其他 素描簿附件 | 0 | 0 | 0 | 0 | 6 | 6 |
| | 設計 | 0 | 0 | 0 | 0 | 4 | 4 |
| | 剪紙 | 0 | 0 | 0 | 0 | 4 | 4 |
| | 總數 | 36 | 575 | 177 | 34 | 216 | 1009件＋29（本） |

表2、作品年代與數量（未含受難著服2件、照片1張）

修復的直接目的是選擇適宜的材質與技術針對各項作品進行修復以恢復或增加強度，延長作品壽命與保持風格特色。然而隨著時間轉化，保存維護事業不會在一次修護作業中立刻能看到點石成金或是一勞永逸的效果。典藏、修復與老化之間的關係如前故宮科技室研究員余敦平先生設計所示（圖1），是必須持續觀察與檢討。

圖1.文物典藏維護與劣化關係圖

以修復技法的演化論而言，現在使用大多數的修復材料技法或想法常是於古代傳統技法的沿用，是將前人誤用的案例引以為戒，保留實用的技法加以延伸總結而成。也就是說，現代的技術其實大多是參考前人的錯誤或未能預知的遺憾後，加以修正或是改良而成。因此此案除了執行修復作業之外，作品修復前損傷現況、修復過程、修復前後比對與相關材料技法研究等均詳實記錄，目的是希望建立長期客觀的觀察與檢測系統，以確保此批作品與文物傳承。

## （二）保存修復方針

修復方針是為了輔助修復倫理原則[5]的方向性，它的作用是為了在龐大而繁複的修復作業中，建立一個共同指標，達到整合性的效果。除此之外，一件作品或文物的價值可分為研究價值、展示價值與市場價值，方針的制定也是為了防止在修復過程中忽略或扭曲作品與文物所涵蘊的價值性。此案根據物件特質將其劃分為下述三種不同意義的修復方針：

1.「既定藝術形式」作品的修復方針：

共計37件，以油畫作品為主36件，膠彩1件。修復方針是以「完整作品的視覺藝術」為目的，以期達到觀賞、展出的宗旨，是一般大眾較為熟習的藝術作品修護形式。修護作業中除了要遵照國際性修復倫理原則之外，更必須兼顧作品的創作特徵與視覺傳達的美感特質，使意識形態適當的呈現。

2.「兼具史料意義」作品的修復方針：

共計963件作品（包含水彩71件、裸女淡彩9件、炭筆素描71件、粉彩1件、單頁速寫763件、素描簿附件6件、水墨7件、書法23件、設計底稿4件、剪紙4件、插畫4件）與素描簿29本。大部分是尚未被作者正式公開的學習課題、習作、底稿或是作品等。因同時具有佐證學習過程、人格特質、創作習性與生涯表徵等功能。是近年來在國際重要博物館、美術館間快速發展，推動重點式保存維護策略並兼具典藏、研究功能的執行方式，修復方針與前者相較則略傾向歷史性的要素或現狀的保存維護。

3.「史料文物類」的修復方針：

共計12件，包含遺書9件、受難著服2件、相片1件等，大部分為資料、書信等重要史料。此類文物的共同特徵是具有或佐證特殊時代（典範或事件）行為特質的代表性意義，修復方針特別著重於歷史性的表徵物。

上述三種方針都不外乎是選擇適宜的材質與技術，延長壽命與保有文物風格特色、確保作品的安全是永遠不會改變的宗旨。而如前文所述是在一種「永久之基礎上」被加以維持、彰顯其存在的歷史特質，以避免過度的「人為干預」是為了平衡作業的過度修飾。

## 二、紙質作品保存修復技法簡介

此章主要探討以紙質類基底材[6]為主的修復作業，對象物按年代編列如表2中，水墨、書法、水彩、素描

（鉛筆、炭筆）、素描簿、遺書等為主的修復技法運用。修復材料在此計劃中最主要的分別是典具帖與無酸夾裱的應用：

## （一）紙質文物強化技法

　　執行修復作業時除了材料技法的配慮外，另一個重要因素便是文化的特質與風格。下述分為東方紙質與西方紙質二類說明：

### 1. 傳統東方繪畫的作品：膠彩、書法、水墨等

　　此類繪畫作品因本身的基底材紙張較薄，所以修復時大多都是以傳統的裝裱技法將作品強化、美化或保存。自古以來幾乎都是使用漿糊將背紙以小托[7]、加托[8]或是更換新背紙的方式強化作品的基底材。或是在前述作業之後，在未乾之際上牆服貼，待乾燥後便可自然攤平等。諸如此類托、裁、鑲、接的裝裱作業累積與交互的結果，開創出傳統的形式如掛軸、鏡片、冊頁、手卷等。因此東方繪畫文物與傳統裝裱技術相輔相成，形成代表傳統、古典亞洲繪畫文物與文化精神的一種特殊保存修復技法。此案的陳澄波作品中，東方繪畫如膠彩、書法、水墨等共計31件，便是以上述方式為主，完成保存修復托裱作業。

圖2.酸性紙的黃化與脆化現象

　　全色時使用天然有機顏料完成缺損處全色，此類顏料雖然對紫外線敏感，容易老化而使色彩褪色變淡，但是可逆性高而且不會發生金屬氧化變色反應。即便發生淡化現象亦可直接重複全色，而不必為了補彩變色而將作品解體重新修復。

### 2. 西方紙質作品：鉛筆素描、炭筆素描、水彩、設計手稿等

#### （1）技術評估

　　西方紙質作品中以水彩、素描、素描簿的數量最為龐大，這些作品大多以當時的機械造紙[9]為主，在歲月更迭下逐漸出現自體酸化現象[10]與伴隨的脆化現象如（圖2）。防止繼續酸化採取了除酸作業[11]，使紙張中的酸性物質釋出，再以趨近中性的穩定物質替代，使作品未來能夠在近中性的保護材質中減緩劣化是第一重點。

　　以形式而言，此類作品的題材與媒材對當時臺灣藝術界而言，都是屬於前衛性的西方藝術，除了油畫之外，水彩、素描、人體的描繪、風景寫生等，這一類的西方文化元素、西方材料技法的作品，如以傳統東方小托背紙的方式修復，雖然可以使作品強化、攤平，並有方便後續管理與典藏，但會造成厚度與形式變更甚至影響西方元素表徵。因此若以傳統東方小托背紙的方式執行，將會是以東方文化的思維去執行保存修復措施，會造成文化上的衝突，這是為達到強化的目的而犧牲作品本質的做法。

　　歐美以常以leaf casting（自動漉補機）方式針對紙張劣化補強，在作品背面增加微薄的纖維厚度以保護脆化的作品是目前處理一般圖書或大量檔案的方法，可以快速修護以印刷品為主的文物、資料之外，亦可以同時執行除酸、填補缺損、強化的作業。文保中心參考leaf casting的相關作業特徵，但考量必須降低脆化作品在紙漿液中波動的危險性而特別設計出將脆弱作品在suction table 的蒸氣加溼（圖5）與水溶性媒材（如炭筆、鉛筆、水彩等）、極不穩定媒材的水分嚴格控制下，使用典具帖[12]（圖3）小托強化與無酸夾裱的應用方式。

圖3.本案使用各式典具帖樣本分別為白色、淡褐、黃褐色，搭配作品色調。

（2）作業要點說明

　　典具帖是以楮皮纖維為主的紙張中最薄的種類，因為楮皮纖維長韌、漉造技法特殊，使紙張有幾近透明的特質，又稱「カゲロウの羽—蜉蝣的翅膀」，厚度是從2.0g-9.0g/m²（每平方公尺的重量），常使用於雙面皆有圖文作品的小托。典具帖早期只有原色，近年來發展出各種古色調或特殊色調[13]，除了應用在繪畫文物之外，更延伸到重要木上彩、染織品修復的加固或封固作業中。

　　此案研發的修復步驟整理規畫為17個步驟如下（圖4）：修復前檢視登錄之後（圖6），進行3-8基礎步驟處理。將作品單、雙面作品分二類，選用與作品基底材相似色調，分別以典具帖完成步驟9-10的不同強化處理，11-14整合作業（圖7-12），最後再以系統化無酸保護材（無酸卡紙、無酸瓦楞紙）夾裱、無酸裝框保存典藏。

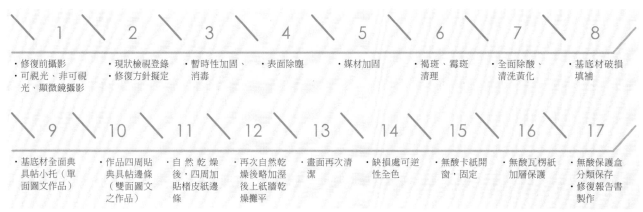

| 1 | 2 | 3 | 4 | 5 | 6 | 7 | 8 |
|---|---|---|---|---|---|---|---|
| ・修復前攝影<br>・可視光、非可視光、顯微鏡攝影 | ・現狀檢視登錄<br>・修復方針擬定 | ・暫時性加固、消毒 | ・表面除塵 | ・媒材加固 | ・褐斑、霉斑清理 | ・全面除酸、清洗黃化 | ・基底材破損填補 |

| 9 | 10 | 11 | 12 | 13 | 14 | 15 | 16 | 17 |
|---|---|---|---|---|---|---|---|---|
| ・基底材全面典具帖小托（單面圖文作品） | ・作品四周貼典具帖邊條（雙面圖文之作品） | ・自然乾燥後，四周加貼楮皮紙邊條 | ・再次自然乾燥後略加溼後上紙牆乾燥攤平 | ・畫面再次清潔 | ・缺損處可逆性全色 | ・無酸卡紙開窗，固定 | ・無酸瓦楞紙加層保護 | ・無酸保護盒分類保存<br>・修復報告書製作 |

圖4.紙質作品修復步驟

圖5.脆弱作品在suction table中的蒸氣加溼過程

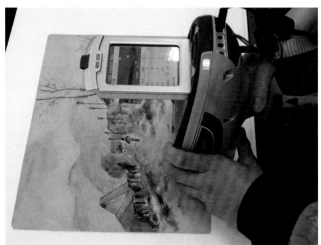

圖6.修復前檢視登錄，顏料成分XRF檢測

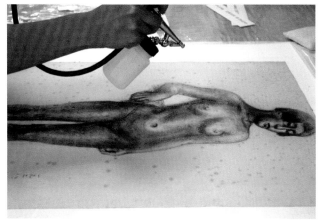

圖7.甲基纖維素加固媒材

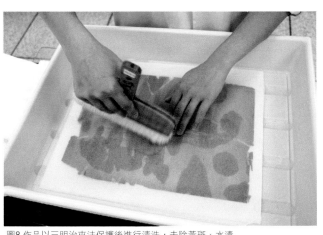

圖8.作品以三明治夾法保護後進行清洗，去除黃斑、水漬

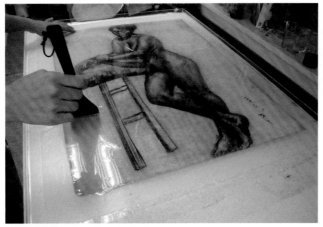

圖9.除酸作業

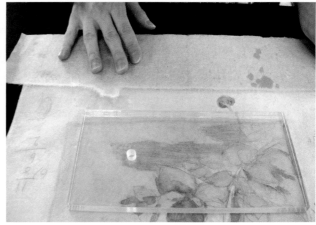

圖10.按作品外緣形狀搭接邊條

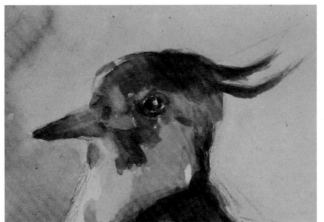

圖11.全色補彩前

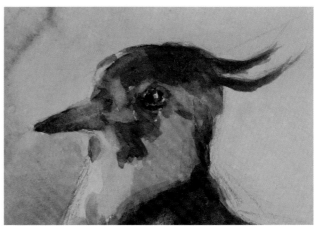

圖12.全色補彩後

（3）典具帖的利點評估

a.以氫氧化鈣製作的稀釋除酸劑（pH8-8.5）浸泡後的作品趨近中性[14]。除酸前約pH5-5.5，除酸後約pH6.5-7，[Chemical reaction：Dilute $Ca(OH)_{2(aq)}$ $+CO_{2(g)} \rightarrow CaCO_{3(s)}+ H_2O_{(g)}$]。

b.脆化的基底材紙張以典具帖強化後，明顯有效的緩解裂痕、脆化現象。

c.典具帖極為薄透，可用非常薄的漿糊小托即可附著於作品，再修復時可以輕易將其揭除，增加日後修復時可逆性的功效。

d.作品固定於無酸夾裱前，依作品厚度選擇強韌的中性楮皮紙（細川紙，厚度3-5仞，依作品厚度調整）製作邊條，並以毛邊搭接於作品反面（圖13，上）。因此在固定作品時，黏著劑不必直接塗布在作品背面，而是塗在楮皮紙邊條上，結構上較利於日後修復的可逆性。

e.強化後的雙面作品與背面有簽名、記事的作品仍可以清楚辨識背面資訊，不會被封蓋。若是作品強度無慮，或是背面必須全面展露時，則以搭典具帖邊條方式

■典具帖　□楮皮紙

單面圖文作品：將畫心背面全面以典具帖強化再將楮皮紙邊條貼黏於典具帖之上。

畫心背面

■典具帖　□楮皮紙

雙面圖文作品：將畫心背面四周先以典具帖強化，再將楮皮紙邊條貼黏於典具帖之上。

畫心背面

圖13.典具帖與楮皮邊條強化示意圖
上：單面作品強化示意圖，下：雙面作品強化示意圖

替代全面小托（圖13，下）。

　　f.一般而言，楮皮紙邊條與作品搭接時，須以較濃漿糊固定，因此在日後重修時，作品四週脆弱的區域會因楮皮紙沾黏過度而導致難以拆解，常在重修時造成周邊受損的情形。為提升作品日後再修復的安全性，此設計可將邊條隔著典具帖，採用間接的方式貼黏在作品四週，而非直接貼附於作品上（同圖13，下），可以保護作品四週脆弱的區域直接承受外力。

　　g.因應典具帖的輕、薄、透的特性，使用相似色調的典具帖在作品背面小托強化後，作品的背面幾乎無法辨識典具帖的存在，作品厚度不會過度增加，亦不會有東方小托紙張將背面封固的情形，比較適合作品西方文化的特質（圖14-15）。

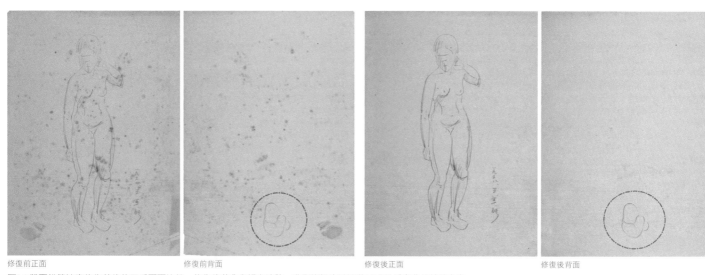

修復前正面　　　　　　　　修復前背面　　　　　　　　修復後正面　　　　　　　　修復後背面

圖14.雙面鉛筆速寫修復前後的正反兩面比較。修復後黃化與褐斑清除，背面資訊未被遮蓋且不易看出典具帖的存在。

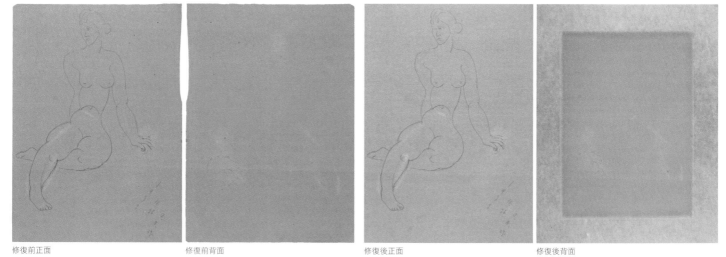

修復前正面　　　　　　　　修復前背面　　　　　　　　修復後正面　　　　　　　　修復後背面

圖15.單面鉛筆速寫修復前後的正反兩面比較。修復後背面典具帖全面強化小托，再以楮皮紙在四周搭接邊條。

## （二）典藏管理—作品無酸夾裱保護設計

　　以無酸系列的保護產品製作夾裱，一方面提供安全的展示功能，一方面亦可亦作為日後保存的微環境控制。系統化的形式與規格則是考量日後展收典藏的便利性與節省收納空間。利點評估如下：

　　1.為完整地呈現畫作，依作品厚度選擇強韌的中性楮皮紙製作搭邊條，並以毛邊搭接於作品反面，以固定作品四緣於無酸卡紙。雙面圖文則採用僅固定單邊的hinge方式，以增加日後翻閱背面資訊的便利性（圖16-17）。

　　2.以無酸卡紙開窗並設定適合統一的尺寸，製成無酸夾裱。夾裱每邊長寬皆大於作品尺寸，可將作品

圖16.（單面作品）固定作品四緣夾裱示意圖。

- 夾裱背板
- 邊條紙
- 作品畫心
- 夾裱面板

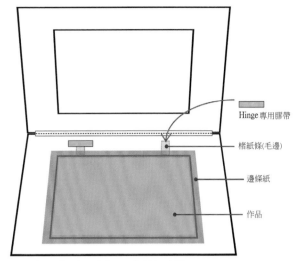

圖17.（雙面作品）固定作品單邊夾裱示意圖。

- Hinge專用膠帶
- 楮紙條(毛邊)
- 邊條紙
- 作品

完全保護於夾裱內。卡紙開窗時大小以不遮蓋作品邊緣為原則，使作品完整呈現（作品邊緣受損處的痕跡亦是作品歷史的一部分），彰顯「兼具史料意義」作品的修護方針。

3. 無酸卡紙夾裱完成後，為加強持拿時的安全與展示強度，上下另加無酸瓦楞紙封面與底板（淺藍灰色）。展示時僅需將瓦楞紙封面打開翻至背面即可呈現作品再與夾裱共同置入木框展示。（圖18-20）

4. 重要的史料文物─遺書，是採取「最低人為干預」的原則進行，以保留歷史當下的事件特徵。因為是雙面書寫，所以僅消毒與略加攤平處理，再以透明聚脂片Mylar（polyethylene terephthalate）製成「M」型護夾（圖21）固定遺書的四邊，此法可以不使用任何黏著劑或是托裱技法，並使遺書完全夾固在透明聚脂片Mylar中保護。之後，再以無酸卡紙雙面開窗保護、展示（圖22）。

5. 典藏方式：相關作品全面以規格化尺寸統一夾裱完成後編列典藏號，約8-10件一組，依序置入以無酸瓦楞紙製作的無酸保護盒中典藏，作品夾裱外層與盒外均註明作品編號、名稱、圖片，以便於日後典藏管理。

圖18.畫框結構示意圖（1-5）：杉木格架、黑電木、無酸夾裱＋作品、壓克力、楓木外框。

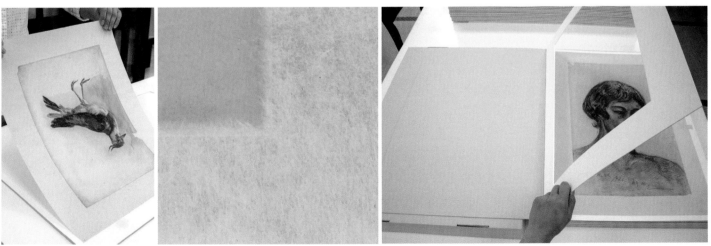

圖19.可翻看作品正、反兩面的hinge固定方式（左圖）；楮皮邊條固定方式（中圖）；無酸卡紙開窗與外加無酸瓦楞紙強化保護的夾裱形式（右圖）。

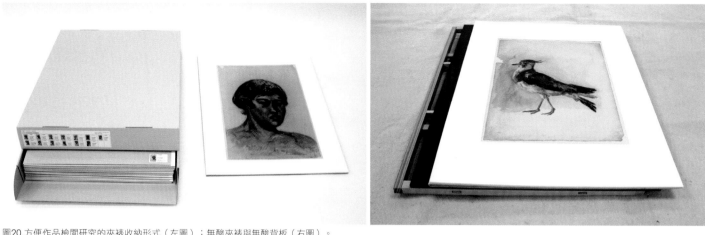

圖20.方便作品檢閱研究的夾裱收納形式（左圖）；無酸夾裱與無酸背板（右圖）。

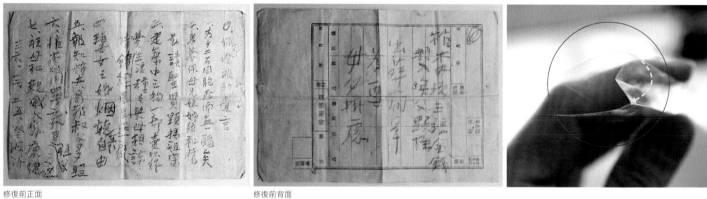

修復前正面　　　　　　　　　　　　　修復前背面

圖21.遺書—雙面書寫文字的重要歷史證物以「最低人為干預」為原則保存，使用透明聚酯片製成可開合（黃色虛線）的「M」型保護夾（紅色），是一種不用黏著劑亦可將遺書固定、保護在夾裱內，又可完全展示的夾裱方式。

圖22.可雙面展示、研究的雙面開窗式無酸夾裱。

　　6. 國內市販的畫框材質不論是外框或是背板，大多以夾板製成。由於夾板本身亦是酸性材質，因此將作品裝釘在以夾板製作的酸性畫框中，造成作品再度處於酸性環境中，是國內另一個導致作品面臨酸化危機的主因。本案定製實木無酸系統框，以實木榫接完成，後加襯木格架、中性黑電木，可配合展示所需裝卸，作品與木框亦可採分離式典藏管理。

在歐美，「酸性紙」所引發的相關問題在19世紀後期開始逐漸發生，尤其以1850年左右發行的書籍最為明顯。1925年瑞典的研究已經開始相關報導，美國方面則是在1957年由修復家William. J. Barrow[15]針對1900-49年間的出版書籍劣化展開綿密的調查後，繼而相關保存修復技法亦開始展開。日本從1980年代針對西方紙張所產生的劣化問題開始注意，因為發現在圖書館的書籍、重要史料、作品、檔案等在50年不到的時間已經開始黃變、脆化，國內則比日本又晚了將近10年才開始陸續展開酸性紙與相關酸性書畫材質的研究。

陳澄波的紙質作品中以素描、水彩、素描簿等西方形式的紙張劣化較為嚴重，這個現象對於當時所有使用西方紙本的作品、書籍、檔案、照片……而言幾乎無一可逃，是20世紀世界文物保存共同面臨的重大危機。本案中此類作品的修復重點主要是除酸、使用為鹼性的氫氧化鈣稀釋溶液（pH8-8.5）浸泡，以達到酸鹼中和的目的。過程中會有微細的碳酸鈣殘留於作品纖維中，以保持日後較穩定的中性體質。修復後典藏以中性無酸卡紙、無酸瓦楞紙、無酸保護盒等材料保護，但由於紙張原本就薄弱，加上數量龐大、曝光率高、研究使用頻率亦高，建議仍須建立定期檢查制度確保安全。

## 三、結論

此案的量、值與收藏者的理念，已使保存修復的作業任務跳脫了過往以技術為主體的架構，必須在全面性「整合」的規範下完成，使欣賞的角度能兼顧文化、美學、繪畫本質、藝術、史料等各方面的立場。它的特殊性已不是單一材料或技術的作業銜接問題，反而是必須將修復目標整合、秩序化之後，規畫一個使作品與修復家、觀賞者、典藏者之間都留有一些空間、可以相互遞補的空間，也可以說是一個比較有彈性的方式，做為上述四者之間的協調地帶。這個想法的產生是因為與策展團隊互動時，經過觀察與學習而產生，嘗試在巡迴展出時，不僅要達到安全的基本，更希望能傳達正確完整的訊息。以下將此案的一些概念加以說明：

### （一）減少人為干預

「減少人為干預」是國際上文保事業公認的重要指標，但也會因應個案需求而有不同的解讀。所謂「盡量減少人為干預」有一體兩面的解釋，一是以「預防性維護」方式維護文物或作品的安全，而非依賴後置的修復手段。另一個將上述延伸解釋則是避免修復行為「太過」，形成矯枉過正、甚至破壞原作的過度行為。但是有些模糊的區域，例如能力上「不能」與「不為」的相異性，常被技術不良或不當的修復者當成藉口，來規避關鍵性的技法操作能力，這樣的問題常發生在資訊或技術封閉的環境中，修復執行者與委託者都應該引以為戒。以下針對此案簡述：

1.保存維護：前述重點中已指出文保事業是無法在一次的作業中達到點石成金或一勞永逸的效果，本案後續保存維護必須持續注意環境控制，並長期的觀察與檢測，隨時掌握作品與文物的變化。

2.預防性維護：建議加強典藏環境控制與日後管理規範。

3.技術調整：本案不論油畫或是紙質作品，都以盡量減輕作品負擔的方式完成。例如油畫作品將蠟托裱更換成非黏合式加襯，紙質作品則將無可避免的小托背紙處理成幾近透明的典具帖，大幅降低漿糊的使用量，二者都意在降低黏著劑對作品的影響，但建議必須同時與上述（一）配合，增加觀察與思考的空間，使作品可根據需求變化，調整適合的措施。

4.全色與補彩的處理方式：此案中將修復後的作品分為三種處理方針下進行，最明顯的重點之一是在於對全色與補彩的控制。例如處理「既定藝術形式」作品時，是以「完整作品的視覺藝術」為目的，追求補彩到位的絕對色感、質感、光澤甚至於清潔感。

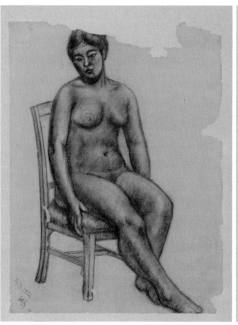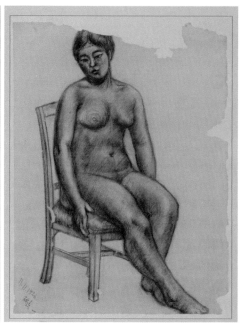

圖23.炭筆素描修復前（左圖）；修復後（中圖）；不遮壓作品四周的卡紙開窗線位置（褐色線為開窗線）（右圖）。

對於「兼具史料意義」作品時，則以保留歷史特徵、不刻意填補邊緣缺損、不遮蓋邊緣缺損的觀點下進行，希望除了「藝術」以外，保留作品與觀賞者更多的對話與想像空間。例如以（圖23）為例，作品邊緣缺損區域並不刻意處理，使藝術與歷史的要素同時保留。開窗的位置也與一般刻意遮壓作品四周的方式不同，採取全面展示的方式。除了可以保護作品邊緣不被卡紙擠壓磨損之外，更希望展現素描樸實的本質。

遺書是以「史料文物類」的方式整理，它是陳澄波在獄中倉促之間竭盡所能地找尋隻紙殘片來表達心中牽掛與對家人訣別的手書，具證明或代表重大歷史事件發生時，相關人、事、物的關鍵性意義，幾經思考後決定以歷史證物的整理方式完成。因此，遺書上的皺摺、灰垢、黃化、斑漬都變成保存的對象之一，除了將可能造成斷裂的嚴重皺折稍加攤平與消毒之外，基本上是現狀保存。相對於繪畫作品的修復作業，遺書的作業相對性地刻意減少，這是對照「史料文物類」的方針執行。而由此也希望觀賞者、典藏管理者、佈展者可以體會「不能」與「不為」的區別性。

油畫是西方的代表性藝術，國內相關保存修復的材料技法也自然以西方的執行程序為主要依據，比較沒有文化特徵上的問題。但「蠟托裱wax lining」造成作品的負擔與操作不當的危險性，完成之後雖然可使畫作平坦，但卻無法擺脫僵硬不自然的感覺。「非黏合式加襯loose lining」技法是改良結構關係的可逆性機能，畫面平坦程度雖然無法達到像蠟托裱後的硬挺效果，但是非黏合式的做法確實大幅降低了作品的負擔（圖24）。

## （二）文化的協調機制

傳統裝裱是東方特有、幾乎與東方書畫有著不能劃分的特殊關係，技法影響的地區從古代中國開始傳達至鄰近的日、韓、東南亞。國內的裝裱技法的普遍性與技術性是世界知名的，但是文化上的習慣性變成過度依賴托裱來解決問題，也造成了外界質疑的觀感。例如一般的書籍、染織、唐卡、版畫、照片等，也常常發生西畫中裱或是全部以小托解決問題的失敗案例。雖然大家都一致認同作品在經中式小托強化攤平後，有利於後續管理與使用上的便利性，但是文化的因素更應該被尊重。

決定修復後的形式並非憑藉一己的喜好或單獨判斷便可執行的，改善作品現狀與後加修復材料之間的連結關係，增加可逆性、可調性機能亦是現今文保發展方向的特點之一（圖25-27）。

圖24.「wax lining」移除後，蠟滲透不均與殘留在畫布的情形，造成作品負擔過重。（左圖）
圖25.東方作品修復前後比對。（傳統技法小托、全色、裝裱、鑲接綾絹後完成。）（中、右圖）

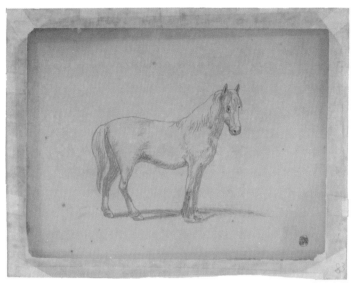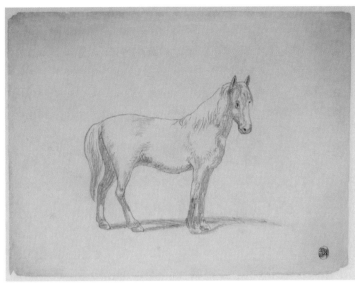

圖26.作品修復前以中式小托強化的狀況，過量的漿糊塗刷與宣紙小托使得簡樸的素描呈現沈重氛圍。（左圖）
移除小托紙，清除褐斑、漿糊、漬痕後，使用透明性高的典具帖技法強化，並搭配無酸卡紙保護夾裱，視覺效果上可降低作品的干擾因素。（右圖）

### （三）修復美學的自我提升與洗鍊

　　　文化紀念物保存維護的本質是會在一種「永久之基礎上」被加以維持，是世界公認的規章，這句話看似簡單但實際執行時卻會覺得困難重重，因為「永久」、「永恆」的定義實在無法在短時間內、或以絕對的因素成立具體的定義。一位日本的好朋友提供了一個保守的參考辦法──以「一百年」為修復後的最小維持單位，想像在一百年後的新世代如何看待這些上一代傳下來的「訊息」便可了解當時的環境、社會與人文。

　　　國內的修復領域發展從理論到實務而言，1999年文保教育開始從大專院校創立研究所是一個重要的創始點，至今約15年後，當初培育的種子現在都已經陸續進入社會。國內培育的修復家們（conservator）約八成左右在大學時期的專攻是相關藝術、建築等創作，其餘分別是文史理論與科技領域。因為材料技法向來是從事創作者喜好而熟習的事物，故筆者認為以發展的趨勢與特徵而言，目前國內文保專業的階段特徵是以追求材料技法的技術層面為主。技法穩固之後現在的目標應該朝著靈活運用、收放自如的方向調整，並使文保專業中包涵設計、視覺、人文的美感，也就是修復美學（conservation art）。15年間的發展當然是得到高度認同與肯定的，但是全面性的美學仍未得到平衡，保存科學、藝術史，甚至材料發展史都未能有充分的專業共同參與。

文物、藝術品保存修復的本質並非擁有技術便可以使永恆被肯定，因此「修復美學」表現在修復完成後視覺上的呈現上僅是基本門檻，修復美學的目標應該設定在科學、人文交織的、更深層的內涵裡。以理性、科學的態度探討過去，再將研究心得轉換成新的論述與科技，才是隱藏在文保專業背後真正的美，如何將此「思考模式」完整傳遞給一百年後的世代，代代傳承，才是修復美學的完整表現。

借此機會感謝財團法人陳澄波文化基金會與策展團隊對本中心的信任與包涵，此修復案可謂是國內民間委託案中規模最大、最完整的案例，從保存修復、記錄、管理、參展到教育推廣，許多的想法與規畫都是在策展團隊與基金會的建言下，才使我們得到修正、反省與學習的機會。感謝東京藝術大學的三位老師在日本、臺灣之間忙碌奔波，三年緊湊的作業下文保中心面對了極大的挑戰，但是其中數位新生代的修復家因此得到珍貴的實務經驗，國際交流的機會教育更促成了在現今教育課程中最難能可貴的跨領域人才培育資源與範例。

【註釋】

1. 張元鳳：國立臺灣師範大學美術學系專任教授暨文物保存維護研究發展中心主任。

2. 指國家公政府部門針對作者本身（人）或其作品（物）特別公開頒發的認定或指定。

3. 石川欽一郎（1871~1945），有臺灣美術之父之稱，當時任職於臺北國語學校美術教師，陳澄波因其影響開始接觸現代藝術思想，並展開赴日留學之旅。資料來源：http://blog.roodo.com/kcn/archives/7788267.html，搜尋日期：2014.08.18

4. 東京美術學校設立於 1887 年（明治 20 年，光緒 13 年），三年後由當時著名的藝術學者岡倉天心接任校長，設立以傳統藝術為主的日本畫科、漆工科、彫金科與木雕科。1896 年（明治 29 年 2 月）黑田清輝自法國返回之後設立西洋畫科。陳澄波專攻的圖畫師範科設立於 1907 年（明治 40 年），是第 19 期畢業生。1949 年改制為東京藝術大學，是亞洲第一所將西方藝術教育體制引進的藝術大學。

5. 國際公認規範概略：1. 三大倫理：安全性（環境、技術材料、人員安全）、歷史性（原創性、歷史紀念性）、完整性（現狀完整、原狀真相完整）。2. 四項原則：預防性原則 Principle of Prevention、適宜性原則 Principle of Compatibility、相似性原則 Principle of Similarity、可逆性原則 Principle of Reversibility。

6. 基底材：繪畫作品結構一般可粗分為「媒材」與「基底材」，媒材包括顏料與展色劑（指與顏料混合後具有黏著性、可使顏料固定在畫面上的黏著劑），而承受繪畫媒材的基底例如紙張、畫布、畫絹等則通稱為基底材。

7. 小托：緊附在作品背面的第一層背紙稱為「命紙」，是保護作品最重要的一層，托命紙的作業稱為「小托」。

8. 加托：第二層之後的托背紙稱為加托。

9. 酸性紙：acid paper，19 世紀中期，大量以木材纖維為主要原料的機械造紙開始生產，造紙過程中為防止墨水滲透加入松香與安定松香的硫酸鋁。存留在紙中的硫酸根（$SO4^{2-}$），是形成酸性紙張黃化的主因。

10. 自體酸化現象：硫酸根殘留在紙層中，引起強脱水作用而引發紙中有機成分酸加水分解所致。Michan, D., Jifi, Z., 1993. Chemical processes in the bleaching of paper in library and archival collections, *Restaurator*. 14(2), 78-101.

11. 除酸：將酸性紙中殘存的硫酸根使用中和藥劑予以固定或進行除酸處理。

12. 典具帖：tengujou，http://www.weblio.jp/content/ 土佐典具帖紙，chlorine free，楮皮纖維以消石灰水（氫氧化鈣）沸煮後去除雜質，再加黃蜀葵根部的汁液以增加粘稠性漉造製成。平成 13 年（2001）被指定為日本重要無形文化財（製造者浜田幸雄指定為人間國寶），歐美如「浮世繪」、書籍等的修復，西斯汀禮拜堂壁畫也是使用這種超薄而強韌的典具帖紙修復。

13. 本案使用的是 Dyed TENGU 3.5g/m$^2$，White TENGU 3.8g/m$^2$。

14. 資料來源：AIC Paper Conservation Catalog: http://www.conservation-wiki.com/wiki/BP_Chapter_20_-_Alkalization_and_Neutralization，搜尋日期：2014.11.18

15. William. J. Barrow Research Laboratory.（1904-1967）維吉尼雅州立圖書館修復家 Permanence/Durability of the Book: a Two-Year Research Program. Richmond, Va., 1963.

【參考文獻】

一、中文專書

· 木島隆康〈從修復作品看陳澄波的繪畫技法與作品再修復〉《陳澄波全集第 16 卷》（臺北：藝術家出版社，2017。）

· 財團法人陳澄波文化基金會《海上煙波—陳澄波藝術作品集》（上海：人民美術出版社，2014。）

· 創價學會藝文中心執行委員會企劃《日治時期臺灣官辦美展（1927-1943）圖錄與論文集》（臺北：勤宣文教基金會，2010。）

二、日文專書

· 木島隆康《修復研究所報告》（Vol.15 1999-2000（修復研究所），2001。）

· 世田谷美術館 《フィレンツェルネサンス 藝術と修復展》（日本放送協會，1991。）

· 田忠智惠子、有村麻里《修復研究所報告》（Vol.17 2003-2004（修復研究所，2005。）

三、英文專書

· MFA Boston(2011), *MFA Highlight - Conservation And Care of Museum Collections* , MFA Publications.

· Paul Jett(2003), *Scientific Research in the Field of Asian Art: Proceeding of the First Forbes Symposium at the Freer Gallery of Art*, Smithsonian Freer Gallery of Art.

· Rutherford J. Gettens and George L. Stout(2013), *Painting Materials- A Short Encyclopaedia*, Dover Publication, Inc., New

# Technique, Aesthetics, and Culture:
## Perspectives from the Conservation of Chen Cheng-po's Works of Art

**Chang Yuan-feng**[1]

## Summary

## I. Introduction

Throughout Chen Cheng-po's studies in painting, Ishikawa Kinichiro's introduction to the field and his academic training at the Tokyo School of Fine Arts were two key influences. Because his unique painting style was exemplified by intense and determined brushstrokes and a bold and resourceful use of color, he was called "the amateur academic painter." Yet, detailed examination and analysis of his artworks reveals that behind his frenetic artistic expression were solid academic techniques and methodical painting methods. Therefore, from the standpoint of a conservator, Chen Cheng-po's works can be described as passionate but not wildly uncontrolled; his skills in expressing emotion in paintings through well-grounded and practiced use of materials and techniques are exemplary.

The works of art treated in the present case span across both Asian and Western paintings, and include oil paintings, watercolors, glue color paintings, ink paintings, pencil sketches, charcoal sketches, ink pen sketches, pastel drawing, among others. Together, they depict in full the education Chen Cheng-po received, the art circles he frequented, and his feelings on the art-making process. By virtue of the comprehensiveness and large number of works, the goals of this treatment were not only conservation, but rather, to employ multidisciplinary research and development, and promote the idea of 'conservation aesthetics.' In addition to explaining the rationale behind conservation principles, this paper also aims to describe special materials used in this project: the application of tengujo and non-acidic materials.

## II. Conservation Objectives and Principles

The essence of heritage conservation is to provide maintenance "on a permanent basis". Concerning whether Chen Cheng-po and his artworks are historically representative, the answer is that his unique artistic style and the way in which he expressed his feelings for his home country have always been significant to contemporary Taiwanese art. Though this outstanding artist, who passed away very early, has so far not received any distinct designation or recognition[2], his influence on Taiwan's art world and his historical significance have long since been acknowledged.

For this reason, after discussion, it was decided that the conservation of works of art and historic relics in this project (1,012 objects and 29 sketchbooks) will be carried out "on a permanent basis."

# 1.Conservation Objectives

Chen Cheng-po's academic training in painting spans a variety of genres. From an art historical perspective, Chen Cheng-po's artistic career can be divided into four periods: his early period (prior to 1913), studying in Japan (1924-1929), his years in China (1929-1933), and his return to Taiwan (1934-1947). While some of his artworks are filled with a passion for learning or a beginner's cautiousness, others are diffused with intense creative concepts and emotion, reflecting the artist's mindset and his background.

In order to fully preserve these works of art for public, exhibition, and educational purposes, a systematic methodology was designed that met the requirements of exhibition and storage. First, the articles were divided into four groups according to the materials used and into different periods as shown in Table 1 (Classification, Period, and Number of Works and Artifacts).

In the present case, in addition to the carrying out of restoration works, there are also detailed notes on the extent of damages before restoration, the process of the conservation, before and after conservation comparisons, and related studies on materials and techniques. The purpose is to set up an objective long-term observation and checking system to ensure the heritage of the current batch of artworks and relics.

| Type | Period | Before 1924 | 1924~1929.3 | 1929.4~1933 | 1934~1947 | Date Unknown | Total Number |
|---|---|---|---|---|---|---|---|
| 1 | Oil paintings | 0 | 4 | 14 | 4 | 14 | 36 |
|  | Glue color painting | 0 | 0 | 0 | 0 | 1 | 1 |
| 2 | Ink painting | 0 | 2 | 0 | 0 | 5 | 7 |
|  | Calligraphy | 0 | 21 | 0 | 0 | 2 | 23 |
|  | Sketchbooks | 0 | 6 | 4 | 17 | 2 | 29 |
|  | Watercolors | 35 | 2 | 2 | 3 | 29 | 71 |
|  | Nude watercolor sketches | 0 | 0 | 5 | 0 | 4 | 9 |
|  | Charcoal sketches | 0 | 69 | 0 | 0 | 2 | 71 |
| 3 | Single-sheet sketches | 1 | 471 | 152 | 1 | 138 | 763 |
|  | Pastels | 0 | 0 | 0 | 0 | 1 | 1 |
|  | Sketchbook enclosures | 0 | 0 | 0 | 0 | 6 | 6 |
|  | Design drafts | 0 | 0 | 0 | 0 | 4 | 4 |
|  | Paper cuts | 0 | 0 | 0 | 0 | 4 | 4 |
|  | Illustrations | 0 | 0 | 0 | 0 | 4 | 4 |
|  | Will | 0 | 0 | 0 | 9 | 0 | 9 |
| 4 | Final garments | 0 | 0 | 0 | 2 | 0 | 2 |
|  | Photograph | 0 | 0 | 0 | 0 | 1 | 1 |
|  | Total | 36 | 575 | 177 | 36 | 217 | 1,012 objects + 29 sketchbooks |

Table 1: Classification, Period, and Number of Works and Artifacts

# 2.Conservation Principles

The value of a work of art or artifact can be classified into research, exhibition, and market value. In the present case, three conservation principles are adopted according to the characteristics of the objects involved:

a.Established art forms: Total of 37 works, including 36 oil paintings and one glue color painting.

b.Works of historic significance: 29 sketchbooks and 963 works of art (71 watercolors, 71 charcoal

sketches, 763 single-sheet sketches, 6 sketchbook enclosures, 7 ink paintings, 23 calligraphies, 4 design drafts, 4 paper cuts, 4 illustrations, 9 watercolors nude sketches and 1 pastel).

c.historical materials and cultural relics: Total of 12 objects, including 9 sheets of Chen Cheng-po's will, 2 final garments, and 1 photograph.

## III. Introduction to Paper Conservation Techniques

This section will describe the techniques of treating works on paper as carried out on ink paintings, watercolors, sketches (pencil and charcoal) and sketchbooks. (Table 1) As far as conservation materials are concerned, in the present scheme, the most important feature is the application of Tengujo and acid-free matting.

### 1.Techniques for strengthening works on paper

Besides the choice of materials and techniques, other important considerations in the treatment of works on paper are cultural characteristics and style. Detailed below are techniques of treating Asian and Western works on paper:

a.Traditional Asian paintings: The paper support for glue color paintings, calligraphy and ink paintings are usually fairly thin, and therefore traditional mounting techniques were used to strengthen these works of art. These methods included applying lining papers[3] to the verso with wheat starch paste to strengthen the primary support.

b.Western works on paper: Single-sheet sketches, charcoal sketches, watercolors, design drafts, and others

(i)Treatment rationale: The majority of Western works on paper treated in this project include watercolors, sketches, sketchbooks. Their paper supports were primarily machine-made paper, thereby resulting in paper acidification and embrittlement (Fig. 1). To halt acidification, acidic elements needed to be removed, followed by replacing them with neutral, stable elements to slow down the rate of deterioration and protect them in a neutral environment. The Research Center for Conservation of Cultural Relics borrowed concepts from leaf casting that minimizes the dangers of fluctuations while immersed in paper pulp (Fig. 3) and while allowing for control of water content. In addition, tengujo paper[4] linings (Fig. 2) and non-acidic mats were also used.

Fig. 1: Yellowing and embrittlement of acidic paper

Fig. 2: Samples of tengujo paper used in this project, ranging in tone from white, light brown, and yellow brown

Fig. 3: Fragile works of art are humidified under a suction table

■Tengujo ■Kozo paper

**Single-sided artwork:**
The verso of the work of art is reinforced with a tengujo lining, kozo feathered edge strips are then adhered on top of the tengujo lining.

Work of art Verso

■Tengujo ■Kozo paper

**Double-sided artwork:**
The four edges of the verso of the work of art are reinforced with tengujo strips, kozo feathered edge strips are then adhered on top of the tengujo lining.

Work of art Verso

Fig. 4: Schematic diagram for tengujo and kozo paper feathered edge strips. Top: Single-sided artwork. Bottom: Double-sided artwork.

(ii) Description of key treatment steps: Tengujo is one of the thinnest types of paper made from kozo (paper mulberry) fibers. The Japanese liken its thinness to the wings of mayflies. It is often used as the lining paper for double-sided works of art.

(iii) Advantages of Tengujo:

- Immersing a work of art in calcium hydroxide (pH8-8.5) will bring it closer to a neutral pH.

- Embrittled papers strengthened with tengujo will show a significant reduction in predilection to tearing and embrittlement.

- Tengujo is very thin and transparent, and can be adhered to a work of art with a minimal amount of paste, thus making it highly reversible.

- After reinforcing with tengujo, information on the verso can still be easily identified. If the paper support is sufficiently strong and the work of art must be exhibited, a full lining may be replaced with tengujo strips. (Fig. 4, top).

- Before an artwork is mounted on an acid-free matting, feathered edge strips made with strong, neutral kozo paper of appropriate thickness are prepared. The feathered edges are adhered to the verso of the work of art (Fig. 4). Therefore, the work of art is mounted onto the mat from the paper strips, making future unmounting easier.

- Feathered edge strips are pasted indirectly to the edges of the work of art with an interleaving layer of tengujo instead of directly on the work of art (Fig. 4) so that the fragile edges of the paper support.

- By virtue of tengujo's lightness and thinness, using a tengujo paper of similar tone to the original paper support as a first lining makes it virtually invisible and does not add thickness to the work of art, making it suitable for treating Western works of art (Fig. 5-6).

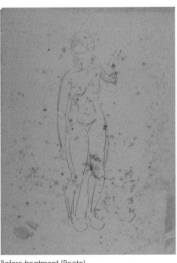

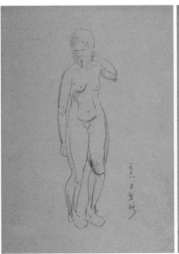

Before treatment (Recto)　　Before treatment (Verso)　　After treatment (Recto)　　After treatment (Verso)

Fig. 5: Comparison of the recto and verso of a pencil sketch before and after treatment—after treatment, yellowing and brown spots are removed, but details on the verso remain visible and the tengujo remains unnoticeable.

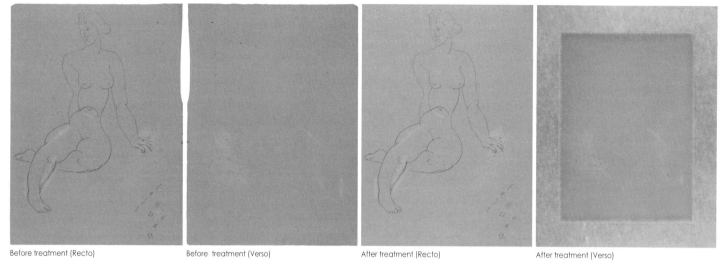

Before treatment (Recto)    Before treatment (Verso)    After treatment (Recto)    After treatment (Verso)

Fig. 6: Comparison of the recto and verso of a pencil sketch before and after treatment —after treatment, the verso is reinforced with a tengujo lining and the kozo feathered edge border strips are added.

## 2.Collections management—designing a non-acidic mat

This design both allows a work of art to be displayed and acts as a stable storage micro-environment. The design is detailed below:

a.For double-sided works of art, a hinge mechanism is designed to make turning over of the work of art easier (Fig. 7-8).

b.Works of art are protected in acid-free mats made from non-acidic mat board. The window mat does not cover the edges of the work of art, thus abiding by the conservation principles of "works of historic significance."

c.Safe handling and exhibition: Acid-free corrugated board is added to the front and back for additional strength (Fig. 9-11).

d.Chen Cheng-po's will: The principle of minimal intervention was applied to the treatment of Chen Cheng-po's will. It was only disinfected and pressed, and placed in a mylar mat with mylar M-style hinges. (Fig. 12). The will was then secured inside two sheets of Mylar without using any adhesives (Fig. 13).

e.Eight to ten mats of uniform size were stored in the same protective box.

f. Solid wood frames, lattice panels, and neutral black Fome-Cor can be added or removed according to exhibition needs, or can be stored separately.

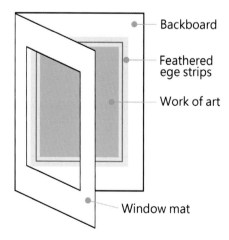

- Backboard
- Feathered ege strips
- Work of art
- Window mat

Fig. 7: (Single-sided works) Matting that adheres the four edges of a work of art.

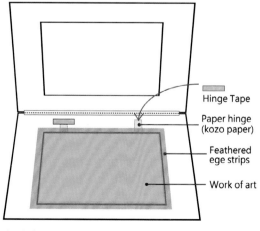

Hinge Tape

Paper hinge (kozo paper)

Feathered ege strips

Work of art

Fig. 8: (Double-sided works) Matting that adheres one edge of a work of art.

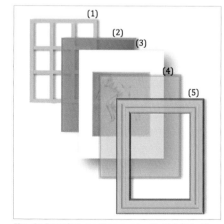

Fig. 9: Framing components: (1-5)：fir lattice panel, 5mm black Fome-Cor®, matted work of art, acrylic glazing, maple frame

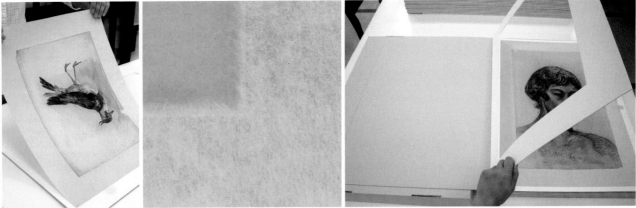

Fig. 10: (Left) Securing the work of art hinges allows both the recto and verso of the work of art to be seen ; (Center) Feathered edges on the verso of the work of art; (Right) Matting with a window mat, reinforced with acid-free corrugated board.

Fig. 11: (Left) Matting storage method for convenient examination and study; (Right) Acid-free matting and acid-free base board.

Before treatment (Recto)        Before treatment (Verso)

Fig. 12: Chen Cheng-po's will - an important historic double-sided document. Adopting a principle of minimal intervention, an M-shaped hinge (red) made of mylar that can be opened or closed (yellow dotted line) is used to secure the document. This non-adhesive method secures the will, protects it inside the mat, and allows for double-sided display.

Fig. 13: Double-sided non-acidic mat allows for double-sided display and study.

In Western countries, problems caused by acidic papers started to appear in the late 19th century, particularly in books published after 1850. First reported in Sweden in 1925, the problem was meticulously investigated in the United States beginning in 1957. Japan first noticed the problem of acidic paper degradation in the 1980's, while in Taiwan this issue began to be studied approximately ten years later.

Among Chen Cheng-po's artworks, the problem of paper degradation is most severe in Western works on paper including sketches, watercolors and sketchbooks. The key issue in the treatment of these works of art and cultural artifacts is deacidification, carried out by washing the object in a pH 8-8.5 calcium hydroxide bath. In the process, an alkaline reserve will be left in the paper, acting as a buffer to maintain a relatively neutral pH.

# IV. Conclusions

This project's main conservation concepts include:

## 1.Minimal intervention

From one point of view, "minimal intervention" means safeguarding a cultural artifact or work of art through preventive care rather than through interventional conservation treatment. In another, it means a refrain from excessive treatment. These concepts are described below:

a.Preservation: In preservation it is imperative to pay continuous attention to environmental control, carry out long-term observation, and note changes in the works of art and cultural objects.

b.Preventive care: Improve environmental control and management practices.

c.Improvement of technical skill: The goal of this project was to reduce the stress on the works of art. For example, for oil paintings wax linings were replaced with loose linings, and works on paper that necessitated lining utilized transparent tengujo paper as their lining paper. In both situations the intention was to minimize the use of adhesives.

d.Inpainting considerations:

(i)Established art forms: The objective was to restore their overall visual appearance, including color tone, texture, luster and surface cleanliness.

(ii)Works of historic significance: The objective was to preserve their historic characteristics and not to cover damage on their edges, thus allowing for fuller discourse and space for contemplation between an artwork and its viewers. For example, in Fig. 14, all damaged areas are on full display.

(iii)Historic artifacts: Chen Cheng-po's will was written while he was imprisoned and on the only fragments of paper that he could find, expressing his worries and concerns about his family biding them a final farewell. It is extremely significant in that it testifies to and represents the occurrence of a major historical event. The goal was to preserve the documents in their original state and intentionally minimize any trace of treatment. The focus was to distinguish between "non-excessive" from "inaction."

## 2.Cultural coordination

Traditional mounting has been inseparable from Asian paintings and calligraphy from its beginnings in ancient China and as it was passed to Japan, Korea and Southeast Asia. Yet this cultural practice has transformed into an over-reliance in using lining to solve problems, and has become a questionable

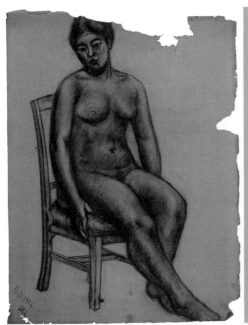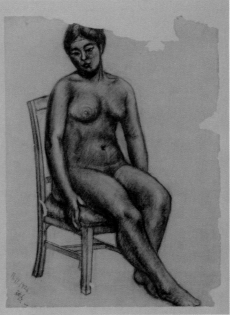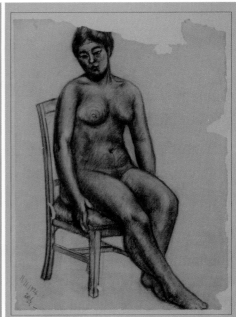

Fig. 14: (Left) Charcoal sketch before treatment; (Center) After treatment; (Right) Window mat does not cover four edges of the work of art (brown line).

practice to those outside of this field. For example, in the restoration of books, textiles, thankas, Western prints and photographs, there are many failed cases in which Chinese mounting techniques are used on Western paintings or when linings are used indiscriminately to deal with problems. Though it is generally believed that using the Chinese lining and flattening methods on a work of art is convenient for subsequent management, cultural considerations should not be ignored.

### 3. Refinement of conservation aesthetics and self-improvement

Though the conservation of cultural relics is usually carried out on a "permanent basis", "permanent" and "perpetual" cannot be defined in absolute terms, so a conservative reference of "one hundred years" is used as the basic unit for conservation.

The essence of conservation of cultural artifacts and works of art is not based on technical skill alone, and thus conservation aesthetics as expressed through the conservation treatment is only a basic requirement. The objectives of conservation aesthetics should be set upon a deeper foundation of science and the humanities. Only by fully imparting this "method of thinking" to our descendants of the next century are we able to completely express the aesthetics of conservation.

I would like to take this opportunity to express my gratitude to the Judicial Person Chen Cheng-po Cultural Foundation and their exhibition team. Many of the ideas and plans as expressed above have been revised and improved through their suggestions.

---

1. Chang Yuan-feng is a professor at National Taiwan Normal University Department of Fine Arts and the Director of the Research Center for Conservation of Cultural Relics.
2. This refers to a designation or recognition issued publicly by national government agencies for artists or works of art.
3. First lining: The first lining on the back of a work of art is its most important protective layer.
4. For information on tengujo, see http://www.weblio.jp/content/土佐典具帖紙.

# 探微觀紙
## ──紙張纖維玻片製作及種類判定

彭元興[1]、徐健國[2]

## 前言

　　造紙是我國四大發明之一，舉凡植物纖維皆可造紙。從古至今，目前尚有用來作為手工造紙的原料可概分木材纖維及非木材纖維。木材纖維主要取自木材木質部，為目前機器紙張最主要來源。木材纖維分針葉樹纖維及闊葉樹纖維二種。非木材纖維分韌皮纖維、種毛纖維、莖葉纖維及禾本纖維四大類。韌皮纖維又分樹皮及麻類。樹皮纖維為目前製作手工紙最主要的原料。常見韌皮纖維有構樹皮、楮皮、雁皮、三椏、青檀皮及桑皮等。麻類纖維主要有苧麻、大麻、亞麻、黃麻等。麻為最早用於造紙之材料，兩漢造紙主要原料為麻及樹皮，唐代主要造紙原料為楮及桑皮。種毛纖維主要是指棉花（cotton），為高級水彩紙主要原料。莖葉纖維主要取自植物莖葉，常見有鳳梨葉、瓊麻、馬尼拉麻等。禾本科纖維有竹材及草類。竹紙始於唐而盛於宋。由宋元至明清，竹紙始終居於領導地位。草類主要是麥稈、稻草稈及龍鬚草纖維。草類纖維至遲於唐代出現，可與樹皮搭配使用。從組成紙張之纖維種類可以做為紙張種類判斷之依據，甚至可以由紙張纖維組成推測該種紙張可能出現之年代而作為書畫鑑定或紙質文物年代判定之參考依據，故纖維判定對紙張種類之判定非常重要。在實際進行紙張纖維種類判定工作，就如同刑事鑑定中以現場尋獲一節手指頭要去判定手指為何人所有一樣困難。假若將新紙樣比喻為手指頭，則舊文物紙樣就如同一節乾掉的手指，要去判定為何人的手指更加困難。進行纖維觀察判定之前需將分散之纖維製成玻片，以利於顯微鏡下觀察纖維形態特徵，鑑定植物纖維種類。同時製成玻片可以長期保存，便於建立基本資料，對研究、教育及鑑定上有其相當程度的幫助。本文僅就手工紙常見纖維種類進行纖維形態觀察及特徵介紹，並將筆者的觀察判定經驗一併陳述供讀者參考。

# 一、玻片製作及纖維觀測

## （一）纖維解織及玻片製作

### 1.如果試片為木片則依下列方式進行纖維之解織

　　取1g纖維植物試樣，置於長170mm，直徑20mm之試管中，加入以冰醋酸與30%雙氧水用1：1（V/V）比例混合而成解織劑（因本解織劑為強氧化劑，所以使用時應避免沾染皮膚衣物），移置試管於60℃之水浴中。輕搖試管使內容物混合，加蓋。反應1小時後以玻璃棒攪動管內液體，蓋緊管口，慎防解織溶液蒸發損失。保持試管於60℃水浴中24小時，然後取出試管，倒出溶液，以蒸餾水沖洗3次，用力激盪試管使纖維均勻散解。視試樣解織之難易，重複上述方法至纖維完全分散（通常試樣變白為度）。將洗清之纖維去除多餘水分並放回試管中，以避免纖維不易吸收染色劑。以剛果紅染色劑染色，用鑷子夾取已染色之纖維，以清水將多餘剛果紅染色劑去除，取部分纖維置於載玻片上，吸除多餘水分，加入甘油，利用甘油的高黏度，以解剖針儘量將纖維單根分散均勻，蓋上蓋玻片，以供顯微鏡之觀察。如要製成永久玻片，則不滴入甘油，而以吸管吸取封片膠，將封片膠滴於纖維上，蓋上蓋玻片，俟乾，即為永久纖維玻片。

### 2.如試片為紙張或漿板則依下列方式進行解織及玻片製作

　　紙張濕潤後取樣，以防撕斷纖維。在有代表之部位取1-2cm的紙片3-5片，將紙張試片置於燒杯中，以攪拌器攪拌至纖維完全分散，將纖維多餘水分濾乾，用剛果紅染色劑染色，以鑷子夾取已染色之纖維，吸除多餘剛果紅染色劑，並以清水清洗多餘染色劑，取部分纖維置於載玻片上，吸除多餘水分，加入甘油，利用甘油的高黏度，以解剖針儘量將纖維單根分散均勻，蓋上蓋玻片，以供顯微鏡之觀察。如要製成永久玻片，則不滴入甘油，而以吸管吸取封片膠，直接將封片膠滴於纖維上，蓋上蓋玻片，俟乾，即為永久纖維玻片。如試片為高上膠度或添加濕強劑之紙張，則需加入1N之NaOH 溶液10mL，加熱至80℃以上，保持1小時，倒出溶液，清洗3次，再加入0.5%HCl 溶液10mL，於20℃保持1小時，清洗3次，將纖維染色並製成玻片供顯微觀察。製作過程照片見圖1至圖6。

圖1.將樣本置於水中分散

圖2.纖維以染料染色

圖3.以解剖針將纖維單根分離

圖4.吸去多餘染料

圖5.滴上封片膠

圖6.蓋上蓋玻片

## （二）纖維觀測

纖維長度之觀測係將纖維玻片置於投影儀（圖7）上，經投射後以尺量測投影機螢幕上纖維長度及寬度，依放大倍率換算成實際長度或寬度後紀錄於記錄表格上。長度每一紙樣最少需量測200根以上，且每一根纖維需為完整之纖維，寬度至少需量測50根以上，並於螢幕上觀察及記錄纖維特徵，並配合已知之纖維玻片進行纖維特徵比對以判定未知試樣之纖維種類。顯微投影儀可以全觀看到多數纖維，對於纖維種類整體判斷頗有助益。如需測量纖維壁厚或擷取所觀測之畫面，則可透過CCD將顯微鏡及電腦連接並搭配專業軟體做影像擷取（圖8），並可將觀測數據統計分析及纖維形態特徵資料數位化建立。需要局部觀察的組織則以光學顯微鏡觀察效果較佳。

圖7.顯微投影儀

圖8.光學顯微鏡

## 二、纖維特徵觀察結果

經纖維鏡觀察結果，茲將常見造紙纖維特徵說明如下：

### （一）構樹纖維

構樹（*Broussonetia papyrifera*）（圖9）及楮（*Broussonetia kasinoki*），屬桑科陽性樹種，從日本、韓國、大陸、臺灣至太平洋諸島皆有分佈。臺灣俗稱鹿仔樹，亦稱楮皮纖維。雖然構樹與楮同屬不同種，但因其纖維長寬等型態相當相似，故一般常將構樹纖維與楮皮纖維當成同一種原料來討論。日本為使用楮皮最多的國家。臺灣使用之構樹皮皆自泰國進口。構樹皮纖維特別長，平均長度9-9.8mm，平均寬度在10-24μm之間，可製成非常強韌之紙張。構樹皮纖維本身有微壓紋（microcompression）（圖10），故纖維形態觀測上往往可見有類似竹子一節一節的形狀，纖維兩端細尖圓，端部常有一層透明膜。一般臺灣書畫用棉紙常以此種纖維作為主要原料並加入木漿以降低成本。

圖9.臺灣構樹

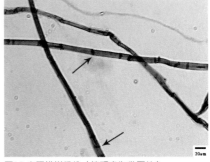

圖10.泰國構樹纖維（箭頭處為微壓紋）

## （二）雁皮纖維

　　雁皮（*Wikstroemia sikokiana*）及蕘花屬或稱雁皮屬植物（*Wikstroemia spp.*），屬瑞香科植物，葉對生排列如雁行，故名（圖11）。產日本、中國南部、臺灣及太平洋諸島，多為野生。菲律賓產地名為Salago。實際上，Salago約有九種之多，所以臺灣進口之樹皮是多種樹皮混合者。平均長度約3-4.4mm，平均寬度約僅10μm左右，適合做薄書畫用紙，為臺灣宣紙主要原料。雁皮木質素含量較高，遇光易變黃。纖維形態觀測上細窄，中段明顯較寬（圖12，箭頭處），兩端變細，纖維常有扭曲現象，微壓紋較不明顯。

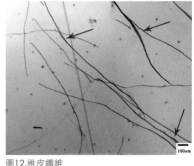

圖11.南嶺蕘花　　　　圖12.雁皮纖維

## （三）三椏纖維

　　三椏（*Edgeworthia papyrifera*）屬瑞香科植物，其枝條分叉處大都為三叉（圖13），故名三椏。產中國、日本一帶，其纖維細密而強韌，皮內含蠟質，鹼煮後不能完全去除，故有特殊光澤且不易被蟲蛀。長度在2-4.5mm之間，寬度在12-15μm之間。三椏在日本也作為鈔票紙原料，臺灣較少用於抄製手工紙。三椏纖維形態觀測上與雁皮極為相似，中段寬大（圖14），但整體纖維寬度稍大，兩端部尖削，壁上常見微壓紋（圖15）。

## （四）桑皮

圖13.三椏

　　桑樹（*Morus australis Poir*）與構樹同屬桑科植物，纖維與構樹相近，為高級手工紙原料。我國古代名紙金粟山藏經紙即以此種原料製成。纖維長度在3-15mm之間，寬度在6-28μm之間，其纖維素含量高，木質素含量低。現今常見之溫州皮紙即以桑皮為主要原料，墨韻與構樹皮相近，但製漿時有許多小樹皮等雜質不易去除，增加生產成本，其缺點也。桑皮纖維與構樹纖維相似亦有微壓紋（圖16），惟不若構樹皮明顯，且常伴有薄壁細胞（圖17）。

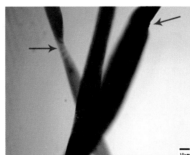

圖14.三椏纖維

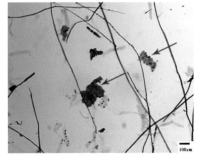

圖15.三椏纖維

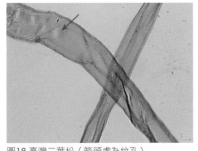

圖16.桑皮纖維之微壓紋

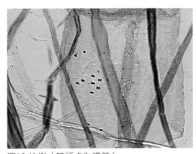

圖17.桑皮纖維及薄壁細胞

## （五）木材纖維

　　有針葉樹木漿及闊葉樹纖維二種。針葉樹木材纖維較長，平均長度約1.5-4.5mm，寬度平均41.1μm。闊葉樹木材纖維較針葉樹木材纖維短且窄，長度0.5-2.7mm，平均1.2mm；寬度平均22.0μm。不論針、闊樹纖維其細胞壁

圖18.臺灣二葉松（箭頭處為紋孔）　　　圖19.桉樹（箭頭處為導管）

上皆有紋孔（圖18，箭頭處），闊葉樹木材纖維尚含有寬短之導管節（圖19），此為闊葉樹木材纖維之一大判斷特徵。

## （六）竹漿纖維

因為細胞壁厚，故少有彎曲，常伴有枕形或腰鼓形薄壁細胞（圖20，箭頭處）。導管較草漿寬大，壁上有網狀紋孔，孔徑大小與分布均勻，纖維長度0.5-3.9mm，平均1.9mm，寬度3-23μm，平均13.2μm，纖維壁上有明顯加厚，部分有縱向條痕，纖維壁上紋孔少，孔徑小（400倍以上才易觀察到）。

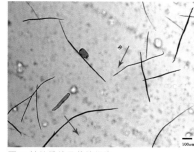
圖20.桂竹纖維及薄壁細胞

## （七）青檀皮纖維

較桑皮、構樹皮纖維細且短，長度0.8-3.7mm，平均2.6mm，寬度平均10.6μm，與雁皮相近。纖維壁上微壓紋不若構樹明顯，兩端鈍形（圖21）。在50倍投影顯微鏡下看細如髮絲（圖22）。大陸宣紙即為青檀皮及稻草漿以不同比例混合抄成，紙張中含青檀皮多者則紙質結實光滑，稻草漿多者則紙質柔軟。

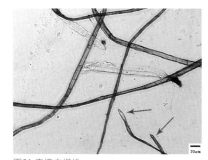
圖21.青檀皮纖維

圖22.青檀皮纖維

## （八）草漿

纖維細短，一般平均長度僅1mm左右，龍鬚草可達1.5-2.0mm，寬度6-15μm，纖維兩端尖削，中間寬度變化不大。常常可見邊緣鋸齒狀的表皮細胞（圖23），導管壁上無交叉區紋孔。薄壁細胞有多種形狀，如棒狀、球狀、枕狀等。

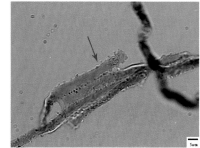
圖23.鋸齒狀表皮細胞

## （九）棉纖維

係由棉花種毛製得，棉纖維有長短之分。長纖維（2-4cm）可經軋棉機取下，一般供織布等之用。而留在棉籽上的短毛稱為棉絨（cotton linter），需經特殊採棉機始可取得，可供造紙、硝化棉（火藥）等之用途。棉纖維因為細胞壁微纖維排列方向多樣，故纖維乾燥後細胞壁常發生扭曲旋轉的現象，市售的棉絨纖維平均長度4.7-8.3mm，寬度平均13-16.4μm，纖維細胞壁沒有任何紋孔或微壓紋（圖24），細胞腔明顯，腔中經常含有若干原生質體（圖25）。許多高級水彩紙會以棉纖維為主要原料。

圖24.棉絨纖維（扭曲無微壓紋）

圖25.棉絨纖維（細胞腔中含原生質體）

## （十）麻

麻類是最早用的造紙原料，多為莖稈韌皮纖維，其纖維長度範圍廣，長者可至20幾公分，如苧麻、亞麻等。從漢代到宋代，麻始終居領導地位。近代出土之古紙殘片及敦煌石室藏經紙多為麻紙。

圖26.苧麻纖維（微壓紋及縱向條紋）

圖27.黃麻纖維（微壓紋及縱向條紋）

常見麻類有大麻、苧麻、亞麻、黃麻、鐘麻等。細胞壁有縱向條紋及微壓紋（圖26、27），細胞腔多明顯。

　　本次所送三件紙樣（水彩、單頁速寫及炭筆素描）中多為老化之碎片，經製成纖維玻片觀察發現其纖維多已殘破非完整之纖維，增加纖維判定之困難度。但仍可以經由纖維比對，推測紙樣中可能含有那些纖維。觀察結果分述如下：

　　水彩：取樣自〔宮燈〕（1916）掉下的小纖維，是這次修復這時代的作品常看到的水彩基底紙張。經纖維玻片觀察其纖維扭曲（圖28-29）且寬度與棉漿相近。故推測應為棉漿。

　　單頁速寫：取樣自數個本來混放在PD5（1927年代）包裝紙袋中的碎

圖28.水彩紙樣

圖29.水彩紙樣（纖維扭曲）

圖30.單頁速寫纖維多已殘碎

圖31.細胞壁有紋孔（箭頭處）

圖32.細胞壁有紋孔（箭頭處）

紙片，因此非特定的某一件。但PD5類（包含27件）的基底紙張也是在陳澄波的水彩常看到的，此次修復的單頁速寫多半是這種紙。單頁速寫纖維老化很嚴重且纖維多已碎裂（圖30），在纖維玻片觀察中發現有木漿之紋孔（圖31、32，箭頭處），且寬度不寬，推測闊葉樹木漿成分居多。

　　炭筆素描：當時從炭筆素描包裝紙內收集所有碎片，但因為又焦又脆，所以紙片邊緣也都無法核對出是哪一張作品的殘片，這批炭筆素描作品大約年代分佈介於1925-1929之間。炭筆素描紙樣纖維寬度（圖33）與棉漿相近，原以為是棉漿，但其纖維扭曲不明顯，加上細胞壁上可見有許多黑點頗似木漿之紋孔（圖33、34，箭頭處），推測係因年久已有灰塵等雜質進入內部造成黑點，加上有許多纖維較寬（圖33），雖無法判定是否為木漿或棉漿，但應以此二種漿料為主。

圖33.炭筆素描紙樣纖維

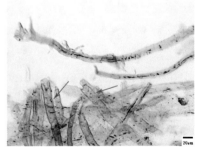
圖34.炭筆素描紙樣纖維

【註釋】
1. 彭元興：大葉大學環境工程學系教授。
2. 徐建國：行政院農業委員會林業試驗所木材纖維組助理研究員。

【參考文獻】
・王菊華《中國造紙原料纖維特徵及顯微圖譜》中國輕工業出版社，1999。
・林明寬《手工紙原料分析與製漿性之比較》中興大學森林學究所碩士論文，1996。
・王國財、徐健國，未公布纖維試驗資料，林業試驗所。
・經濟部標準檢驗局。1991。CNS 12888非木植物纖維鑑定法。

# Microscopic Study of Paper:
## Slide Preparation and Fiber Identification

**Peng Yuan-shing**[1] and **Hsu Chien-kuo**[2]

## Summary

Papermaking is one of the four ancient inventions of China. Paper can be made from any plant fiber. Raw materials that have been used in ancient times are still used for handmade paper today, and can be categorized into wood fibers and non-wood fibers. Wood fibers mainly come from the xylem in wood and are the main fiber source for machine-made paper. Wood fibers can be sub-divided into coniferous fibers and deciduous fibers. Non-wood fibers are sub-divided into phloem fibers, seed fibers, stem and leaf fibers and grass fibers. There are two kinds of phloem fibers: bark and hemp. At present, bark fibers are the main material for handmade paper. The most common kinds of bark fibers are: common paper mulberry bark, paper mulberry bark, gampi bark, mitsumata, blue sandalwood bark, and mulberry bark. Hemp fibers include ramie, hemp, flax and jute. Hemp was the earliest material used for papermaking. During the Han Dynasty, the major material for papermaking was hemp fibers and bark. In the Tang Dynasty, paper mulberry and mulberry bark were used. Seed fibers mainly refer to cotton, which are the key material for making top-quality watercolor paper. Leaf fibers are mainly taken from the leaves of plants; commonly used leaves are those of pineapple, sisal and Manila hemp. Examples of grass fibers are bamboo and grass. Bamboo paper first appeared in the Tang Dynasty and became popular during the Song Dynasty. Until the Qing and Ming Dynasty, bamboo paper had always predominated papermaking fibers. Grass refers to the fiber taken from wheat straw, rice straw and eulaliopsis. Grass fibers did not appear until the Tang Dynasty; they can be used together with bark. Since the fiber composition of paper aids in identifying the paper type and period of manufacture, it acts as an important reference for authenticating works of art and determining their age. In other words, identifying papermaking fibers is integral to characterizing paper. However, authentication through identification of paper fiber is rather complicated and difficult in practice. Before identifying papermaking fibers, slides of dispersed fibers need to be prepared for easier observation of their morphological characteristics and determination of plant fiber types. Since slides can be kept for a long time, these samples can be gathered together into a database which will be of significant importance for research, education and authentication purposes. Common fiber types, morphological features and characteristics of handmade paper are as follows:

1. The fibers of common paper mulberry bark are particularly long, with an average length of 9-9.8cm and an average width of 10-24μm. They can be made into very tough paper. There are micro-compressions on the fiber surface resembling the nodes of the bamboo. A fiber is tapered and round at its two ends and a layer of transparent membrane can often be found at the tip. This kind of fiber is

the major material for making cotton paper commonly used for books and paintings in Taiwan.

2. Gampi bark fibers are about 3-4.4mm in length but only about 10μm in width. They are best for making very thin paper for books and paintings, and are the major material for making xuan paper (for Chinese calligraphy and paintings) in Taiwan. Gampi bark fibers are slender in shape, markedly wider in the middle and tapered at the ends. Twisting of the fibers is quite common. Micro-compressions are not visible.

3. Mitsumata fibers are 2-4.5mm in length and 12-15μm in width. They resemble gampi bark fibers in appearance. They are both wide in the middle, but mitsumata fibers are generally wider. Their tips are pointed and light micro-compressions on the surface are common.

4. Mulberry bark fibers are 3-15mm in length and 6-28μm in width. The common Wenzhou parchment is mainly made of mulberry bark. Similar to the common paper mulberry bark fibers, there are light micro-compressions, though not so clearly marked. They are often accompanied by parenchyma cells.

5. Wood fibers: These can be divided into coniferous wood fibers and deciduous wood fibers. Coniferous wood fibers are longer with an average length of 1.5-4.5mm and an average width of 41.11μm. Deciduous wood fibers are comparatively shorter and narrower with a length of 0.5-2.7mm (average 1.2mm) and an average width of 22.0μm. Both types of fibers have pits on the cell walls. Deciduous wood fibers have wide and short vessel segments, which is a major distinguishing characteristic.

6. Bamboo fibers: They rarely bend because of the thick cell wall, and the fibers are often accompanied by cushion or kidney-shaped parenchyma cells. The vessels are broader than those of straw. There are mesh pits with uniform aperture and distribution pattern on its walls. The fibers are 0.5-3.9mm in length (average 1.9mm) and 3-23μm in width (average 13.2μm). There is an overt thickening of the fiber wall and vertical streaks may be observed in some fibers. The few pits on the fiber wall have small apertures.

7.  Blue sandalwood bark fibers: They are smaller and shorter than those from mulberry bark and common paper mulberry bark. They have a length of 0.8-3.7mm (average 2.6mm) and an average width of 10.6μm, similar to gampi bark fibers. The micro-compressions on the fiber walls are not as distinct as those of the common paper mulberry fibers. The fiber ends are obtuse. The fiber is as fine as a strand of hair when examined under 50x magnification.

8.  Grass fibers: The fibers are small and short with an average length of only about 1mm. Eulaliopsis fibers can be as long as 1.5-2.0mm. Its width is 6-15μm.The two ends of a fiber are pointed and there is little variation in the width in the center of the fiber. Epidermal cells with jagged edges are commonly found. There is no cross-field pitting on the vessel wall. The parenchyma cells are variously rod shaped, spherical or pillow shaped.

9.  Cotton fibers: These come from cotton seed. Since the microfibers on the cell walls of cotton fibers are arranged in a variety of ways, the cell walls may be twisted or rotated when the fibers are dried. The linters sold in the market are on average 4.7-8.3mm in length and 13.6-16.4μm in width. The cell walls of the fibers do not have any pits or micro-compressions. Cell cavities are discernable and are usually filled with protoplasts.

10.Hemp: Hemp is the earliest papermaking material, and is mostly composed of phloem fibers. Hemp fibers come in a wide range of lengths, with the longest close to 20cm. There are longitudinal streaks and micro-compressions on the cell walls. Cell cavities are present.

The three paper specimens analyzed (from Chen Cheng-po's watercolors, Single-sheet sketches and charcoal sketches) were aged fragments. Their fibers were mostly worn-out and ragged. The watercolor specimen sample fibers were taken from *Palace Lantem* (1916), which was a common paper support used by Chen Cheng-po for painting watercolors from this time period. Examination of the slides showed that the twisting and the width of the fibers bore resemblance to cotton, therefore it was concluded that the paper fibers were composed of cotton. The Single-sheet sketch paper samples were taken from a few small paper fragments inside the wrapping for PD5 sketches (1927). The paper fragments in PD5 (27 total works of art) were similar to the paper support of many of Chen Cheng-po's watercolors. Most of the sketches were drawn on this type of paper. The fibers of the sketches showed serious signs of aging and disintegration. Under the microscope, we observed wood pulp pits. Since the fibers were not particularly wide, it was ascertained that they were primarily composed of deciduous pulp. The charcoals sketches' paper fragments were also taken

from inside their wrapping paper. Because they were degraded and brittle, there was no way to identify from which charcoal sketch the fragments came. What could be confirmed, however, was that the charcoal sketches were completed between 1925 and 1929. After fiber examination, it was concluded that the paper supports consisted mainly of wood and cotton pulp.

1. Peng Yuan-shing is a professor at Department of Environmental Engineering, Da-Yeh University.
2. Hsu Chien-kuo is an assistant researcher at Wood Cellulose Division of Taiwan Forestry Research Institute.

# 多樣性：中國、臺灣、日本紙張用於填補和補強的修復應用與思維

陳詩薇[1]

## 前言

　　東方紙張，尤其是日本楮皮紙經過長期的研究調查後已被廣泛地應用在書籍、紙質文物甚至19世紀的印度項鍊[2]等修復上。因楮皮紙張具有強韌的長纖維特性適合用於穩定文物結構與強度，亦可有效調整厚度的增加。但相較於以棉、亞麻、草等短纖維組成的傳統西式手工紙張相比楮皮紙較為透明，但是要調整到文物所需的表面質感、色澤仍然有限，也因此近年才有較多談到宣紙與其他中式紙張在裝裱應用以外[3]的修復研究發表。宣紙的柔軟性佳、輕薄不透明、簾紋等特性，比起西式紙張或日式楮皮紙也非常適合用於修復上。本文將介紹中國、臺灣及日本[4]的各式亞洲紙張的結合並運用於財團法人陳澄波文化基金會典藏作品的修復上。

## 一、財團法人陳澄波文化基金會的典藏文物

　　財團法人陳澄波文化基金會（以下簡稱基金會）致力保存二十世紀初臺灣大師畫家——陳澄波的油畫、紙本繪畫與素描、書法、水墨畫等文物作品。 1895年2月2日在日治時期的嘉義市出生的陳澄波是第一代至東京美術學校留學的學生之一，而後於蓬勃發展的臺灣現代藝術上成為重要指標的代表性人物。尤其透過他的油畫作品可以看出當時西方藝術哲學對日本文化的影響，再經重新詮釋成為臺灣本地美學。然而深受敬重、為人熱忱的陳澄波不幸在1947年3月25日逝世成為政治事件下的文化英雄。一甲子歲月過後，基金會正極盡所能的展開一連串的作品保存計畫，希望在新興藝術思潮下，陳澄波的作品能夠完整、安全地保存在臺灣這個政治變動但文化豐富的島嶼中。

　　從2011到2014年間，陳澄波文化基金會委託國立臺灣師範大學文物保存維護研究發展中心修復1,012件文物作品與29本素描簿。文物種類涵括油畫、水彩、炭筆素描與單頁速寫、水墨、書法、膠彩畫、照片、遺書等。作品數量不僅龐大、媒材與材料種類深具多樣性，同時要配合東亞國際巡迴大展的展出，因此在有限的時間下建立一套修復標準S.O.P是有其必要性的。另外也針對特殊性、無法適用標準化的作品研發出量身打造的修復技法，利用中、臺、日式各紙張的獨特性運用於以下三件特殊作品的修復上。

## 二、中國、臺灣、日本紙張的簡介

　　以下為幾種東亞常用的修復紙張，並以中、日文和漢語羅馬拼音列出名稱[5]提供參考。

# （一）楮皮紙 KOZO / CHUPI（PAPER MULBERRY）BAST FIBER PAPER

根據不同的厚薄、透明度、柔韌性及顏色因此楮皮紙的種類很多。有些楮皮紙會參雜其他纖維，但修復專用的楮皮紙為純楮皮纖維、pH呈中性的紙張。以下說明日本與臺灣製造的楮皮紙張：

## 1.典具帖（Tengujo／Dianjutie）

典具帖紙（圖1）源起日本室町時代（1392-1573 C.E.）[6]的岐阜縣，能被製成不同厚薄、色澤。典具帖紙質輕薄透明、纖維長且強韌，用於紙質作品的修復可強化兼具透明性。因為紙張很薄僅需使用少量的漿糊便能與文物黏合，反之也只需少量的水分即可移除，可逆性高。使用染色典具帖[7]小托在黃化或變色的紙質文物的背面有三個好處：（1）可強化紙張的結構力。（2）使用染色略帶有黃棕色調的典具帖可搭配紙質文物因黃化或變色後呈現的色調。（3）可適用於雙面皆有繪畫或資訊的作品。

## 2.美濃和紙（Minogami／Meinong）

美濃和紙（圖2）源起日本奈良時代（710-794 C.E.）的美濃市，2014年11月已被列入聯合國科教文組織（UNESCO）的無形文化遺產。美濃和紙是pH呈中性，纖維交織均勻具柔軟、強韌且高透明度。在日本長久被用於生活用品如障子、油傘，在此案中的修復應用可做為托襯背紙嵌折（mending）、頂條、隱補、固定用紙片（hinging）等。

## 3.細川紙（Hosokawa／Xichuan）

日本細川紙（圖3）[8]比典具帖與美濃和紙厚，適合用於較厚或尺幅較大的作品。細川紙在潮濕狀態下，其橫向與直向的簾紋會在強度上產生相當程度的差異性。因為當紙張在乾燥時抗拉強度極佳，且紙張原色非常接近老紙的色感，因此在此修護案中，細川紙常被使用於邊條紙或加托紙，進而調整文物的厚度與平坦性。

圖1.ひだか和紙有限会社5.0g/m²典具帖，NAJ color

圖2.長谷川和紙2.3勾美濃和紙

圖3.Tanako Paper Factory, 5.0勾細川紙

圖4.福隆棉紙廠白楮皮紙

## 4.臺灣楮皮紙（Taiwanese kozo／chupi）

臺灣楮皮紙（圖4）在臺灣埔里鎮製造，區分為不同的厚度，在修復上有不少的應用性[9]。其中比較薄的漂白楮皮紙比一般原色楮皮紙白，修復時若需要強、薄、半透明質感的補紙時非常實用。

## （二）宣紙（Xuan Paper）

宣紙（圖5-6）起源於唐代安徽省的宣城涇縣。宣紙使用於書法與繪畫的基底材，也是中國書畫裝裱的重要材料之一。漢代（206B.C.-220A.D.）造紙時以麻、草、藤、桑、構樹為原料，唐代開始加入黃麻、亞麻、苧麻、竹及稻草。宣紙質感、紋路、顏色與品質種類很多，嚴格來說，青檀樹皮和砂田稻草為宣紙的主要原料，但現在許多紙張可能包含其他無名纖維[10]也一律統稱宣紙。紅星是中國大陸知名的宣紙製造業者[11]之一，根據青檀樹皮和稻草比例的不同而有淨皮單宣、淨皮綿連、棉料單宣、棉料綿連[12]等類別。

書法、繪畫、或修復用的宣紙選擇取決於纖維成分與比例，因為這些因素會影響到紙張的柔軟性、厚薄、與吸水性。宣紙雖有市售染色的色宣，但實際上修復師多會自行染製宣紙到適合文物的色調後使用。

圖5.紅星牌淨皮宣紙　　　　　　　　　　　圖6.紅星牌宣紙（整刀100張）

## 三、紙板水彩：使用乾、濕式紙漿纖維兩階段填補破損

〔公園一景〕（圖7）是紙板水彩（laminated paper board），修復前狀況有紙張酸化及黃化、紙板分層、蟲啃食破損、黴斑、紙張磨損問題。尤其本作品中紅色顏料對水份極為敏感容易暈彩掉色，隱補破損時得小心地控制水量與水份，避免因毛細現象使水份擴散而影響顏料。本案例的隱補破損是自製中性手工純紙漿，利用抽氣桌來控制水份將會引起的問題，同時能讓紙漿纖維透過抽力填入紙層空隙內，是一種沒有使用黏著劑方式來填補紙層與加強紙板結構的做法。

首先，使用修復專用粉末橡皮將作品正、背面表面除塵。沾黏於紙板周邊的髒污異物以手術刀輕移剔

| 名稱 | 公園一景 | |
|---|---|---|
| 年代 | 年代不詳 | |
| 尺寸 | 24.7×34 cm | |
| 媒材分類 | 紙板水彩 | |
| 修復前狀態 | ・破洞<br>・紙板分層<br>・磨損<br>・褐斑<br>・黃化<br>・水性染料易掉色 | 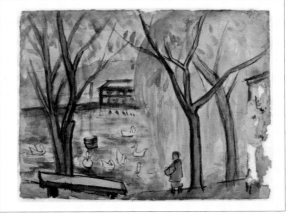 |

圖7.修復前照片與狀態紀錄

除。在進行作品清洗前，須對水分敏感的顏料以2% Klucel G[13]乙醇溶液加固。顏料完全穩定後，針對畫面餘白處的黴斑以1％過氧化氫（$H_2O_2$）漂白。作品先放置於濕氣箱中待紙張軟化展開後移至抽氣桌上作業，作品下方墊著不織布和吸水紙支撐保護。控制在較小的抽力下將作品全面清洗，黃化在透過抽力吸附到下方的吸水紙。黃化析出後，抽氣桌繼續抽引到作品全面乾燥後再進行填補破損。

　　將日本楮皮紙、紅星牌宣紙與Arches純棉水彩紙解纖後混合成紙漿，並使用微量甲基纖維素（methylcellulose）使三種纖維凝聚結合（圖8）。因日本楮皮紙的纖維較長可讓破損處的填補穩定性佳，宣紙的短纖維則讓紙漿較好操作，Arches純棉水彩紙提供較好的填充體積與不透明性。先將作品置於潮箱內軟化後至抽氣桌上，從破損中央處進行填補處理，藉由抽氣桌的抽力將裝有紙漿的定量吸管輔以鑷子慢慢填入（圖9）。謹慎控制填入的紙漿量以避免過多水分造成漬痕或引起紙板變形，操作過程須留意對水分敏感而易暈色的顏料。

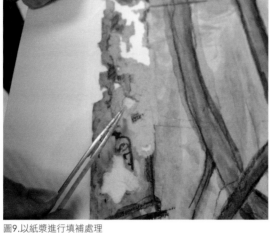
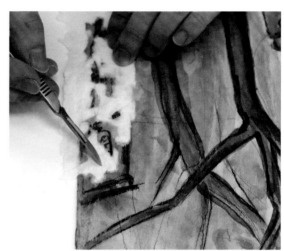

圖8.準備紙漿　　　　　　　　圖9.以紙漿進行填補處理　　　　　　　　圖10.以手術刀修整填補處

　　紙漿填補到一定厚度時持續抽氣乾燥，然後於作品上、下使用不織布和吸水紙重壓至完全乾燥。由於破損面積過大很難做到一次性的表面平坦，因此還需使用乾的紙漿纖維調整表面。乾式紙漿纖維的修復應用已被研究發表[14]，與濕式紙漿纖維的差別在於乾式紙漿還需使用黏著劑。乾式紙漿比較容易壓實與好操作，因此適合填補在破洞的外緣。以〔公園一景〕為例，是以手術刀輕刮Arches水彩紙的纖維加入小麥澱粉糊後填補。最後，用鐵弗龍骨刀將表面撫平壓緊，再以手術刀輕刮調整不均勻處（圖10），這兩個步驟持續做到表面完全平整為止。

　　大部分的水彩作品幾乎畫滿整個紙張，夾裱的保存方式是將畫面完整顯現。諸多作品將進行為期一年的東亞國際巡迴大展展出，作品需在夾裱型式下同時兼具保存與展出功能。以紙片（Float hinging）將作品固定於夾裱的方式雖可讓畫面完整露出，但日後會有下垂[15]問題，並不適合做為長期保存的方法。經與陳澄波文化基金會討論後決定將作品的四邊加寬，以這四條邊條將作品黏貼固定在無酸卡紙板上，正面卡紙開窗後能讓整幅作品的畫面完全可見。本中心特地研發一種夾裱方式可讓整幅作品易於整理與收納方式，兼顧便利性並能預防有害氣體或微生物的入侵、溫濕度變化的影響或人為翻看、運輸造成的損傷，同時安全地在受控制的環境中保存，並於展覽時容易展示[16]。

　　作品四邊加寬的作法如下，選用染色典具帖[17]小托在作品背面，待乾燥後裁切四邊多餘的典具帖。作品加濕攤平並將毛邊細川紙條貼搭作品的背面四邊。配合作品紙張厚度增加細川紙的層數。自然乾燥後上板繃平，於填補破損處塗佈隔離層後以天然有機顏料補彩全色。補彩全色的顏料不僅為可逆性且視覺上能夠融合周遭原作的媒材顏色，但細看時能與原作有所區別。最後整體視覺調整以運用可逆性又帶有自然的舊色[18]（從老畫的覆背紙熬煮出）使作品更為協調完整（圖11）。

圖11. 正光　修復前後對照

## 四、素描簿：純紙纖維、宣紙、臺灣楮皮紙、典具帖、細川紙的應用

　　編號SB08的素描簿年代約在1927-29年，內頁多為鉛筆、色鉛筆為主的人物素描。劣化問題有昆蟲啃食造成紙張穿孔破損、紙張酸化引起變色、媒材磨損、漬痕、髒污、結構性的損傷，例如：素描簿的線圈孔洞損傷及書針生鏽腐蝕。以有機物質紙張、黏著劑等所組成的書籍容易遭受蟲害，輕者為單頁紙張受損、嚴重者為整冊紙頁啃食穿透。因此紙張清潔步驟時可大約透過損傷狀況判斷出害蟲種類，另常見附著於書內的昆蟲屍體或蟲糞，越完整的蟲體將助於害蟲種類的鑑別。

　　關於SB08（圖12）修復案例，害蟲將封面、封底與整個內頁嚴重啃食穿透（大多數的破洞多為寬0.2cm以下、長度0.2到1cm）。雖然有多種的隱補材料及修復手法，但在有限的修復時間、封面和封底厚度、鉛筆媒材穩定性，與每頁的正、背面修復後視覺美感等衡量下選擇便有限了。

| 名稱 | SB08 |
|---|---|
| 年代 | 1927.9-1929.4 |
| 尺寸 | 24×28cm |
| 媒材分類 | 素描簿 |
| 修復前狀態 | ・騎縫脆化<br>・破洞<br>・黃化<br>・媒材磨損<br>・油漬損害<br>・附著物<br>・釘子生鏽 |

圖12.修復前照片與狀態紀錄

　　除了上述昆蟲造成的問題外，尚有封底的疑似油漬痕，每頁的易撕虛線孔洞的破損與脆化、表面髒污、蟲食破損（每頁至少5個蛀洞以上）與紙張酸化造成顏色不勻（圖13）。其中，最耗費時間的「隱補破損」步驟必須於有限時間內有效執行。最初考慮使用自動漉補機（leaf casting），但因鉛筆素描有遇水易掉色的考量所以必須選擇最少量的水份修復方法。以宣紙的紙張纖維加入甲基纖維素成為填補材料也是其中一個選擇，但因為素描簿紙張內頁厚度偏厚，此做法太過耗時且填補區域質感偏硬，不適合素描簿未來的使用性。

　　在進行填補破洞前，先將封面、封底的黑色騎縫帶與鏽蝕釘書針移除（圖14-15）。每一頁依序順序小心分

離後以粉末橡皮、中性清潔海綿進行表面除塵。紙張有嚴重、不均勻的色差從深者到深棕色問題。每頁的左下角靠近書背處紙質黃化且脆弱，因此在清洗步驟的考量以背面的吸附式清洗（blotter washing）取代全面性的浸泡清洗（bath immersion），此種方式可降低鉛筆素描的掉色且使紙張整體色澤較為均勻，在填補破洞時較不易形成水漬痕跡。初步測試後此種方式可達到預期效果，吸附出很多黃化、清洗後紙張較為明亮柔軟（圖16）。待乾燥後，將作品稍微潮濕軟化，上下以不織布保護再置入於中性吸水紙內重壓乾燥。

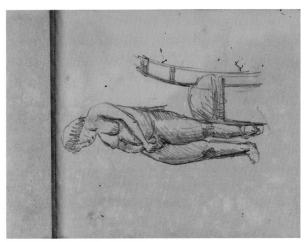

圖13.破損包含啃食破損、油漬損害

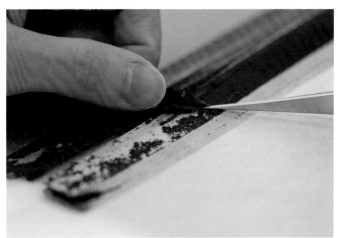

圖14.將騎縫帶移除

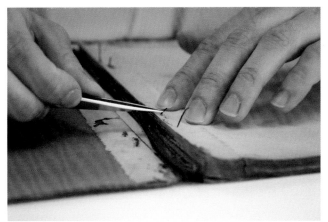

圖15.將生鏽釘子鬆開

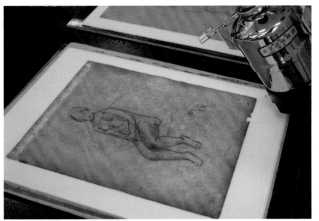

圖16.清洗內頁（Blotter washing）

圖17.在聚酯片（Mylar）上描繪破洞輪廓

圖18.以染色宣紙補洞

圖19.將補洞紙敲實壓平

　　針對內頁破洞處理則以採取先染製補紙顏色後填補的方式；因每張內頁的底色相近，須挑選相近內頁質感的紙張進行染色，經染製完成的用紙即為「補紙」。內頁的主要破損孔洞數量眾多、外型約2mm左右的孔洞，由於孔洞過小並具有厚度，測試後無法以濕式紙漿填補（wet paper pulp，如本文第3個修復案例），所以採用填補破洞的技法。內頁紙張的表面質感柔軟且不透明，因此選擇以厚度略薄於內頁的宣紙做為填補

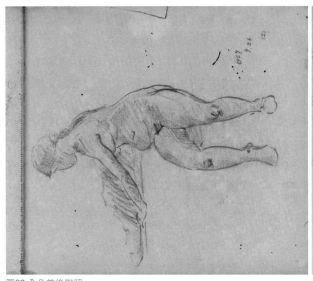
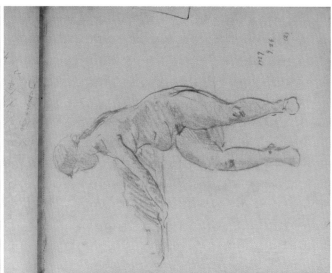

圖20.全色前後對照

破洞的補紙，後再用天然有機的顏料手工刷染宣紙，染製色調以內頁紙張最明亮的顏色為基準，先在光桌上於內頁紙張背面墊上無酸聚酯片，並描繪出破損的外形輪廓（圖17），再將聚酯片放在隱補紙上以針錐按線點出比破損處略大1mm的外輪廓，以手術刀將補紙邊緣1mm打薄呈毛邊狀（圖18）。貼黏時使用小麥澱粉漿糊黏貼於內頁背面再以豬鬃拓刷敲實壓平，隱補的整體厚度須與內頁紙張達成均衡（圖19），故選擇比內頁紙質厚度略薄的宣紙是考量補紙與內頁的黏貼處厚度，並且將補紙邊緣打薄呈毛邊狀以避免造成磨損與擠壓。

　　破洞填補完成後，在補紙處薄塗一層甲基纖維素（methylcellulose）做為補彩前的隔離防水層，以天然有機顏料進行補紙處的補彩，整合色調使視覺美感一致。但是內頁背面經填補完成的破洞處則不做補彩處理，留下補紙原色可明顯以視覺肉眼分辨何處為補紙（圖20）。

　　遭蟲蝕孔洞的封面及封底採取不以水清洗的修復處理方法，修復作業時須避免過多水份造成紙板嚴重受濕變形或隱藏在紙板內的色素被析出擴散產生漬痕。因此，從Arches水彩紙製成的乾式紙纖維加入適量小麥澱粉漿糊後填補破洞。此做法可加強紙板的結構穩定性而避開水份引起濕氣的處理步驟。使用手術刀刮取Arches水彩紙的纖維後以鑷子緊壓填入洞內（圖21）。若填入的紙張纖維夠緊實即無須使用小麥澱粉漿糊為黏著劑，只需要塗在表面，讓最表層的纖維固定即可且當作表面防水隔離層，再塗一層甲基纖維素後，以天然有機顏料補彩（圖22-24）。

　　易撕虛線的補強：內頁背面的易撕虛線以小麥澱粉漿糊黏貼約1公分寬的典具帖頂條，可強化易撕虛線的紙力結構避免日後產生斷裂。貼完典具帖頂條以不織布、吸水紙重壓乾燥（圖25）。

圖21.用乾紙纖維來補封面的破洞

圖22.塗佈甲基纖維素於補紙處作為防水隔離層

圖23.封底　補洞後，全色前

圖24.封底　全色後

　　以紙釘取代鏽蝕釘書針：在修復倫理中，紙張內的金屬物質須盡可能清除或減少，避免金屬元素引起未來性的劣化，如金屬鏽蝕（staining）、灼燒（burning）、缺損（loss）。任何含有金屬元素如迴紋針、釘書針等裝訂型式，均以pH中性紙張製成的「紙釘」取代[19]。選擇紙釘修復考量有：紙捲起來時能穿進原釘書針孔洞內，同時紙釘的結構力足以承受書簿的翻閱。SB08的紙釘製作以臺灣楮皮紙[20]為材料，長纖維能承受定向拉伸、紙質輕薄柔順，較不會磨損原釘書針的孔洞，質感色澤於視覺上很契合素描簿的色調。中性紙釘的製作如下：將楮皮紙切成平行四邊形再對折（圖26、27）。計算原釘書針的長度，把左、右邊捻好可穿進原洞口（圖28、29）。

　　封面、封底重新裝回：原有的黑色騎縫帶（hinge tape）區域，因為紙板脆化、漬痕嚴重，所以使用細川紙做為新騎縫取代，以小麥澱粉糊黏貼在書背脊內面（圖30）。內頁調整好在封面、封底內，再黏貼另一

圖25.使用典具帖頂條補強易撕虛線

圖26.紙釘　製作前、後

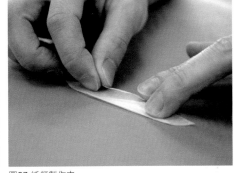

圖27.紙釘製作中

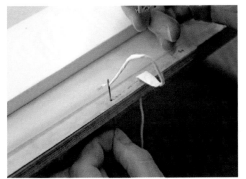

圖28.將紙釘放入原裝釘孔洞內

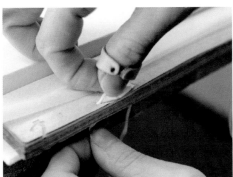

圖29.調整紙釘位置

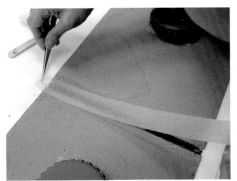

圖30.將細川紙黏貼在書背脊內面

圖31.黏新細川紙騎縫

圖32.封面　修復前後對照

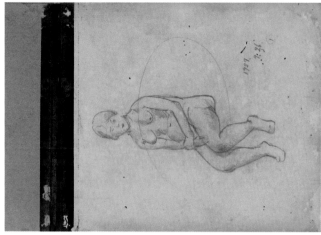
圖33.第1頁　修復前後對照

圖34.內頁背面　修復前後對照

細川紙條（圖31）黏貼在原來黑色騎縫帶位置，但在封面側比書背騎縫進去一點，讓這兩層細川紙騎縫搭接厚度錯開，減少對內頁潛藏性的磨損。整冊重壓至完全乾燥後修復完成（圖32-34）。

## 五、單線圈裝訂型式的素描簿：製作複合式紙張以加寬書背

　　第三本編號SB19的素描簿年代為1935（圖35）。此素描簿為鉛筆和墨水素描，劣化現狀有裝訂的線圈生鏽（圖36）、紙張漬痕與磨損、封面裂痕、破洞及黃化。針對素描簿修復後的呈現型式多次與陳澄波文化基金會商討，決定修復後素描簿維持原本的裝訂「單線圈」型式，但線圈含有金屬物日後將引起有機紙質鏽蝕、

| 名稱 | SB19 |
|---|---|
| 年代 | 1934-1935.4 |
| 尺寸 | 25×28.5cm |
| 媒材分類 | 素描簿 |
| 修復前狀態 | ・單線圈生鏽<br>・水害、油害<br>・磨損<br>・封面裂痕<br>・黃化 |

圖35.修復前照片與狀態紀錄

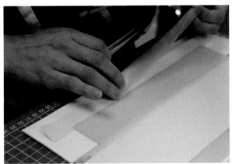

圖36.封面內頁與書背皆有單線圈造成的磨損、裂痕與破洞

圖37.加寬書背的側面結構圖示

褐斑、漬痕與其他劣化問題。因此，修復方針必須兼具委託者對於文物期望原有裝訂形式的維持盼望，同時站在修復者角度盡可能降低金屬物質將引起作品的潛藏性破壞的原則制定了以下的修復方式。

先製作複合式紙張把書背加寬[21]，所謂「複合式紙張」是選用不同的紙張，重新設計一個加寬書背的結構，將封面封底與每一頁分別以染色過的典具帖與宣紙加強。考量原作品的內頁和封面、封底紙張材質偏厚且硬，表面質感平順光滑，經多方評估彈性、透明的日本楮皮紙並不適合此素描簿，而選用多層、經染過色的宣紙於視覺上更為合適。

因作品的原書背紙性的柔軟，新製的書背搭接於原書背處的漿糊與水分須控制於最少量，先黏貼一層染色典具帖[22]再依序外加宣紙、典具帖。此作法基於修復材料可逆性條件且較不會傷及作品搭接處（圖37）。因為封面、封底紙板較厚，新書背的製作總計四層宣紙。

因為原本的金屬線圈直徑太小造成內頁孔洞磨損嚴重，修復方法是從背面使用紙張覆蓋強化線圈孔洞，但從正面看時孔洞是露出的（圖38-42）。

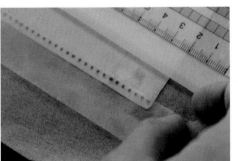

圖38.將典具帖黏於內頁背面的書背處

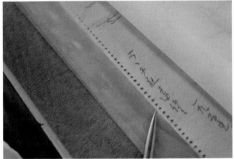

圖39.將宣紙黏於背面的典具帖上

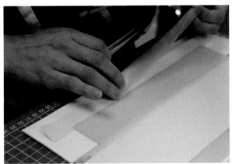

圖40.將典具帖黏貼於內頁正面的書背處

圖41.將宣紙黏貼於正面的典具帖上

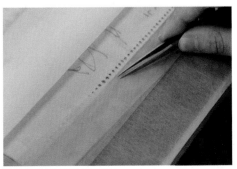

圖42.將典具帖黏貼於宣紙上

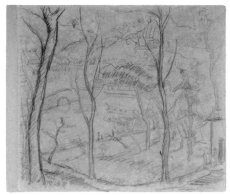

圖43.完成新書背

圖44.在新書背上鑽出新孔洞

圖45.將線圈裝在新的書背

由於原作的紙質光滑與宣紙很容易磨損所以外加具帖，目的可保護宣紙，幫助固定新製的加寬書條在原作上。宣紙與典具帖條黏後，每頁分別以不織布、吸水紙上下隔開如三明治方式重壓乾燥定型（圖43）。

最後，線圈規格經多次試驗後調整如下：圓形孔洞、孔位間距為4：1（每6mm的孔位間距鑽出4mm的圓形孔洞在新的書背處上）是原線圈洞型的兩倍寬（圖44）。目的是製作較大孔徑將降低線圈對孔洞的磨損。線圈材質選擇使用不鏽鋼材質外層塗刷兩層壓克力黏著劑（Acryloid B72）製成新線圈。塗刷無酸黏著劑保

圖46.封面　修復前後對照

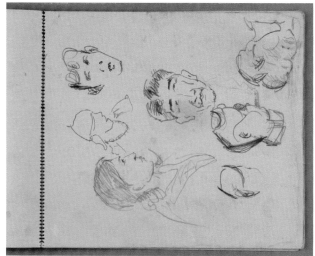
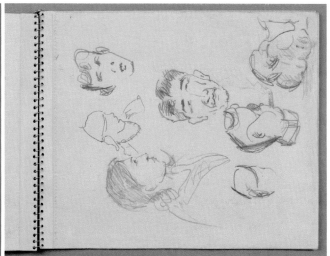

圖47.內頁　修復前後對照

護是為降低日後線圈鏽蝕而造成破壞。再把新線圈以每6毫米的距離纏繞在1公分的金屬棍子上，完成單線圈裝設在新書背上（圖45-47）。

## 六、結論

東方紙張的廣泛應用提供了修復上多元化的選擇。可依藉各種紙張的柔軟性、透明度、強力和色調特性可單獨使用亦可混合搭配，於一定修復技術掌握下除了可以用來做紙材厚度的調整，亦可使各種紙性充分融合，像紙板、素描簿封面及封底的修復運用，甚至是取代金屬類的材質。然而，於實際修復考量下須將含有金屬因素的原文物型式改變時，衡量折衷下儘量地保留原型式，就如SB19的線圈裝訂修復特殊案例。

尤其是宣紙在隱補破損時具有很多潛在性應用，因為宣紙紙性柔軟且有時相較於楮皮紙更適合使用在具不透明性的紙質文物上。另外，也容易隱補如SB08案例遭昆蟲啃蝕穿洞。宣紙不僅可做為紙質文物修復時的厚薄調整同時保有柔軟性。最後，典具帖已廣泛地運用紙質修復上例如小托、裂痕修補、隱補，而本文介紹的幾個案例更進一步擴展其運用性，做為文物的表面保護層有輕薄、透明及耐磨且具有畫龍點睛的功能。

【註釋】

1. 陳詩薇：國立臺灣師範大學文物保存維護研究發展中心助理修復師。

2. Kataoka, Masumi and Joel Thompson, "From Mummies to Modern Dress: Adhesive Treatments in Textile Conservation at the Museum of Fine Arts, Boston." Canadian Conservation Institute Symposium, 2011.

3. Liu, Angela Wai-sum, Restoration of a 1930s Lease Document: Combination of a Traditional Chinese Mounting Technique with a Western Splitting Method (2004) and Comparing the Properties of Contemporary Chinese Papers Manufactured in China with Japanese Kozo Washi Paper (2008).

4. 詳見本卷李季衡著〈從陳澄波紙質作品修復多面向探討保存修復材料之應用〉p.102-113。

5. 同上註。

6. 參考來源：japanese-paper.hidakawashi.com/paper-TENGU/index.html

7. 本修復案例使用5.0g/m²淺棕色典具帖。

8. 本中心使用的細川紙是日本紙工房ひたか製造。

9. 臺灣楮皮紙的成分可能會含有竹、稻草、龍鬚草漿、亞麻、木漿與再生紙漿等。參考來源http://www.handmadepaper.com.tw/page6.php。修復用紙為全楮皮纖維。筆者認為臺灣楮皮紙比同重量的日本楮皮紙的柔軟度高。

10. 參考來源http://cultural-conservation.unimelb.edu.au/PapermakingFibres/bluesandalwood1.html

11. 紅星宣紙（www.hongxingxuanpaper.com.cn）只含青檀皮與稻草，為修復上常用的宣紙。

12. 每一家工廠製造的宣紙成分不同、但傳統宣紙是以青檀皮與稻草為成分。

13. Klucel G 是一種修復專用的纖維素黏著劑。

14. Hamm, Patricia D, "Dry Paper Pulping," Book and Paper Group Annual 25 (2006): 69-70.

15. American Institute for Conservation of Historic and Artistic Works, "Paper Conservation Catalog," Chapter 40, Matting and Framing.

16. 詳見本卷張元鳳著〈技術、美學與文化性的探討──以陳澄波作品保存修復為例〉p.42-55。

17. 同註6。

18. Gordon, Erin, "Comparing Paper Extract to Traditional Toning Materials," Association of North American Graduate Programs in the Conservation of Cultural Property 2008 Student Conference Paper (2008).

19. 楮皮紙紙釘做法參考於Florian, Mary Lou E. et al., The Conservation of Artifacts Made from Plant Materials. California: J. Paul Getty Trust（2012）。

20. 福隆棉紙廠，No. 368白楮皮紙。

21. 這種修復步驟只適用於SB19素描簿案例，因為相較其素描簿是相對穩定，所以能將新不鏽鋼線圈重新裝回原孔洞。

22. 同註6。

# Versatility of Paper:

## Considerations and Applications of Chinese, Taiwanese, and Japanese Papers for Loss Infilling and Reinforcement

**Melody Chen**[1]

## Summary

## I. Introduction

The versatility of Asian papers, particularly the Japanese kozo (paper mulberry) bast fiber varieties, has been well-documented and applied in a wide range of conservation treatments on works of art ranging from books and fine works on paper to jewelry. The long fibers of kozo papers are well-suited to stabilizing artifacts where long-term strength and flexibility without added thickness is necessary. However, one of the drawbacks of Japanese kozo papers is their relative transparency in comparison to traditional handmade Western papers made from cotton, linen and other rags. They can be manipulated to match the desired surface texture, color, or tone of the work of art, but only to a certain degree. Only recently has more research been published on the uses of xuan and other Chinese papers in conservation beyond scroll mounting. Given its softness, the quality of being thin yet opaque, and the presence of visible chain lines, xuan paper is well suited to a variety of conservation treatments where Western or Japanese kozo papers may not be appropriate. This paper includes a brief introduction to various Asian papers from China, Taiwan, and Japan, followed by a discussion on their combination and application in treatments on works of art from the collection of the Judicial Person Chen Cheng-po Cultural Foundation.

From 2011 to 2014, the National Taiwan Normal University Research Center for Conservation of Cultural Relics was entrusted with the treatment of 1,012 works of art and cultural objects plus 29 sketchbooks from the collection of the Judicial Person Chen Cheng-po Cultural Foundation. The sheer number of works to be treated, time constraints, and diversity of artists' media and materials among this group of works of art presented a challenge of establishing a standardized treatment methodology for similar works of art while at the same time devising new techniques for the treatment of unique pieces where an expedient, standardized approach could not be applied. This paper discusses several examples of these novel approaches that utilized the unique characteristics of Asian papers including those from China, Taiwan, and Japan.

## II. Watercolor on paper board: Dry and wet pulp infill

*Scenic Park* is a watercolor painted on a laminated paper board that suffered from acidification, discoloration, and delamination of the overall paper board support, severe insect damage, foxing, and

surface abrasion. Because the colorants, particularly red, were very water sensitive and prone to sinking into the paper support, it was imperative that water application be carefully controlled and minimized during loss infilling. Further, the water applied had to be drawn away from the paper support in order to avoid horizontal bleeding of watercolor colorant. The decision was made to infill the losses with neutral pH handmade paper pulp on a suction table in order to minimize potential water-induced damage and to allow paper fibers to fill the interstices between paper layers as a non-adhesive method of strengthening and relaminating the different layers.

In preparation for paper pulp infilling on a suction table, a paper pulp slurry was prepared from a mixture of Japanese kozo paper, white xuan paper and Arches cotton watercolor paper, adding methylcellulose to act as a flocculent. The Japanese paper provided for longer fibers in the paper mix, ensuring the planar stability of the infill while offering multi-dimensional flexibility. The shorter fibers of xuan paper allowed for easier workability and manipulation, while the Arches cotton watercolor paper provided bulk and opacity. The watercolor was placed on a suction table on low suction, and the paper slurry was infilled into the loss using a pipette and tweezers. Paper pulp was slowly added in small increments to prevent excess water from causing tidelines or distortion of the paper board. In addition, pulp was not added very close to the original support in order to avoid bleeding of the watercolor colorants.

Due to the large size of the loss, it was difficult to infill the loss to a fully even surface. To accommodate for the uneven surface texture, dry paper pulp was added. Dry paper pulp was made by scraping paper fibers off Arches watercolor paper, adding wheat starch paste and inserting the pulp to the losses. The pulp was then compressed and slightly burnished with a Teflon bone folder and allowed to dry. Uneven areas were smoothed by gently scraping the surface with a scalpel. This process was continued until the infill's surface was sufficiently even.

## III. Sketchbook: Dry cotton paper pulp for thick infill, xuan infill, Taiwanese kozo paper staples, and tengujo reinforcement strips

Sketchbook SB08 contains primarily figures sketches drawn in pencil and colored pencil. The book

suffered from widespread insect-induced paper support losses, discoloration, media abrasion, staining, surface accretions, and structural damage including loose spine hinges and rusted staples. Insects are attracted to book binding adhesives and papers, and, depending on the species, will eat through many layers of paper, or graze upon the surface of a single layer of paper.

In the case of SB08, hole-boring insects caused support loss to both the sketchbook covers and inner leaves. Most losses were 2mm or less in width, and varying from 2mm to 1cm in length. A pre-toned xuan paper was selected as the infilling material, and toned with natural organic colorants to the lightest base tone of the inner pages. A scalpel was used to shave the edges of the infills to a size slightly larger than the loss, thus overlapping the original paper support by no more than 1mm. The losses were adhered onto the verso of each page using dry wheat starch paste.

Infilling the insect-induced losses in the cover boards required a different approach, as the boards were not washed, and could not be exposed to excess humidity lest they warp or dirt within the boards migrated towards the outer surface, resulting in tidelines. Therefore, the decision was made to use dry paper pulp made from Arches watercolor paper and dry wheat starch paste to infill the losses. This allowed for increased structural stability of the paper boards without an unnecessarily wet aqueous treatment. As the losses were very small, it was decided that by sufficiently compacting the paper fiber wheat starch paste was not needed for initial adhesion of paper pulp with cover board, but that minimal application of paste to the outer-most fibers would be sufficient to hold the infill in place.

In accordance with conservation ethics, metallic elements should be removed from paper materials when possible in order to avoid the formation of metal-induced damage such as staining, 'burning' or loss. Correspondingly, metallic elements such as paper clips and staples are removed, and replaced with stable, neutral pH materials such as paper. For SB08, the decision was made to select a Taiwanese-made bleached kozo paper that not only provided the long fibers necessary to withstand directional stretching, but also thin enough not to cause abrasion within the original staple puncture holes, and with a color tone aesthetically appropriate to the newly rebound book.

## IV. Spiral-bound sketchbook: composite paper spine addition

The third work of art under study is a spiral-bound sketchbook (SB19). The sketchbook, containing both pencil and pen sketches, suffered from a rusted spiral binding, staining and abrasion of the paper support, torn cover spines, support losses, and overall discoloration. After discussion with Judicial Person Chen Cheng-po Cultural Foundation, it was decided that after treatment the sketchbook should look as similar as possible to its original appearance, and should be rebound with a spiral binding. This required developing a treatment methodology that would allow the work of art to retain an appearance as close as possible to the original while minimizing potential metal-induced damage to the work.

The decision was made to increase the width of the sketchbook by adding an added spine edge that was achieved by making paper laminated strips to the same thickness of the paper support. The

original paper supports, including front and back covers, were relatively thick and rigid, with a smooth and sheen surface. It was decided that Japanese bast fiber papers, being flexible and transparent, were not a suitable match for this paper, and that layering pre-toned xuan paper was a more aesthetically appropriate choice for the added edge.

To allow for reversibility, it was necessary that this laminated paper be easily removable. However, given the short fibers of both xuan paper and the softness of the original paper support, if xuan paper was directly attached to the original paper support it could not be removed without also dislodging or removing some of the original paper fibers. Thus, the conservators made a laminated paper 'sandwich' – from inside to out – of two layers of tengujo, followed by an outer layer of xuan paper, and finally, another layer of tengujo to reduce the xuan paper's vulnerability to surface abrasion. The two layers of xuan paper were each doubled – for a total of four xuan paper layers – to compensate for the thicker covers.

## V. Conclusion

The broad range of Asian papers allows for a versatility and plethora of selection when considering the needs of a conservation treatment. Not only can individual sheets be selected based upon flexibility, transparency, strength, and color, but can be combined in a composite structure to seamlessly blend and complement thicker materials such as paper boards and book covers and used in lieu of metallic elements. However, when aesthetic needs demanding the replacement of such metallic accessories, adjustments and compromises can be made that preserve as much of the original appearance as possible, such as was shown in the treatment of SB19.

In particular, xuan paper has many potential applications in infilling thin, rag pulp papers as its softness imparts little to no stiffness, while its opacity is more similar to these papers as opposed to kozo papers. It can also be easily manipulated to infill small losses as is shown with SB08. Significantly, xuan paper can be used to compensate for thinned papers, while adding slight opacity to the paper support.

While tengujo has already found many uses in paper conservation including lining, tear repair, and paper compensation, this project has further expanded its application as a finishing layer for paper infills, functioning as a thin, transparent protection barrier against surface abrasion.

---

1. Melody Chen is an assistant conservator at the National Taiwan Normal University Research Center for Conservation of Cultural Relics

# 陳澄波書法及水墨作品修復

丁婉仟[1]

## 前言

　　藝術家陳澄波先生23件書法與7件水墨共計30件紙本作品，落款年代在1924至1927年間，為陳澄波就讀東京美術學校（現為東京藝術大學）圖畫師範科期間的作品。書法以楷、行體書寫節錄碑帖、詩詞、曲賦與歌集，部分墨跡筆劃有紅色朱批於上圈註及修改筆順的痕跡；水墨以沒骨形式描繪花卉枝葉，部分花葉罩以石綠、藤黃、赭石、洋紅等顏料。

## 一、作品保存現狀檢視

　　書法作品對開尺寸8件、四開尺寸15件，水墨作品對開尺寸1件、八開尺寸6件，所使用紙張簾紋間距寬度介於1.4至1.9公分之間（圖1），所有畫心均沒有托裱，部分書法作品紙張短邊一側紙緣留有紅、藍兩色刀印染料（圖2、3）。

圖1.〔小野果〕紙張簾紋（局部）

圖2.實體顯微鏡下〔大伴家持‧萬葉集卷4-786〕紙緣紅色刀印（局部）

圖3.實體顯微鏡下〔紀女郎‧萬葉集卷4-763〕紙緣藍色刀印（局部）

　　由於沒有托裱而且折疊存放，基底材普遍發生黃化、劣化，產生裂痕、折痕、褐斑與蟲蝕孔洞。媒材經點測無滲色、褪色現象，唯部分書法作品上的紅色朱批有顏料暗化現象，進一步加以可視光進行攝影紀錄，並另以非可視光輔助觀察紀錄作品顏料特性。

　　書法作品23件中，共有19件畫心上的書法筆順經朱批圈改，其中17件的朱墨顏料呈現了暗紅色與棕紅色等不同程度的媒材暗化現象，另外2件則無。以X射線螢光分析儀檢測朱墨顏料元素，與鉛丹和朱砂顏料相比對後可知，17件作品上洋紅色的變色朱墨，測得顏料元素為鉛、鋅、鐵，推測為鉛丹（$Pb_3O_4$），而另外2件作品上紅色偏橘的朱墨，測得顏料元素為汞、鐵、鋅，推測為朱砂（$HgS$）[2]（表1）。

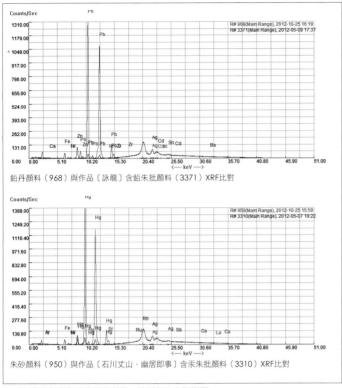

鉛丹顏料（968）與作品〔詠龍〕含鉛朱批顏料（3371）XRF比對

朱砂顏料（950）與作品〔石川丈山‧幽居即事〕含汞朱批顏料（3310）XRF比對

表1.陳澄波書法作品朱墨與鉛丹、朱砂XRF比對譜圖

鉛丹又稱為紅丹、彰丹，化學名稱為四氧化三鉛，化學式為$Pb_3O_4$，不溶於水與酒精中，微溶於冰醋酸且能溶於硝酸與熱鹼水中[3]。鉛丹與密陀僧（PbO）同為鉛白（$2PbCO_3‧Pb(OH)_2$）在不同溫度與時間下氧化焙燒所製成之人工顏料，皆屬鉛系顏料[4]。

根據前人研究已知顏料暗化形成原因，鉛系顏料由於耐光性不佳，當暴露於酸性環境中會與空氣中的二氧化碳起化學反應，或者與成份含硫之顏料混色後，若環境相對濕度較高使化學反應加速，顏料便容易受到影響而轉色為褐色或灰黑色硫化物[5]。

1991年《文物保護與考古科學》王進玉統整1983、1989年《敦煌研究》關於鉛系顏料變色的研究，已知紫外線、硫化氫（$H_2S$）、高相對濕度是影響鉛系顏料變色的主要因素，進一步在控制模擬實驗中，發現鉛丹對210-400nm紫外線吸收較強，因吸收紫外光能量hv後變成激發態分子而具有較高能量，易失去電子而氧化為$PbO_2$。在較低相對濕度時相當穩定，然而一旦相對濕度高於RH60%時，顏料薄層已有變色、粉狀現象，在相對濕度為RH80%時，表面變色更加嚴重。鉛丹受紫外線照射氧化過程以下式表示：

$$Pb_3O_4 \xrightarrow{hv} Pb_3O_4 \xrightarrow{O_2} 3PbO_2$$

敦煌壁畫與彩塑上大部分的棕黑色顏料，可同時測得黑色二氧化鉛與紅色四氧化三鉛的存在，代表黑色的二氧化鉛自鉛丹生成的。以拉曼光譜觀察鉛丹變色過程，發現橘紅色的四氧化三鉛生成棕黑色的β型二氧化鉛與棕黑色的硫酸鉛，而於電子顯微鏡下觀察，發現暗化情形發生自顏料表面，且部分甚至僅發生於顏料表面[6]。

西北大學文博學院團隊實驗研究發現，紫外輻射UVB波段（波長310nm）造成鉛丹暗化的速度較紫外輻射UVC波段（波長254nm）來得更快，即使在乾燥條件下，顏料也容易暗化。因此文物必須避免紫外線輻射的照射。但是作為彩繪中顏料黏著劑的動物膠體於實驗老化前期，對鉛丹顏料亦具有保護功能[7]。

李最雄研究光照與濕度對莫高窟壁畫中鉛丹顏料的變色影響發現，在較高濕度環境下，洞窟壁畫中鉛丹顏料的彩繪會變黑並轉變性質成為二氧化鉛，故推論洞窟壁畫上的鉛丹經過溫濕變化和紫外光照射後，易先生成鉛白，再因高濕環境與生物作用而生成黑色二氧化鉛，推論反應式如下：

$$Pb_3O_4+2H_2O+2CO_2 \rightarrow 2PbCO_3‧Pb(OH)_2+O_2$$
$$2PbCO_3‧Pb(OH)_2+O_2+H_2O \rightarrow 3PbO_2+2CO_2+O_2+H_2O \text{ [8]}$$

此外，黴菌滋生亦可能誘發鉛丹顏料變色作用：

$$Pb_3O_4 \xrightarrow{H_2O_2 \text{ 黴菌}} 2PbCO_3‧Pb(OH)_2 \xrightarrow{H_2O_3 \text{ 黴菌}} PbO_2$$

然而實際上述兩式卻無法得到實驗應證。在進一步實驗研究中，研究者控制環境相對濕度為RH70%，鉛丹雖生成鉛白但未能生成二氧化鉛，與原本認知假設不同，故鉛丹顏料暗化的作用機制可能相當複雜，同時還包含溫度、濕度、硫酸鹽濃度、微生物活動等其它條件變化[9]。

## 二、修復計畫擬訂

變色鉛系顏料的修復處理稱之為「返鉛」。鉛系顏料用於藝術創作的年代很早，西方世界中世紀的手稿中，有鉛丹暗化的文字記載。於文物修復方面，美國Norgate於1624年發表使用去離子的迷迭香溶液或光氧化法（photo-oxidation）進行暗化顏料處理得到良好的效果[10]，19世紀以後英美等國則廣泛使用過氧化氫作為主劑，因應文物材料特性及顏料暗化程度調整溶液性質與濃度，以清洗、濕敷或薰蒸等方式接觸顏料暗化處並以純水洗淨殘餘藥劑，有效使暗化的鉛系顏料逐步恢復明亮[11]。

波士頓美術館（Museum of Fine Arts, Boston）藏品——江戶時期哥川國貞浮世繪版畫上的鉛丹顏料，以及芝加哥藝術學院（The Art Institute of Chicago）藏品——17世紀以前的義大利繪畫上的鉛白顏料，都發生嚴重鉛系顏料變暗的劣化現象，後者因為展覽需求，使用pH7.5及3%的過氧化氫膠體溶液濕敷的作法，於很短的時間內成功為超過50張畫作上變暗的鉛白顏料進行返鉛處理，但Margo R. Mcfarland亦發現並非所有顏料暗化處，皆能得到相同的返鉛效果，畫面上有些區域即使溶液濃度相對提高，顏料依然無法回復原色，此時，維持畫面整體和諧的必要性即會大過顏料返鉛的需求[12]。

陳澄波的23件書法與7件水墨作品紙本畫心，有紙張黃化、暗化、變形情形，並生成褐斑、裂痕或蟲食孔洞，部分鉛丹顏料發生暗化現象。為兼顧展示、典藏及研究的需求，經作品持有者與修復單位於修復期間共同討論決議，為作品進行乾式清潔、媒材加固、濕式清潔、返鉛處理、命紙小托、隱補破損、全色、鑲覆、中性夾裱後，以無酸盒及梧桐木盒存放並搭配無酸木框展示。

## 三、修復步驟

### （一）檢視登錄

著手修復前，以可視光及非可視光進行作品的非破壞性檢視。以正、側、透光攝影並紀錄下作品的基本資料與劣化狀況（圖4-6）。利用紅外線具有穿透多數有機顏料但不穿透碳、鉛等元素（圖7），與不同物質吸收紫外線後會產生不同呈色螢光反應等特性（圖8-9），觀察並攝影紀錄作品基底材保存現狀與媒材異同。

於正、側光、透光下檢視，部分作品基底材有常見的裂、折痕、孔洞（圖10-12），媒材方面，書法作品上

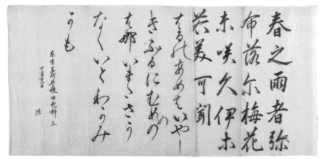

圖4.〔大伴家持‧萬葉集卷4-786〕正光攝影

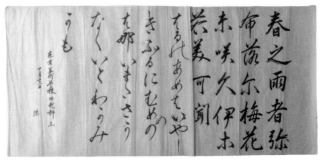

圖5.〔大伴家持‧萬葉集卷4-786〕側光攝影

圖6.〔大伴家持‧萬葉集卷4-786〕透光攝影

圖7.〔大伴家持‧萬葉集卷4-786〕紅外光攝影下鉛丹顏料（局部）

朱砂顏料偏橘紅色，而鉛丹顏料偏洋紅色並伴隨顏料暗化現象，於紅外光下檢視，朱砂顏料幾乎不可見得（圖13-14），而鉛丹顏料相形下仍十分明顯（圖15-16）。另以X射線螢光分析儀檢測書法上暗化顏料位置[13]，以瞭解顏料內所含元素與顏料變色程度之關聯，朱墨筆劃上測得較高含鉛量之處，顏料暗化情形亦顯為嚴重。

### （二）媒材點測與加固

為了解媒材的穩定性，以00號數的細筆，將修復中預計會使用到的溶液，點測於媒材邊緣不明顯處，再以純棉製成之吸水紙張輕按10秒後，於放大鏡下觀察媒材是否發生溶解掉色（圖17）。點測結果顯示，媒材於50℃淨水與pH5.5過氧化氫水溶液點測下相當穩定，墨、朱墨、紅色、黃色、赭色、綠色均無溶解、暈色、變色情形，刀印則為水溶性，於淨水點測時易暈染。考量後續紙張黃化清洗與小托命紙時媒材會接觸到較多水份，因此於黃化清洗前，以濃度1%三千本膠依作品筆順加固作品媒材（圖18），以Kucel G乙醇溶液1%加固刀印。

圖8.〔菊花〕正光攝影下紙張褐斑（局部）

圖9.〔菊花〕紫外光攝影下紙張褐斑螢光反應（局部）

圖10.〔紅柿〕正光攝影下紙張裂痕（局部）

圖11.〔牽牛花〕側光攝影下紙張折痕（局部）

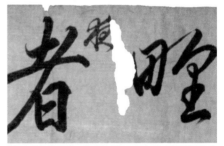

圖12.〔大伴家持・萬葉集卷4-781〕透光攝影下蟲食孔洞（局部）

圖13.可視光下檢視〔石川丈山・幽居即事〕含汞朱批顏料

圖14.紅外光下檢視〔石川丈山・幽居即事〕含汞朱批顏料幾乎消失

圖15.可視光下檢視〔大伴家持・萬葉集卷4-783〕含鉛朱批顏料

圖16.紅外光下檢視〔大伴家持・萬葉集卷4-783〕含鉛朱批顏料可見

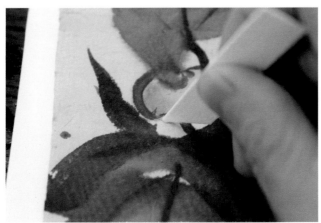

圖17.媒材溶解性點測

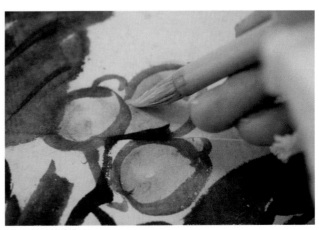

圖18.清洗前媒材加固

圖19.以修復用無酸橡皮粉末進行作品表面清潔

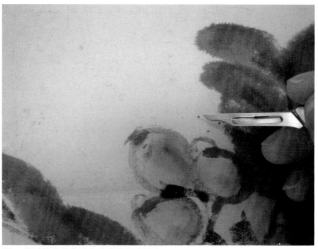

圖20.機械性移除作品上黏附的昆蟲排遺

## （三）乾式清潔

依畫圓方向帶動聚乙烯橡皮粉末移除作品紙張表面髒污（圖19），並以手術刀小心剔除昆蟲排遺或卵鞘等附著於紙張表面的異物（圖20）。

## （四）褐斑與黴點漂洗

以棉花棒蘸pH8-9過氧化氫水溶液，小心地漂洗作品紙張空白處的褐斑（圖21-22）。考量到部分媒材可能對藥劑或水份較為敏感，於媒材區域下方處生成的褐斑，則經顏料測試無滲色、變色反應後，以pH5-5.5的過氧化氫水溶液局部漂洗1-2次，隨後以淨水清洗數次以帶離藥劑和髒污。

## （五）返鉛處理

此類作品為陳澄波於東京美術學校在學期間所繳交的作業，為使這批手稿更加接近當年甫完成情形，對於變色紅色朱批之修護方式，經研究並討論後決定，針對局部發生朱批變暗並與書法墨跡難以辨識的區域稍加處理，以具體呈現「朱批」朱紅色的效果。經處理後的朱批於淨水，再以動物膠加固避免媒材與空氣反應，以減少氧化發生並增加穩定性。

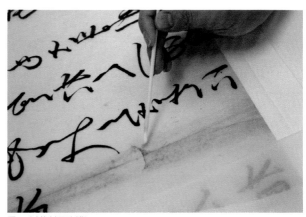

圖21.以藥劑漂洗髒污

過氧化氫水溶液使黑色二氧化鉛返鉛作用之理想化學式可表示如下：

$$2PbO_2 + Pb + 2H_2O_2 \rightarrow Pb_3O_4 + 4H_2O + O_2$$

理論上返鉛處理的反應時間越長、溫度越高、pH值越高、溶液濃度越大，返鉛效果越好，然而，顏料發生變色的化學變化實際更為複雜，使鉛丹暗化的環境因素並不只有一種，並且，返鉛的效果並不是永遠的，在高溫濕條件具備時，顏料暗化情形會再度發生，作品因此需要在適當恆溫恆濕的環境中保存，才能確保顏料不容易氧化變色。

圖22.以藥劑漂洗深色褐斑

圖23.〔紀女郎・萬葉集卷4-763〕鉛丹顏料局部發生暗化現象

圖24.實體顯微鏡下觀察作品P2-5暗化鉛丹顏料表面

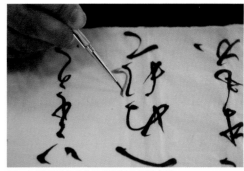

圖25.以藥劑進行暗化鉛系顏料的返鉛處理

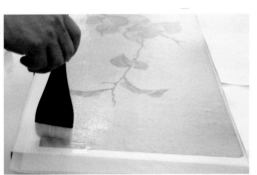

圖26.淨水清洗帶離殘留藥劑

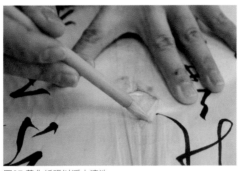

圖27.黃化紙張以淨水清洗

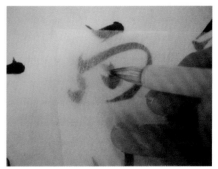

圖28.清洗返鉛後媒材加固

　　書法作品中，以作品〔詠龍〕鉛丹暗化情形最為嚴重，顏料顏色已由紅色轉為紅黑色，肉眼下看幾乎與墨色相近，而以作品〔紀女郎・萬葉集卷4-763〕、〔大伴家持・萬葉集卷4-764（1）〕次之，作品〔張繼・楓橋夜泊〕、〔賴山陽・泊天草洋〕、〔紀女郎・萬葉集卷4-763〕則最為輕微。於實體顯微鏡下觀察，可見鉛丹暗化現象主要發生在顏料表面（圖23-24）。

　　進行返鉛處理時，以小筆塗刷pH5-5.5、濃度低於0.5%過氧化氫溶液於顏料暗化之處，同時注意媒材返鉛後的視覺效果，需與原筆劃深淺濃淡一致（圖25）。對於比較頑強的變色，則於溶液塗刷後，剪裁適當尺寸之吸水紙覆蓋其上，以延長藥劑反應時間。

### （六）黃化清洗

　　溫水比冷水更能有效帶離作品紙張內的黃污，可降低清洗次數，於全面清洗紙張黃化區域時，保持以50℃淨水清洗，以免破壞顏料內的黏著劑造成顏料鬆動。

　　於使用過氧化氫漂洗、返鉛之處，溫和地清洗數次後，再以濃度1%三千本膠加固以保護作品媒材（圖26-28）。

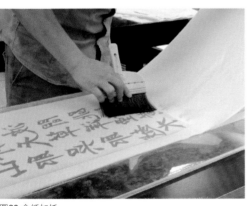

圖29 命紙加托

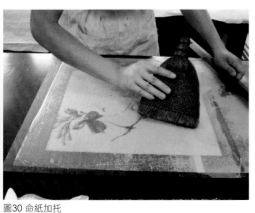

圖30 命紙加托

### （七）命紙加托

　　書法作品使用1.6公斤仿古色楮皮紙作為命紙。水墨作品6件使用1.6公斤仿古色楮皮紙作為命紙、2.8kg臺灣原色楮皮紙作為托紙，1件使用棉料綿連作為命紙、以薄美濃作為托紙。選用與畫心顏色相近、重量相仿的修復用長纖維紙張作為命紙以加大畫心，增加作品整體強度（圖29-30）。

## （八）隱補、全色補彩

於光桌上，依作品紙張孔洞的形狀，以原色楮皮紙製作厚度相仿的補紙，於命紙後方隱補紙張孔洞後。補紙與畫心四邊1公分處托邊條紙，再於邊條紙上塗佈膠礬水作為防水隔離層，最後以有機顏料於補紙上進行可辨識性的全色。

全色時補彩不補筆的作法使補紙與周圍畫面協調，降低紙張缺損處所造成畫面欣賞的干擾，並加大了作品的畫心以保護作品紙緣（圖31-34）。

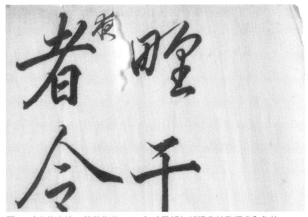

圖31.〔大伴家持・萬葉集卷4-781〕（局部）紙張蟲蝕孔洞處全色前

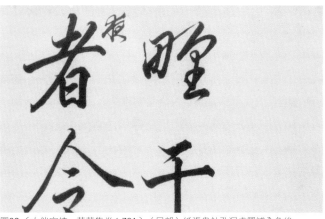

圖32.〔大伴家持・萬葉集卷4-781〕（局部）紙張蟲蝕孔洞處隱補全色後

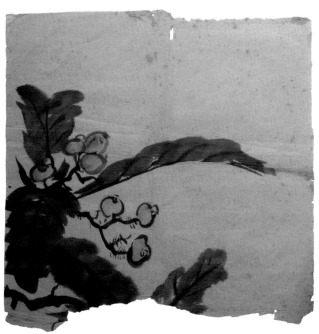

圖33.〔枇杷〕畫心托紙全色、畫心加大前

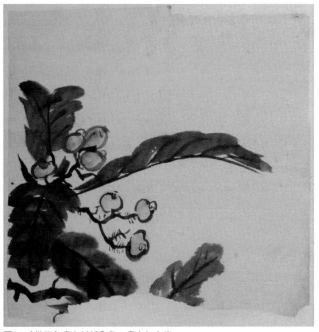

圖34.〔枇杷〕畫心托紙全色、畫心加大後

## （九）作品鑲覆

書畫裝裱是依宣紙紙張特性而發展成的作品保存、觀賞形式。為兼顧作品保存與展示需求，依作品畫意選擇使用黃、綠色錦，各以搭接和挖鑲形式進行裝裱鑲覆，裝裱鑲料皆搭接於加大的畫心上，而非直接黏貼於作品表面，因此不損及作品畫心（圖35-37）。

## （十）裝幀保存

修復裝裱完成的作品，以中性卡紙、無酸瓦楞紙與無酸不織布夾裱，書法作品與水墨作品分別以梧桐木盒與無酸保護盒收存，典藏於恆溫恆濕庫房內（圖38-40）。

圖35.以針錐於作品外0.15公分處定位挖鑲裁切線

圖36.鑲料搭接於加大的畫心上

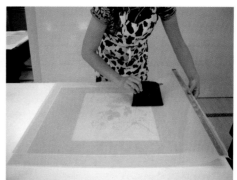

圖37.作品覆背

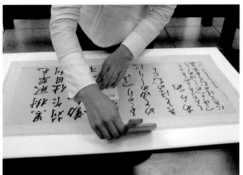

圖38.以中性、無酸材料為作品夾裱

圖39.以中性、無酸材料為作品夾裱

圖40.作品存放於無酸夾裱與無酸保護盒中

圖41.〔論語·子罕第九〕修復前

圖42.〔論語·子罕第九〕修復後

圖43.〔論語·子罕第九〕
修復返鉛處理前

圖44.〔論語·子罕第九〕
修復返鉛處理後

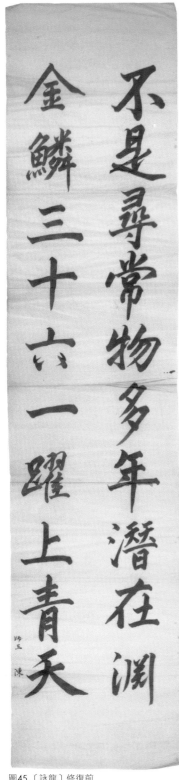

圖45.〔詠龍〕修復前

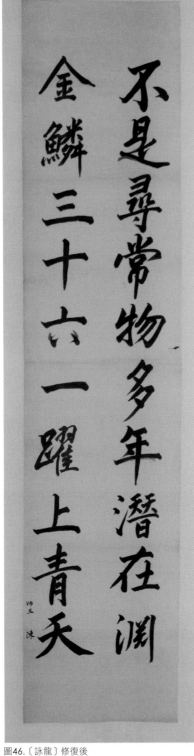

圖46.〔詠龍〕修復後

圖47.〔詠龍〕修復返鉛處理前（局部）

圖48.〔詠龍〕修復返鉛處理後（局部）

## 四、結論

　　此次修復的30件作品，經過作品清潔與返鉛處理後，紙張黃化、褐斑、鉛丹暗化的現象減輕，如〔詠龍〕經修復後作品上朱批位置已能夠被辨識。另藉由小托命紙、置於無酸夾裱材料中保存，增強了作品紙張的強度與保存性。

　　芝加哥藝術學院Margo R. Mcfarland曾經以過氧化醚類進行返鉛修復處理的手繪聖經插畫，其返鉛

處理之處卻於1996年巡迴展覽期間再次變暗，鉛白顏料顏色再度轉為灰色、黑色，因此即便作品以博物館等級的保存材料存放、運輸，也可能有尚未察覺的劣化因素存在。由於鉛系顏料極易因光照及濕度變化而發生氧化、暗化，因此鉛系顏料暗化現象的發生條件與修復、保存的方式，是我們持續觀察與研究的議題。

圖49.〔花及花苞〕修復前

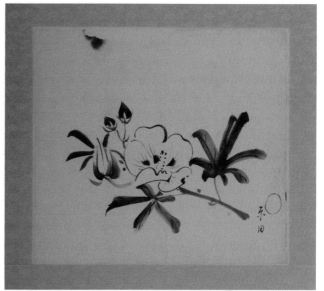

圖50.〔花及花苞〕修復後

【註釋】

1. 丁婉仟：國立臺灣師範大學文物保存維護研究發展中心專案修復師。
2. 蕭郁芬〈101年國立臺灣師範大學美術系館典藏品修護紀錄與心得〉《文物保存維護年刊》p.126-127，2013。
3. Elisabeth West Fitzhugh, "Red Lead and Minium", Artists' Pigments, p.109-12, 1985.
4. 鍾晨〈從硫化鉛精礦中製備紅丹和黃丹〉《有色冶煉》4：39-41，1997。
5. Stephanie M. Lussier and Gregory D. Smith, 'A review of the phenomenon of lead white darkening and its conversion treatment', Reviews in Conservation, Vol. 8, p.41-53, 2007.
6. 王進玉〈古代鉛顏料的應用及其變色問題〉《文物保護與考古科學》3(2)：28-34，1991。
7. 巩夢婷、辛小虎、韓飛、王麗琴〈關於鉛丹變色的研究〉《文博》p.479-486，2009。
8. 李最雄〈莫高窟壁畫中的紅色顏料及其變色肌理探討〉《敦煌研究》3：41-54，1992。
9. 蘇伯民、胡之德、李最雄〈敦煌壁畫中混合紅色顏料的穩定性研究〉《敦煌研究》3：149-162，1996。
10. 同註5。
11. 沈明芬〈鉛白顏料的變色處理之研究〉《臺灣藝術大學書畫藝術學刊》p.362，2006。
12. Margo R. McFarland, 'The Whitening Effects of Peroxide Gels on Darkened Lead White Paint', The Book and Paper Group Annual, Vol. 16, p.55-65, 1997.
13. 以Niton XL 3t GOLDD+®手持式X射線螢光分析儀檢測，照射直徑8mm，每個點施測30秒。

【參考資料】

1. Elisabeth West Fitzhugh, 'Red Lead and Minium', in Artists' Pigments: A Handbook of Their History and Characteristics, ed. Robert L. Feller, Vol. 4, p.109-125, 1985, Archetype Publications.
2. 李最雄、Stefan Michalski〈光和濕度對土紅、朱砂和鉛丹變色的影響〉《敦煌研究》3：80-93，1989。
3. 王進玉〈古代鉛顏料的應用及其變色問題〉《文物保護與考古科學》3(2)：28-34，1991。
4. 李最雄〈莫高窟壁畫中的紅色顏料及其變色肌理探討〉《敦煌研究》3：41-54，1992。
5. 李最雄〈敦煌壁畫中混合紅色顏料的穩定性研究〉《敦煌研究》3：149-161，1996。
6. 蘇伯民、胡之德、李最雄〈敦煌壁畫中混合紅色顏料的穩定性研究〉《敦煌研究》3：149-162，1996。
7. Margo R. McFarland, 'The Whitening Effects of Peroxide Gels on Darkened Lead White Paint', The Book and Paper Group Annual, Vol. 16, p.55-65, 1997.
8. 沈明芬〈鉛白顏料的變色處理之研究〉《臺灣藝術大學書畫藝術學刊》p.362，2006。
9. Stephanine M. Lussier and Gregory D. Smith, 'A review of the phenomenon of lead white darkening and its conversion treatment', Reviews in Conservation, Vol. 8, p.41-53, 2007.
10. 巩夢婷、辛小虎、韓飛、王麗琴〈關於鉛丹變色的研究〉《文博》p.479-486，2009。

# Conservation Treatment of Chen Cheng-po's Calligraphy and Ink Paintings

**Ding Wen-chian**[1]

## Summary

Under this project, 23 calligraphy works and 7 ink paintings by Chen Cheng-po dating to the period 1924-1927 were treated. These 30 works were not previously mounted and suffered from various physical problems including paper yellowing, tears, creases, foxing and insect-induced losses, though media tests did not reveal indications of ink bleeding or fading. Red pigment found in 17 of the calligraphy had unevenly darkened to maroon and brownish red. When the discolored and undiscolored red pigments were examined with an X-ray fluorescence spectrometer and compared with standard red lead and vermilion samples, the red pigment was identified as red lead, while the non-discolored pigment was identified as vermilion. One sample with varying levels of darkening was red lead with traces of zinc and iron. Previous studies have indicated that lead paints are susceptible to environmental changes. When exposed to an acidic environment, they will react with carbon dioxide; when mixed with sulfur-containing paints in a high humidity environment, chemical reactions are accelerated, turning the paints into brownish or grey black sulfides. Sulfurization and oxidation usually occur on the surface of the paint layer.

Museum conservators from other countries have observed that photo-oxidation and it was learned that the use of photo-oxidation and solvent-induced oxidation, combined with sterilization and humidification, proved to be effective in reverting red lead darkening. Knowing the causes of deterioration and possible treatment results, the conservators decided upon a reversion method of brush-applying 0.5% pH5-5.5 hydrogen peroxide to the darkened red lead, paying attention to the thickness of the brushstroke. At the same time, care was taken to ensure the reverted red lead was visually coherent with the tone of the original strokes. For more severely darkened red lead, after brushing with hydrogen peroxide, a small sheet of blotting paper was used to cover the treated area, thus prolonging the time of the chemical reaction.

After the reversion treatment, hydrogen peroxide needed to be rinsed out. Because lukewarm water is more effective than cold water in washing out paper yellowing, thereby reducing the number of washings required, filtered water of no more than 50°C was used to rinse out the hydrogen peroxide. This method avoided damaging the paint binder, damage of which would lead to the paint loss. Painting consolidation of the brushstrokes was carried out with 1% animal glue. Consolidation reduced the probability of media oxidation.

After aqueous cleaning, the work of art was lined with 1.6kg dyed kozo paper to provide additional physical support. The work of art was transferred to a light table, and support losses were infilled with kozo paper of appropriate thickness. Infills and feathered edges were coated with an isolating layer of alum-glue. Inpainting was then carried out with organic colorants. Losses and edges were toned (brushstrokes were not retouched) so that the infills blended with the surrounding paper support and restore visual cohesiveness.

To meet preservation and exhibition needs, the works of art were either stored in non-acidic window mats paired with wutong boxes, or wutong frames. Not only were the aqueous treatment and red lead reversion treatments successful, paper yellowing and foxing were significantly reduced. In one of her treatments, Margo R. Mcfarland of the Chicago Art Institute used ether peroxide for red lead reversion in hand-painted Bible illustrations, only to find that the treated areas darkened again to a gray and black tone during the 1996 travelling exhibition. Therefore, it is possible that even if treated works are carefully preserved in museum-grade materials, there may still be unknown causes of deterioration. Since lead paints will easily oxidize and darken with changes in light and humidity, the causes of lead darkening, its reversion, results, and environmental monitoring are issues that we must continuously monitor and research.

---

1. Ding Wen-chian is an assistant conservator at the National Taiwan Normal University Research Center for Conservation of Cultural Relics.

# 從陳澄波紙質作品修復多面向探討保存修復材料之應用

李季衡[1]

## 前言

　　陳澄波先生作品之保存修復委託案自2010年起至2014年。期間修復作品包含油畫、水墨、水彩、書法、素描、書信檔案⋯⋯等不同基底材及媒材之受損作品。其中紙質類作品更是多達千件之多（油畫36件、水彩71件、炭筆素描71件、單頁速寫763件、水墨書法30件、素描簿29本⋯⋯），雖然同為紙張基底材，但在造紙過程中的原料變因影響了每件作品的不同體質，為了考慮到多種不同體質病狀之文物，修復方針的擬定及修復材料的選擇便是相當重要的工作。並且文物修復完成在離開修復室後將持續經過運輸、展示、典藏⋯⋯等過程，因此文物保護材料的選擇更是一門學問。坊間已有專門的保存修復材料提供修復人員多樣選擇，但是除了材料的穩定、耐久⋯⋯等基本重要選擇要素之外，什麼樣的特質才是適合本案的修復使用呢？

　　本篇文章主要介紹此次陳澄波先生紙質類作品保存修復材料的選擇及其特性，從無酸材料之化學性層面到文物修復倫理原則之哲學性層面去探討保存修復的材料選擇重要性。

## 一、無酸材料（Acid-free Material）使用的重要性

　　此次修復陳澄波紙質文物面臨最大的問題便是紙張嚴重黃化現象，黃化是指紙材全面性變黃的現象。常見於酸性材質的文物上，也會伴隨著紙質脆化、強度遞減等劣化情況發生[2]。工業革命後，改變了傳統造紙方式，機械造紙的出現使造紙原料與傳統手漉紙有了很大的不同，現代機械紙張主要是由纖維素（Cellulose）、半纖維素（Hemicellulose）、木質素（Lignin）所構成。其中根據許多研究指出，木質素是造成紙張黃化的重要因素之一。引起木漿紙黃化的光輻射波長，與木質素的紫外光吸收曲線幾乎相同，這說明木質素的光吸收是導致文物泛黃的主要原因之一[3]。再者現代造紙技術中要在紙漿中添加亞硫酸、硫酸鹽等酸性物質，施膠過程中也需要加入明礬和松香，其中明礬是含水硫酸鋁鉀，遇水會發生水解產生硫酸[4]。機械造紙雖然帶來了便利性，但也因此替文物種下了先天性體質不良的病徵。

　　酸性物質是導致文物老化的重要因素之一，因此使用無酸的修復材料或除酸是對於延長文物壽命的一大方針。無酸材料是指凡酸鹼值（pH值）在7以上之材料，又分為「無鹼性貯存物（Unbuffered）pH＝7

之中性材料」及「有鹼性貯存物（Buffered）pH＞7之鹼性材料」。鹼性材料是含有鹼性貯存物（通常為碳酸鈣$CaCO_3$）於材料中，可以中和環境中的酸性物質（例如空氣中二氧化硫）或抑制文物自體酸化反應，防止文物持續酸化，但也因此無酸材料並非會一直處於無酸狀態，會隨著時間的累積轉換其酸鹼值[5]。

因此存放陳澄波作品的夾裱材料亦分為兩種，內層以不經漂白的純棉漿中性卡紙接觸作品，外層以含碳酸鈣緩衝劑的無酸瓦楞紙板包覆，使作品間接存放於中性環境中（其材料特性將會於後續單元解說）。

雖然使用鹼性材料依照酸鹼中和反應的概念對文物酸化的延遲有很大的幫助，但因為有媒材是屬於對鹼性敏感之特質（例如照片、鞣酸鐵墨水……等），所以在面對不同文物的保存材料選擇，如何對症下藥是對修復師很重要的課題。

## 二、文物修復倫理與修復材料之選擇密切性

現代文物保存修復的倫理原則啟蒙於1930-1950年代，1930年代以前，西方國家雖然已有修復師進行相關工作，但此時期的修復模式沿襲著15、16世紀文藝復興時期以來的修復系統，較著重於文物表面視覺性[6]，因此文物雖然可以修改容貌但是對其安全性、歷史性等現代文保修復倫理是有著相當大的差距，甚至修復後改變了原創作者所想表達之意涵，這樣對文物及原創作者不但是非常不尊重的行為，而且影響了文物本身的歷史意義。

因此陳澄波作品在修復前須先對其特性作過完整的檢視登錄，藉由攝影的方式完整記錄作品狀況，越是完整收集修復前的各種資訊，對於往後的研究、應用、修復……等建立了更完善的資料。現代修復與傳統修復的最大差別在於科學儀器檢視的參與，科學分析幫助修復人員更深層瞭解文物的材質，進行文物分析很重要的準則就是不能損傷原物件，因此非破壞性的分析是對於文物最好的檢驗方法。其中紅外光及紫外光的光學檢測是修復前檢視登錄中的步驟之一，特別是紫外光對於畫作上的螢光反應更是直接顯現了褐斑的生成狀況，對於此案修復材料、藥劑的選擇及後續的修復動作提供了很大的參考。

瞭解文物的體質後，修復材料的選擇就要根據之前的相關檢測作為依據來判斷，並且要符合文物保存修復原則的其中三項：

### （一）適宜性原則 Principle of Compatibility

材料的使用是要最適當的延長原作品壽命及增加強度，而並非加重文物不必要的負擔。因此修復材料的物化性、穩定度、未來老化機制等因素都需要考量，如同上述無酸材料使用的重要性，都是為了要符合文物修復的適宜性原則。

### （二）相似性原則 Principle of Similarity

材料的使用要最接近原作品的材質，就如同人體器官移植般，材料物化性相差越大，導致隨著時間的推進物件本身的強度落差越趨明顯，對於作品的保存會有很大的影響，相對的材質越是相近，對於作品的整體強度更可達到較均衡的效果。

以此案為例，此案的單頁速寫作品中有很多蟲蛀現象，因此在選擇隱補破洞的修復紙張就要考慮與作品本身的相似性，並非越貴越強韌的修復紙材就是適合所有的案例。

### （三）可逆性原則 Principle of Reversibility

修復使用的材料在必要時可經再處理恢復到被修復前的狀況。每個修復案都是以此時此刻技術所能做到

最合適的程度，但隨著修復技術日新月異，未來的保存修復科學及修復技術都可能提供更先進的修復方式，因此在修復的材料技法上必須考慮到可以達成作品保存修復目標的結構強度，但又不能成為影響未來面臨二次修復的障礙。

其中本次修復案有出現部分西式單頁速寫紙張作品遇到被小托的動作，畫作背面托上一層不穩定的紙張，並且其在進行小托時所使用之漿糊成分也不得而知，小托紙已經產生黃化等劣化現象，並影響到了原作品。小托在東方繪畫領域是相當重要的裝裱技術，雖然可以幫助增強原作品的結構強度，但是在不當的材料使用下及未考慮此作品並非東方作品範疇，這問題牽扯到再修復對原件受損程度的提高及衝突了與原件風格之哲理問題，由此可見材料的可逆性原則對於延續作品的壽命有著舉足輕重的地位[7]。

修復材料的選擇所要考量的因素不僅僅只是材質本身特性所需的基本要求，更已延伸到當代修復思潮等思考性層面問題。以下文章會將此次修復案所使用之材料分為「修復材料」及「保護材料」兩單元介紹，以便瞭解修復時不同步驟使用之材料及修復後保護作品於穩定環境及安全之材料。

## 三、文物修復概念與材料簡介

每件作品都如同一位病人，所以面對不同的病狀及先天性體質的不同也就會有不同的修復療程，因此將整個修復案流程歸納為以下幾個步驟：

1. 表面除塵
2. 基底材暫時性加固
3. 媒材加固
4. 褐斑漂白
5. 水洗
6. 除酸
7. 補紙
8. 頂條[8]
9. 小托
10. 攤平
11. 全色

以下之介紹都是上述修復過程中所會使用到之修復材料。均需符合不含有害物質、穩定且耐久，呈中性或弱鹼性防止作品酸化，具可逆性⋯⋯等特質[9]。

### （一）Staedtler PVC-free 粉末橡皮／塊狀橡皮（Eraser Crumbs / Eraser）（圖1-3）

- 表面除塵用。
- 市面上多為塊狀橡皮擦，已有廠商提供磨成粉末之選項，分為粗、中、細三種，可配合不同文物之基底材挑選粗細（例如：絹本作品為了避免橡皮粉末卡在絹網中，所以不使用最細之粉末橡皮）。
- 橡皮擦的目的是藉由物理式清潔移除文物表面上汙垢、灰塵等髒污。物理性的清潔是最有可能導致紙質文物撕裂的步驟，因此粉末橡皮有別於塊狀橡皮可以更溫柔且全面性的用手搓除表面汙垢。
- 一般市售橡皮都含PVC聚氯乙烯，雖然穩定不會釋放氯，但就如同我們認知的塑膠會有老化後的問題，且現今觀念都已知道聚氯乙烯含有添加劑（例如塑化劑），為了確保文物的安全性，所以此次修復使用之粉末橡皮及塊狀橡皮皆不含PVC。

圖1.粉末橡皮

圖2.粉末橡皮使用比對

圖3.塊狀橡皮

## （二）乾式清潔海綿（Dry Cleaning Sponge，又稱煙燻海綿）（圖4-5）

- 表面除塵用。
- 乾式清潔海綿顧名思義需使用於乾燥表面上，並且非天然海綿是硫化橡膠做成[10]。
- 可以有效的帶起附著於文物表面之髒污、塵垢等，相較於粉末橡皮會產生較大的摩擦力，因此在使用上要更小心造成文物的物理性傷害或表面磨損。

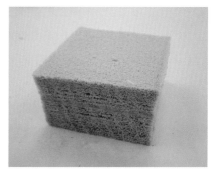

圖4.乾式清潔海綿

## （三）甲基纖維素（Methyl Cellulose）（圖6-7）

- 黏著劑，呈中性，於文物修復中用途廣泛，常作為基底材、媒材加固用黏著劑。
- 白色纖維狀或顆粒狀粉末，無臭無味，一般使用置於水中溶脹至透明性膠體溶液。一般不溶於無水乙醇、乙醚……等溶劑。
- 對光照穩定、且不會像漿糊吸引蟲害，可逆性好相當易溶於水[11]，集各方面優點是相當適用於文物修復的黏著劑。
- 擁有良好的潤濕性，因此可以用來做局部加濕，且可以更穩定的控制其潤濕速度（筆者於博物館實習期間有用於作來揭除黏著紙張之加濕方法）。

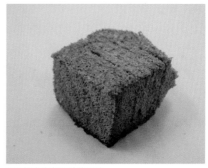

圖5.乾式清潔海綿使用後

## （四）小麥澱粉漿糊（Zen Shofu Japanese Wheat Paste）（圖8-10）

- 黏著劑，呈中性，為最傳統使用之黏著劑，不論於東方繪畫或紙質修復都是非常重要的存在，常用於紙張之間的黏著使用（例如頂條、補紙、小托……等步驟）。
- 現已有經機械提煉出無蛋白質（去筋）的純小麥澱粉。市售化學漿糊於製作過程中添加化學藥品（例如明礬[12]等），含添加物之漿糊雖可以延長使用壽命但會導致漿糊的性值不穩且pH值偏低（酸性），也有相關研究指出含明礬等酸性物質之漿糊不利於紙質文物保存[13]。因此於文物修復使用之漿糊應需排除其材料不穩定之因素，需由修復師親自製糊[14]來確保其品質。
- 漿糊的濃度需求因不同的材料情況而定，也會依不同的修復步驟而有所調整，依照每個修復師習慣，在製糊過程就會有不同

圖6.粉末狀甲基纖維素

圖7.膠狀甲基纖維素

圖8.去筋小麥澱粉

圖9.未練之漿糊

圖10.已練之漿糊

的方式，在國外相關文獻也有指出，部分工作室會於一開始就製作出濃度較高之漿糊，相對也有習慣製作含水量較高之漿糊[15]，因此漿糊的使用與修復師經驗息息相關。

## （五）羥丙基纖維素（Klucel G）（圖11-12）

- 黏著劑，呈中性，常用於素描作品之媒材加固。
- 可溶於水和無水乙醇，因此相較於甲基纖維素，如果使用無水乙醇代替水，其揮發效果好，因此適合用來加固遇水易暈開掉色之媒材，以本案為例，有作品媒材為水性色鉛筆，對水敏感，也因此在水洗、除酸等會遇到大量淨水使用之過程會有相當大的風險，就會使用Klucel G作為媒材加固劑。
- 同甲基纖維素無臭無味，乾燥後透明，具可逆性。

圖11.粉末狀Klucel G

圖12.液狀Klucel G

## （六）過氧化氫（Hydrogen Peroxide，化學式：$H_2O_2$俗稱雙氧水）（圖13）

- 非氯系氧化型漂白劑（Chlorine-free oxidizing bleaches），呈酸性，能與水、乙醇或乙醚以任何比例混合，一般與水混和至3%以下來使用。其漂白機制為漂白時分解電子自由基，自由基為不成對電子，為不穩定存在，所以易和有機分子結合，因此自由基與漂白效果關係密切，為了使參與反應自由基大量形成，會於過氧化氫溶液添加氨水，使其維持鹼性[16]。
- 閱讀文獻可發現早期許多作品漂白褐斑是使用含氯之氧化型漂白劑（Chlorine oxidizing bleaches）但最大的問題是，氯非常容

圖13.過氧化氫

易與木質素產生其他氯化物，不易清除易殘留於文物上，於修復倫理原則，固不建議使用含氯漂白劑[17]。扣除掉含氯系漂白劑，也有人使用過次氯酸鈉、過錳酸鉀、硼氫化鈉……等非氯系氧化或還原漂白劑[18]（根據其漂白化學機制之不同[19]）。經過實驗後，本此修復案僅使用過氧化氫來進行褐斑漂白。
- 使用時必須注意並非所有褐斑皆適合使用過氧化氫漂白。褐斑的生成有可能來自生物性黴菌或是金屬雜質。藉由紫外光檢查，生物性褐斑呈現橘黃色之螢光反應，而金屬導致的褐斑則呈現深色[20]。如果為金屬離子導致之褐斑則不適用過氧化氫漂白，可能會加速其氧化作用[21]。

## （七）氫氧化鈣（Calcium Hydroxide，化學式：$Ca(OH)_2$）（圖14-15）

- 除酸劑，呈鹼性，化性穩定。氧化鈣加水後成為氫氧化鈣，氫氧化鈣再和空氣中二氧化碳結合成為碳酸鈣。

- 其除酸原理就是酸鹼中和的概念，藉由鹼性物質中的氫氧根（OH⁻）與酸中的氫離子根（H⁺）作用產生水加鹽。因此將紙質作品泡在氫氧鈣水溶液（pH值約8-9）中，不僅可以將文物去酸也可藉由殘餘的氫氧化鈣與空氣中之二氧化碳結合成碳酸鈣滲入紙纖維中，增加紙質的白度也可有效防止紙張酸化。（例如：東方繪畫修復常用到美栖紙作為命紙，因為美栖紙纖維含有碳酸鈣鹼性貯存物，托在畫心後可減緩畫作酸化時間 22。）

圖14.粉末狀氫氧化鈣

圖15.氫氧化鈣水溶液

## （八）典具帖（Tengujo）（圖16-18）

- 修復用紙材，呈中性（市面上也出現含鹼性貯存物之典具帖），楮皮纖維為主，為目前修復材料中最薄的紙張，呈半透明，有不同顏色、厚度可選則來搭配不同的作品。
- 典具帖以韌皮纖維（楮皮）為原料屬皮料紙，其特性纖維長、拉力強韌，所以雖然厚度薄但還是有足夠的強度作為修復材料。
- 因其半透明性的特質，常用於雙面檔案之小托用紙，不但可以增加基底材結構強度，也可保有被托面的畫面完整性。本次修復案因作品本身酸化嚴重，紙張脆弱，藉由小托典具帖使其結構穩定，並且因典具帖半透明特性，固雖有做小托卻看不太出修復動作痕跡，尊重原作品為西式紙材之歷史性。

圖16.白色典具帖

圖17.染色典具帖

圖18.典具帖纖維

## （九）宣紙（Xuan Paper）（圖19-21）

- 修復用紙材，呈弱鹼性（pH值約在8左右），青檀樹皮與稻草纖維為主，相較於楮皮纖維，纖維較短，柔軟度較高。
- 陳澄波的紙張作品因酸化問題，纖維強度較弱，考量到未來老化機制，運用宣紙韌性較差的特性，選擇為此次修復案隱補破洞的紙張。

圖19.原色宣紙

圖20.染色宣紙

圖21.宣紙纖維

## （十）細川紙（**Hosokawas Paper**）（圖22-23）

- 修復用紙材，呈弱鹼性，楮皮纖維，纖維非常強韌的紙張，有不同的刃數。
- 細川紙已於1978年被指定為日本重要無形文化遺產，並且大量使用於傳統日式紙屏風的製作上。
- 因為此紙張有良好的韌性及強度，所以此次修復案選擇細川紙作為作品黏貼於夾裱上的輔助搭邊，幫助作品可以於夾裱中長時間呈現穩定狀況[23]。

圖22.細川紙

圖23.細川紙纖維

## （十一）吸水紙（**Blotting Paper**）（圖24-25）

- 修復用紙材，呈中性（市面上也出現含鹼性貯存物之吸水紙），無酸無木質素紙漿製成，吸水性高[24]。
- 德國化學家Gerhard Banik與紙質修復師Irene Beückle於2011年出版專書（*Paper and Water: A Guide for Conservators*），從中可以了解到紙質修復與水之間的重要性，不論是造紙、修復……等，因此好的紙質修復師必須很擅長與水玩遊戲。吸水紙的使用輔助修復師用於乾燥、清洗、持拿作品等過程。
- 紙張作品修復在進行加濕攤平後正反面蓋上不織布，再用多張吸水紙上下夾住，重壓壓平。相較於東方繪畫作品會將作品黏貼於乾燥板撐平，吸水紙對於紙質類作品是不可欠缺的修復材料。

圖24.吸水紙

## （十二）嫘縈人造不織布（**Rayon Paper**）（圖26-28）

- 保存與輔助修復用材料，呈中性，應用層面廣，可作為暫時性加固材料、清洗輔助材料、保護修復中脆弱文物之隔襯……等。因其透氣透水等特性，也用於保護藏品包覆襯墊材料，表面光滑可減少對作品的磨損。
- 不織布（non-woven fabric）的定義為纖維少去捻紗（twisting）、紡織（weaving）等過程，直接成為平面布狀物，在織物學範疇上屬於非織物，因此雖然中英文名稱有些差異，但其本質就是纖維經機械氈黏（bonding or interlocking）或特殊高溫高壓處理而成之布狀物。保存修復上使用之不織布排除一切施膠粘合……等含有不穩定材質之方式，一律以高溫高壓之特殊處理來確保其材料穩定度。

圖25.吸水紙纖維

- 嫘縈（Rayon）屬於再生性纖維（Regenerated Fiber），是第一種人類藉由化學操控仿製之纖維素纖維。主要成分也是纖維素（例如下腳綿），因為人工控制所以可以控制其長或短纖維、品質等物性，但嫘縈有一特性為在水中強度變弱（例如：我們市售所買嫘縈纖維家族之服飾不可以水洗），所以在使用Rayon Paper作為作品水洗輔助材料時要小心此特點。

圖26.整卷Rayon Paper　　　　圖27.Rayon Paper　　　　圖28.Rayon Paper纖維

### （十三）紡紗網不織布（**Hollytex® Polyester Webbing**）[25]（圖29-31）

- 保存與輔助修復用材料，呈中性，功能與Rayon Paper相似。
  主要成分是聚酯纖維（Polyester）為與Rayon Paper最大之不同，屬於人工合成纖維（Synthetic Fiber）即塑膠類材料非纖維素材料。
- 因為水分子與聚酯纖維不會產生極性的氫鍵，所以是含水及吸水性最低之纖維。

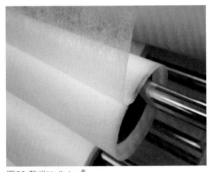

圖29.整卷Hollytex®　　　　圖30.Hollytex®　　　　圖31.Hollytex®纖維

### （十四）**Gore-Tex®**（圖32-34）

- 輔助修復用材料，呈中性，不織布狀，Gore-Tex®為PTFE（聚四氟乙烯即鐵氟龍Teflon®），美國W.L.Gore公司在實驗中發現PTFE於薄膜狀態含多孔，且這些孔洞小於水滴卻大於水分子，因此Gore-Tex®為一種多孔薄膜技術之專利名稱。一般於紙質修復所使用為美國杜邦公司之Sontara®，將Gore-Tex®與100%Polyester藉高溫高壓而成之不織布[26]。
- 藉由其特性讓水份的氣態通過來達到紙質作品加濕，又可以隔絕液態水通過，可以有效地控制水份對紙質加濕的程度與速度。

圖32.Gore-Tex®薄膜面　　　　圖33.Gore-Tex®纖維面　　　　圖34.Polyester纖維

### （十五）纖維素粉（Cellulose Powder）（圖35）

- 為經機械精煉純化之纖維素粉末，部分萃取於植物纖維。為一種白色，無臭無味之粉末，性質穩定，呈中性。
- 可藉由加熱使其白色逐漸轉深，依修復師習慣可選擇不同程度之纖維素粉作為全色材料。
- 調合甲基纖維素可作為全色用顏料或補洞填補材[27]。因為調和甲基纖維素，可以很輕易被水洗掉，屬於高可逆性全色材料。
- 本次陳澄波作品修復案，最後全色收尾使用纖維素粉作畫面統整。

圖35.纖維素粉（圖中最左邊為最白之纖維素粉，往右依序烤深）

## 四、文物保存概念及材料簡介

相較於文物修復，文物保存是屬於預防性的體質長期調理。現今修護哲學強調「預防重於治療」，修復是為了替處於危險狀態之文物進行搶救，除去危險因子延長其壽命；保存則是藉由典藏環境的控制與保存材料適當地選擇，提供文物安全良好的長期居住環境。

國內外博物館於典藏文物的環境設計都有其長期考量，並且不同材質之文物適合的環境也都會有些許不同。以紙質藏品為例，環境設計需要考量的因素[28]有：

### （一）相對濕度（RH）及溫度

紙張是吸水性很強的材質，不但容易從外在潮濕空氣吸水，也容易排出水氣於乾燥空氣。吸水之後紙張會膨脹，乾燥後則收縮。如果紙質長期處於波動的溫濕度變化（溫度的高低會影響相對濕度），不斷的膨脹收縮會影響紙質文物的壽命。

於劉藍玉小姐翻譯之藏品維護手冊一書中，紐約大都會博物館修復師Majorie Shelley於文章提到，在15-18℃的溫度及45%-55%的相對濕度適合紙質的保存[29]。舉國內國立臺灣博物館為例，其庫房24小時全天候保持於溫度20±1℃及相對濕度55±5%[30]。

### （二）空氣品質

空氣中含有的二氧化硫……等酸性物質會導致紙質藏品的酸化，配合無酸（buffered or unbuffered）保護盒、檔案夾、夾裱……等無酸材料存放形勢，保護藏品處於無酸微環境。

### （三）光照問題

於典藏時，讓紙質藏品處於黑暗狀態是最有利之環境，例如光線中的紫外線會導致紙張的老化及有機顏料的褪色。因此不論是修復室、庫房或展場照明都要注意光線對於藏品的潛在危機。

### （四）生物因子（黴菌生長、蟲害）

紙張不論於材質特性及原料，都是黴菌、細菌等微生物的理想溫床。可藉由環境溫濕度之控制抑制其生長。紙張不僅吸引微生物，因為其原料（纖維素、澱粉等）對於許多昆蟲是營養的美食。所以典藏空間要隨時保持清潔且禁止飲食，並定時得做檢查。

以上等典藏環境之重要觀念是所有博物館研究員及修復師……等專業人員所需具備之專業知識，博物館也都有提供相當量好的庫房環境及優秀的庫房管理員隨時對典藏環境做第一手把關。一般收藏家需要做到以

上之環境變因控制相對來說是比較困難的，因此文物的保存形式及保護材料的選擇可以提供適合文物貼身的微環境狀況。

　　以下介紹之材料為本次替陳澄波紙質修復案所挑選之保護材料。響應陳澄波先生百二誕辰，於2014年開始至隔年3月之跨國巡迴展，部分作品將於修復後進行展覽，因此為了考量作品不會在短時間進入庫房典藏，面臨多次的運輸及長期的展覽狀況，因此替作品選擇的保存形式及材料都將提供作品有良好及安全的微環境狀態。

## （一）無酸瓦楞紙板（Acid-free Corrugated Board）（圖36-38）

- 藍灰色保存用紙材，市售提供E-Flute、B-Flute及雙層結構（BB-Flute、E-Flute雙層交錯型）等不同厚度之選擇，為無酸無木質素等不良化性之紙材。含碳酸鈣鹼性貯存物，紙板物性堅實、外表滑順，適合用於製作展示作品之夾裱外框、文物保護盒提供文物鹼性微環境。
- E-Flute為1/16"單浪（1.6mm）厚，較B-Flute緊實耐撞擊。
- B-Flute為1/8"單浪（3mm）厚，較E-Flute厚實所以耐壓。
- BB-Flute為1/4"雙浪（6mm）厚，為兩層B-Flute雙層型（有雙層同向及雙層交錯兩種選擇），可提供較堅實之物性，用於大型保護盒製作。雙層交錯之瓦楞紙板因交錯方向相反因此支撐力較高（因為紙張都會有一順向方向較易摺，藉由雙層交錯補足彼此之順向方向易摺的狀況）。
- 本次陳澄波修復案使用E-flute之無酸瓦楞紙板製作單頁速寫及炭筆素描作品之夾裱外框及全部紙質類作品之保護盒。

圖36.E-Flute無酸瓦楞紙板　　　　　圖37.B-Flute 無酸瓦楞紙板　　　　　圖38.無酸瓦楞紙板纖維

## （二）博物館無酸卡紙板（Acid-free Museum Mounting Board）（圖39-40）

- 多色之保存用紙材，市售有2、4、6、8ply[31]之不同厚度選擇，為純棉漿製成，為無酸無木質素等不良化性之紙材。有中性及含碳酸鈣鹼性貯存物兩種選擇。適合用於製作展示作品之夾裱內框（作品直接接觸之材料）。

圖39.白色無酸卡紙板　　　　　圖40.無酸卡紙板纖維

- 本次陳澄波修復案使用白色4ply之無酸（中性）卡紙板製作單頁速寫及炭筆素描之夾裱內框。

## （三）無酸檔案夾紙板（Acid-free Folder Stock）（圖41-42）

- 米黃色之保存用紙材，市售有0.01"（0.25mm）及0.02"（0.5mm）兩種厚度，為無酸無木質素

等不良化性之紙材，含碳酸鈣鹼性貯存物，常用於製作檔案夾或四折翼形式之保護盒（用於包裝書籍類之文物）。

- 本次陳澄波修復案使用0.02"之無酸檔案夾紙板製作素描本、部分遺書及單頁速寫之四折翼保護盒。

圖41.米黃色無酸檔案夾紙板　　圖42.無酸檔案夾紙板纖維

## （四）透明聚酯片（**Mylar® Polyester Film**）（圖43-44）

- 透明之保存用塑料，市售有多種厚度可選擇（0.001"稱為1mil），原料為聚酯纖維（Polyester）。Mylar®也是美國杜邦公司旗下之產品，為一透明薄片，修復所使用之透明聚酯片是沒有塗層（Coating）的。用途廣泛，不只可用來保存材料也可輔助修復動作。防水、防塵但會有靜電問題。

- 本次陳澄波修復案使用4mil之透明聚酯片製作檔案夾（封一邊）保存未夾裱之紙質作品。

圖43.整卷Mylar®　　圖44.Mylar®用於作品保存形式

## （五）**Photo-Tex® Tissue**（圖45-46）

- 白色之保存紙材，為純棉漿製成，為無酸無木質素等不良化性之紙材，呈中性，專門做為保護對鹼性敏感之文物（照片、織品……等），表面光滑可減少對作品的磨損，用途廣泛，可用於包裹文物、隔層、填充……等。

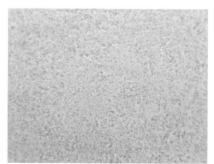

圖45.Photo-Tex® Tissue　　圖46.Photo-Tex® Tissue纖維

- 本次陳澄波修復案使用Photo-Tex® Tissue作為隔層紙（包覆作品介於Mylar與作品之間），保存未夾裱之紙質作品。

其他還有如Rayon Paper、Hollytex®等同時用於修復及保存之材料，可墊在已夾裱之紙質作品正面，隔層作品與無酸卡紙。

## 五、結論

文物修復是一門跨領域之專門學科，除了需要有保存科學及材料科學的專業知識外，還要有熟練的傳統技法技術。現代修復藉由科學的幫助，提供修復師更精確對於文物的體質判斷，且多虧保存科學家對於修護材料的開發不遺餘力，讓文物修復隨著時代的演進可以得到更好的照顧。目前市面上所能提供之修護材料已有相當好的穩定性，可以很安全的延長文物的壽命，因此期盼拙文可以提供基本的文物保存概念，傳達正確的文物保存修復倫理原則及正確的材料使用概念。

【註釋】

1. 李季衡：國立臺灣師範大學文物保存維護研究發展中心專案修復助理。

2. 參考喬昭華等撰《織品服飾、紙質文物保存專有名詞類編》p.94，2010，文建會文化資產總管理處籌備處

3. 參考張承志著《文物保藏學原理》p.181，2010，北京科學出版。

4. 同上註，p.353-354。

5. 參考喬昭華等撰《織品服飾、紙質文物保存專有名詞類編》p.167-168，2010，文建會文化資產總管理處籌備處。

6. 參考王竹平〈從天衣無縫到若隱若現─由幾個國際規章與案例談當代修護理論〉《故宮文物月刊》第317期，2009，國立故宮博物院。

7. 文物修復倫理原則可參考張元鳳主持，《檔案保護技術及制度之研究─以紙質媒體為例》p.17-20，2009，行政院研究發展考核委員會。

8. 頂條主要是在畫心斷裂處多貼一層紙條，來增強支撐能力。可參考潘怡伶〈絹本重彩掛軸之劣化特徵研究與探討─以清初名臣王杰書法為例〉國立臺南藝術大學古物維護研究所碩士論文，p.46-48，2009。

9. 詳細對於修復材料之要求可參考張元鳳主持，《檔案保護技術及制度之研究─以紙質媒體為例》行政院研究發展考核委員會，P59-65，2009。

10. 參考喬昭華等撰《織品服飾、紙質文物保存專有名詞類編》文建會文化資產總管理處籌備處，p.172，2010。

11. 參考張元鳳主持《檔案修護技術及制度之研究─以紙質媒體為例》行政院研究發展考核委員會，p.64，2009。

12. 參考張豐吉、徐建國〈裱褙用漿糊性質之分析〉《林業研究季刊》p.37-46，2000。

13. 同上註。

14. 漿糊製作可參考潘怡伶〈絹本重彩掛軸之劣化特徵研究與探討─以清初名臣王杰書法為例〉國立臺南藝術大學古物維護研究所碩士論文，p.53-55，2009。

15. 參考Katherine Sanderson. *Making It Stick: Paste on Paper. The Book and Paper Annual 26*, p.155-159, 2007.

16. 參考陳信憲《漂洗處理對著生褐斑紙質文物潛在劣化問題之探究》國立臺南藝術學院古物維護研究所碩士論文，p.44-45，2004。

17. 參考Theresa Smith, *"Historical Bleaching of Ingres Drawings at the Fogg Art Museum"*, The Book and Paper Annual 27, P.89-96, 2008.

18. 參考陳心怡〈泡水紙質文物之乾燥與修復〉國立中興大學森林研究所碩士論文，p.7-8，2002。

19. 關於文物漂白劑可參考陳信憲〈漂洗處理對著生褐斑紙質文物潛在劣化問題之探究〉國立臺南藝術學院古物維護研究所碩士論文，p.40-47，2004。

20. 參考喬昭華等撰《織品服飾、紙質文物保存專有名詞類編》文建會文化資產總管理處籌備處，p.96，2010。

21. 參考張元鳳主持《檔案修護技術及制度之研究─以紙質媒體為例》行政院研究發展考核委員會，p.74，2009。

22. 參考平山郁夫等撰《図解 日本画用語事典》東京藝術大學大學院文化財保存学日本画研究室，p.37，2009。

23. 文物作品四周以日本修復紙材搭邊方式可參考葉濱翰〈雙面水彩畫的修復與夾裱〉《文物保存維護年刊》國立臺灣師範大學文物保存維護研究發展中心，p.159-161，2013。

24. 參考蔡斐文等作《修護揭密：臺博館暨南藝大修護研究成果專題》p.124，2009，臺灣博物館。

25. 織物名稱常會出現®之標誌，代表此為一廠牌之商標產品（Market Brand），因此我們一般會直接以Hollytex來稱呼此布料。中文名稱參考蔡斐文等作《修護揭密：臺博館暨南藝大修護研究成果專題》p.126，2009，臺灣博物館。

26. 參考Nancy Purinton and Susan Filter, *"Gore-Tex: An Introduction to the Material and Treatments"*, The Book and Paper Annual 11, p.11-33, 1992。

27. 參考高宜君〈細説「西清續鑑鏡匣」修護〉《故宮文物月刊》第352期，p.56-63，2012，國立故宮博物院。

28. 詳細關於各文物典藏環境之資料可參考劉藍玉譯《藏品維護手冊：收藏家與博物館典藏研究人員必備》p.60-67，2002，五觀藝術。

29. 參考劉藍玉譯《藏品維護手冊：收藏家與博物館典藏研究人員必備》p.60-67，2002，五觀藝術。

30. 參考蔡斐文等作《修護揭密：臺博館暨南藝大修護研究成果專題》p.104，2009，臺灣博物館。

31. 2ply為0.03"即0.75mm；4ply為0.06"即1.5mm以此類推。

【參考資料】

1. 喬昭華等撰《織品服飾、紙質文物保存專有名詞類編》2010，文建會文化資產總管理處籌備處。

2. 張承志著《文物保藏學原理》2010，北京科學出版。

3. 張元鳳主持《檔案修護技術及制度之研究─以紙質媒體為例》2009，行政院研究發展考核委員會。

4. 平山郁夫等撰《図解 日本画用語事典》2009，東京藝術大學大学院文化財保存学日本画研究室。

5. 蔡斐文等作《修護揭密：臺博館暨南藝大修護研究成果專題》2009，臺灣博物館。

6. 張元鳳總編《文物保存維護年刊》2013，國立臺灣師範大學文物保存維護研究發展中心。

7. 劉藍玉譯《藏品維護手冊：收藏家與博物館典藏研究人員必備》2002，五觀藝術。

8. 王瓊花翻、澤田正昭著《文化財保存科學紀要》2001，國立歷史博物館。

9. 王竹平〈從天衣無縫到若隱若現─由幾個國際規章與案例談當代修護理論〉《故宮文物月刊》第317期，2009，國立故宮博物院。

10. 高宜君〈細説「西清續鑑鏡匣」修護〉《故宮文物月刊》第352期，2012，國立故宮博物院。

11. 張豐吉、徐建國〈裱褙用漿糊性質之分析〉《林業研究季刊》2000。

12. 潘怡伶〈絹本重彩掛軸之劣化特徵研究與探討─以清初名臣王杰書法為例〉國立臺南藝術大學古物維護研究所碩士論文，2009。

13. 陳信憲〈漂洗處理對著生褐斑紙質文物潛在劣化問題之探究〉國立臺南藝術學院古物維護研究所碩士論文，2004。

14. 陳心怡〈泡水紙質文物之乾燥與修復〉國立中興大學森林研究所碩士論文，2002。

15. Katherine Sanderson, *"Making It Stick: Paste on Paper"*, The Book and Paper Annual 26, 2007.

16. Theresa Smith, *"Historical Bleaching of Ingres Drawings at the Fogg Art Museum"*, The Book and Paper Annual 27, 2008.

17. Nancy Purinton and Susan Filter, *"Gore-Tex: An Introduction to the Material and Treatments"*, The Book and Paper Annual 11, 1992.

# Conservation of Chen Cheng-po's Works on Paper:
## A Multi-perspective Study on the Use of Conservation Materials

Lee Chi-heng[1]

## Summary

This commission for the conservation of Chen Cheng-po's works of art was carried out from 2011 to 2014. The treated works included damaged oil paintings, ink paintings, watercolors, Chinese calligraphy, sketches and documents of varying media and supports. There were over a thousand works on paper (36 oil paintings, 71 watercolors, 71 charcoal sketches, 763 single-sheet sketches, 30 ink paintings and calligraphy, 29 sketchbooks, among others). Although the common support was paper, variability in the papermaking process and raw materials often resulted in the differences in physical constitution of the papers. Considering that the artworks exhibited a diversity of physical conditions, the selection of a treatment approach and the choice of conservation materials are very important. Moreover, once the artworks had been fully treated and left the conservation studio, they had yet to be transported, exhibited, and placed in storage. Thus, the process of selecting conservation materials is itself a form of scholarship.

This article focuses on the selection and characteristics of materials used in the conservation of Chen Cheng-po's works on paper. The importance of the selection of conservation materials will be discussed from two perspectives: the chemical properties of acid-free materials and the ethical principles of art conservation.

The biggest issue we encountered in treating Chen Cheng-po's works on paper was severe yellowing of the paper support. Modern machine-made paper is largely made up of cellulose, hemicellulose, and lignin. According to published research, lignin is the main cause of paper yellowing.

Acidic materials are an important factor in the aging of cultural objects. Therefore, acid-free materials are used as the main method in extending the life of these works of art. Acid-free materials refer to those with a pH7 or above, and can be divided into neutral (pH7) or alkaline materials (pH>7). Alkaline materials contain a buffer (including calcium carbonate, $CaCO_3$), which can absorb and neutralize acidic components in the environment (e.g., carbon dioxide) and slow down or stop acidification of works of art. It is for this reason that acid-free materials will gradually become acidic.

Prior to the conservation treatment, Chen Cheng-po's paintings were thoroughly examined and their physical conditions fully documented. The more complete the before treatment information, the more comprehensive the information will be for later research, application and conservation purposes. The biggest difference between modern and traditional conservation lies in the use of scientific instruments for examination, which provide useful analytical data for conservators to gain an in-depth

understanding of the materials of the works of art in question. A very important criterion for analysis is that the object must not be damaged. For this reason, the best option is non-destructive analysis. Inspection with infrared and ultraviolet (UV) radiation is one of the procedures for before treatment examination and documentation. For example, UV radiation can induce fluorescence of mold growth on works of art. Results such as these act as useful references when selecting conservation materials and solvents as well as the subsequent treatment methodology.

After understanding the physical condition of a work of art, the choice of restoration materials will be determined based on examination results. Additionally, there are three principles of conservation of cultural heritage that must be observed:

1. Principle of Compatibility
2. Principle of Similarity
3. Principle of Reversibility

Considerations in the selection of conservation materials does not only take into account the properties of the materials, but also includes the trends in modern conservation ethics and philosophies.

Every treated work of art is like a patient. Differences in symptoms and inherent condition require different treatment plans. The general paper conservation process can be summarized in the following steps:

1. Removal of surface dust
2. Support reinforcement
3. Media consolidation
4. Reduction of foxing spots
5. Washing
6. Alkalization and neturalization
7. Infilling
8. Reinforcement strips
9. Lining
10. Pressing
11. Inpainting

Below are materials often used in the conservation treatment process. All of them meet the requirements of being non-toxic, stable, durable, neutral or weakly alkaline to prevent acidification and reversible.

1. Eraser Crumbs
2. Dry Cleaning Sponge
3. Methyl Cellulose
4. Zen Shofu Japanese Wheat Paste
5. Hydroxypropylcellulose (Proprietary name: Klucel G)
6. Hydrogen Peroxide
7. Calcium Hydroxide

8. Tengujo Paper
9. Xuan Paper
10. Hosokawa Paper
11. Blotting Paper
12. Rayon Paper
13. Hollytex® Polyester Webbing
14. Gore-Tex®
15. Cellulose Powder

In comparison to conservation, heritage preservation is concerned with long-term preservation. Modern conservation ethics emphasize that 'prevention is better than a cure.' The purpose of conservation is to rescue works of art from harmful conditions, reducing these risk factors to prolong their lives; preservation aims to control the environment and select appropriate materials to provide a long-term, stable environment.

Taking works on paper for example, the following environmental factors should be considered:

1. Relative humidity (RH) and temperature
2. Environmental conditions
3. Lighting
4. Biological factors (mildew, pests)

Below are several of the preservation materials chosen for the current Chen Cheng-po paper conservation project. Because part of the collection was to be exhibited after treatment, the treatment procedure considered the fact that they would be travelling extensively and be placed on long-term display. The choice of preservation materials would be a significant factor in ensuring a favorable and safe environment for the artworks.

1. Acid-free Corrugated Board
2. Acid-free Museum Mounting Board
3. Acid-free Folder Stock
4. Mylar® Polyester Film
5. Photo-Tex® Tissue

In addition to the above, there are materials such as Hollytex® that can be used simultaneously for conservation and preservation. It can be used as interleaving for matted objects.

Art conservation is an inter-disciplinary field of study. Beyond professional knowledge in conservation science and material science, proficiency in traditional skills and technology is integral. With the help of contemporary science, conservators can now more precisely identify the physical components of each work of art. Thanks to the great effort of scientists in the development of new preservation materials, conservators are constantly supported in their ongoing efforts with each passing day.

---

1. Lee Chi-heng is a project technician at the National Taiwan Normal University Research Center for the Conservation of Cultural Relics.

# 紙質作品
## Works on Paper

## 修復報告
## Selected Treatment Reports

國立臺灣師範大學文物保存維護研究發展中心

National Taiwan Normal University Research Center for Conservation of Cultural Relics

# 東方書畫：膠彩、水墨、書法
## Asian paintings: Glue color painting, ink paintings, calligraphies

此次修復陳澄波東方書畫作品共31件，完成時間推測大都集中在東京美術學校求學期間，包括：膠彩畫1件（年代不詳）；水墨畫7件（其中2件年代在1924-25，其餘5件年代不詳）；書法共23件（其中21件年代在1924-27，其餘2件年代不詳）。

A total of 31 Asian paintings and calligraphy were treated, most of which were completed during Chen Cheng-po's time at the Tokyo School of Fine Arts . These works include 1 glue color painting (date unknown), 7 ink paintings (1 dating to 1924-25, 5 date unknown) and 23 calligraphy (21 dating to 1924-27, 2 date unknown).

膠彩畫〔天竺聖人飛來入懷中〕是一幅臨摹作品，先前已有修復過，包含裝裱與固定在無酸卡紙板上並保存在木框內。雖然無酸卡紙板與木框保存完善，但畫心黃化、黴害、媒材易溶解於水中，所以修復此作品時須特別注意顏料層的穩固。此外，畫面中一個人物的臉部有補彩過，在修復中要將臉部補彩先清理後使其恢復原本樣貌。完整修復步驟為先將畫心與鑲料解體，再經過乾式清潔、媒材加固、黴斑漂洗、清洗、解體背紙、小托命紙、加托與無酸夾裱保存、裝框。

The glue color painting *Tianzhu Sage Flying into Her Arms* was previously treated, including the addition of a silk mounting, mounting onto a non-acidic mat board and framing in a wooden frame. Although the mat board and wooden frame are in good condition, the painting suffered from yellowing, mold damage and water-induced media loss, thus requiring added media consolidation. The face of one of the figures was overpainted, and therefore treatment including removing this overpaint to restore its original appearance. Complete conservation treatment included the removal of old mounting materials, dry cleaning, media consolidation, bleaching of mold-induced foxing spots, aqueous cleaning, removing old lining papers, adding new lining papers and remounting onto a non-acidic mat board and framing.

水墨作品7件，以沒骨形式勾勒花卉枝葉為主。作品無正式簽名落款，但〔紅柿〕和〔漁村〕於紙張左下角寫有「師一 陳澄波」鉛筆字樣。作品未經裝裱，有基底材缺失、紙張孔洞、折痕、黃化、黴害等劣化情形，並於確認媒材穩定性後，進行作品清潔與媒材加固，結合東方繪畫托裱與無酸夾裱兩者於美學及保存維護之優點，搭配無酸楓木框以鏡片形式展示。

A total of seven ink paintings were treated. They were paintings of flowers and foliage painted in the mogu, or 'boneless' style. There are no formal signatures, but on the lower left corner of *Persimmon* and *Fishing Village* is written [First year student - Chen Cheng-po] in pencil. The paintings were never mounted, and suffered from support losses, creases, yellowing and mold damage. After testing media stability, the works of art underwent cleaning and media consolidation. Next, combining Asian-style silk mounting with mounting on a mat board has the advantages of preserving the paintings' aesthetics and providing physical protection. Finally, the paintings were paired with non-acidic maple wood frames for exhibition.

書法作品23件，一部分有紅色朱批於上以糾正字形的筆順，推論為陳澄波求學階段圖畫師範科老師的批改。作品未經裝裱，仍留有紙邊刀印，並因自然老化而發生基底材斷裂、缺失、紙張孔洞、折痕、黃化、黴害、灰塵髒污等現象；其中使用紅色鉛丹顏料批改墨跡上，呈現深淺不一的暗化。此為高溫高濕的環境所造成的變色現象，並非作品原本樣貌，經討論後，稍將暗化顏料進行返鉛處理。透過點測瞭解媒材穩定性之後進行作品清潔、媒材加固、暗化顏料返鉛處理與基底材小托，以東方繪畫托裱形式增加基底材強度，並搭配無酸夾裱存放，另配合無酸楓木框鏡片形式展示。

　　A total of 23 calligraphy were treated. Several works contained red correction marks, most likely written by a teacher while Chen Cheng-po was still a student. The works have never been mounting and have marks from the paper supports' original paper ream. They suffered from natural aging, tears, losses, creases, yellowing, mold damage, and surface dirt and accretion. Red correction marks that used red lead have now darkened, most likely caused by a high temperature and high humidity environment. The darkening is not original, and therefore required reversion. After testing for media stability, the works of art underwent cleaning, media consolidation, reversion of red lead, lining, reinforcing the primary paper support, mounting onto a non-acidic mat, and pairing the works of art with maple frames for exhibition.

# 修復步驟與範例 Treatment procedure

## I. 修復前狀態 Before treatment condition

天竺聖人飛來入懷中 Tianzhu Sage Flying into Her Arms　年代不詳 Date unknown　紙本膠彩 Glue color on paper　27×133cm

### ・天竺聖人飛來入懷中 **Tianzhu Sage Flying into Her Arms**

修復紀錄 Conservation history

　　□未曾修復Not treated before ■曾修復：裝裱Previously treated: Mounted

基底層 Primary support

　　■灰塵髒污Surface dirt ■黴害Mold damage □褐斑Foxing □水害Tidelines ■油害Oil stains
　　□蟲害（排泄物、啃食破損）Insect damage (accretions, losses) ■黃化Yellowing □燒傷Fire damage
　　□割傷Cuts □破洞Losses □附著物Accretions ■折痕Creases □裂痕Tears □變色Discoloration
　　□磨損Abrasion □變形Distortions □膠帶Tapes □脫糊Non-adhesive paste □紙纖維翹起Lifted fibers □其他Other

媒材層 Media

　　□脫離Friable □磨損Abrasion □褪色Fading □暈水Bleeding □透色Sinking
　　■其他Other：補彩Inpainting

裝裱 Mounting

　　□無No ■有Yes

裝裱種類 Mounting material

　　□紙Paper ■絹Silk □其他Other

裝裱層 Mounting condition

　　■灰塵髒污Surface dirt ■黴害Mold damage □褐斑Foxing □水害Tidelines ■油害Oil stains
　　□蟲害（排泄物、啃食破損）Insect damage(accretions, losses) ■黃化Yellowing □燒傷Fire damage
　　□割傷Cuts □破洞Losses □附著物Accretions ■折痕Creases □裂痕Tears □變色Discoloration
　　□磨損Abrasion □變形Distortions □膠帶Tapes □脫糊Non-adhesive paste
　　□紙纖維翹起Lifted fibers □空鼓Delamination
　　□畫心分離Separation of painting from mounting □其他Other

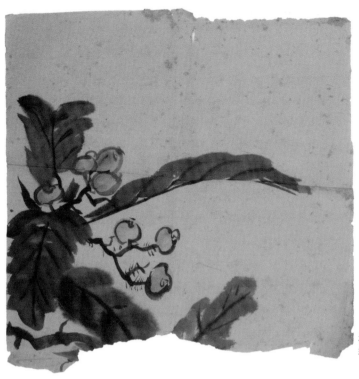

枇杷Loquat 年代不詳Date unknown
紙本彩墨Ink-color on paper 33×32.6cm

## · 枇杷 Loquat

### 修復紀錄 Conservation history

■未曾修復Not treated before □曾修復Previously treated

### 基底層 Primary support

■灰塵髒污Surface dirt ■黴害Mold damage □褐斑Foxing □水害Tidelines □油害Oil stains

□蟲害（排泄物、哨食破損）Insect damage(accretions, losses) ■黃化Yellowing □燒傷Fire damage

□割傷Cuts ■破洞Losses ■附著物Accretions ■折痕Creases ■裂痕Tears □變色Discoloration

□磨損Abrasion □變形Distortions □膠帶Tapes □脫糊Non-adhesive paste □紙纖維翹起Lifted fibers □其他Other

### 媒材層 Media

□脫離Friable □磨損Abrasion □褪色Fading □暈水Bleeding □透色Sinking □其他Other

### 裝裱 Mounting

■無No □有Yes

### 裝裱種類 Mounting material

□紙Paper □絹Silk □其他Other

### 裝裱層 Mounting condition

□灰塵髒污Surface dirt □黴害Mold damage □褐斑Foxing □水害Tidelines □油害Oil stains

□蟲害（排泄物、哨食破損）Insect damage(accretions, losses) □黃化Yellowing □燒傷Fire damage

□割傷Cuts □破洞Losses □附著物Accretions □折痕Creases □裂痕Tears □變色Discoloration

□磨損Abrasion □變形Distortions □膠帶Tapes □脫糊Non-adhesive paste □紙纖維翹起Lifted fibers

□空鼓Delamination □畫心分離Separation of painting from mounting □其他Other

大伴家持・萬葉集卷4-781　Otomono Yakamochi, Man Yoh Shuh Vol.4-781　1926　紙本水墨 Ink on paper　29.4×65.3cm

## ・大伴家持・萬葉集卷4-781 Otomono Yakamochi, Man Yoh Shuh Vol.4-781

### 修復紀錄 Conservation history

■未曾修復Not treated before □曾修復Previously treated

### 基底層 Primary support

■灰塵髒污Surface dirt ■黴害Mold damage □褐斑Foxing □水害Tidelines ■油害Oil stains

□蟲害（排泄物、啃食破損）Insect damage(accretions, losses) ■黃化Yellowing □燒傷Fire damage

□割傷Cuts ■破洞Losses □附著物Accretions ■折痕Creases □裂痕Tears □變色Discoloration

□磨損Abrasion □變形Distortions □膠帶Tapes □脫糊Non-adhesive paste □紙纖維翹起Lifted fibers □其他Other

### 媒材層 Media

□脫離Friable □磨損Abrasion □褪色Fading □暈水Bleeding □透色Sinking

■其他Other：鉛丹暗化Red lead darkening

### 裝裱 Mounting

■無No □有Yes

### 裝裱種類 Mounting material

□紙Paper □絹Silk □其他Other

### 裝裱層 Mounting condition

□灰塵髒污Surface dirt □黴害Mold damage □褐斑Foxing □水害Tidelines □油害Oil stains

□蟲害（排泄物、啃食破損）Insect damage(accretions, losses) □黃化Yellowing □燒傷Fire damage

□割傷Cuts □破洞Losses □附著物Accretions □折痕Creases □裂痕Tears □變色Discoloration

□磨損Abrasion □變形Distortions □膠帶Tapes □脫糊Non-adhesive paste □紙纖維翹起Lifted fibers

□空鼓Delamination □畫心分離Separation of painting from mounting □其他Other

## II. 修復作業內容 Conservation treatment

### 1. 修復前攝影 Before treatment examination and documentation（圖1-5）

　　作品修復前的整體狀況紀錄及調查，包括：修復前進行可見光（正光、側光、透光）、非可見光（紫外光螢光反射與紅外光）檢測。透過上述不同特殊光源的攝影技術交互比對下，全面性了解文物材質及損傷的狀態。另以X光螢光分析儀（XRF）檢測紀錄，在朱墨筆劃上測得較高含鉛量之處，顏料暗化情形亦顯為嚴重。

　　The before treatment condition of the works of art was examined and documented with normal and raking illumination, non-visible photographic methods (UV-induced visible fluorescence and infrared radiation reflectography). Comparison of these different photographic methods allowed the conservators to better understand the object's composition and physical condition. X-ray fluorescence spectrophotometry revealed a high level of lead in the calligraphy's red writing, indicating that the red lead had undergone severe darkening.

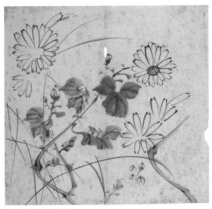

圖1.正光（正面）
Normal illumination (Recto)

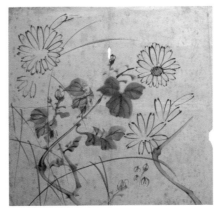

圖2.側光（正面）
Raking illumination (Recto)

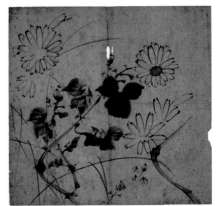

圖3.透光（正面）
Transmitted illumination (Recto)

### 2. 媒材點測 Media solubility tests（圖6）

　　為瞭解媒材的穩定性，將修復中預計會使用到的溶液，點測於媒材邊緣不明顯處，再以純棉製成之中性吸水紙張輕按10秒後，於放大鏡下觀察媒材是否發生溶解掉色。

　　Media on each work of art was tested for solubility to ensure they would be stable during conservation treatment and the application of various solvents. After a nondescript area in the media was selected for testing, water was applied to the area with a blotting paper for ten seconds, and the area was observed under magnification for fading or color changes.

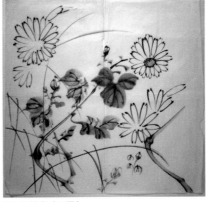

圖4.紅外光（正面）
Infrared radiation (Recto)

圖5.紫外光（正面）
UV radiation (Recto)

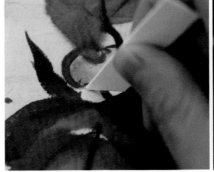

圖6.進行溶液點測以瞭解作品媒材之穩定性 Testing media's solvent solubility

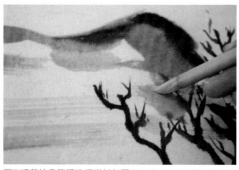

圖7.順著繪畫筆觸進行媒材加固 Media consolidation

### 3. 媒材加固 Media consolidation（圖7）

經點測確認媒材均無溶解掉色之情形，但為避免後續修復過程中所使用的水分造成顏料的鬆動，乃以1%三千本膠順著筆意加固作品媒材。但發現作品未經方裁的紅色紙邊刀印具有水溶性反應，以1% Klucel G乙醇溶液加固。

Although it was determined that media were stable, in order to avoid potential media loss during the proceeding aqueous treatment the media were brush-consolidated with 1% animal glue. For packing printing inks on non-cut edges of the calligraphy, 1% Klucel G dissolved in ethanol was used as a consolidant.

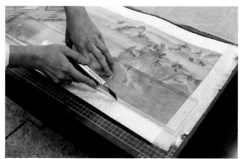

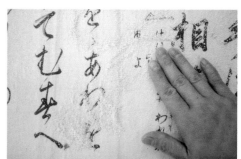

圖8.將舊裝裱材料移除
Removing old mounting materials

圖9.以手術刀剔除昆蟲排泄物和表面異物
Surface accretions are removed with a scalpel

圖10.以粉末橡皮清潔表面灰塵髒污
Surface dirt is removed with eraser crumbs

### 4. 解體（膠彩畫）Unmounting (Glue color painting)（圖8）

將畫心與舊裝裱材料解體。

The painting was separated from its old mounting materials.

### 5. 表面除塵 Surface cleaning（圖9-10）

依畫圓方向帶動粉末橡皮移除作品紙張表面灰塵髒污，並以手術刀小心剔除昆蟲排泄物和附著於紙張表面之異物。

Eraser crumbs were used to remove surface dirt on the recto and verso of the work of art. Insect and surface accretions were removed with a scalpel.

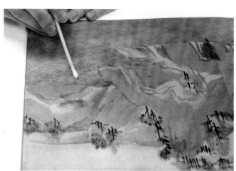

### 6. 黴斑漂洗 Bleaching of mold-induced foxing（圖11）

棉花棒沾調整酸鹼值為pH8-8.5之1%過氧化氫水溶液，小心地漂洗作品紙張空白處的褐斑。於媒材區域下方處生成的黴斑，則經顏料測試無滲色、變色反應後，以pH5-5.5的過氧化氫水溶液局部漂洗1-2次，隨後以淨水清洗數次以帶離藥劑和髒污。

圖11.以過氧化氫水漂洗黴斑
Bleaching mold-induced foxing spots with hydrogen peroxide

Mold-induced foxing spots in non-image areas were bleached with a cotton swab dampened with pH8-8.5 1% hydrogen peroxide. After ensuring that media would not bleed nor change color, foxing spots in colored and image areas were cleaned with pH5-5.5 hydrogen peroxide one to two times, followed by washing with water.

### 7. 返鉛處理（書法）Reverting red lead darkening (Calligraphy)（圖12-13）

理論上返鉛處理的反應時間越長、溫度越高、pH值越高、溶液濃度越大，則返鉛效果越好。進行返鉛處理時，以小筆塗刷pH5-5.5、濃度低於0.5%過氧化氫溶液於顏料暗化之處，並注意媒材返鉛後的視覺效果稍加調整與原筆劃深淺濃淡相近。

Theoretically, for reverting red lead darkening the longer the treatment, higher the temperature and pH, more concentrated the solvent, the better the results. For this treatment, pH5-5.5 0.5% hydrogen peroxide was brush-applied onto darkened red lead areas, while observing the color changes to determine whether additional hydrogen peroxide needed to be applied.

圖12.顯微鏡下不同程度鉛丹顏料暗化情形
Photomicrograph showing different degrees of reverted red lead

圖13.暗化鉛丹處以藥劑塗刷
Brushing hydrogen peroxide onto darkened red lead

### 8. 清洗 Aqueous cleaning（圖14-15）

於清洗容器內，將作品襯於濕吸水紙上，以較低溫的淨水清洗作品，以免高溫造成黏著劑的溶解使顏料鬆動。特別是針對書法作品，作品經漂洗、返鉛之處，以淨水溫和地清洗數次，返鉛處朱墨再以1%三千本膠加固，以減少媒材氧化的再發生。

The work of art was washed on sheet of blotting paper, dampened with lukewarm water, in a photography tray. (Hot water was not used to avoid solubilizing media binder.) Care was taken to wash previously bleached and reverted red lead areas several times. Reverted red lead was then consolidated again with 1% animal glue to minimize future oxidation.

### 9. 解背紙（膠彩）Removing lining papers (Glue color painting)（圖16）

將畫心加濕攤平後，小心將覆背紙、命紙移除。

After the work of art is humidified and brushed flat, lining papers are removed.

圖14.以軟毛刷加濕攤平作品
A soft sheep's hair brush is used to flatten the work of art

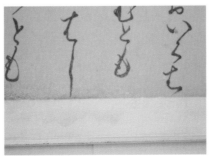

圖15.作品上黃污藉由水分移至吸水紙上
Yellowed discoloration is washed out from the work of art onto blotting paper

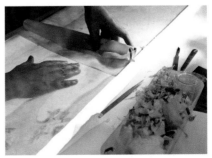

圖16.揭除覆背紙、命紙
Removing the first and final lining papers

## 10. 小托命紙 Applying first lining

【水墨】（圖17-18）選用與畫心顏色相近、重量相仿的修復用長纖維紙張作為命紙。長纖維紙質作品的命紙與加托紙為楮皮紙，〔菊花〕因為畫在宣紙上，以宣紙為命紙。

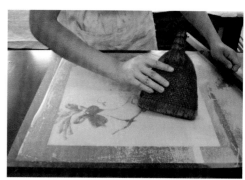

圖17.以宣紙小托〔菊花〕以增強基底材支撐
Xuan paper lining is used to strengthen the paper support

圖18.以楮皮紙小托〔花〕以增強基底材支撐
Kozo lining is used to strengthen the paper support

[Ink painting] A long-fibered kozo (paper mulberry) paper of similar color and thickness to the work of art was selected as the first and second lining papers. Because *Chrysanthemum* was painted on xuan paper, a xuan paper was selected for its first lining.

【書法】（圖19）選用與畫心顏色相近、重量相仿的楮皮紙作為命紙與托紙，以加大畫心，增加作品基底材強度。

[Calligraphy] A kozo paper of similar color and thickness to the work of art was selected as the first and second lining papers to expand the size of the work of art and strengthen the primary paper support.

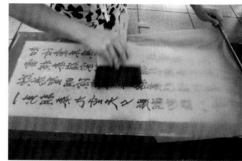

圖19.以楮皮紙小托書法以增強基底材支撐
Kozo lining is used to strengthen the paper support

【膠彩】（圖20）選用與畫心顏色相近、重量相仿的楮皮紙作為命紙與托紙，以加大畫心，增加作品基底材強度。

[Glue color painting] A kozo paper of similar color and thickness to the work of art was selected as the first and second lining papers to strengthen the paper support.

## 11. 破損補洞 Infilling losses

於光桌上，依作品紙張孔洞的形狀，以原色楮皮或宣紙製作厚度相仿的補紙，於命紙後方隱補紙張孔洞。

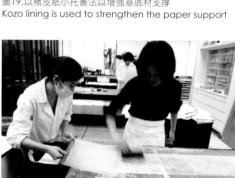

圖20.將膠彩小托命紙
Applying first lining to glue color painting

Using a light table, after applying the first lining losses are infilled with an appropriately thick kozo or xuan paper.

## 12. 加托 Applying second lining

再於作品背面加托一層背紙，增加作品整體強度。〔菊花〕的加托紙為宣紙，其他作品為楮皮紙。

A second lining is applied to the verso of the work of art to increase its structural strength. With the exception of *Chrysanthemum*, which was lined with xuan paper, the second lining for all other works of art was kozo paper.

## 13. 全色補彩 Inpainting （圖21-22）

於畫心四邊向外1公分處的補紙上塗佈膠礬水作為防水隔離層，再以有機顏料於補紙上進行可辨識性的全色。全色時以補彩不補筆的作法使補紙與周圍畫面協調，降低紙張缺損處所造成畫面鑑賞的干擾，並加大了作品的畫心以保護作品紙緣。

Four borders surrounding each work of art were inpainted up to 1cm wide. First, an isolating layer of alum-glue was brush applied to act as an isolating layer. Reversible organic colorants were then used to inpaint the borders. Inpainting did

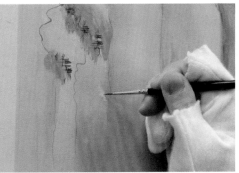

圖21.以有機顏料於補紙上進行可逆性的全色
Losses are inpainted with reversible organic colorants.

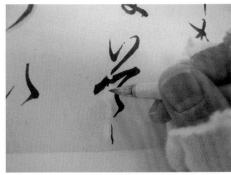

圖22.於孔洞補紙處塗佈防水隔離層後進行可辨識性全色
Inpainting after an isolating layer has been applied

not include painting lost images or brushstrokes, but only toned the borders to match the surrounding paper support and allow the work of art to be more visual readable. In addition, inpainting the borders also increased the size of the work of art and protected the original paper support during the mounting process.

## 14. 作品鑲接、覆背（水墨）Silk mounting and applying final lining (Ink painting)（圖23-24）

　　搭配作品畫意選擇使用蠶絲綾絹，以搭接和挖鑲兩種形式進行作品的裝裱鑲接。裱料皆以小麥澱粉漿糊搭接於加大後的畫心上，而非直接黏貼於作品表面，因此不損及作品原本畫心邊緣。

Mounting silks were selected for the paintings and adhered in one of two methods. The silks were adhered with wheat starch paste to the added border edge of the work of art, not the painting's original paper support, thereby not harming the work of art.

圖23.裱料搭接於作品加大後的畫心上
Mounting silks are adhered to the painting's added border edge

## 15. 裝幀保存 Mounting and storage

　　由於單頁作品數量多並且因為展出需要會不定時會更換存放環境，因此作品的整理與收納方式，要兼顧便利性並能預防有害氣體或微生物的入侵、溫濕度變化的影響或人為翻看、運輸造成的損傷，故分別以無酸卡紙、瓦楞紙夾裱保護存放作品，書法與水墨存放於梧桐木盒並典藏於恆溫恆濕庫房內。膠彩夾裱後再搭配無酸楓木框展示。

圖24.作品覆背
Applying a final lining to the work of art

Due to the large number of works of art and exhibition needs, a storage system was developed that was convenient, and protected the work of art from harmful pollutants and microbiological attack, temperature and humidity fluctuations, and damage from handling. A non-acidic mat and non-acidic corrugated board folder was designed to house each work of art. Calligraphy and ink paintings were placed in a wutong box, and stored in an environmentally controlled storage space. The glue color painting was adhered to a window mat and stored in a maple frame.

# 西方紙質：炭筆素描
## Western paper: Charcoal sketches

　　陳澄波於1925至1929年間所繪的71件炭筆素描作品，其中60幅為標準開大小（63×48cm），內容為多幅女性全身像素描、1幅頭像、1幅手腳描繪，另外11幅為四開大小（48×31.5cm），其中10幅為女性頭像描繪、1幅腿部描繪。以粗黑的外輪廓線與明確的體積感，描繪於帶簾紋與浮水印之紙張上，是此系列炭筆作品的共同特徵。早期作品都是用堆疊方式保存，故每張炭筆素描都有複印到上一張作品的背面。即便如此，此複印痕跡亦可算是炭筆素描在時間刻劃下所呈現出來的，屬於應保留之歷史痕跡，因此在修復處理時刻意保留。

From 1925-1929 Chen Cheng-po drew 71 charcoal sketches, 60 of which measured 63x48cm (including many sketches of nudes, 1 bust portrait and 1 sketch of feet), and 11 measuring 48x31.5cm (among with 10 are bust portraits, and 1 sketch of feet). These charcoal sketches were drawn with bold contours and a clear sense of volume on watermarked laid paper. Previously, these works of art were stored stacked together, causing the sketches to leave a shadow impression on the adjoining sheet. It was decided that these shadow impressions should be preserved, as they are a historical record of these charcoal sketches.

　　大部份作品堆疊存放，紙張生成黴斑、褐斑、邊緣累積灰塵髒污。而受潮或蟲害的作品，紙張常有昆蟲啃食破損、孔洞、排遺、污跡與黴害。修復前藉由顯微鏡、紅外光、紫外光輔助檢視，可看出水漬、油漬、黴斑、褐斑及指紋等痕跡。所有作品進行攝影紀錄、清潔、修復，最後以無酸開窗夾裱並存放於無酸保護盒中。

Most of the works of art were stacked together, resulting in mold damage, foxing and dirt accumulation on the edges of the paper support. Many of the works suffered from water and insect damage including losses, surface accretions and mold-induced foxing. Before treatment examination including photomicrography, infrared and UV radiation observation revealed tidelines, oil stains, mold damage, foxing spots, mold damage and fingerprints. All charcoal sketches underwent examination and documentation, cleaning, treatment and storage in a non-acidic window mat and box.

# 修復步驟與範例 Treatment procedure

## I. 修復前狀態 Before treatment condition

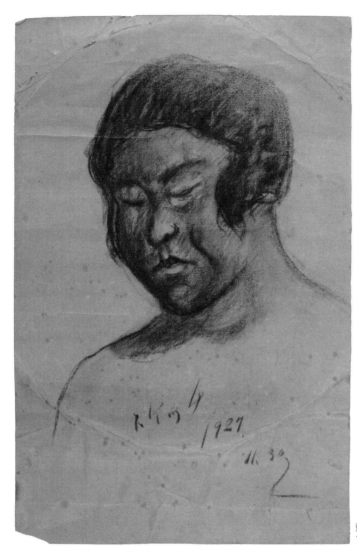

頭像素描-27.11.30（10）Portrait Sketch-27.11.30 (10)
1927　紙本炭筆 Charcoal on paper　48×31.5cm

**· 頭像素描-27.11.30（10）**

修復紀錄 Conservation history

　　■未曾修復Not treated before □曾修復Previously treated

基底層 Primary support

　　■灰塵髒污Surface dirt ■黴害Mold damage □褐斑Foxing □水害Tidelines ■油害Oil stains
　　□蟲害（排泄物、啃食破損）Insect damage(accretions, losses) ■黃化Yellowing □燒傷Fire damage
　　□割傷Cuts □破洞Losses □附著物Accretions ■折痕Creases ■裂痕Tears ■變色Discoloration
　　■磨損Abrasion ■變形Distortions □膠帶Tapes □其他Other

媒材層 Media

　　□脫離Friable ■磨損Abrasion ■褪色Fading □暈水Bleeding □透色Sinking □其他Other

# II. 修復作業內容 Conservation treatment

## 1. 修復前攝影 Before treatment examination and documentation（圖1-5）

作品修復前的整體狀況紀錄及調查，包括：修復前進行可見光（正光、側光、透光）、非可見光（紫外光螢光反射與紅外光）檢測。透過上述不同特殊光源的攝影技術交互比對下，全面性了解文物材質及損傷的狀態。

The before treatment condition of the charcoal sketches was examined and documented with normal and raking illumination, non-visible photographic methods (UV-induced visible fluorescence and infrared radiation reflectography). Comparison of these different photographic methods allowed the conservators to better understand the object's composition and physical condition.

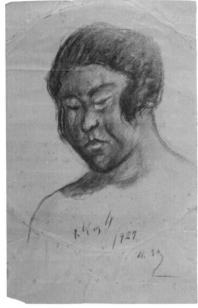 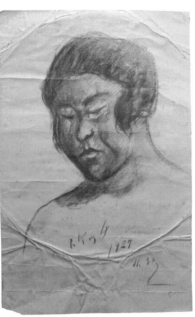 

圖1.正光（正面）Normal illumination (Recto)
黴斑在正光下表現清晰
Mold-induced foxing spots are clearly visible under normal illumination

圖2.側光（正面）Raking illumination (Recto)
嚴重折痕在側光下表現清晰
Severe creases are clearly visible under raking illumination

圖3.透光（正面）
Transmitted illumination (Recto)

 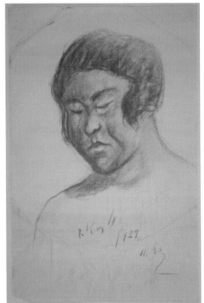

圖4.紫外光（正面）UV radiation (Recto)
黴斑在紫外光下產生橘色螢光反應
Mold-induced foxing spots fluoresce orange under UV radiation

圖5.紅外光（正面）
Infrared radiation (Recto)

## 2. 媒材點測 Media solubility tests

溶液點測結果，作品對水分溶解反應較為穩定，因此決定以濕式清潔方式移除紙張黃污。但為了避免清潔過程中可能的媒材耗損或移動，故於清潔前需加固作品媒材。

After solubility tests, it was determined that the media was stable in water. However, in order to avoid potential media loss during the proceeding aqueous treatment the media were consolidated.

## 3. 紙張纖維檢測分析 Fiber identification

紙張纖維檢測分析樣品取自炭筆素描作品已斷裂殘片。觀察比對其紙張纖維寬度相似於棉纖維，且於細胞壁上有疑似木漿紋孔之特徵，推測作品紙張含棉漿與木漿之成分[1]。

Fiber samples taken from charcoal sketch fragments were analyzed and identified. The thickness of the fiber samples matched those of cotton, whereas pits were found in the cell wall, leading to the conclusion that the paper was composed of both cotton and wood pulp.[1]

## 4. 表面除塵 Surface cleaning （圖6-8）

以修復用煙燻海綿與粉末橡皮，清潔作品正反兩面空白區域之灰塵髒污。由於紙性脆弱、破損較嚴重或清潔面積較小區域，改以羊毛軟刷進行細微的清潔。附著於畫面之昆蟲排遺、顆粒或膠體等異物，以手術刀尖端粉碎以降低其黏著力，再以修復用橡皮清潔移除。

A conservation-use synthetic sponge and eraser crumbs were used to remove surface dirt from non-image areas on the recto and verso. For weakened papers, areas with severe loss or finer detail, a soft sheep's hair brush was used to

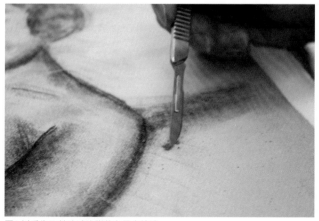

圖6.以手術刀敲碎破壞附著之昆蟲排遺
Insect accretions are broken into smaller pieces with a scalpel

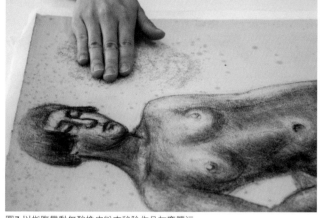

圖7.以指腹帶動無酸橡皮粉末移除作品灰塵髒污
Eraser crumbs are used to remove surface dirt

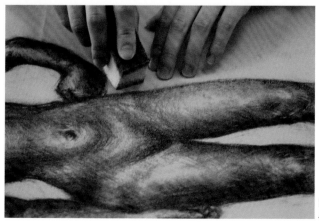

圖8.以修復用煙燻海綿移除紙張表面髒污
A synthetic sponge is used to remove surface dirt

gently maneuver the eraser crumbs. Insect accretions were broken into smaller pieces with a scalpel in order to reduce their adhesiveness, and then removed using eraser crumbs.

## 5. 媒材加固 Media consolidation（圖9-10）

於濕式清潔前，作品上之繪畫區域以1%Klucel G乙醇溶液均勻噴灑加固，以維持炭粉在濕式清潔過程中的附著力。

Media were spray-consolidated with 1% Klucel G to ensure their stability during the aqueous cleaning process.

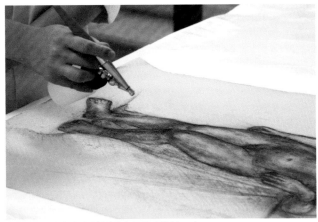

圖9.於濕式清潔前以噴槍均勻加固作品媒材1-2次
Media are evenly spray-consolidated one to two times prior to aqueous cleaning

圖10.順著繪畫筆觸進行媒材加固
Inscriptions are consolidated by brush

## 6. 黴斑漂洗 Bleaching of mold-induced foxing（圖11）

以調整酸鹼值為pH8-8.5之1%過氧化氫溶液，漂洗作品上的局部黴斑和漬痕，對於部分難以移除之黴點，則將此過程移至修復專用抽氣桌上進行，以增加漂洗成效。

Mold-induced foxing spots and stains were locally bleached with pH8-8.5 1% hydrogen peroxide. For difficult to treat foxing spots, the work of art was transferred to a suction table for repeated bleaching.

圖11.以pH8-8.5之1%過氧化氫溶液漂洗黴斑
Mold-induced foxing spots and stains were locally bleached with pH8-8.5 1% hydrogen peroxide.

圖12.於作品清洗過程中帶出水溶性黃污
Discoloration is washed out from the work of art during washing

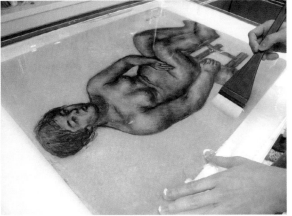

圖13.以軟毛刷調整水流方向以幫助帶出紙張黃污
A soft sheep's hair brush is used to allow water movement in the bath and help wash out discoloration

圖14.自作品反面以典具帖頂條加固紙張裂痕
Applying tengujo paper reinforcement strips to tears

圖15.按紙張破洞形狀製作補紙以平衡紙張厚度
Infill papers are shaped to match the outline and thickness of the original loss

## 7. 黃化清洗 Washing out paper discoloration（圖12-13）

壓克力槽內裝入調整酸鹼值為pH8之淨水，放置一層修復用不織布，再將作品放入槽內，以羊毛軟刷調整水流方向以帶出作品紙張的黃污，十分鐘後，將作品連同下層不織布一併取出，置於羊毛毯上晾乾。

An acrylic tray was filled with pH8 water, followed by a sheet of rayon paper. The work of art was placed in the tray, and a soft sheep's hair brush was used to allow water movement in the bath, encouraging discoloration to wash out into the bath. After ten minutes, the work of art and the rayon paper below were removed from the water bath and placed on a felt blanket to dry.

## 8. 紙張除酸 Deacidification

在作品半乾時，將pH8碳酸鈣溶液噴在作品背面，可將紙張除酸並且能讓鈣離子存留在紙張內，減緩未來紙張酸化的現象。碳酸鈣溶液沒有噴在正面是為了避免在媒材（炭筆）上產生白色粉末。

When the work of art was partially dry, pH8 calcium hydroxide solution was sprayed on the verso to alkalize the paper and provide a calcium reserve, slowing down paper acidification. Calcium hydroxide solution was not sprayed on the recto of the work of art to avoid creating a white powdery appearance.

## 9. 頂條與破損補洞 Reinforcement strips and infilling losses（圖14-15）

於濕式清潔後，作品連同不織布晾至全乾，使用寬度0.3公分典具帖自作品背面按照紙張裂痕方向進行頂條加固。作品上孔洞與破損之處，選用相似於作品紙張厚度及柔軟性的長纖維楮皮紙做為填補用紙，於光桌上按破損孔洞的形狀與厚薄落差，製作外形輪廓相吻合的補紙，再從作品反面黏貼固定。

After aqueous cleaning, the work of art was fully air dried. Tengujo paper reinforcement strips 0.3cm wide were adhered to tears from the verso of the work of art. Support losses were infilled with long-fibered bast paper, which had a thickness and softness that was compatible with the original paper support. After the work of art was placed face-down on a light table, the infill was shaped according to the outline of the original loss and then adhered to the verso of the work of art.

## 10. 小托命紙與貼毛邊 Applying lining and feathered edges（圖16-17）

使用3.5g/m²的典具帖作為作品命紙，以濃度稍淡的小麥澱粉糊進行小托，以提供基底材必要的支撐力但不過份厚硬。於作品平整後，按照作品紙張四邊形狀裁去多餘的命紙，再按照作品四緣形狀，

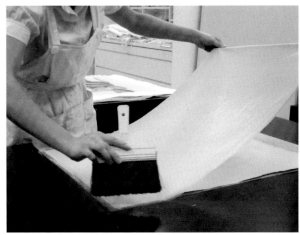

圖16.以典具帖小托命紙以增強基底材支撐力
Tengujo lining is added to strengthen the paper support

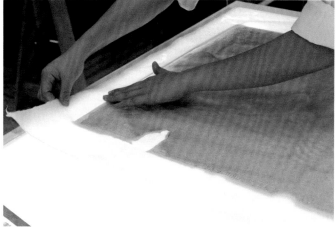

圖17.自作品反面搭接毛邊邊條於命紙之後
After the lining is applied, feathered edges are added to the work of art's four edges

製作細川楮皮紙與臺灣楮皮紙雙層毛邊邊條，分次於毛邊的各側，搭接固定於作品命紙後方，用以加大畫心，避免裝框時作品畫面受到開窗卡紙邊緣的磨擦。

A lining of 3.5g/m² tengujo paper was applied to the verso of each work of art with dilute wheat starch paste. After the work of art was flattened and dried, excess tengujo was trimmed. Hosokawa feather-edged paper strips were adhered to the verso of the work of art, followed by a secondary layer of Taiwanese bast paper. These double-layered feathered edges were applied to expand the size of the work of art, thus reducing surface abrasion to the paper support caused by a window mat.

## 11. 全色補彩 Inpainting（圖18）

塗佈2% Klucel G乙醇溶液於補紙處作為防水隔離層，待乾後，以可逆性的天然有機顏料於其上進行全色補彩。對於無法完全去除而明顯影響畫意的斑點，以修復用紙張纖維素粉稍微予以覆蓋以降低畫面的干擾。

2% Klucel G was applied to the recto of the infill to act as an isolating layer. Reversible organic colorants were then used to inpaint the infill. Cellulose powder was used to cover non-removable stains and infill small losses in order to restore visual coherency to the work of art.

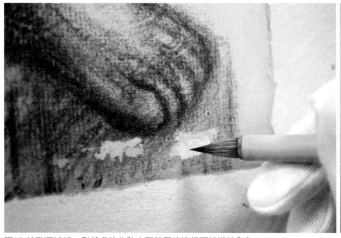

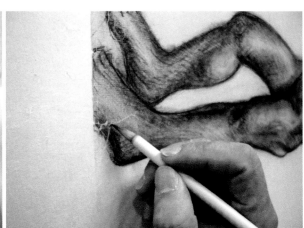

圖18.於孔洞補紙、裂縫處塗佈防水隔離層後進行可辨識性全色
After infilling the losses, an isolating layer is applied and inpainting is carried out

## 12. 裝幀保存 Mounting and storage（圖 19-20）

待作品平整後，方裁作品上的細川紙邊條，於邊條反面四邊上糊固定於無酸夾裱上。

The works of art are adhered by their hosokawa feathered edges to a non-acidic mat using wheat starch paste.

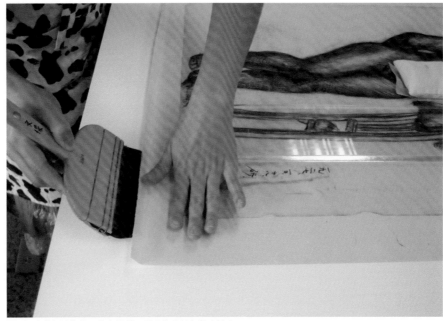

圖 19. 自外加邊條的四緣上薄糊，固定作品於無酸夾裱中
A work of art is adhered by its feathered edges onto a non-acidic mat with thin wheat starch paste

圖 20. 無酸開窗夾裱與無酸瓦楞紙保護盒
Non-acidic window mat and non-acidic corrugated board box

【註釋】

1. 參閱彭元興、徐健國〈探微觀紙——紙張纖維玻片製作及種類判定〉。
   Peng Yuan-shing and Hsu Chien-kuo, "Microscopic Study of Paper: Slide Preparation and Fiber Identification".

# 西方紙質：水彩
# Western paper: Watercolors

水彩作品計71件，完成年代推測是介於1914年至1939年間，共橫跨26年、4個時期，藝術家描繪各時期之生活環境與相遇之人事物，內容包括遠眺山景、海邊、公園、湖景、鄉村風景、建築物等風景與靜物、人物、裸女與動物的寫生。

A total of 71 pieces of watercolors were completed in the twenty-six years from 1914-1939, spanning four of Chen Cheng-po's artistic periods. In each of these periods the artist was painting the environment and people around him, including mountainscapes, seasides, gardens, lakes, countryside landscapes and architecture, to still life, figures, nudes and animals.

作品紙張黃化、分層，生成黴斑，並伴隨折痕、裂痕、蟲啃食破損，與蟲排泄物的附著。作品使用的早期合成有機顏料大多屬於微酸性，耐光性不佳，部分並對鹼性較敏感，因此水彩作品不做紙張除酸處理。作品清潔完成後，於紙張破洞處進行補紙，重新以透明度高的典具帖小托以增加紙張強度。作品補紙處使用天然有機顏料進行全色，而紙張上多處細小的孔洞則以純化的纖維素粉填補，使修復處得以辨識，同時也減少紙張孔洞對畫面觀賞造成的干擾。

The watercolors' paper supports have suffered from yellowing, delamination, mold damage, creases, tears and insect-induced losses and accretions. The paints he used were slightly acidic and light sensitive. Several of these are particuarly sensitive to alkalinity, and therefore alkalinization was not carried out for these works of art. After cleaning, losses were infilled, and a sheet of highly transparent tengujo was used to line and strengthen the work of art. Infills were inpainted with natural organic colorants, and small losses were infilled with cellulose powder. These methods ensured that the treated areas were distinguishable from the original work, while reducing the visual distraction caused by support losses.

# 修復步驟與範例 Treatment procedure

## I. 修復前狀態 Before treatment condition

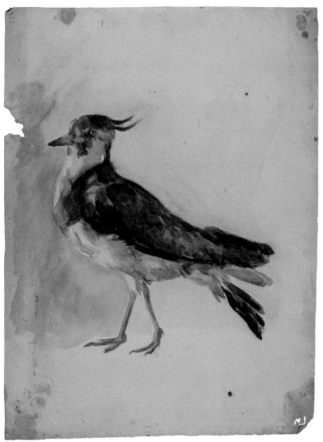 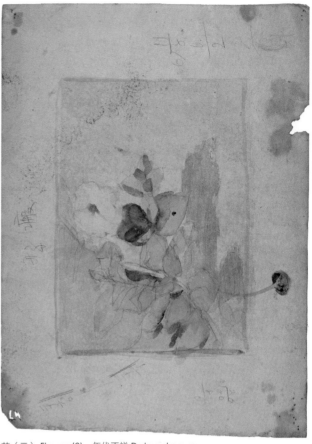

鳥 Bird　年代不詳 Date unknown
紙本水彩 Watercolor on paper
34×25.3cm（正面Recto）

花（二）Flower (2)　年代不詳 Date unknown
紙本水彩 Watercolor on paper
34×25.3cm（背面Verso）

### ・鳥 Bird／花（二）Flower (2)

修復紀錄 Conservation history

　　■未曾修復Not treated before □曾修復Previously treated

基底層 Primary support

　　■灰塵髒污Surface dirt ■黴害Mold damage ■褐斑Foxing □水害Tidelines ■油害Oil stains

　　□蟲害（排泄物、啃食破損）Insect damage(accretions, losses) ■黃化Yellowing ■燒傷Fire damage

　　□割傷Cuts ■破洞Losses □附著物Accretions ■折痕Creases ■裂痕Tears ■變色Discoloration

　　■磨損Abrasion □變形Distortions □膠帶Tapes □其他Other

媒材層 Media

　　□脫離Friable ■磨損Abrasion ■褪色Fading □暈水Bleeding □透色Sinking □其他Other

# II. 修復作業內容 Conservation treatment

### 1. 修復前攝影 Before treatment examination and documentation（圖1-9）

　　作品修復前的整體狀況紀錄及調查，包括：修復前進行可見光（正光、側光、透光）、非可見光（紫外光螢光反射與紅外光）檢測。透過上述不同特殊光源的攝影技術交互比對下，全面性了解文物材質及損傷的狀態。

The before treatment condition of the watercolors was examined and documented with normal and raking illumination, non-visible photographic methods (UV-induced visible fluorescence and infrared radiation reflectography). Comparison of these different photographic methods allowed the conservators to better understand the object's composition and physical condition.

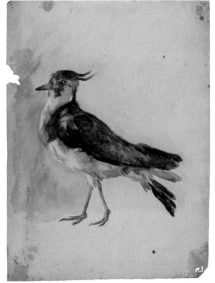

圖1.正光（正面）
Normal illumination (Recto)

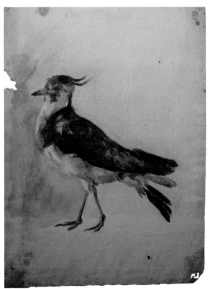

圖3.側光（正面）
Raking illumination (Recto)

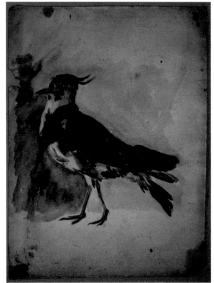

圖5.紫外光（正面）
UV radiation (Recto)

圖2.正光（背面）
Normal illumination (Verso)

圖4.側光（背面）
Raking illumination (Verso)

圖6.紫外光（背面）
UV radiation (Verso)

徽斑、作品上的附著物在正光下表現清晰
Mold-induced foxing spots cand accretions are clearly visible under normal illumination

四邊變形可能是紙張之前有接觸到水分
Cockling of the four edges may have been due to water exposure

紫外光下徽斑呈現較亮螢光反應
Mold-induced foxing spots fluoresce under UV

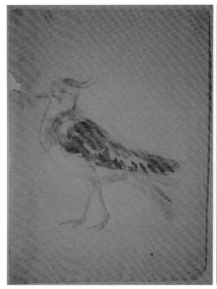

圖7.紅外光（正面）
Infrared radiation (Recto)

圖8.紅外光（背面）
Infrared radiation (Verso)

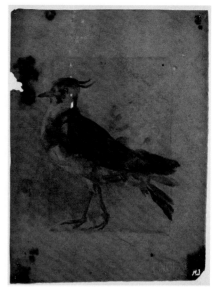

圖9.透光（正面）
Transmitted illumination (Recto)

鉛筆筆稿在紅外光下表現清晰 Underdrawing is clearly visible under infrared radiation

### 2. 媒材點測 Media solubility tests（圖10）

透過溶液點測，確認每一件作品的媒材對於修復過程中不同性質或濃度的溶液之反應。

Media on each work of art was tested for solubility to ensure they would be stable during conservation treatment and the application of various solvents.

### 3. 紙張纖維檢測分析 Fiber identification

由於水彩作品除少數蟲啃食破損外，紙張較柔軟無脆斷情形，因此幾乎沒有脫落的殘片，故取其1916年完成之作品〔宮燈〕附著在邊緣晃動的小殘片進行纖維分析，檢測結果作品紙張主要以棉漿製成。[1]

With the exception of a few insect-induced losses, most of the watercolor paper supports were supple and complete. Therefore, there were few fragments from which to take fiber samples. A sample was taken from a small fragment adhered to the edge of *Palace Lantern* (dating to 1916), and results showed that it was composed of cotton fibers.[1]

### 4. 表面除塵 Surface cleaning（圖11-12）

以手指帶動粉末橡皮，依畫弧方向清潔作品正反兩面的灰塵髒污二至三次，於繪畫筆觸上將粉末橡皮輕輕帶過以免傷及顏料。附著於紙上之昆蟲排遺，小心地以手術刀尖端敲碎成較小顆粒以降低其

圖10.進行溶液點測以瞭解作品媒材之穩定性
Using solvents to test media solubility

圖11.以手術刀剔除昆蟲排遺和附著於紙張表面的異物
Scalpel is used to remove insect and foreign accretions

圖12.以粉末橡皮清潔作品紙張表面灰塵髒污
Eraser crumbs are used to remove surface dirt

黏著力，再以修復用橡皮黏附移除。

　　Eraser crumbs were used to remove surface dirt on the recto and verso of the work of art for a total of two or three times. Care was taken to gently clean over image areas and avoid disrupting the media. Insect accretions were broken into smaller pieces with a scalpel in order to reduce their adhesiveness, and then removed using eraser crumbs.

## 5. 黴斑漂洗 Bleaching of mold-induced foxing（圖13）

　　作品空白區域之黴斑，以調整酸鹼值為pH8-8.5之2%過氧化氫溶液漂洗，而於顏料區域生成的黴斑，僅以 pH5-5.5之1%過氧化氫溶液小範圍稍微漂洗並隨即以淨水帶離藥劑。

　　Mold-induced foxing spots in non-image areas were bleached with pH8-8.5 2% hydrogen peroxide. Colored and image areas were cleaned with pH5-5.5 1% hydrogen peroxide, followed by washing with water.

圖13.以過氧化氫水漂洗黴斑 Bleaching mold-induced foxing spots with hydrogen peroxide

## 6. 媒材加固 Media consolidation（圖14）

　　經點測可知媒材在乾燥的狀況下仍具有一定的附著力，故顏料部分以1%甲基纖維素加固，印章部分以1%三千本膠加固，以預防後續清潔步驟可能造成的顏料鬆動或滲色。

　　After testing for their stability, media were consolidated with 1% methyl cellulose, and ink stamps were consolidated with 1% animal glue to prevent media loss during the proceeding aqueous cleaning steps.

圖14.以1%甲基纖維素加固媒材 Using 1% methyl cellulose to consolidate media

圖15.於修復用抽氣桌上自作品正面噴上淨水 Spraying the work of art on top of a suction table

### 7. 清洗 Aqueous cleaning （圖15）

於濕式清潔前，先以適度水分揭除部分作品背面舊有的黃化補紙或背紙並攤平紙張折痕。於修復用抽氣桌上，將無酸吸水紙襯於作品下方，自作品正面噴上淨水，使水分帶離作品黃污。

Prior to aqueous cleaning, a minimal amount of water was applied to the verso to remove yellowed infills or lining papers and open creases. For cleaning, a sheet of dampened blotting paper was placed on a suction table, and the work of art was placed on top, spraying the recto with water in order to wash out discoloration.

### 8. 小托命紙與貼毛邊 Applying lining and feathered edges（圖16-17）

使用5.0g/m²的典具帖作為作品命紙，以極薄的修復用小麥澱粉糊進行托命紙。使小托後的作品反面的文字註記仍能清楚被閱讀。正反兩面皆有繪畫之作品，僅以寬度1.5cm典具帖小托紙張托襯在作品四緣以增加紙邊強度，預防因人為拿取不慎而造成的作品損傷。待作品平整後，按照作品四邊形狀裁去多餘的命紙，再按照作品四緣形狀，製作細川楮皮紙與楮皮紙毛邊邊條，以毛邊搭接固定於作品命紙後方以加大畫心，避免作品畫面受到開窗夾裱卡紙邊緣的磨擦。

A lining of 5.0g/m² tengujo paper was applied to the verso of each work of art with dilute wheat starch paste. After lining, inscriptions on the verso were still clearly legible. For double-sided works of art, a 1.5cm wide tengujo paper strip

圖16.以典具帖小托命紙以增強基底材支撐
Tengujo lining is used to strengthen the paper support

圖17.按作品形狀製作並以毛邊邊條搭接於作品命紙之後
After the lining is applied, feathered edges are added to the work of art's four edges

was adhered to the four edges of the verso to both reinforce the edges and reduce handling damage. After the work of art was flattened and dried, excess tengujo was trimmed. Hosokawa paper feathered edges were then adhered to the verso, on top of the tengujo paper strips, in order to expand the size of the work of art and reduce surface abrasion to the paper support caused by a window mat.

## 9. 破損補洞 Infilling losses（圖18-19）

破損孔洞處則依作品紙張厚度選擇適當之楮皮紙進行補紙，依作品紙張厚度，選擇以長纖維、紙性柔軟、紙張基重介於楮皮紙作為補紙，於光桌上按破損孔洞的形狀與厚薄落差，製作形狀相吻合的補紙，自作品反面固定。

Because of its thickness and softness, compatible to the original paper support, kozo (paper mulberry) papers were selected to infill support losses. After the work of art was placed face-down on a light table, the infill was shaped according to the outline of the original loss and then adhered to the verso of the work of art.

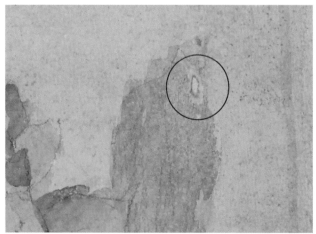

圖18.破損補洞前Before infilling

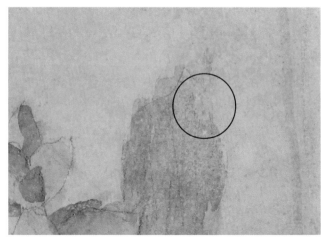

圖19.破損補洞後After infilling

## 10. 全色補彩 Inpainting（圖20-21）

作品補紙處塗佈1% Klucel G乙醇溶液作為防水隔離層，待乾後，以可逆性的天然有機顏料於其上進行全色。對於無法完全去除而明顯影響畫意的斑點或紙張上的細小孔洞，以修復用紙張纖維素粉予以覆蓋、填補，以降低其對畫意觀賞上的干擾。

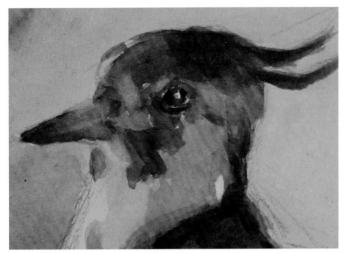

圖 20. 全色補彩前 Before inpainting

圖 21. 全色補彩後 After inpainting

1% Klucel G was applied to the recto of the infill to act as an isolating layer. Reversible organic colorants were then used to inpaint the infill. Cellulose powder was used to infill non-removable stains and small losses in order to restore visual coherency to the work of art.

## 11. 裝幀保存 Mounting and storage（圖 22）

由於單頁作品數量多並且因為展出需要不定時會更換存放環境，因此作品的整理與收納方式，要兼顧便利性並能預防有害氣體或微生物的入侵、溫濕度變化的影響或人為翻看、運輸造成的損傷，故分別以無酸開窗夾裱保護存放作品，夾裱作品再搭配無酸楓木框展示。

Due to the large number of watercolors and exhibition needs, a storage stystem was developed that was convenient, and protected the work of art from harmful pollutants and microbiological attack, temperature and humidity fluctuations, and damage from handling. A two-layered non-acidic folder composed of mylar and Photo-tex was developed to house unmounted individual works of art. Works that were to be exhibited were adhered to a window mat and stored in a maple frame.

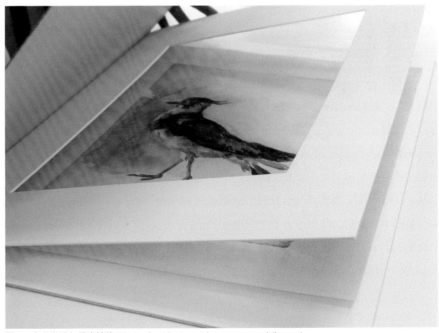

圖 22. 作品裝進無酸夾裱後 Work of art is stored into a non-acidic mat

【註釋】

1. 參閱彭元興、徐健國〈探微觀紙——紙張纖維玻片製作及種類判定〉。
   Peng Yuan-shing and Hsu Chien-kuo, "Microscopic Study of Paper: Slide Preparation and Fiber Identification".

# 西方紙質：單頁速寫
## Western paper: Single-sheet Sketches

此次修復的陳澄波763件單頁速寫作品，以模特兒人體、群像速寫為主題，時而簡化人物五官並配合流暢的線條筆觸，表現出人體結構、姿勢、人群間互動和構圖的多樣性，其中少部份是靜物、動物、山景或城鎮的描寫，媒材大多是以墨水、色鉛筆、水性顏料等不同媒材繪製，但是仍以人物描繪為主題之鉛筆畫居多。

A Total of 763 single-sheet sketches were treated, most of which were nude models and groups of people as well as simple human sketches, drawn lines of which emphasized the human form, posture, relationships between figures and a diversity of compositions. A few of these sketches depicted still life, animals, landscapes and cities, whereas others were drawn with ink, colored pencils, water-soluble pigments and other media. However, the majority of these sketches was drawn in pencil and depicted human figures.

大部份作品因長時間存放堆疊緣故，而有紙張氧化現象發生。紙張顏色由內而外漸層為黃褐色，紙緣累積了些許塵垢、髒污，並產生干擾畫面觀賞的點狀的黴斑或帶有方向性的紙張折痕。部份紙張失去柔軟度，變得較為酥脆、紙緣翻折、缺角、產生橫向或縱向裂痕，少數則因受潮或蟲害，生成漬痕、蟲啃食破損、帶輕微黏性的髒污、變色纖維。修復前藉由顯微鏡、紅外光、紫外光輔助檢視，可看出水漬、油漬、褐斑、黴斑及指紋等痕跡。墨水、色鉛筆、軟質鉛筆的單頁速寫作品，媒材對紙張附著性較弱，應以乾式清潔方法為主，再以小面積的局部濕式清潔方式以移除作品髒污；附著力良好的，則使用濕式清潔輔助。

Most of the sketches were stacked together for a long period of time, resulting in oxidation of the paper support. From the center outwards, the papers are discolored yellow, changing to brown. The works of art have accumulated a significant amount of surface dirt and accretions, plus visually distracting mold-induced foxing spots and creases. Several of the papers have lost their softness, becoming more brittle, fragmented, and gained vertical or horizontal creases. A few of the sketches suffer from insect damage including staining, paper loss, tacky surface accretions and discolored fibers. Before treatment examination including photomicrography, infrared and UV radiation observation revealed tidelines, oil stains, foxing spots, mold damage and fingerprints. Sketches drawn in ink, colored pencil and soft pencil were more friable and therefore treated with dry cleaning methods, and only locally aqueously cleaned to remove surface dirt and accretions; works of art with non-friable media were aqueously cleaned.

所有單頁速寫作品經由委託者選件分類，205件進行攝影紀錄、修復、無酸開窗夾裱，181件進行攝影紀錄、修復、L型無酸聚酯檔案夾存放，其餘377件進行攝影紀錄、乾式清潔、L型無酸聚酯與無酸紙雙層檔案夾存放。

Of the sketches were selected by Judicial Person Chen Cheng-po Cultural Foundation, 205 underwent examination and documentation, treatment and mounting in a non-acidic window mat; 181 underwent examination and documentation, treatment and storage in a two-layered non-acidic folder composed of mylar and Photo-tex; the remaining 377 sketches underwent examination and documentation, dry cleaning, and storage in a two-layered non-acidic folder composed of mylar and Photo-tex.

# 修復步驟與範例 Treatment procedure

## I. 修復前狀態 Before treatment condition

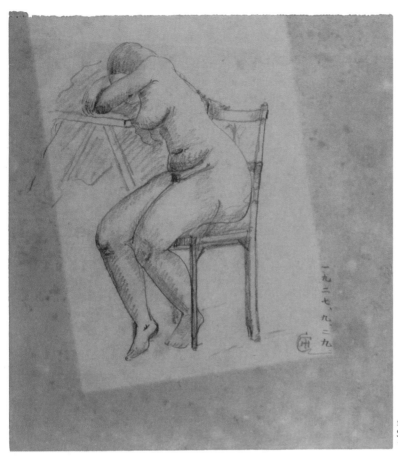

坐姿裸女速寫-27.9.29（101）
Seated Female Nude Sketch-27.9.29 (101)
1927　紙本鉛筆Pencil on paper　26.6×23.9cm

・**坐姿裸女速寫-27.9.29（101）**

修復紀錄 Conservation history

　　　■未曾修復Not treated before □曾修復Previously treated

基底層 Primary support

　　　■灰塵髒污Surface dirt ■黴害Mold damage ■褐斑Foxing □水害Tidelines
　　　■油害Oil stains □蟲害（排泄物、啃食破損）Insect damage(accretions, losses)
　　　■黃化Yellowing □燒傷Fire damage □割傷Cuts □破洞Losses
　　　□附著物Accretions ■折痕Creases ■裂痕Tears ■變色Discoloration
　　　■磨損Abrasion □變形Distortions □膠帶Tapes
　　　□其他Other

媒材層 Media

　　　□脫離Friable ■磨損Abrasion ■褪色Fading □暈水Bleeding □透色Sinking
　　　□其他Other

## II. 修復作業內容 Conservation treatment

### 1. 修復前攝影 Before treatment examination and documentation（圖1-5）

作品修復前的整體狀況紀錄及調查，包括：修復前進行可見光（正光、側光、透光）、非可見光（紫外光螢光反射與紅外光）檢測。透過上述不同特殊光源的攝影技術交互比對下，全面性了解文物材質及損傷的狀態。

The before treatment condition of the sketches was examined and documented with normal and raking illumination, non-visible photographic methods (UV-induced visible fluorescence and infrared radiation reflectography). Comparison of these different photographic methods allowed the conservators to better understand the object's composition and physical condition.

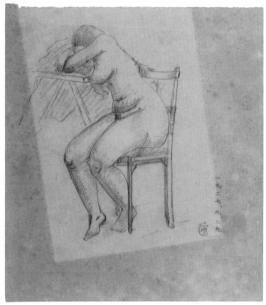

圖1.正光（正面）Normal illumination (Recto)
嚴重的黴斑破損 Severe mold damage

圖2.側光（正面）Raking illumination (Recto)
側光下橫折痕較清楚 Creases are visible under raking illumination

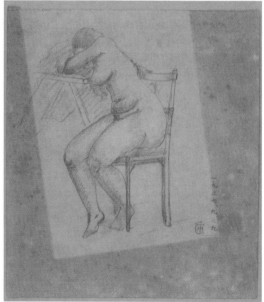

圖3.紫外光（正面）UV radiation (Recto)
紫外光下黴斑呈現較亮螢光反應，但紅外光下沒有反應
Mold-induced foxing spots fluoresce under UV, but are invisible under infrared radiation

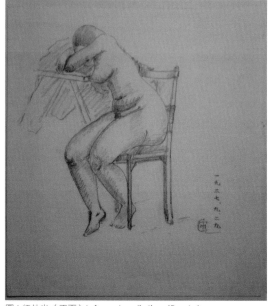

圖4.紅外光（正面）Infrared radiation (Recto)
紅外光下清晰顯現作品原有筆觸
Underdrawing is clearly visible under infrared radiation

圖5.透光（正面）Transmitted illumination (Recto)

## 2. 媒材點測 Media solubility tests

透過溶液點測，確認每一件作品的媒材對修復過程中將使用到不同性質或濃度的溶液之穩定性。點測結果，水性顏料、鉛筆線條與印章等媒材不太穩定。

Media on each work of art was tested for solubility to ensure they would be stable during conservation treatment and the application of various solvents. Solubility test results showed that colorants, pencil, and ink stamps were not stable.

## 3. 紙張纖維檢測分析 Fiber identification

單頁速寫之紙張纖維檢測分析，樣品取自畫家於1927年所繪之坐姿裸女系列紙張殘片。[1]具歷史性的脆化紙張纖維不易取得完整纖維，因此增加纖維比對分析的困難性，但藉由觀察比對作品具有木漿紋孔之纖維特徵，推測這些單頁速寫的紙張含闊葉樹木漿成分。[2]

Fibers taken from loose fragments of pencil sketches dating to 1927 were analyzed and identified.[1] Because it is not easy to obtain intact fibers from embrittled historic papers, fiber identification was rather difficult. However, because the samples contained pits characteristic of wood pulp fibers, it was concluded that these papers contained wood pulp.[2]

## 4. 表面除塵 Surface cleaning（圖6-7）

圖6.以手術刀清潔紙張表面附著物
Scalpel is used to remove surface accretions

以手指帶動粉末橡皮，依畫弧方向清潔作品正反兩面的灰塵髒污，過程中需注意避開繪畫筆觸以維持稍觸即模糊的鉛筆線條的清晰。面對紙性脆弱、破損較嚴重或清潔面積較小之作品，改以羊毛軟刷以代替手進行細微地乾式清潔。部分附著於畫面之昆蟲排遺、膠體異物等，以手術刀尖端先行敲碎成較小顆粒降低其黏著力。

Eraser crumbs were used to remove surface dirt on the recto and verso of the work of art. Care was taken to avoid image areas. For weakened papers, areas with severe loss or finer detail, a soft sheep's hair brush was used to gently maneuver the eraser crumbs. Adhesive and insect accretions were broken into smaller pieces with a scalpel in order to reduce their adhesiveness.

## 5. 基底材暫時加固 Temporary reinforcement（圖8）

為維護修復中作品安全，作品上之裂痕與嚴重的折痕，以修復用不織布頂條暫時性加固。

In order to provide structural strength during the treatment process, tears and creases were first reinforced with temporary rayon paper strips.

## 6. 媒材加固 Media consolidation

經點測評估，以可逆性高的1%甲基纖維素加固媒材，保護以軟質

圖7.以無酸橡皮粉末清潔紙張表面灰塵髒污
Eraser crumbs are used to remove surface dirt

筆芯繪製之作品，無媒材脫落
疑慮之作品則不予加固。

After testing, a reversible
adhesive (1% methyl cellulose)
was used to consolidate the media.
Sketches drawn with soft pencil and
those without friable media were
not consolidated.

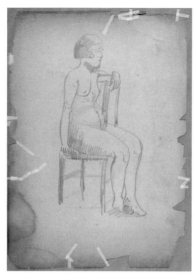
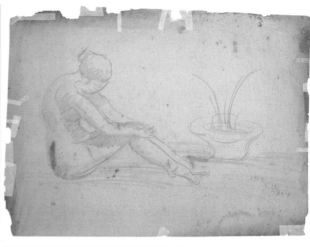

圖8.紙張破損處於濕式清潔前予以暫時性加固
Damaged areas are temporarily reinforced prior to aqueous cleaning

## 7. 移除背紙、補紙 Lining and infill removal（圖9-12）

以適度水分移除部分作品
背面舊有的黃化背紙和不適當形
狀、顏色的補紙及殘留黏著劑。

An appropriate amount of
water was applied to the verso of the
work of art to remove old discolored
linings, oversized colored infills,
and residual adhesive.

圖9.移除舊覆背紙
Removing old lining

圖10.移除舊不適當形狀、顏色的補紙
Removing oversized, colored infills

## 8. 黴斑漂洗 Bleaching of mold-induced foxing（圖13-14）

以小筆沾pH8-8.5過氧化氫
溶液，漂洗作品上局部黴斑。對
於部分難以達到漂洗成效的黴
斑，將此過程移至修復專用抽氣
桌上進行並增加漂洗次數。

pH8-8.5 hydrogen peroxide
was locally applied with a fine-
tipped brush to bleach mold-
induced foxing spots. For difficult
to treat foxing spots, the work of art
was transferred to a suction table
and repeatedly bleached.

圖11.分離背紙後發現作品背面也有速寫
Removal of the old lining paper revealed a sketch on the paper verso

圖12.分離背紙後發現作品背面也有速寫
Removal of the old lining paper revealed a sketch on the paper verso

## 9. 黃化清洗 Aqueous cleaning

（圖15-16）

於清洗盆內，將作品襯於
調整酸鹼值為pH8-8.5之乾淨濕

圖13.以1%過氧化氫溶液漂洗作品上局部黴斑
Using 1% hydrogen peroxide to locally bleach mold-induced foxing spots

圖14.於修復用抽氣桌上處理難漂洗之黴斑
Suction table is used to bleach difficult to treat foxing spots

圖15.作品襯於濕吸水紙上
Work of art is placed on dampened blotting paper

吸水紙上,使盆內吸水紙富有水分,待作品上黃污轉移至吸水紙上後即更換下層吸水紙,此步驟反覆數次直到不再有髒污被析出為止。

A sheet of blotting paper, dampened with pH8-8.5 water, was placed in a photography tray. The work of art was placed on top and allowed to blotter wash. When a significant amount of paper discoloration had been absorbed by the blotting paper, this layer was replaced with a new dampened sheet of blotting paper and the step repeated until no more discoloration could be washed out.

圖16.濕式清潔將作品上黃污帶至盆內吸水紙上
Aqueous cleaning has caused paper discoloration to be absorbed into the blotting paper

## 10. 紙張除酸 Deacidification（圖17-18）

為鉛筆作品紙張除酸時,備一清洗盆,內盛酸鹼值調整成pH8.5之碳酸鈣溶液,並放置薄壓克力板與修復用不織布於內,小心地將預備除酸之作品以三明治夾法保護後,從紙張長邊一側至另一側依序沒入盆內水中,以軟毛刷調整水流方向以幫助帶出紙張黃污。約15分鐘後連同其下的不織布與壓克力板將作品取出,置於羊毛毯上晾乾。

In preparation for deacidification, a photography tray was filled with pH8.5 calcium hydroxide solution, followed by an acrylic sheet and rayon paper. The work of art was slowly immersed in the water bath, moving from one end of the paper to the other. A soft sheep's hair brush was used to allow water movement in the bath, encouraging discoloration to wash out into the bath. After approximately fifteen minutes, the work of art, together with the rayon paper and acrylic sheet, were lifted out of the water and placed on a felt blanket to dry.

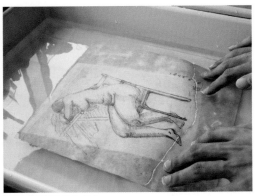
圖17.將紙張入盆內水中
Immersing the work of art in the water bath

## 11. 頂條 Reinforcement strips（圖19）

於濕式清潔後使作品連同不織布一起晾乾,以寬度0.3cm典具帖自反面按紙張裂痕方向進行頂條加固。

After aqueous cleaning and air drying, 0.3cm wide tengujo paper reinforcement strips were adhered to tears from the support verso.

圖19.自作品反面以典具帖頂條加固紙張裂痕
Applying tengujo paper reinforcement strips to tears

## 12. 小托命紙與貼毛邊
### Applying lining and feathered edges（圖20-21）

使用3.5g/m²的典具帖作為作品命紙,以極薄的修復用小麥澱粉糊進行托命紙。作品紙張強度較好或正反雙面皆有繪畫之作品,以寬度1.5公分典具帖小托紙張四緣以增加紙邊強度,使紙緣強度增加並預防因人為拿取不慎而造成的作品損傷。待作品平整後,按照作品四邊形狀裁去多

圖18.以軟毛刷調整水流方向以幫助帶出紙張黃污
Using a soft sheep's hair brush to allow water movement in the bath and encourage the washing out of paper discoloration

餘的命紙；部分規劃以無酸開窗夾裱保存之作品，再依樣為其製作細川紙毛邊邊條，並以毛邊搭接固定於作品命紙後方以加大畫心，以防止作品畫面受到開窗夾裱卡紙邊緣的磨擦。

A lining of 3.5g/m² tengujo paper was applied to the verso of each work of art with dilute wheat starch

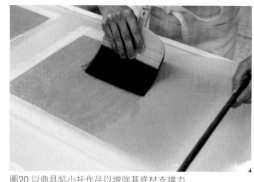

圖20.以典具帖小托作品以增強基底材支撐力
Tengujo lining is added to strengthen the paper support

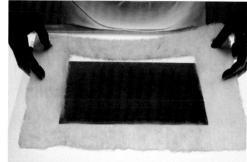

圖21.按作品形狀製作毛邊邊條並搭接於作品命紙之後
After the lining is applied, feathered edges are added to the work of art's four edges

paste. For works of art that were either more structurally stable or double-sided, a 1.5cm wide strip of tengujo was applied to the four edges of the verso, to both reinforce the edges and reduce handling damage. After the work of art was flattened and dried, excess tengujo was trimmed. Some of the works were directly stored in non-acidic folders, whereas others were given an added feathered edge made of hosokawa paper. The feathered edges were applied to expand the size of the work of art, thus reducing surface abrasion to the paper support caused by a window mat.

## 13. 破損補洞 Infilling losses（圖22-23）

作品上蟲蝕孔洞與破損之處，因為柔軟度與厚度的考量，選擇用宣紙補洞。於光桌上按作品破損孔洞形狀製作與其形狀吻合之補紙，並自作品反面固定。比較厚的紙張需在宣紙的背面再加一層楮皮紙，以調整補紙的厚度。

Support loss were infilled with xuan paper. Xuan paper was selected

圖22.於光桌上按紙張破洞形狀製作補紙進行補洞
The infill paper is shaped according to the outline of the original loss

圖23.破損補洞
Infilling the loss

due to its compatibility to the original paper support's softness and thickness. The work of art was placed face-down on a light table, and the infill was shaped according to the outline of the original loss. For thicker paper supports, another layer of xuan paper was added to the verso.

## 14. 全色補彩 Inpainting（圖24-25）

塗佈膠礬水於補紙處作為防水隔離層，待乾後以可逆性有機顏料進行全色補彩，將紙張上少部分較亮的地方，用可逆性舊色（從老畫的覆背紙熬煮出）補色，使其與周圍顏色接近。

Alum-glue was applied to the recto of the infill to act as an isolating

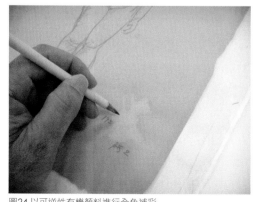

圖24.以可逆性有機顏料進行全色補彩
Reversible organic colorants are used to inpaint infills

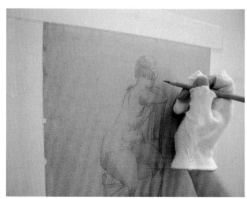

圖25.以紙張纖維素粉填補作品上的細小孔洞
Cellulose powder is used to infill small losses

layer. Reversible organic colorants are then used to inpaint the infill. Susu (solubilized paper dirt) is used to tone down brighter areas on the original paper support to match the surrounding paper.

## 15. 裝幀保存 Mounting and storage（圖26-28）

由於作品數量多，並且因為展出需要，不定時會更換存放環境，因此作品的整理與收納方式，要兼顧便利性並能預防有害氣體或微生物的入侵、溫濕度變化的影響或人為翻看、運輸造成的損傷，故分別以無酸開窗夾裱與L型無酸聚酯、無酸紙雙層檔案夾兩種形式保護存放作品，夾裱作品再搭配無酸楓木框展示。

Due to the large number of sketches and exhibition needs, a storage stystem was developed that was convenient, and protected the work of art from harmful pollutants and microbiological attack, temperature and humidity fluctuations, and damage from handling. A two-layered non-acidic folder composed of mylar and Photo-tex was developed to house unmounted individual works of art. Works that were to be exhibited were adhered to a window mat and stored in a maple frame.

圖26.以邊條固定作品於無酸開窗夾裱中
A work of art is adhered by its feathered edges onto a non-acidic window mat

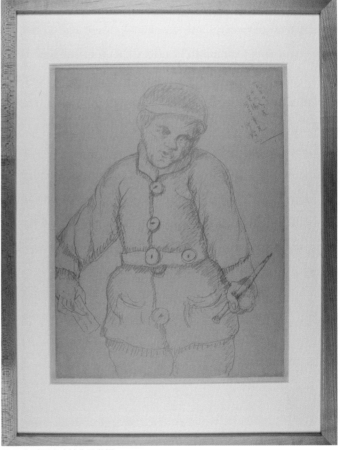

圖27.作品存放於無酸夾裱、無酸聚酯、無酸紙雙層檔案夾與無酸保護盒
Different storage conditions for works of art: non-acidic mat, mylar and Photo-tex folder, and non-acidic storage box

圖28.無酸開窗夾裱作品裝框
Work of art is mounted in a non-acidic window mat and frame

【註釋】

1. 由林業試驗所木材纖維組助理研究員徐健國與大葉大學環境工程學系教授彭元興進行分析。
   This analysis was carried out by Taiwan Forestry Research Institute assistant researcher Hsu Chien-kuo and Prof. Peng Yuan-shing of the Da-Yeh University Department of Environmental Engineering.

2. 參閱彭元興、徐健國〈探微觀紙──紙張纖維玻片製作及種類判定〉。
   Peng Yuan-shing and Hsu Chien-kuo, "Microscopic Study of Paper: Slide Preparation and Fiber Identification."

# 西方紙質：素描簿
# Western paper: Sketchbooks

素描簿總共有29本送到國立臺灣師範大學文物保存維護研究發展中心進行修復。素描簿皆有黃化及脆化，但是整體結構尚可。在與財團法人陳澄波文化基金會討論過後，結構穩定安全者，若僅是表面磨損或油漬則盡量保留原狀。部分素描簿需要更深入的修復計劃與研究，因為它們嚴重破損，但仍須盡可能地保留其修復前的樣貌，在修復過程中需要更特殊的方式去平衡其美學與結構穩定性。除了編號SB04的素描簿（非裝訂）外，其餘可歸為四類：精裝（2本）、釘書針（10本）、單線圈（6本）與線裝（10本）。針對後三類特殊修復的考量與辦法將分別介紹如下：

A total of twenty-nine sketchbooks were sent to the National Taiwan Normal University Research Center for Conservation of Cultural Relics (RCCCR) for treatment. Besides yellowing and embrittlement, the sketchbooks were in overall good condition. After discussion with Judicial Person Chen Cheng-po Cultural Foundation, it was decided that minimal treatment should be carried out, and original abrasion and oil stains should be preserved. Several sketchbooks required more in depth treatment planning and research, as their more damaged condition, combined with the need to preserve the sketchbook's original appearance as much as possible, demanded more creative ways to compromise between aesthetics and structural integrity. With the exception of SB04, a unbound sketchbook of individual leaves, the sketchbooks can be divided into four general categories: case binding (2 books), staple and tape binding (10 books), spiral binding (6 books) and smyth sewing (10 books). Except case binding, three of the more unique sketchbook treatments are described below.

# 修復步驟與範例 Treatment procedure
## 一、釘書針裝訂 Staple and tape binding

編號SB08之素描簿為釘書針裝訂結構。於修復倫理中，為了避免因金屬釘書針引起未來性的劣化，如金屬鏽痕、灼燒、與破損。所以，紙張內的金屬物質須盡可能清除或減少，任何含有金屬元素如迴紋針、釘書針等裝訂方式，將以pH中性紙製成的「紙釘」取代。選擇紙釘修復考量有：紙捲製作的紙釘能穿進原釘書針洞孔洞，同時紙釘結構力足以承受書簿的翻閱。紙釘使用臺灣楮皮紙，因長纖維能承受定向拉伸、紙質薄，較不會磨損原釘書針的孔洞，質感顏色於視覺上很契合素描簿的色調。對於封面與內頁的第一頁以黑色膠帶作為騎縫帶的素描簿，由於黑色膠帶都已老化裂開致無法固定內頁，故全部的黑色膠帶都以雙層的細川紙製作的騎縫帶取代。

SB08 is an example of staple and tape binding. According to conservation ethics, all metallic elements should be removed from paper if possible in order to minimize metal-induced damage including rusting, metallic burning and loss. Therefore, metallic paper clips and staples were replaced with pH neutral 'paper staples'. Paper staples were used as a sympathetic replacement for the original metal ones, as they were able to be threaded through the original staple holes, while providing sufficient strength for the sketchbook to be read and handled. The paper staples were made from Taiwan kozo (paper mulberry) paper because its long fibers are flexible and the paper is thin, making it less likely to abrade the

original staple holes. In addition, its texture and color is visually appropriate for the sketchbook. Because the black tape that were original used to join the front cover and first aged textblock leaf was torn and unable to hold together these two sections, it was replaced with a double layer of hosokawa paper hinges.

SB08　1927.9-1929.4　24×28cm

## I. 修復前狀態 Before treatment condition

### ・SB08

修復紀錄 Conservation history
　　■未曾修復Not treated before □曾修復Previously treated

封面、封底基底層 Front and back covers
　　■灰塵髒污Surface dirt ■黴害Mold damage □褐斑Foxing □水害Tidelines ■油害Oil stains
　　■蟲害（排泄物、啃食破損）Insect damage(accretions, losses) ■黃化Yellowing □燒傷Fire damage
　　□割傷Cuts ■破洞Losses ■附著物Accretions ■折痕Creases ■裂痕Tears □變色Discoloration
　　□磨損Abrasion □變形Distortions □膠帶Tapes ■其他Other：釘子生鏽Rusted nails

內頁基底層 Textblock
　　■灰塵髒污Surface dirt ■黴害Mold damage □褐斑Foxing □水害Tidelines ■油害Oil stains
　　■蟲害（排泄物、啃食破損）Insect damage(accretions, losses) ■黃化Yellowing □燒傷Fire damage
　　□割傷Cuts ■破洞Losses □附著物Accretions ■折痕Creases ■裂痕Tears ■變色Discoloration
　　□磨損Abrasion ■變形Distortions □膠帶Tapes □其他Other

媒材層 Media
　　□脫離Friable ■磨損Abrasion ■褪色Fading □暈水Bleeding □透色Sinking □其他Other

## II. 修復作業內容 Conservation treatment

### 1. 修復前攝影 Before treatment examination and documentation（圖1-4）

　　作品修復前的整體狀況紀錄及調查，包括：修復前進行可見光（正光、側光、透光）、非可見光（紫外光螢光反射與紅外光）檢測。透過上述不同特殊光源的攝影技術交互比對下，全面性了解文物材質及損傷的狀態。

The before treatment condition of the sketchbooks was examined and documented with normal and raking illumination, non-visible photographic methods (UV-induced visible fluorescence and infrared radiation reflectography). Comparison of these different photographic methods allowed the conservators to better understand the object's composition and physical condition.

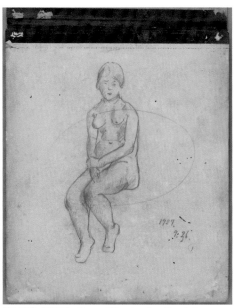

圖1.正光（正面）Normal illumination (Recto)

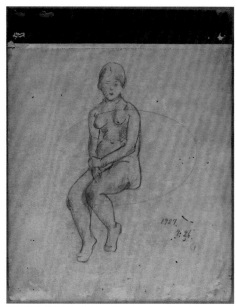

圖2.側光（正面）Raking illumination (Recto)

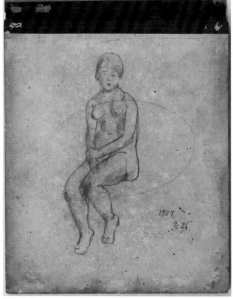

圖3.紫外光（正面）UV radiation (Recto)

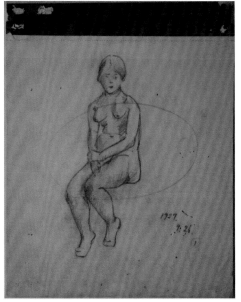

圖4.紅外光（正面）Infrared radiation (Recto)

紙張不均勻黃化在正光與紫外光下表現清晰。
Uneven yellowing of the paper support is clearly visible under normal illumination and UV radiation

## 2. 解體 Disbinding（圖5-11）

因為黑色的騎縫已經明顯脆化與破洞，無法將其把封面與內頁固定，因此先將少許的水沾濕騎縫使騎縫帶展色劑軟化，用鑷子輕輕將騎縫帶剝下，再把殘留在封面與內頁上的騎縫帶用手術刀刮除乾淨。取下膠帶後，將生鏽的釘子拔起。最後用竹起子將每一頁分開。

Because the black hinge tape had already embrittled and had losses, it no longer securely attached the front cover to the textblock. Therefore, after applying a minimal amount of water to soften the adhesive, tweezers were used to slowly peel and remove the tape. Residual adhesive on the front cover and textblock were mechanically removed using a scalpel. After the tape was fully cleaned, the exposed rusted staples were removed. Finally, a bamboo spatula was used to separate the individual textblock pages.

圖5.脆化、破損的騎縫帶
Embritted hinge tape with losses

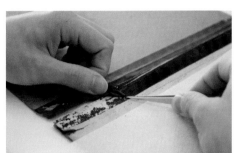

圖6.用水沾濕騎縫使騎縫帶展色劑軟化
Applying water to soften the hinge

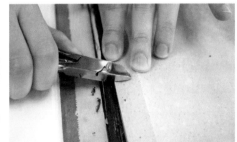

圖7.用鑷子將騎縫帶移除
Using tweezers to remove the hinge tape

圖8.騎縫帶移除後露出生鏽釘子
Removing the hinge tape reveals rusted staples

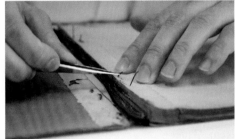

圖9.將生鏽釘子鬆開
Loosening rusted staples

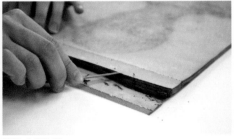

圖10.將生鏽釘子拔出
Removing rusted staples

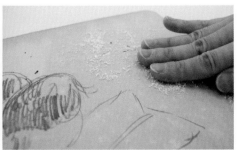

圖11.分開內頁
Separating textblock leaves

## 3. 表面除塵 Surface cleaning（圖12-13）

針對封面封底與內頁的表面灰塵，以手指帶動粉末橡皮，依畫弧方向清潔作品，過程中需注意避開繪畫筆觸以維持鉛筆線條的清晰。部分附著於畫面之蟲排泄物、膠體異物等，以手術刀尖端先行敲碎成較小顆粒降低其黏著力，再以修復用橡皮清潔移除。

Each textblock leaf and both front and back covers were surface cleaned using eraser crumbs. Care was taken to avoid disrupting the image areas. Insect accretions were broken into smaller pieces with a scalpel in order to reduce their adhesiveness, and then cleaned using eraser crumbs.

圖12.以指腹帶動粉末橡皮移除作品灰塵髒污
Eraser crumbs are used to remove surface dirt and accretions

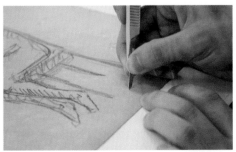

圖13.以手術刀敲碎破壞附著之昆蟲排遺，以移除黏性
Insect accretions were broken into smaller pieces with a scalpel in order to reduce their adhesiveness

## 4. 黴斑漂洗 Bleaching of mold-induced foxing（圖14）

以小筆沾1%過氧化氫溶液，漂洗作品上局部黴斑，對於部分難以去除的黴斑則移至修復專用抽氣桌上小心進行並增加漂洗次數。

1% hydrogen peroxide was locally applied with a fine-tipped brush to bleach mold-induced foxing spots. For difficult to treat foxing spots, the work of art was transferred to a suction table and repeatedly bleached.

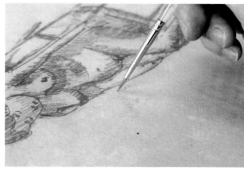

圖14.以過氧化氫溶液局部漂洗黴斑
Using 1% hydrogen peroxide to locally bleach mold-induced foxing spots

## 5. 清洗 Aqueous cleaning（圖15-16）

因為年代久遠，內頁紙質黃化，故每頁都必須整張清洗。在清洗之前，測試媒材對水的穩定性以防溶解於水裡。此外，為了避免紙張尺寸變形，使用較為柔順的blotter washing方式清洗，一方面不會傷害紙張，另一方面也因為清洗速度較慢，可以檢視其完整清洗過程。清洗過程為將作品襯於調整酸鹼值為pH8-8.5之乾淨濕吸水紙上，使盆內吸水紙水分飽合，待作品上黃化轉移至吸水紙上後即更換下層吸水紙，此步驟反覆數次直到不再有髒污被析出為止，放置使其自然風乾。

Because the paper support of the text block had yellowed from aging, the decision was made to aqueously clean the individual leaves. Prior to washing, the pencil was tested for water sensitivity, and it was determined that the media was stable enough to withstand aqueous treatment. To avoid changes in paper size and potential media loss, it was decided to use the gentle technique of blotter washing, which would also allow the conservators to carefully observe the washing process. A leaf was placed on top of a sheet of blotting paper dampened with pH8-8.5 water, and sprayed thoroughly with water from the recto. When a significant amount of the yellow discoloration had absorbed into the blotting paper, the blotting paper was replaced and the step repeated until all discoloration was washed out. After washing the leaves were left to air dry overnight.

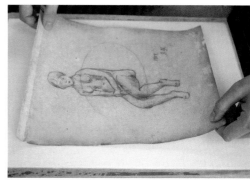

圖15.作品襯於濕吸水紙上
Work of art is placed on a dampened sheet of blotting paper

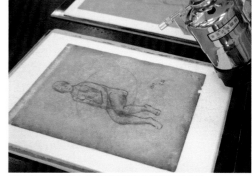

圖16.將淨水噴灑在作品正面讓黃化轉移至吸水紙
Water is sprayed on the recto to allow discoloration to absorb into the blotting paper

## 6. 壓乾壓平 Pressing

將紙張每一頁加濕、展開，再放置於吸水紙中，用玻璃板與紙鎮將其壓乾壓平。

Each leaf was humidified and pressed between blotting papers until dry.

## 7. 頂條 Reinforcement strips（圖17-18）

下個步驟是易撕孔虛線的補強。以小麥澱粉漿糊黏貼約0.5公分寬染色過的典具帖頂條來補強易撕虛線，可強化易撕孔線處的結構，避免日後產生斷裂。因染色過的典具帖顏色和內頁的底色相近，因此乾了之後幾乎看不出任何差異。

A 0.5cm strip of 5.0g/m² toned tengujo paper was applied to the verso of each perforation to increase its structural strength and prevent possible tearing caused by handling. The toned tengujo matched the color of the original paper support, making the reinforcement strip nearly invisible.

圖17.用典具帖頂條補強易撕線
Tengujo paper strips are used to reinforce perforations

圖18.以刷子將典具帖頂條固定在作品上
A brush is used to tamp and set down the tenguo reinforcement strip

## 8. 破損補洞 Infilling losses（圖19-21）

內頁破洞以染製過的宣紙進行填補。在光桌上於內頁紙張背面墊上無酸聚酯片，並描繪出破損的外形輪廓，再將聚酯片放在隱補紙上。以手術刀將補紙邊緣打薄並呈毛邊狀，再使用小麥澱粉漿糊黏貼於內頁背面再以豬鬃拓刷敲實壓平，重壓至全乾為止。蟲蝕孔洞的封面及封底採取不以水清洗的修復處理方法。用宣紙製成的乾紙纖維調和適量小麥澱粉漿糊後填補破洞，使用手術刀刮取宣紙纖維後以鑷子緊壓填入洞內。

Losses on individual leaves were infilled with a single layer of toned xuan paper. The leaf was placed face down on a light box, overlaid with a small mylar sheet, and the loss was outlined onto the mylar using a black marker. The infilling paper was transferred to the top of the mylar sheet, and the outline of the loss was shaped using a scalpel. Wheat starch paste was used to paste the infill onto the verso of the leaf, and the infill was then tamped using a stiff short-bristled brush. The infill was pressed with weights and left to dry for several hours. Water exposure needed to be minimized for insect-induced losses on the front and back covers, and therefore dry paper pulp made from teasing out fibers from xuan paper and mixing it with wheat starch paste, which was then used to infill the losses.

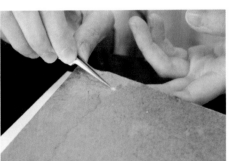

圖19.用宣紙製成的乾紙纖維來補封面的洞
Dry paper pulp is inserted into losses in the front cover

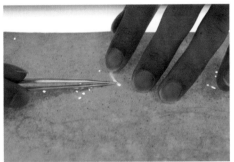

圖20.將補洞紙貼於內頁背面
Infilling paper is adhered to the leaf verso

圖21.以豬鬃拓刷敲實壓平
A stiff short-bristled brush is used to tamp the infill

## 9. 全色補彩 Inpainting（圖22）

塗佈甲基纖維素於補紙處作為防水隔離層，待乾後，以可逆性有機顏料進行全色補彩與用可逆性舊色（從老畫的覆背紙熬煮出）補色，使其與周圍顏色接近。

Methyl cellulose was applied to the recto of the infill to act as an isolating layer. Reversible organic colorants are then used to inpaint the infill. Susu (solubilized paper dirt) was used to tone down brighter areas on the original paper support to match the surrounding paper.

## 10. 紙釘 Paper staples（圖23-25）

於修復倫理中，紙張內的金屬物質須盡可能清除或減少，避免因金屬元素引起未來性的劣化。所以，任何含有金屬元素如迴紋針、釘書針等裝訂方式，將以中性紙製成的「紙釘」取代。中

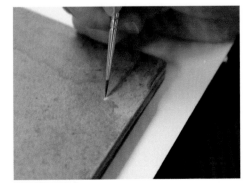

圖22.將封面全色
Inpainting the front cover

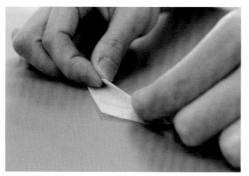

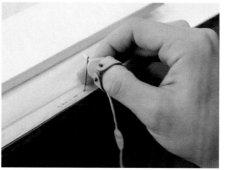

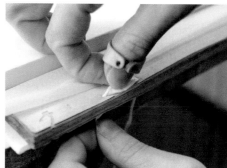

圖23.準備紙釘
Preparing the paper staple

圖24.將紙釘放入原裝釘孔洞內
Threading the paper staple into the staple holes

圖25.調整紙釘位置
Adjusting the paper staple

性紙釘的製作如下：將楮皮紙切成平行四邊形再對折，衡量原釘書針的長度，把左、右邊捻好可穿進原洞口。

According to conservation ethics, all metallic elements (such as paper clips and staples) should be removed from a work of art if possible to avoid future metallic-induced damage. Therefore, 'paper staples' were designed to replace the original, rusty staples. Paper staples were made by cutting a trapezoidal form out of white kozo paper and folding them into the necessary form. The center of the paper staple was measured to the same width as the original staple, and the paper ends were then twisted into a tight coil to be threaded into the staple holes.

## 11. 書背與騎縫頂條 Spine and new hinge（圖26-29）

　　書背內面用一層5.0匁細川紙補強，再將封面內頁封底平整對齊。原有的黑色寒冷紗（騎縫帶）區域，因為紙板脆化、漬痕嚴重，所以使用5.0匁細川紙騎縫取代。首先，細川紙以小麥澱粉糊黏貼在書背的內面。內頁調整好在封面、封底中，再黏細川紙騎縫。這條騎縫黏在原來黑色膠帶的同位置，但在封面側比書背騎縫進去一點，讓這兩層細川紙騎縫呈現梯子狀之層次，減少對內頁的潛在性的磨損。

The original spine cloth was reinforced from the inside with a spine inlay made from 5.0 monme (匁) hosokawa paper, and the text block was aligned with the covers. Because the original black hinge tape had embrittled and was severely stained, a 5.0 monme hosokawa hinge was used to replace it. First, a hosokawa paper strip was applied to the inside of the spine with wheat starch paste. After the textblock was aligned with the covers, a new hosokawa hinge was adhered to the recto. This strip was applied in the same position as the original black tape on the textblock, but slightly inside the hosokawa spine strip, allowing the two hosokawa strips to form a step-ladder gradation and minimize surface abrasion to the textblock.

圖26.將細川紙黏在書背的內面
A hosokawa paper spine inlay is adhered to the inside of the spine

圖27.黏新細川紙騎縫在原來黑色膠帶的同位置
A new hosokawa hinge is applied in the same position as the original black hinge tape

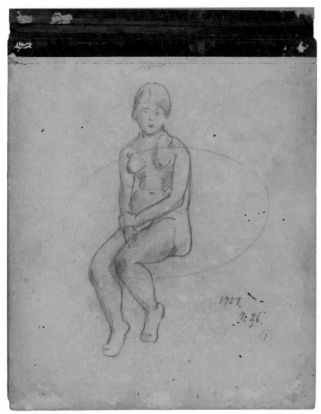
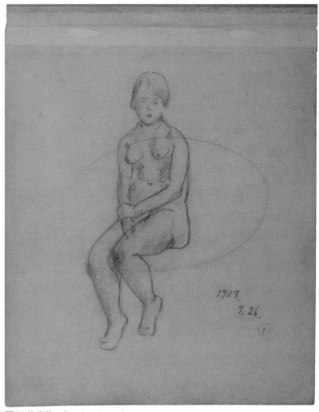

圖28.修復前 Before treatment　　　　　圖29.修復後 After treatment

## 12. 最後壓乾壓平 Final pressing

將完成的書本夾於兩張吸水紙中，並用玻璃板與紙鎮將其壓平，放置兩週。

The finished book was pressed and dried under blotting paper and weights for two weeks.

## 13. 裝幀保存 Storage

為保護素描簿，使用無酸檔案夾紙製作四折翼保護盒，並於外面黏貼無酸標籤。

The sketchbook was stored in a four-flap non-acidic enclosure that was labeled on the outside with a non-acidic label.

# 二、單線圈裝訂 Spiral binding

編號SB19之素描簿為單線圈裝訂結構。此本素描簿為鉛筆和鋼筆墨水速寫，劣化現狀有裝訂的線圈有些已經氧化、圓徑過小造成封面內頁與書背皆有磨損、裂痕與脫落、破洞的現象。針對素描簿修復後所要呈現的形式多次與陳澄波文化基金會商討，皆認為保留其原先的單線圈形式具有其特殊的歷史意義，決定修復後素描簿維持原本的裝訂「單線圈」形式，但金屬物質日後將引起有機紙質生鏽、褐斑、漬痕與其他劣化問題的潛在性危險，因此，修復方針在兼具委託者的期望維持原有裝訂形，但兼顧修復者角度盡可能降低金屬物質將引起作品的潛藏性破壞的原則來進行修復。重新選擇以不銹鋼的單線圈、加大線圈直徑、製作結合式書背紙張把書背加寬等措施，裝訂後單線圈完全沒有接觸到原書背，也避免金屬對書本的磨損，翻閱時加大直徑的線圈也不會折損頁面。

SB19 is an example of spiral binding and contains pencil and black ink sketches. It suffered from oxidation of the binding coil, abrasion to the front cover and textblock caused by the small binding coil, tears and losses. After discussion with Judicial Person Chen Cheng-po Cultural Foundation, it was decided that since it had historical significance, the

original appearance of the spiral binding should be preserved. Therefore, after treatment the sketchbook was rebound with a spiral binding, but in a manner that metallic elements would not cause future rusting, foxing, staining, and other deterioration problems. To accommodate for the owner's request to preserve the original binding style while adhering to conservation ethics that dictate that metallic elements should be removed when possible to minimize future damage. A new, larger diameter stainless steel binding coil was made and threaded through a spine addition, thereby avoiding threading through the original binding holes and reducing metal-induced abrasion to the sketchbook.

# I. 修復前狀態 Before treatment condition

SB19　1934-1935.4　25×28.5cm

## · SB19

修復紀錄 Conservation history

　　■未曾修復Not treated before □曾修復Previously treated

封面、封底基底層 Front and back covers

　　■灰塵髒污Surface dirt ■黴害Mold damage □褐斑Foxing
　　■水害Tidelines ■油害Oil stains □蟲害（排泄物、啃食破損）Insect damage(accretions, losses)
　　■黃化Yellowing □燒傷Fire damage □割傷Cuts □破洞Losses □附著物Accretions
　　■折痕Creases ■裂痕Tears □變色Discoloration ■磨損Abrasion ■變形Distortions □膠帶Tapes
　　■其他Other：單線圈生鏽Rusted spiral

內頁基底層 Textblock

　　■灰塵髒污Surface dirt ■黴害Mold damage □褐斑Foxing □水害Tidelines
　　■油害Oil stains □蟲害（排泄物、啃食破損）Insect damage (accretions, losses) ■黃化Yellowing
　　□燒傷Fire damage □割傷Cuts □破洞Losses □附著物Accretions ■折痕Creases □裂痕Tears
　　□變色Discoloration ■磨損Abrasion ■變形Distortions □膠帶Tapes □其他Other

媒材層 Media

　　□脫離Friable □磨損Abrasion □褪色Fading □暈水Bleeding □透色Sinking □其他Other

## II. 修復作業內容 Conservation treatment

### 1. 修復前攝影 Before treatment examination and documentation（圖1-4）

作品修復前的整體狀況紀錄及調查，包括：修復前進行可見光（正光、側光、透光）、非可見光（紫外光螢光反射與紅外光）檢測。透過上述不同特殊光源的攝影技術交互比對下，全面性了解文物材質及損傷的狀態。

The before treatment condition of the sketchbooks was examined and documented with normal and raking illumination, non-visible photographic methods (UV-induced visible fluorescence and infrared radiation reflectography). Comparison of these different photographic methods allowed the conservators to better understand the object's composition and physical condition.

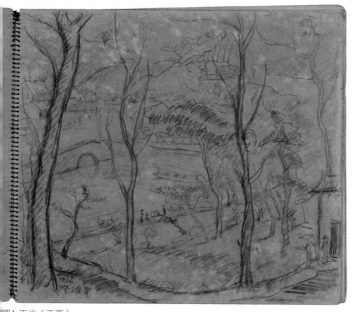

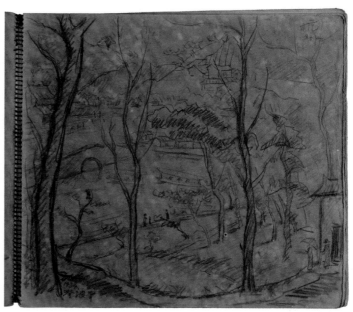

圖1.正光（正面）
Normal illumination (Recto)

圖2.側光（正面）
Raking illumination (Recto)

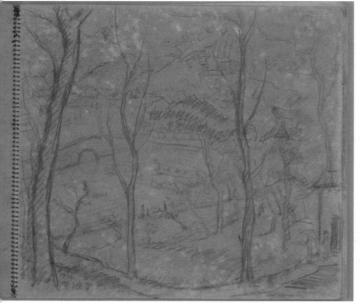

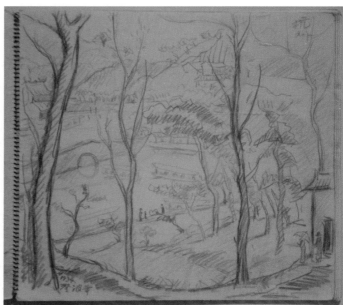

圖3.紫外光（正面）
UV radiation (Recto)

圖4.紅外光（正面）
Infrared radiation (Recto)

## 2. 解體 Disbinding（圖5-6）

因為單線圈生鏽造成紙張磨損，因此使用鉗子將它小心拔出，避免紙張再度磨損。

Because the rusted binding coil was causing paper abrasion, pliers were used to carefully cut and remove the coil.

圖5.封面內頁與書背皆有單線圈造成的磨損、裂痕與破洞
Binding coil-induced abrasion, tears, and losses on the front cover, textblock and spine

圖6.將舊生鏽的單線圈移除
Removing the rusted coil

## 3. 表面除塵 Surface cleaning（圖7）

針對封面封底與內頁的表面灰塵，以手指帶動粉末橡皮，依畫弧方向清潔作品，過程中需注意避開繪畫筆觸以維持鉛筆線條的清晰。 部分附著於畫面之昆蟲排泄物、膠體異物等，以手術刀尖端先行敲碎成較小顆粒降低其黏著力，再以修復用橡皮清潔移除。

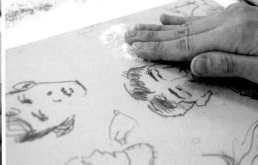

圖7.以指腹帶動粉末橡皮移除作品灰塵髒污
Eraser crumbs are used to remove surface dirt and accretions

Each textblock leaf and both front and back covers were surface cleaned using eraser crumbs. Care was taken to avoid disrupting the image areas. Insect accretions were broken into smaller pieces with a scalpel in order to reduce their adhesiveness, and then cleaned using eraser crumbs.

## 4. 黴斑漂洗 Bleaching of mold-induced foxing（圖8）

以小筆沾1%過氧化氫溶液，漂洗作品上局部黴斑，對於部分難以達到漂洗成效黴斑，將此過程移至修復專用抽氣桌上進行並增加漂洗次數。

1% hydrogen peroxide was locally applied with a fine-tipped brush to bleach mold-induced foxing spots. For difficult to treat foxing spots, the work of art was transferred to a suction table and repeatedly bleached.

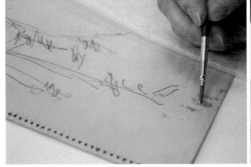

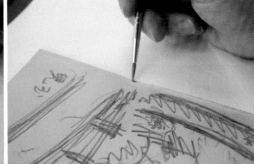

圖8.以1%過氧化氫溶液漂洗局部黴斑
Using 1% hydrogen peroxide to locally bleach mold-induced foxing spots

## 5. 清洗 Aqueous cleaning（圖9-11）

因為年代久遠，內頁紙質黃化，故每頁都必須整張清洗。在清洗之前，測試媒材對水的穩定性很高，不會溶解於水。此外，為了避免紙張尺寸變形，使用較為柔順的blotter washing方式清洗，一方面不會傷害紙張，另一方面也因為清洗速度較慢，可以檢視其完整清洗過程。清洗過程為將作品襯於調整酸鹼值為

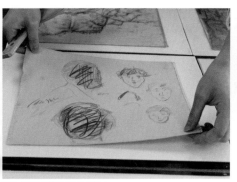

圖9.將作品襯於濕吸水紙上
Work of art is placed on a dampened sheet of blotting paper

圖10.以軟羊毛刷將作品刷平
A soft sheep's hair brush is used to flatten the work of art

圖11.濕式清潔將作品上黃污帶至吸水紙上
Aqueous cleaning has washed out yellowed discoloration from the works of art onto blotting paper

pH8-8.5之乾淨濕吸水紙上，使盆內吸水紙富有水分，待作品上黃污轉移至吸水紙上後即更換下層吸水紙，此步驟反覆數次直到不再有髒污被析出為止，放置使其自然風乾。

Because the paper support of the text block had yellowed from aging, the decision was made to aqueously clean the individual leaves. Prior to washing, the pencil was tested for water sensitivity, and it was determined that the media was stable enough to withstand aqueous treatment. To avoid changes in paper size and potential media loss, it was decided to use the gentle technique of blotter washing, which would also allow the conservators to carefully observe the washing process. A leaf was placed on top of a sheet of blotting paper dampened with pH8-8.5 water, and sprayed thoroughly with water from the recto. When a significant amount of the yellow discoloration had absorbed into the blotting paper, the blotting paper was replaced and the step repeated until all discoloration was washed out. After washing the leaves were left to air dry overnight.

### 6. 複合紙張以加寬書背 Spine addition（圖12-22）

此素描簿最大的問題為原本裝訂孔洞的間距太小，在開闔之間容易造成孔洞與書背的磨損。為了解決此問題，在與財團法人陳澄波文化基金會討論過後，我們重新設計一個加寬書背的結構，將封面封底與每一頁分別以染色過的典具帖與宣紙加強，結構如圖12，能使單線圈孔洞間距較寬、減少孔洞磨損的同時，又可以接近其原有樣貌。

One of this sketchbook's major structural problems is that the original binding coil diameter was too small, thus causing the binding holes and spine to be creased and abraded upon repeated opening. After consultation with Judicial Person Chen Cheng-po Cultural Foundation, the conservators designed a spine addition constructed from toned tengujo and xuan paper that could be distinguished from the original covers and pages (see figure 12). This construction would allow wider spine holes to be punched on the added spine, reducing spiral-induced abrasion while preserving the original appearance of the spiral binding.

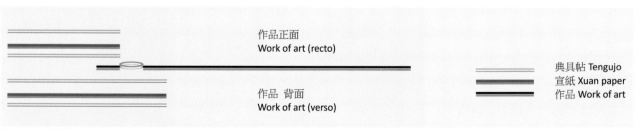

作品正面
Work of art (recto)

作品 背面
Work of art (verso)

典具帖 Tengujo
宣紙 Xuan paper
作品 Work of art

圖12.加寬書背結構 Construction of added spine

a.將兩條染色過的典具帖分別黏於內頁正反兩面的書背處，正面需露出孔洞，背面則蓋住孔洞。因為高可逆性的需求，加典具帖能讓未來取下宣紙時比較容易。（圖13-14）

Two strips of dyed tengujo paper were adhered onto the verso and recto of the spine edge of each leaf with wheat starch paste. The verso strip overlapped onto the inner side of both covers inside the binding holes, while the outer side of both covers left the binding holes exposed. In consideration of reversibility, this layer was added in order to allow the proceeding layers of xuan paper to be easily removable.

b.將兩條染色過的宣紙再分別黏於兩條典具帖上，完全覆蓋，正面需露出孔洞，背面則蓋住孔洞。（圖15-16）

Two strips of the toned xuan paper were applied on top of the tengujo strips, also leaving the recto binding holes exposed but covering the verso binding holes.

c.為了避免宣紙磨損，再用兩條染色過的典具帖分別黏於宣紙上，正面需露出孔洞，背面則蓋住孔洞。（圖17-18）

In order to avoid surface abrasion to the xuan paper layer, a final strip of dyed tengujo paper was applied to the top of the xuan paper layer, again leaving the recto binding holes exposed while covering the verso binding holes.

d.將完成的內頁、封面、封底分別夾於兩張吸水紙中，並用玻璃板與紙鎮將其壓平，放置一週。

Each leaf and cover was placed

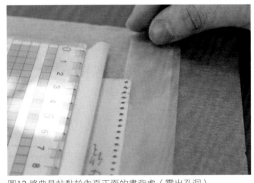
圖13.將典具帖黏於內頁正面的書背處（露出孔洞）
Applying first tengujo layer to recto (leaving exposed binding holes)

圖14.將典具帖黏於內頁背面的書背處（蓋住孔洞）
Applying first tengujo layer to verso (covering binding holes)

圖15.將宣紙黏於正面的典具帖上
Applying xuan paper on top of recto tengujo strips

圖16.將宣紙黏於背面的典具帖上
Applying xuan paper on top of verso tengujo strips

圖17.將典具帖黏於宣紙上
Applying final tengujo layer

圖18.以軟刷敲緊新書背
Using a soft brush to tamp the new spine addition

圖19.在新書背上鑽出新孔洞
Punching binding holes in the new spine addition

圖20.每6毫米的距離點在金屬棍子上
Making a coil template with 6mm pitch

圖21.纏繞新線圈
Coiling wire around the template

圖22.將線圈裝在新的書背
Threading the finished coil through the new spine addition

between blotting papers and pressed for one week.

e.在每6毫米的孔位間距鑽出4毫米的圓形孔洞在新的書背處上。（圖19）

4mm holes with 6mm pitch (distance between holes)

f.新線圈材質選擇使用不鏽鋼材質並於外層塗刷兩層壓克力黏著劑做成新線圈，不鏽鋼與無酸黏著劑的使用考量是為了減少潛在性生鏽將於日後造成破壞。再把新線圈以每6毫米的距離纏繞在1公分的金屬棍子上。最後就可以把完成的單線圈裝在新的書背。（圖20-22）

The decision was made to use a stainless steel wire, coated with two layers of Acryloid B72 to construct the new binding coil. Stainless steel wire was selected because it was more resistant to rusting, thus reducing future rust-induced damage. The new coil was constructed with 6mm pitch and a 1cm diameter. After completion, it was threaded into the new binding holes and notched at top and bottom.

### 7. 裝幀保存 Storage

為保護素描簿，使用無酸檔案夾紙製作四折翼保護盒，並於外面黏貼無酸標籤。

The sketchbook was stored in a four-flap non-acidic enclosure that was labeled on the outside with a non-acidic label.

## 三、線裝裝訂 Smyth sewing

編號SB10之素描簿為線裝結構。這些素描簿結構大部分鬆動，破損包含局部灰塵髒污、裂痕、破洞。修復目標為穩定結構，因此除了處理上述破損外，將線裝加強固定與重新換棉線裝訂。SB10狀況較差，因為書背已經與封面完全分離，所以將封面封底書背與內頁分開，在書背內面以楮皮紙加強，並使已脫落的內頁更加牢固後，再把書本裝訂回去。

SB10 is an example of smyth sewing. Most of the smyth sewn sketchbooks in this project suffered from loosened construction, localized surface dirt, tears, and losses. Because the conservation goal was to stabilize their structures, treatment included not only infilling losses, but also reinforcing and replacing the old sewing threads. SB10 was in poorer condition than the other sketchbooks, and its front cover had fully separated. Therefore, treatment included separating both covers from the textblock, reinforcing the spine with a kozo paper strip, securing and reattaching loosened textblock pages and rebinding the sketchbook.

# I. 修復前狀態 Before treatment condition

SB10　1932.7-1933.5　10.7×18.2cm

## ・SB10

修復紀錄 Conservation history

　　■未曾修復Not treated before □曾修復Previously treated

封面、封底基底層 Front and back covers

　　■灰塵髒污Surface dirt □黴害Mold damage □褐斑Foxing □水害Tidelines □油害Oil stains
　　□蟲害（排泄物、啃食破損）Insect damage(accretions, losses)
　　■黃化Yellowing □燒傷Fire damage □割傷Cuts □破洞Losses ■附著物Accretions □折痕Creases
　　■裂痕Tears □變色Discoloration □磨損Abrasion □變形Distortions □膠帶Tapes
　　■其他Other：書背和封面分離Separation of covers from spine

內頁基底層 Textblock

　　■灰塵髒污Surface dirt □黴害Mold damage □褐斑Foxing □水害Tidelines □油害Oil stains
　　□蟲害（排泄物、啃食破損）Insect damage(accretions, losses) ■黃化Yellowing □燒傷Fire damage
　　□割傷Cuts □破洞Losses □附著物Accretions □折痕Creases □裂痕Tears □變色Discoloration □磨損Abrasion
　　□變形Distortions □膠帶Tapes □其他Other

媒材層 Media

　　□脫離Friable ■磨損Abrasion ■褪色Fading □暈水Bleeding □透色Sinking □其他Other

# II. 修復作業內容 Conservation treatment

## 1. 修復前攝影 Before treatment examination and documentation（圖1-5）

　　作品修復前的整體狀況紀錄及調查，包括：修復前進行可見光（正光、側光、透光）、非可見光（紫外光螢光反射與紅外光）檢測。透過上述不同特殊光源的攝影技術交互比對下，全面性了解文物材質及損傷的狀態。

　　The before treatment condition of the sketchbooks was examined and documented with normal and raking illumination, non-visible photographic methods (UV-induced visible fluorescence and infrared radiation reflectography). Comparison of these different photographic methods allowed the conservators to better understand the object's composition and physical condition.

圖1.正光（正面）Normal illumination (Recto)
全面黃化、灰塵髒污 Overall discoloration and surface dirt

圖2.側光（正面）Raking illumination (Recto)

圖3.紫外光（正面）UV radiation (Recto)

圖4.紅外光（正面）Infrared radiation (Recto)

## 2. 解體 Disbinding

　　因為封面與書背幾乎快斷掉，故先使用手術刀與鑷子將封面封底書背與內頁分開，再把封面內面的裂縫貼頂條加強。

Because the spine had almost completely separated from the cover, a scalpel and tweezers were used to separate the back cover from the textblock, followed by applying a spine reinforcement to support the spine.

圖5.書背分離（局部）Separation of spine (Detail)

## 3. 表面除塵 Surface cleaning

（圖6-7）

　　針對封面、封底與內頁的表面灰塵，以手指帶動粉末橡皮，依畫弧方向清潔作品，過程中需注意避開繪畫筆觸以維持鉛筆線條的清晰。 部分附著於畫面之蟲排泄物、膠體異物等，以手術刀尖端先行敲碎成較小顆粒降低其黏著力，再以修復用橡皮清潔移除。

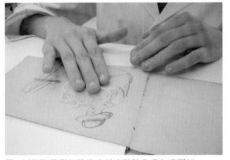
圖6.以指腹帶動無酸橡皮粉末移除作品灰塵髒污
Eraser crumbs are used to remove surface dirt and accretions

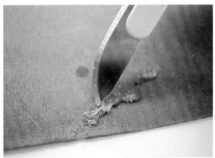
圖7.以手術刀敲碎破壞附著之昆蟲排遺，以移除黏性
Breaking insect accretions into smaller pieces with a scalpel in order to reduce their adhesiveness

Each textblock leaf and both front and back covers were surface cleaned using eraser crumbs. Care was taken to avoid disrupting the image areas. Insect accretions were broken into smaller pieces with a scalpel in order to reduce their adhesiveness, and then cleaned using eraser crumbs.

## 4. 黴斑漂洗 Bleaching of mold-induced foxing spots

以小筆沾1%過氧化氫溶液，漂洗作品上局部黴斑，對於部分難以達到漂洗成效黴斑，將此過程移至修復專用抽氣桌上進行，並增加漂洗次數。

1% hydrogen peroxide was locally applied with a fine-tipped brush to bleach mold-induced foxing spots. For difficult to treat foxing spots, the work of art was transferred to a suction table and repeatedly bleached.

## 5. 固定脫落的內頁 Reattaching loose leaves（圖8）

用典具帖頂條將脫落的內頁與下一頁固定住。

Loose leaves were reattached to the adjoining page with a tengujo reinforcement strip.

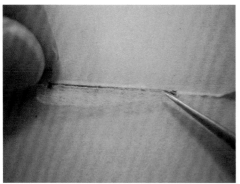
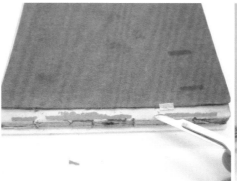

圖8.以典具帖頂條將脫落的內頁與下一頁固定住
A loose leaf was reattached to the adjoining page with a tengujo reinforcement strip

圖9.封面分離後將殘留膠體異物移除
After the cover is separated, residual adhesive is removed from the spine

## 6. 書背頂條補強 Spine reinforcement（圖9-12）

a.書背殘留膠體異物清洗乾淨。

Residual adhesive was removed from the spine.

b.內頁的書背處以典具帖補強。

A tengujo reinforcement strip is applied as a spine lining to the textblock spine.

c.書背內面以楮皮紙加強，再將封面封底書背結合。

After a kozo spine inlay was applied to the inside of the cover, the covers and textblock were realigned and assembled.

圖10.書背以典具帖頂條補強
Applying spine lining to textblock spine

圖11.將楮皮紙黏於書背的內面
Applying a kozo spine inlay to the inside of the cover

圖12.以楮皮紙補強封面與內頁第一頁間之騎縫
Applying a kozo hinge the first page of the textblock to front cover joint

### 7. 重組 Book reassembly

封面內頁封底平整對齊，再用兩層楮皮紙和漿糊把封面與第一頁黏緊。依上述方式再把封底與最後頁黏緊。

After the covers and textblock were realigned, two strips of kozo paper were adhered to the first page of the textblock and front cover joint with wheat starch paste. The same process was repeated for the back cover and last page of the textblock.

### 8. 全色補彩 Inpainting（圖13-14）

塗佈膠礬水於補紙處作為防水隔離層，待乾後，以可逆性有機顏料於其上進行全色補彩，將紙張上少部分較亮的地方用可逆性舊色（從老畫的覆背紙熬煮出）補色，使其與周圍顏色接近。

Alum-glue was applied to the recto of infills to act as an isolating layer. Reversible organic colorants are then used to inpaint the infill. Susu (solubilized paper dirt) was used to tone down brighter areas on the original paper support to match the surrounding paper.

圖13.用可逆性舊色補色
Inpainting with susu

圖14.全色書背
Inpainting the spine

### 9. 最後壓乾壓平 Final pressing

將完成的書本夾於兩張吸水紙中，並用玻璃板與紙鎮將其壓平，放置兩週。

The finished book was pressed and dried under blotting paper and weights for two weeks.

### 10. 裝幀保存 Storage

為保護素描簿，使用無酸檔案夾紙製作四折翼保護盒，並於外面黏貼無酸標籤。

The sketchbook was stored in a four-flap non-acidic enclosure that was labeled on the outside with a non-acidic label.

# 紙質作品
## Works on Paper

---

# 修復前後對照
## Before and After Treatment

國立臺灣師範大學文物保存維護研究發展中心
National Taiwan Normal University Research Center for Conservation of Cultural Relics

# 書法 Calligraphies

每件作品以修復前和修復後做為對照，共兩張圖。
修復前置於左側（上方）、修復後置於右側（下方）。

CA001
鄭文公碑（部分）Stele of Zheng Wengong (part)

CA002
石川丈山 · 幽居即事 Ishikawa Jozan, Life in Seclusion

CA003
大伴家持 · 萬葉集卷 4-779 Otomono Yakamochi, Man Yoh Shuh Vol.4-779

CA004
大伴家持 · 萬葉集卷 4-780 Otomono Yakamochi, Man Yoh Shuh Vol.4-780

CA005
大伴家持・萬葉集卷4-781 Otomono Yakamochi, Man Yoh Shuh Vol.4-781

CA006
論語・子罕第九 Confucian Analects, Book IX: Zi Han

CA007
李昂・夏日聯句 Li Ang, Summer Day Linked Verse

CA008
張繼・楓橋夜泊 Zhang Ji, Anchored Overnight at Maple Bridge

CA009
紀女郎・萬葉集卷4-782 Kinoiratsume, Man Yoh Shuh Vol.4-782

CA010
大伴家持・萬葉集巻4-783 Otomono Yakamochi, Man Yoh Shuh Vol.4-783

CA011
大伴家持・萬葉集巻4-785 Otomono Yakamochi, Man Yoh Shuh Vol.4-785

CA012
大伴家持・萬葉集巻4-786 Otomono Yakamochi, Man Yoh Shuh Vol.4-786

CA013
紀女郎・萬葉集巻4-763（1） Kinoiratsume, Man Yoh Shuh Vol.4-763 (1)

CA014
紀女郎・萬葉集巻4-763（2） Kinoiratsume, Man Yoh Shuh Vol.4-763 (2)

CA015
蘇軾・前赤壁賦（部分）Su Shi, Qan Chibi Fu (part)

CA016
大伴家持・萬葉集卷4-764（1）Otomono Yakamochi, Man Yoh Shuh Vol.4-764 (1)

CA017
大伴家持・萬葉集卷4-764（2）Otomono Yakamochi, Man Yoh Shuh Vol.4-764 (2)

CA018
柴野栗山（邦彦）・詠富士山 Shibano Ritsuzan, Mount Fuji

CA019
韓愈・左遷至藍關示姪孫湘 Han Yu, En Route

CA020
紀友則・古今和歌集卷6-337 Kino Tomonori, Kokin Wakashu Vol.6-337

CA021
賴山陽・泊天草洋 Rai Sanyo, Anchoring off Amakusa (Tiancao)

CA022
詠龍 Dragon

CA023
大伴家持・萬葉集卷4-777 Otomono Yakamochi, Man Yoh Shuh Vol.4-777

# 水墨 Ink Paintings

每件作品以修復前和修復後做為對照，共兩張圖。
修復前置於左側、修復後置於右側。

IW001
紅柿 Persimmon

IW003
漁村 Fishing Village

IW004
枇杷 Loquat

IW005
花 Flower

IW006
花及花苞 Flower and Flower Bud

IW007
小野果 Wild Fruit

IW010
菊花 Chrysanthemum

# 膠彩 Glue Color Painting

作品以修復前和修復後做為對照。
修復前置於上方、修復後局部照置於下方。

GC009
天竺聖人飛來入懷中 Tianzhu Sage Flying into Her Arms

# 炭筆素描 Charcoal Sketches

每件作品以修復前和修復後做為對照，共兩張圖。
修復前置於左側、修復後置於右側。

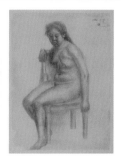

CS001
立姿裸女素描 -25.4（1）Standing Female Nude Sketch-25.4 (1)

CS002
坐姿裸女素描 -25.5.7~9（1）Seated Female Nude Sketch-25.7~9 (1)

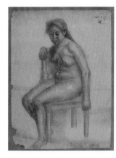

CS003
穿衣男子 -25.5.17 Dressing Man-25.5.17

CS005
坐姿裸女素描 -25.5.22（2）Seated Female Nude Sketch-25.5.22 (2)

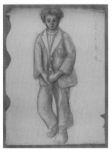
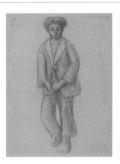

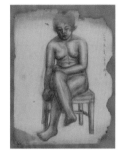

CS006
立姿裸女素描 -25.5.16（2）Standing Female Nude Sketch-25.5.16 (2)

CS007
裸女胸像素描 -25.5.25（1）Nude Bust Sketch-25.5.25 (1)

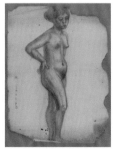
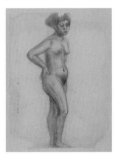

CS008
立姿裸女素描 -25.5.29（3）Standing Female Nude Sketch-25.5.29 (3)

CS009
立姿裸女素描 -25.6.4（4）Standing Female Nude Sketch-25.6.4 (4)

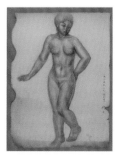
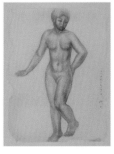

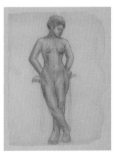

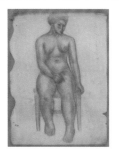 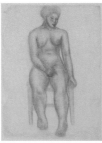

CS010
坐姿裸女素描-25.6.6（3）Seated Female Nude Sketch-25.6.6 (3)

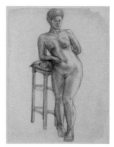 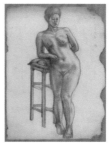

CS011
立姿裸女素描-25.6.6（5）Standing Female Nude Sketch-25.6.6 (5)

CS013
立姿裸女素描-25.6.20（6）Standing Female Nude Sketch-25.6.20 (6)

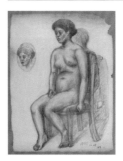 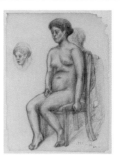

CS014
坐姿裸女素描-25.10.15（5）Seated Female Nude Sketch-25.10.15 (5)

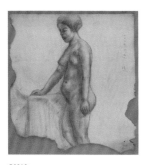 

CS015
立姿裸女素描-25.10.24（7）Standing Female Nude Sketch-25.10.24 (7)

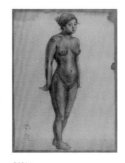 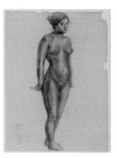

CS016
立姿裸女素描-25.11.17（8）Standing Female Nude Sketch-25.11.17 (8)

 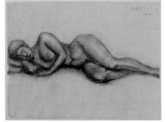

CS017
臥姿裸女素描-25.11.5（1）Reclining Female Nude Sketch-25.11.5 (1)

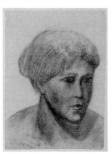

CS018
頭像素描-25.11.28（2）Portrait Sketch-25.11.28 (2)

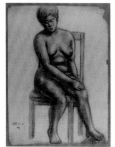 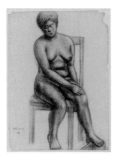

CS021
坐姿裸女素描-25.12.17（7）Seated Female Nude Sketch-25.12.17 (7)

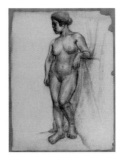 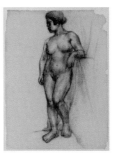

CS022
立姿裸女素描-26.1（10）Standing Female Nude Sketch-26.1 (10)

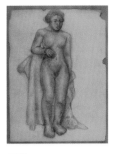 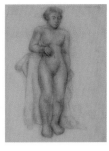

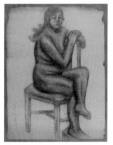 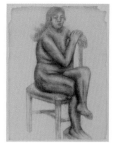

CS023
立姿裸女素描-26.1（11）Standing Female Nude Sketch-26.1 (11)

CS024
坐姿裸女素描-26.1.14（8）Seated Female Nude Sketch-26.1.14 (8)

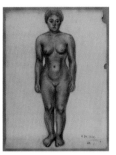 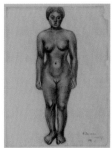

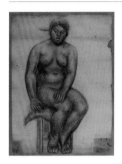 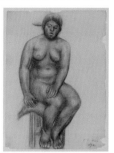

CS026
立姿裸女素描-26.4.30（13）Standing Female Nude Sketch-26.4.30 (13)

CS027
坐姿裸女素描-26.5.5（9）Seated Female Nude Sketch-26.5.5 (9)

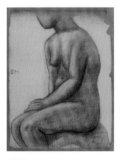 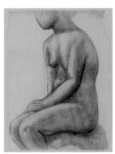

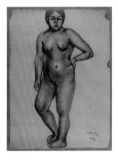 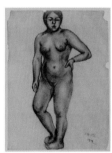

CS028
坐姿裸女素描-26.5.10（10）Seated Female Nude Sketch-26.5.10 (10)

CS029
立姿裸女素描-26.5.14（14）Standing Female Nude Sketch-26.5.14 (14)

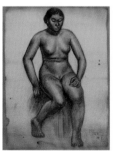 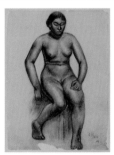

CS030
坐姿裸女素描-26.5.27（11）Seated Female Nude Sketch-26.5.27 (11)

CS031
手足素描-26.5.28 Hands and Feet Sketch-26.5.28

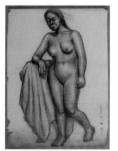 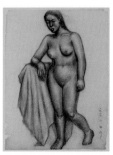

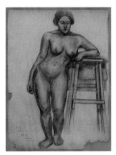 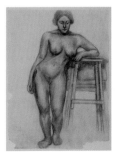

CS032
立姿裸女素描-26.6.4（15）Standing Female Nude Sketch-26.6.4 (15)

CS034
立姿裸女素描-26.6.16（16）Standing Female Nude Sketch-26.6.16 (16)

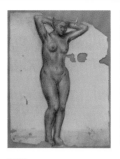
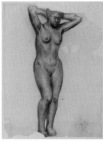

CS036
立姿裸女素描-26.10.8（17） Standing Female Nude Sketch-26.10.8 (17)

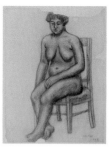
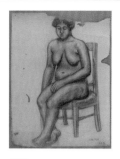

CS037
坐姿裸女素描-26.10.14（12） Seated Female Nude Sketch-26.10.14 (12)

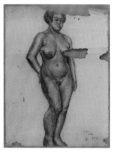

CS038
立姿裸女素描-26.10.20（18） Standing Female Nude Sketch-26.10.20 (18)

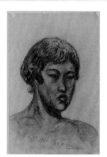
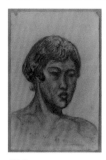

CS040
頭像素描-26.10.22（3） Portrait Sketch-26.10.22 (3)

CS041
立姿裸女素描-26.10.28（19） Standing Female Nude Sketch-26.10.28 (19)

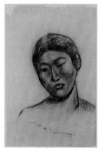
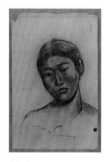

CS042
頭像素描-26.10.29（4） Portrait Sketch-26.10.29 (4)

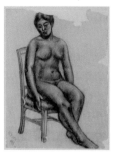

CS044
坐姿裸女素描-26.11.11（13） Seated Female Nude Sketch-26.11.11 (13)

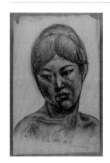
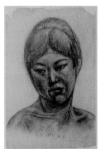

CS045
頭像素描-26.11.12（6） Portrait Sketch-26.11.12 (6)

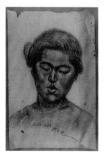
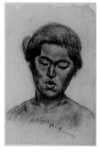

CS046
頭像素描-26.11.18（7） Portrait Sketch-26.11.18 (7)

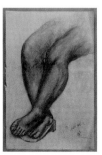

CS047
腳部素描-26.11.19 Feet Sketch-26.11.19

CS048
立姿裸女素描-26.11.24（20）Standing Female Nude Sketch-26.11.24 (20)

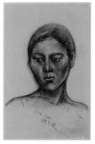 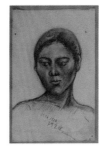

CS049
頭像素描-26.11.26（8）Portrait Sketch-26.11.26 (8)

 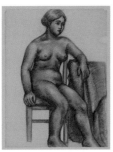

CS050
坐姿裸女素描-27（14）Seated Female Nude Sketch-27 (14)

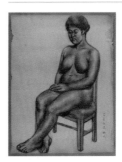 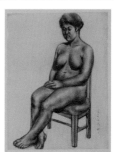

CS051
坐姿裸女素描-27.2.18（15）Seated Female Nude Sketch-27.2.18 (15)

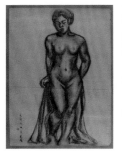 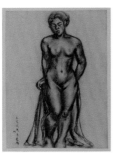

CS054
立姿裸女素描-27.3.14（21）Standing Female Nude Sketch-27.3.14 (21)

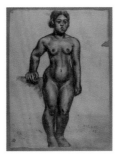 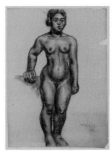

CS055
立姿裸女素描-27.3.17（22）Standing Female Nude Sketch-27.3.17 (22)

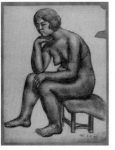 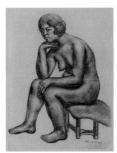

CS057
坐姿裸女素描-27.3.31（19）Seated Female Nude Sketch-27.3.31 (19)

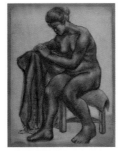 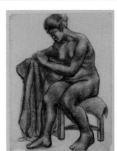

CS061
坐姿裸女素描-27.4.15（20）Seated Female Nude Sketch-27.4.15 (20)

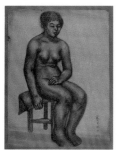 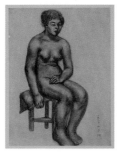

CS062
坐姿裸女素描-27.4.20（21）Seated Female Nude Sketch-27.4.20 (21)

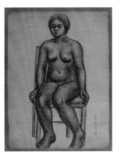 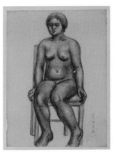

CS063
坐姿裸女素描-27.5.6（22）Seated Female Nude Sketch-27.5.6 (22)

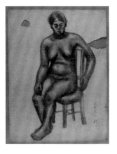
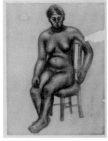

CS064
坐姿裸女素描-27.10.6（23）Seated Female Nude Sketch-27.10.6 (23)

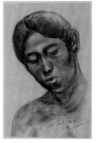

CS065
頭像素描-27.10.7（9）Portrait Sketch-27.10.7 (9)

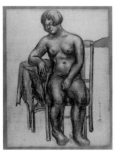
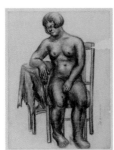

CS066
坐姿裸女素描-27.10.14（24）Seated Female Nude Sketch-27.10.14 (24)

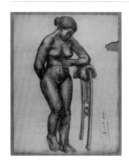
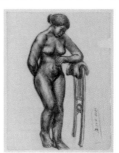

CS067
立姿裸女素描-27.10.18（24）Standing Female Nude Sketch-27.10.18 (24)

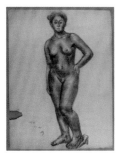
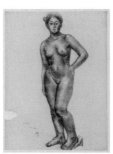

CS068
立姿裸女素描-27.10.27（26）Standing Female Nude Sketch-27.10.27 (26)

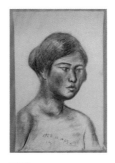
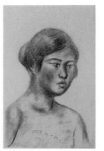

CS070
裸女胸像素描-27.11.10（3）Female Nude Bust Sketch-27.11.10 (3)

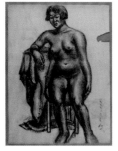
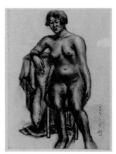

CS071
坐姿裸女素描-27.11.17（25）Seated Female Nude Sketch-27.11.17 (25)

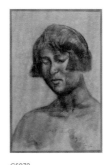
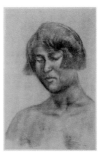

CS072
裸女胸像素描-27.11.18（4）Female Nude Bust Sketch-27.11.18 (4)

CS074
裸女胸像素描-27.11.25（5）Female Nude Bust Sketch-27.11.25 (5)

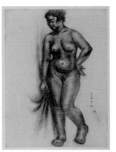
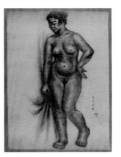

CS075
立姿裸女素描-27.11.30（27）Standing Female Nude Sketch-27.11.30 (27)

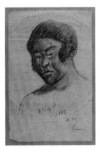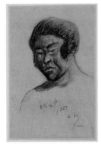

CS076
頭像素描-27.11.30（10） Portrait Sketch-27.11.30 (10)

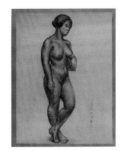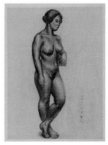

CS078
立姿裸女素描-28.2.16（28） Standing Female Nude Sketch-28.2.16 (28)

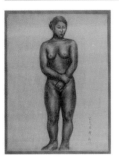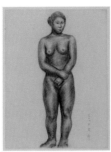

CS079
立姿裸女素描-28.3.6（29） Standing Female Nude Sketch-28.3.6 (29)

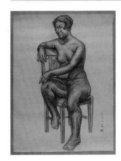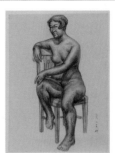

CS080
坐姿裸女素描-28.3.15（28） Seated Female Nude Sketch-28.3.15 (28)

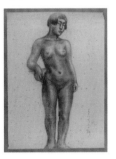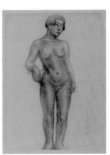

CS081
立姿裸女素描-28.3.21（30） Standing Female Nude Sketch-28.3.21 (30)

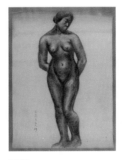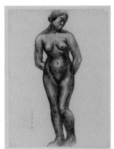

CS082
立姿裸女素描-28.3.30（31） Standing Female Nude Sketch-28.3.30 (31)

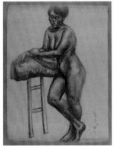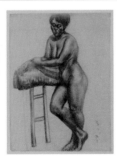

CS084
立姿裸女素描-28.11.7（33） Standing Female Nude Sketch-28.11.7 (33)

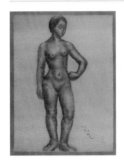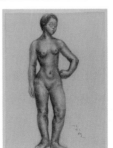

CS085
立姿裸女素描-28.12.6（34） Standing Female Nude Sketch-28.12.6 (34)

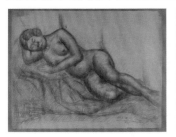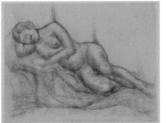

CS086
臥姿裸女素描-28.12.18（3） Reclining Female Nude Sketch-28.12.18 (3)

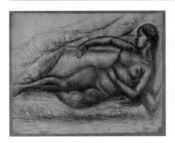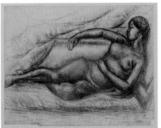

CS087
臥姿裸女素描-29.5.3（4） Reclining Female Nude Sketch-29.5.3 (4)

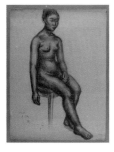

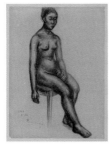

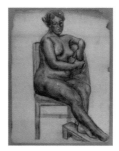

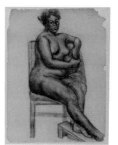

CS088
坐姿裸女素描-29.3.22（29） Seated Female Nude Sketch-29.3.22 (29)

CS090
坐姿裸女素描（31） Seated Female Nude Sketch (31)

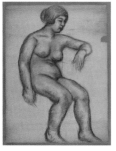

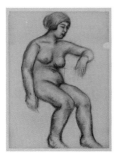

CS092
坐姿裸女素描（32） Seated Female Nude Sketch (32)

# 水彩 Watercolors

每件作品以修復前和修復後做為對照，共兩張圖。
修復前置於左側、修復後置於右側。

WA001
測候所 The Meteorological Station

WA002
山澗 Mountain Stream

WA003
臨摹 Imitate

WA005
神嘗祭 The God's Tasting Festival

WA007
池邊小屋 Small House Next to Pond

WA008
竹林下 Under the Bamboo Grove

WA009
嘉義附近—湖仔內 Huzinei Village

WA011
忍 Endurance

WA014
山路旁小屋 Mountain Wayside Cottages

WA015
草山瀑布 Waterfall

WA016
竹林間 Bamboo Forest

WA017
郊外散步 A Stroll in the Countryside

WA018
村落 Village

WA019
母女郊遊 Mother and Daughter on an Outing

187

WA020
竹與屋 Bamboo and House

WA021
農夫 Farmer

WA022
郊外 The Outskirts

WA023
台北東門 Taipei East Gate

WA025
京都渡月橋 Kyoto Togetsukyo

WA026
海邊 Cliff

WA027
古亭村牛奶屋 Milkhouse in Guting Village

WA028
遠望空中船 A Distant View of the Airship

WA029
白兵古蹟 White Soldiers Monument

WA030
遠望公賣局 A Distant View of the Monopoly Bureau

WA031
帆船 Sailboat

WA032
博物館一隅 A Corner of the Museum

WA033
野外的水牛 Wild Buffalo

WA034
宮燈 Palace Lantern

WA035
紫色山景 Purple Mountain View

WA037
酒瓶與杯 Bottle and Cup

WA038
鳥 Bird

WA039
水果 Fruits

WA040
花（1） Flower (1)

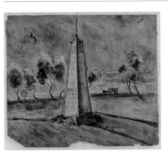
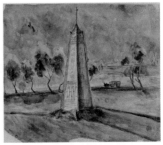

WA041
北回歸線立標 Torpic of Cancer Post

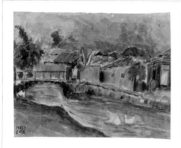

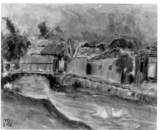

WA042
池塘 Pond

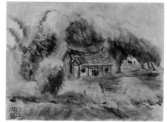

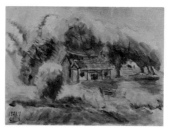

WA045
農舍與農夫 Farm House and Farmer

WA047
盆栽 Potted Plants

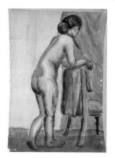

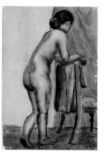

WA050
裸女倚椅立姿 Standing Nude Female Leaning Against a Chair

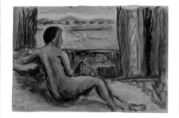

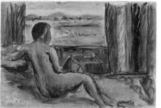

WA051
窗前裸女 Nude Female in Front of the Window

WA053
海邊岩石 Coast Cliffs

WA055
海邊 The Coast

WA056
倒影 Reflection

WA057
裸女與花瓶 Nude Female and Vase

WA058
女孩頭像 Girl Portrait

WA059
鳥 Bird

*為〔鳥〕之背面圖

WA060
花（2）Flower（2）

WA061
湖景 Lake View

WA062
屋頂 Roof

WA063
海邊村落 Seaside Village

WA064
溪畔漁夫 Fisher on the Stream

WA065
農舍雞群 Farmhouse and Chickens

WA066
宗祠 Ancestral Temple

WA067
大樹下的農家 Farmhouse and Trees

WA076
有吊橋的溪邊風景 Drawbridge by a Brook

WA077
樹林邊 By the Woods

WA078
薄暮 Dusk

WA079
晨曦 Dawn

WA080
山腳村落 Village at the Foot of the Mountain

WA081
山谷（1）Valley (1)

WA082
山谷（2）Valley (2)

WA083
熱蘭遮城 Zeelandia

WA085
山景 Mountain View

WA086
街景 Street View

WA087
浴女 Bathing Woman

WA088
老者 Elder

WA089
港邊 The Harbor

WA090
公園一景 Scenic Park

WA092
林蔭 Alameda

WA093
貓 Cat

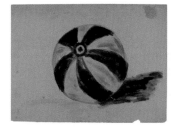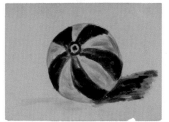

WA094
球（1）Ball (1)

WA096
球（3）Ball (3)

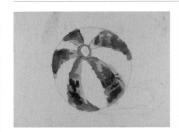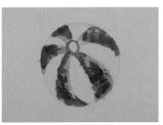

WA097
球（4）Ball (4)

# 其他 Others

每件作品以修復前和修復後做為對照，共兩張圖。
修復前置於左側、修復後置於右側。

PA001
粉彩裸女 Pastel Nude

DE001
第二回台陽展海報設計（1） 2nd Taiyang Exhibition Poster Design (1)

DE002
第二回台陽展海報設計（2） 2nd Taiyang Exhibition Poster Design (2)

DE005
圖案設計 Pattern Design

DE006
校園規劃 Campus Planning

IL001
故事（1） Story (1)

IL002
故事（2）Story (2)

IL003
歌謠（1） Ballad (1)

IL004
歌謠（2）Ballad (2)

PC001
剪紙（1）Paper Cut (1)

PC002
剪紙（2）Paper Cut (2)

PC003
剪紙（3）Paper Cut (3)

PC004
剪紙（4）Paper Cut (4)

# 淡彩 Watercolor Sketches

每件作品以修復前和修復後做為對照，共兩張圖。
修復前置於左側、修復後置於右側。

WS289
臥姿裸女（72）Lying Nude (72)

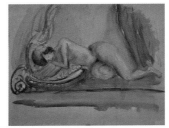

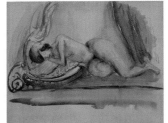

WS365
人物（20）Figure (20)

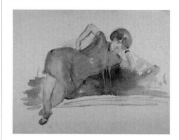 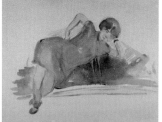

WS366
人物（21）Figure (21)

WS367
人物（22）Figure (22)

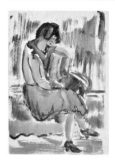 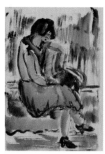

WS402
人物（26）Figure (26)

WS408
坐姿裸女（159）Seated Nude (159)

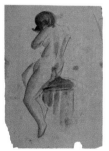 

WS409
坐姿裸女（160）Seated Nude (160)

 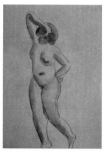

WS410
立姿裸女（83）Standing Nude (83)

WS411
坐姿裸女（161）Seated Nude (161)

# 單頁速寫 Single-sheet Sketches

每件作品以修復前和修復後做為對照，共兩張圖。
修復前置於左側、修復後置於右側。

① 修復、未夾裱：181 件（2 件雙面）
181 works (2 double-sided) - treated, not stored in folder

SK0002
立姿裸女速寫 -25.10.5（1） Standing Female Nude Sketch-25.10.5 (1)

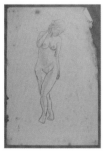

SK0043
立姿裸女速寫 -26.1（23） Standing Female Nude Sketch-26.1 (23)

SK0052
跪姿裸女速寫 -26.2.1（2） Kneeling Female Nude Sketch-26.2.1 (2)

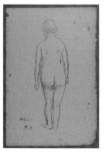

SK0083
立姿裸女速寫 -27.2.5（45） Standing Female Nude Sketch-27.2.5 (45)

SK0099
臥姿裸女速寫 -27.2.26（6） Reclining Female Nude Sketch-27.2.26 (6)

SK0143
立姿裸女速寫 -27.3.19（68） Standing Female Nude Sketch-27.3.19 (68)

SK0144
立姿裸女速寫 -27.3.19（69） Standing Female Nude Sketch-27.3.19 (69)

SK0145
蹲姿裸女速寫-27.3.19（5） Squatting Female Nude Sketch-27.3.19 (5)

SK0148
立姿裸女速寫-27.3.19（72） Standing Female Nude Sketch-27.3.19 (72)

SK0149
立姿裸女速寫-27.3.19（73） Standing Female Nude Sketch-27.3.19 (73)

SK0150
立姿裸女速寫-27.3.19（74） Standing Female Nude Sketch-27.3.19 (74)

SK0151
坐姿裸女速寫-27.3.19（50） Seated Female Nude Sketch-27.3.19 (50)

SK0152
坐姿裸女速寫-27.3.19（51） Seated Female Nude Sketch-27.3.19 (51)

SK0153
坐姿裸女速寫-27.3.19（52） Seated Female Nude Sketch-27.3.19 (52)

SK0154
坐姿裸女速寫-27.3.19（53） Seated Female Nude Sketch-27.3.19 (53)

SK0155
坐姿裸女速寫-27.3.19（54） Seated Female Nude Sketch-27.3.19 (54)

SK0156
坐姿裸女速寫-27.3.19（55） Seated Female Nude Sketch-27.3.19 (55)

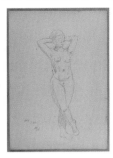

SK0157
立姿裸女速寫-27.3.26（75） Standing Female Nude Sketch-27.3.26 (75)

SK0158
立姿裸女速寫-27.3.26（76） Standing Female Nude Sketch-27.3.26 (76)

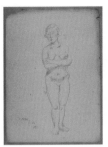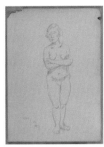

SK0159
立姿裸女速寫-27.3.26（77） Standing Female Nude Sketch-27.3.26 (77)

SK0160
立姿裸女速寫（78） Standing Female Nude Sketch (78)

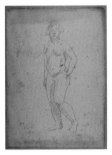

SK0161
立姿裸女速寫-27.3.26（79） Standing Female Nude Sketch-27.3.26 (79)

SK0162
坐姿裸女速寫-27.3.26（56） Seated Female Nude Sketch-27.3.26 (56)

SK0163
坐姿裸女速寫-27.3.26（57） Seated Female Nude Sketch-27.3.26 (57)

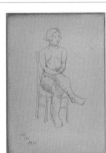

SK0164
坐姿裸女速寫-27.3.26（58） Seated Female Nude Sketch-27.3.26 (58)

SK0165
坐姿裸女速寫-27.3.26（59） Seated Female Nude Sketch-27.3.26 (59)

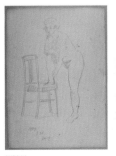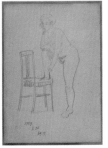

SK0166
立姿裸女速寫-27.3.26（80） Standing Female Nude Sketch-27.3.26 (80)

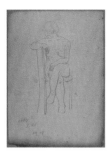

SK0167
坐姿裸女速寫-27.3.26（60）Seated Female Nude Sketch-27.3.26 (60)

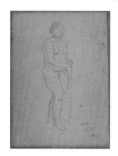
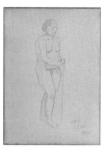

SK0168
立姿裸女速寫-27.3.26（81）Standing Female Nude Sketch-27.3.26 (81)

SK0169
立姿裸女速寫-27.3.26（82）Standing Female Nude Sketch-27.3.26 (82)

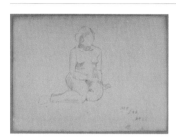

SK0170
坐姿裸女速寫-27.3.26（61）Seated Female Nude Sketch-27.3.26 (61)

SK0171
坐姿裸女速寫-27.3.26（62）Seated Female Nude Sketch-27.3.26 (62)

SK0172
坐姿裸女速寫-27.3.26（63）Seated Female Nude Sketch-27.3.26 (63)

SK0173
坐姿裸女速寫-27.3.26（64）Seated Female Nude Sketch-27.3.26 (64)

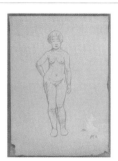

SK0174
立姿裸女速寫（83）Standing Female Nude Sketch (83)

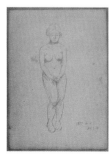

SK0175
立姿裸女速寫-27.4.2（84）Standing Female Nude Sketch-27.4.2 (84)

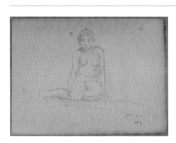
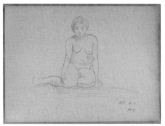

SK0176
坐姿裸女速寫-27.4.2（65）Seated Female Nude Sketch-27.4.2 (65)

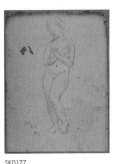

SK0177
立姿裸女速寫-27.4.2（85）Standing Female Nude Sketch-27.4.2 (85)

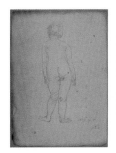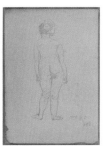

SK0179
立姿裸女速寫-27.4.2（86）Standing Female Nude Sketch-27.4.2 (86)

SK0180
坐姿裸女速寫-27.4.2（66）Seated Female Nude Sketch-27.4.2 (66)

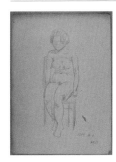

SK0182
坐姿裸女速寫-27.4.2（68）Seated Female Nude Sketch-27.4.2 (68)

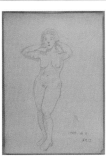

SK0183
立姿裸女速寫-27.4.2（87）Standing Female Nude Sketch-27.4.2 (87)

SK0184
坐姿裸女速寫-27.4.2（69）Seated Female Nude Sketch-27.4.2 (69)

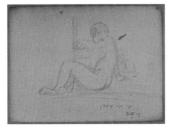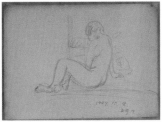

SK0186
坐姿裸女速寫-27.4.2（71）Seated Female Nude Sketch-27.4.2 (71)

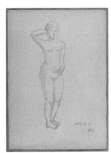

SK0188
立姿裸女速寫-27.4.9（88）Standing Female Nude Sketch-27.4.9 (88)

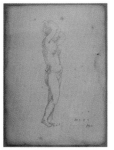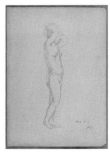

SK0189
立姿裸女速寫-27.4.9（89）Standing Female Nude Sketch-27.4.9 (89)

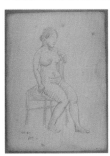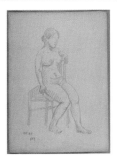

SK0190
坐姿裸女速寫-27.4.9（72）Seated Female Nude Sketch-27.4.9 (72)

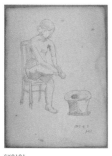 

SK0191
坐姿裸女速寫-27.4.9（73）Seated Female Nude Sketch-27.4.9 (73)

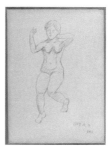 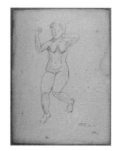

SK0192
蹲姿裸女速寫-27.4.9（6）Squatting Female Nude Sketch-27.4.9 (6)

SK0193
坐姿裸女速寫-27.4.9（74）Seated Female Nude Sketch-27.4.9 (74)

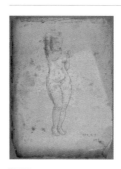 

SK0194
立姿裸女速寫-27.4.9（90）Standing Female Nude Sketch-27.4.9 (90)

SK0195
立姿裸女速寫-27.4.9（91）Standing Female Nude Sketch-27.4.9 (91)

SK0196
坐姿裸女速寫-27.4.9（75）Seated Female Nude Sketch-27.4.9 (75)

SK0197
坐姿裸女速寫-27.4.9（76）Seated Female Nude Sketch-27.4.9 (76)

SK0198
立姿裸女速寫-27.4.9（92）Standing Female Nude Sketch-27.4.9 (92)

 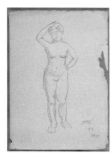

SK0199
立姿裸女速寫-27.4.9（93）Standing Female Nude Sketch-27.4.9 (93)

SK0200
立姿裸女速寫-27.4.9（94）Standing Female Nude Sketch-27.4.9 (94)

SK0201
立姿裸女速寫-27.4.16（95） Standing Female Nude Sketch-27.4.16 (95)

SK0202
立姿裸女速寫-27.4.16（96） Standing Female Nude Sketch-27.4.16 (96)

SK0203
立姿裸女速寫-27.4.16（97） Standing Female Nude Sketch-27.4.16 (97)

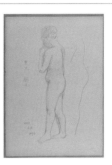

SK0204
立姿裸女速寫-27.4.16（98） Standing Female Nude Sketch-27.4.16 (98)

SK0206
坐姿裸女速寫-27.4.16（77） Seated Female Nude Sketch-27.4.16 (77)

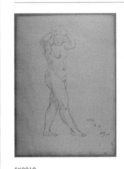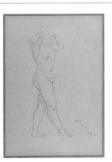

SK0210
立姿裸女速寫-27.4.16（100） Standing Female Nude Sketch-27.4.16 (100)

SK0211
坐姿裸女速寫-27.4.16（79） Seated Female Nude Sketch-27.4.16 (79)

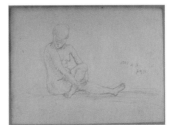

SK0212
坐姿裸女速寫-27.4.16（80） Seated Female Nude Sketch-27.4.16 (80)

SK0213
立姿裸女速寫-27.4.16（101） Standing Female Nude Sketch-27.4.16 (101)

SK0214
立姿裸女速寫-27.4.16（102） Standing Female Nude Sketch-27.4.16 (102)

SK0215
立姿裸女速寫-27.4.16（103） Standing Female Nude Sketch-27.4.16 (103)

SK0216
坐姿裸女速寫-27.4.16（81） Seated Female Nude Sketch-27.4.16 (81)

SK0217
跪姿裸女速寫-27.4.16（5） Kneeling Female Nude Sketch-27.4.16 (5)

SK0218
立姿裸女速寫-27.4.23（104） Standing Female Nude Sketch-27.4.23 (104)

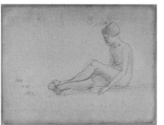

SK0219
坐姿裸女速寫-27.4.23（82） Seated Female Nude Sketch-27.4.23 (82)

SK0220
坐姿裸女速寫-27.4.23（83） Seated Female Nude Sketch-27.4.23 (83)

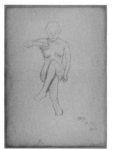
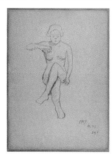

SK0221
坐姿裸女速寫-27.4.23（84） Seated Female Nude Sketch-27.4.23 (84)

SK0222
女體速寫-27.4.23（2） Female Body Sketch-27.4.23 (2)

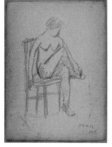

SK0223
坐姿裸女速寫-27.4.23（85） Seated Female Nude Sketch-27.4.23 (85)

SK0224
女體速寫-27.4.23（3） Female Body Sketch-27.4.23 (3)

SK0225
坐姿裸女速寫-27.4.23（86） Seated Female Nude Sketch-27.4.23 (86)

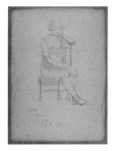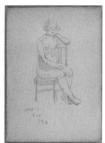

SK0226
坐姿裸女速寫-27.4.30（87） Seated Female Nude Sketch-27.4.30 (87)

SK0227
坐姿裸女速寫-27.4.30（88） Seated Female Nude Sketch-27.4.30 (88)

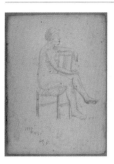

SK0228
坐姿裸女速寫-27.4.30（89） Seated Female Nude Sketch-27.4.30 (89)

SK0230
立姿裸女速寫-27.4.30（105） Standing Female Nude Sketch-27.4.30 (105)

SK0231
立姿裸女速寫-27.4.30（106） Standing Female Nude Sketch-27.4.30 (106)

SK0232
坐姿裸女速寫-27.4.30（91） Seated Female Nude Sketch-27.4.30 (91)

SK0233
坐姿裸女速寫-27.5.14（92） Seated Female Nude Sketch-27.5.14 (92)

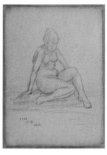

SK0234
坐姿裸女速寫-27.5.14（93） Seated Female Nude Sketch-27.5.14 (93)

SK0235
坐姿裸女速寫-27.5.14（94） Seated Female Nude Sketch-27.5.14 (94)

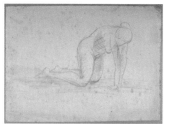
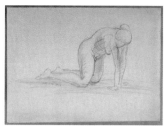

SK0236
坐姿裸女速寫-27.5.14（95）Seated Female Nude Sketch-27.5.14 (95)

SK0237
跪姿裸女速寫-27.5.14（6）Kneeling Female Nude Sketch-27.5.14 (6)

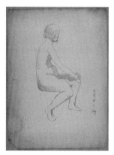
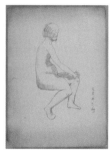

SK0238
坐姿裸女速寫-27.5.14（96）Seated Female Nude Sketch-27.5.14 (96)

SK0239
立姿裸女速寫-27（107）Standing Female Nude Sketch-27 (107)

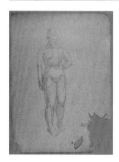
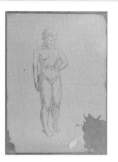

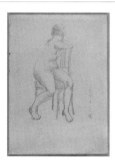

SK0240
坐姿裸女速寫-27.5.21（97）Seated Female Nude Sketch-27.5.21 (97)

SK0242
坐姿裸女速寫-27.5.21（99）Seated Female Nude Sketch-27.5.21 (99)

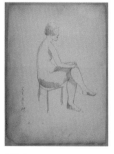
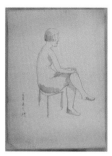
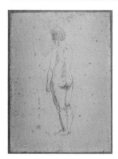

SK0243
坐姿裸女速寫-27.5.21（100）Seated Female Nude Sketch-27.5.21 (100)

SK0244
立姿裸女速寫-27.5.21（108）Standing Female Nude Sketch-27.5.21 (108)

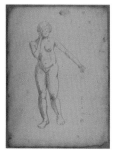
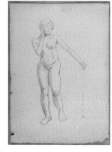

SK0245
立姿裸女速寫-27.5.21（109）Standing Female Nude Sketch-27.5.21 (109)

SK0246
立姿裸女速寫-27.5.21（110）Standing Female Nude Sketch-27.5.21 (110)

SK0247
立姿裸女速寫-27.5.21（111）Standing Female Nude Sketch-27.5.21 (111)

SK0248
立姿裸女速寫-27.5.21（112）Standing Female Nude Sketch-27.5.21 (112)

SK0249
立姿裸女速寫-27.5.21（113）Standing Female Nude Sketch-27.5.21 (113)

SK0250
立姿裸女速寫-27.5.21（114）Standing Female Nude Sketch-27.5.21 (114)

SK0251
立姿裸女速寫-27.5.21（115）Standing Female Nude Sketch-27.5.21 (115)

SK0254
立姿裸女速寫-27.11.19（116）Standing Female Nude Sketch-27.11.19 (116)

SK0255
立姿裸女速寫-27.11.19（117）Standing Female Nude Sketch-27.11.19 (117)

SK0256
立姿裸女速寫-27.11.19（118）Standing Female Nude Sketch-27.11.19 (118)

SK0257
立姿裸女速寫-27.11.19（119）Standing Female Nude Sketch-27.11.19 (119)

SK0258
蹲姿裸女速寫-27.11.19（8）Squatting Female Nude Sketch-27.11.19 (8)

SK0260
坐姿裸女速寫-27.11（104） Seated Female Nude Sketch-27.11 (104)

SK0261
坐姿裸女速寫-27.11（105） Seated Female Nude Sketch-27.11 (105)

SK0263
立姿裸女速寫-27.11（120） Standing Female Nude Sketch-27.11 (120)

SK0264
立姿裸女速寫-27.11（121） Standing Female Nude Sketch-27.11 (121)

SK0265
跪姿裸女速寫-27.11（7） Kneeling Female Nude Sketch-27.11 (7)

SK0408
坐姿裸女速寫（148） Seated Female Nude Sketch (148)

SK0467
立姿裸女速寫（195） Standing Female Nude Sketch (195)

SK0468
立姿裸女速寫（196） Standing Female Nude Sketch (196)

SK0506
人物速寫（17） Figure Sketch (17)

SK0517
頭像速寫（16） Portrait Sketch (16)

SK0525
立姿裸女速寫-28.2.10（216）Standing Female Nude Sketch-28.2.10 (216)

SK0534
女體速寫-28.2.17（19）Female Body Sketch-28.2.17 (19)

SK0584
立姿裸女速寫-28.3.3（240）Standing Female Nude Sketch-28.3.3 (240)

SK0585
立姿裸女速寫-28.3.3（241）Standing Female Nude Sketch-28.3.3 (241)

SK0594
立姿裸女速寫-28.3.10（243）Standing Female Nude Sketch-28.3.10 (243)

SK0595
立姿裸女速寫-28.3.10（244）Standing Female Nude Sketch-28.3.10 (244)

SK0597
立姿裸女速寫-28.3.15（245）Standing Female Nude Sketch-28.3.15 (245)

 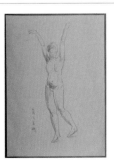

SK0599
立姿裸女速寫-28.3.15（247）Standing Female Nude Sketch-28.3.15 (247)

SK0601
坐姿裸女速寫-28.3.18（232）Seated Female Nude Sketch-28.3.18 (232)

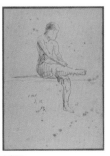 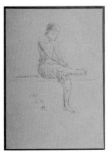

SK0602
坐姿裸女速寫-28.3.18（233）Seated Female Nude Sketch-28.3.18 (233)

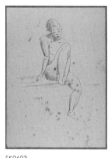 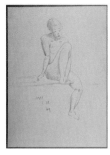

SK0603
坐姿裸女速寫-28.3.18（234） Seated Female Nude Sketch-28.3.18 (234)

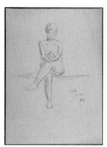 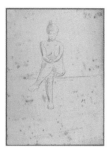

SK0606
坐姿裸女速寫-28.3.18（237） Seated Female Nude Sketch-28.3.18 (237)

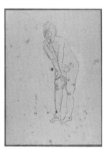 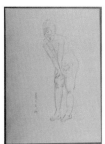

SK0610
立姿裸女速寫-28.3.18（248） Standing Female Nude Sketch-28.3.18 (248)

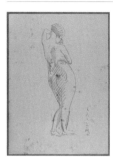 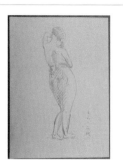

SK0611
立姿裸女速寫-28.3.18（249） Standing Female Nude Sketch-28.3.18 (249)

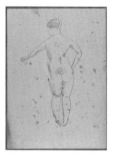 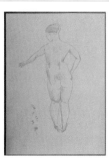

SK0612
立姿裸女速寫-28.3.18（250） Standing Female Nude Sketch-28.3.18 (250)

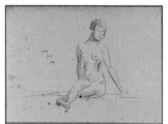 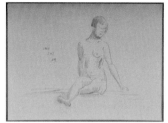

SK0617
坐姿裸女速寫-28.3.23（241） Seated Female Nude Sketch-28.3.23 (241)

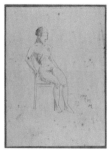 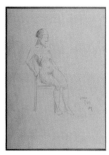

SK0618
坐姿裸女速寫-28.3.23（242） Seated Female Nude Sketch-28.3.23 (242)

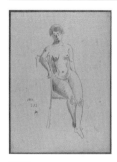 

SK0619
坐姿裸女速寫-28.3.23（243） Seated Female Nude Sketch-28.3.23 (243)

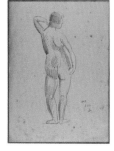 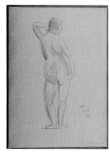

SK0624
立姿裸女速寫-28.3.23（256） Standing Female Nude Sketch-28.3.23 (256)

SK0625
立姿裸女速寫-28.3.23（257） Standing Female Nude Sketch-28.3.23 (257)

SK0626
立姿裸女速寫-28.3.23（258） Standing Female Nude Sketch-28.3.23 (258)

SK0627
立姿裸女速寫-28.3.23（259） Standing Female Nude Sketch-28.3.23 (259)

SK0628
立姿裸女速寫-28.3.23（260） Standing Female Nude Sketch-28.3.23 (260)

 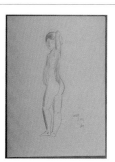

SK0629
立姿裸女速寫-28.3.23（261） Standing Female Nude Sketch-28.3.23 (261)

 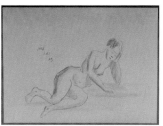

SK0631
臥姿裸女速寫-28.3.23（28） Reclining Female Nude Sketch-28.3.23 (28)

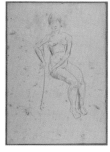 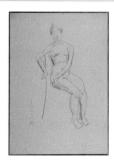

SK0634
坐姿裸女速寫-28.3.31（246） Seated Female Nude Sketch-28.3.31 (246)

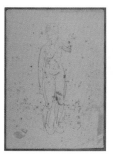 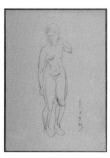

SK0643
立姿裸女速寫-28.3.31（265） Standing Female Nude Sketch-28.3.31 (265)

*為前一張之背面圖。

SK0644
頭像速寫（18） Portrait Sketch (18)

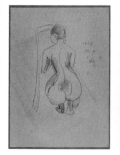 

SK0669
蹲姿裸女速寫-28.12.7（15） Squatting Female Nude Sketch-28.12.7 (15)

 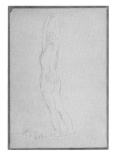

SK0674
立姿裸女速寫-29.2.10（282） Standing Female Nude Sketch-29.2.10 (282)

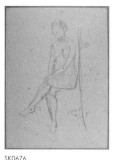 

SK0676
坐姿裸女速寫-29.3.9（258） Seated Female Nude Sketch-29.3.9 (258)

SK0677
坐姿裸女速寫-29.3.9（259） Seated Female Nude Sketch-29.3.9 (259)

SK0681
立姿裸女速寫-29.3.9（284） Standing Female Nude Sketch-29.3.9 (284)

SK0682
立姿裸女速寫-29.3.9（285） Standing Female Nude Sketch-29.3.9 (285)

SK0683
立姿裸女速寫-29.3.9（286） Standing Female Nude Sketch-29.3.9 (286)

SK0684
立姿裸女速寫-29.3.9（287） Standing Female Nude Sketch-29.3.9 (287)

 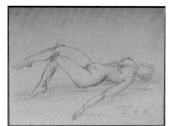

SK0685
立姿裸女速寫-29.3.9（288） Standing Female Nude Sketch-29.3.9 (288)

SK0687
臥姿裸女速寫-29.3.9（33） Reclining Female Nude Sketch-29.3.9 (33)

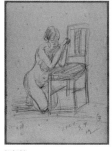 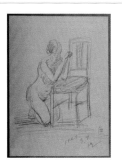

SK0688
臥姿裸女速寫-29.3.9（34） Reclining Female Nude Sketch-29.3.9 (34)

SK0689
跪姿裸女速寫-29.3.9（21） Kneeling Female Nude Sketch-29.3.9 (21)

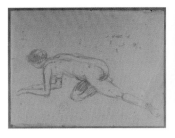

SK0690
跪姿裸女速寫-29.3.9（22）Kneeling Female Nude Sketch-29.3.9 (22)

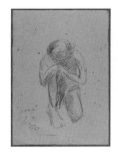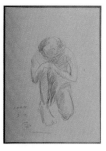

SK0691
跪姿裸女速寫-29.3.9（23）Kneeling Female Nude Sketch-29.3.9 (23)

SK0694
坐姿裸女速寫-29.3.23（265）Seated Female Nude Sketch-29.3.23 (265)

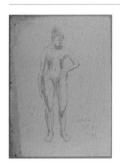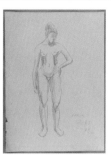

SK0696
立姿裸女速寫-29.3.23（289）Standing Female Nude Sketch-29.3.23 (289)

SK0697
立姿裸女速寫-29.3.23（290）Standing Female Nude Sketch-29.3.23 (290)

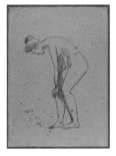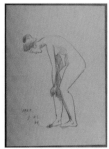

SK0699
立姿裸女速寫-29.3.23（292）Standing Female Nude Sketch-29.3.23 (292)

SK0713
立姿裸女速寫-29.7.13（295）Standing Female Nude Sketch-29.7.13 (295)

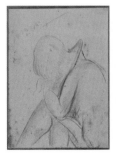

SK0736
人物速寫-30.1.15（24）Figure Sketch-30.1.15 (24)

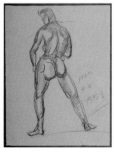

SK0737
立姿裸男速寫-30.4.2（1）Standing Male Nude Sketch-30.4.2 (1)

SK0738
立姿裸男速寫-30.4.2（2）Standing Male Nude Sketch-30.4.2 (2)

SK0740
立姿裸男速寫-30.4.2（4）Standing Male Nude Sketch-30.4.2 (4)

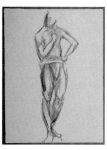
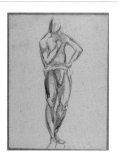

SK0753
立姿裸男速寫（6）Standing Male Nude Sketch (6)

SK0754
立姿裸男速寫（7）Standing Male Nude Sketch (7)

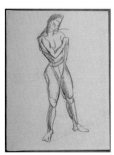
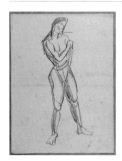

SK0755
立姿裸男速寫（8）Standing Male Nude Sketch (8)

SK0759
人物速寫（25）Figure Sketch (25)

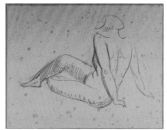
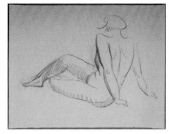

SK0916
坐姿裸女速寫（339）Seated Female Nude Sketch (339)

SK0944
坐姿裸女速寫（362）Seated Female Nude Sketch (362)

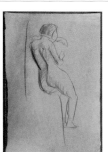
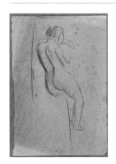

SK0948
坐姿裸女速寫（366）Seated Female Nude Sketch (366)

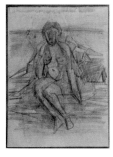

SK0955
坐姿裸女速寫（372）Seated Female Nude Sketch (372)

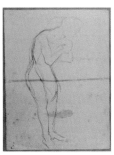
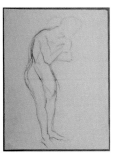

SK0959
立姿裸女速寫（342）Standing Female Nude Sketch (342)

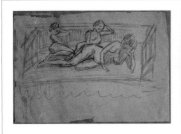

SK0990
臥姿裸女速寫（58） Reclining Female Nude Sketch (58)

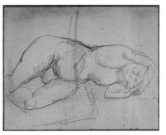

SK0994
臥姿裸女速寫（62） Reclining Female Nude Sketch (62)

SK1019
人物速寫（47） Figure Sketch (47)

SK1057
人物速寫（83） Figure Sketch (83)

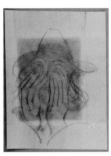

SK1067
頭像速寫（32） Portrait Sketch (32)

*為前一張之背面圖。

SK1068
頭像速寫（33） Portrait Sketch (33)

② 修復、夾裱：205件（16件雙面）
205 works (16 double-sided) - treated, stored in folder

SK0001
手部速寫（1） Hand Sketch (1)

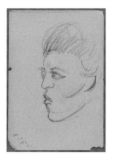

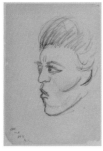

SK0009
頭像速寫-25.10.16（2） Portrait Sketch-25.10.16 (2)

SK0013
坐姿裸女速寫-25.10.17（1） Seated Female Nude Sketch-25.10.17 (1)

SK0038
立姿裸女速寫（21）Standing Female Nude Sketch (21)

 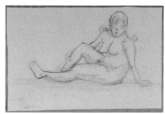

SK0039
坐姿裸女速寫-26.1.16（8）Seated Female Nude Sketch-26.1.16 (8)

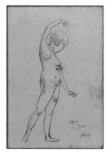 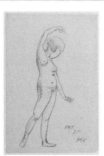

SK0040
坐姿裸女速寫-26.1.16（9）Seated Female Nude Sketch-26.1.16 (9)

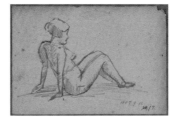 

SK0114
頭像速寫-27.2.26（4）Portrait Sketch-27.2.26 (4)

 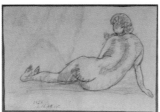

SK0135
立姿裸女速寫-27.3.12（65）Standing Female Nude Sketch-27.3.12 (65)

SK0141
坐姿裸女速寫-27.3.12（48）Seated Female Nude Sketch-27.3.12 (48)

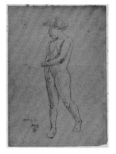 

SK0146
立姿裸女速寫-27.3.19（70）Standing Female Nude Sketch-27.3.19 (70)

SK0178
臥姿裸女速寫-27.4.2（7）Reclining Female Nude Sketch-27.4.2 (7)

SK0181
坐姿裸女速寫-27.4.2（67）Seated Female Nude Sketch-27.4.2 (67)

 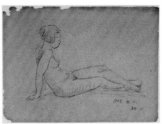

SK0185
坐姿裸女速寫-27.4.2（70）Seated Female Nude Sketch-27.4.2 (70)

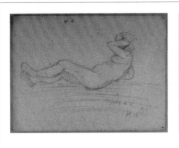

SK0187
臥姿裸女速寫-27.4.2（8）Reclining Female Nude Sketch-27.4.2 (8)

SK0205
蹲姿裸女速寫-27.4.16（7）Squatting Female Nude Sketch-27.4.16 (7)

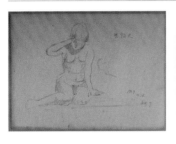

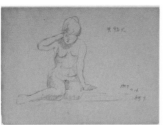

SK0207
坐姿裸女速寫-27.4.16（78）Seated Female Nude Sketch-27.4.16 (78)

SK0208
臥姿裸女速寫-27.4.16（9）Reclining Female Nude Sketch-27.4.16 (9)

SK0209
立姿裸女速寫-27.4.16（99）Standing Female Nude Sketch-27.4.16 (99)

SK0229
坐姿裸女速寫-27.4.30（90）Seated Female Nude Sketch-27.4.30 (90)

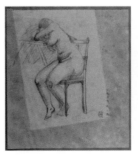

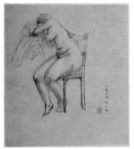

SK0241
坐姿裸女速寫-27.5.21（98）Seated Female Nude Sketch-27.5.21 (98)

SK0252
坐姿裸女速寫-27.9.29（101）Seated Female Nude Sketch-27.9.29 (101)

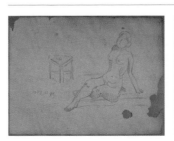

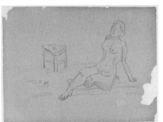

SK0253
坐姿裸女速寫-27.11.19（102）Seated Female Nude Sketch-27.11.19 (102)

SK0259
坐姿裸女速寫-27.11（103）Seated Female Nude Sketch-27.11 (103)

SK0262
坐姿裸女速寫-27.11（106）Seated Female Nude Sketch-27.11 (106)

SK0326
坐姿裸女速寫（132）Seated Female Nude Sketch (132)

SK0469
臥姿裸女速寫（18）Reclining Female Nude Sketch (18)

SK0475
坐姿裸女速寫（199）Seated Female Nude Sketch (199)

SK0476
立姿裸女速寫（200）Standing Female Nude Sketch (200)

SK0477
立姿裸女速寫（201）Standing Female Nude Sketch (201)

SK0478
立姿裸女速寫（202）Standing Female Nude Sketch (202)

SK0479
臥姿裸女速寫（20）Reclining Female Nude Sketch (20)

SK0480
立姿裸女速寫（203）Standing Female Nude Sketch (203)

SK0484
立姿裸女速寫（206）Standing Female Nude Sketch (206)

SK0485
臥姿裸女速寫（21）Reclining Female Nude Sketch (21)

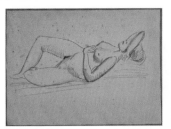
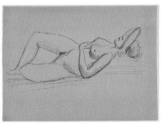

SK0486
臥姿裸女速寫（22）Reclining Female Nude Sketch (22)

SK0487
臥姿裸女速寫（23）Reclining Female Nude Sketch (23)

SK0488
立姿裸女速寫（207）Standing Female Nude Sketch (207)

SK0489
立姿裸女速寫（208）Standing Female Nude Sketch (208)

SK0491
立姿裸女速寫（209）Standing Female Nude Sketch (209)

SK0493
立姿裸女速寫（210）Standing Female Nude Sketch (210)

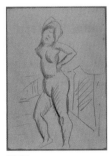
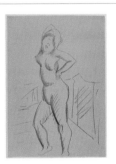

SK0494
立姿裸女速寫（211）Standing Female Nude Sketch (211)

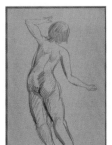
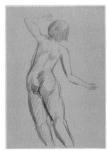

SK0495
立姿裸女速寫（212）Standing Female Nude Sketch (212)

SK0508
頭像速寫（7）Portrait Sketch (7)

SK0533
坐姿裸女速寫-28.2.17（205） Seated Female Nude Sketch-28.2.17 (205)

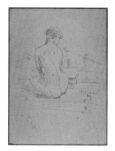
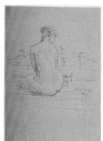

SK0549
坐姿裸女速寫-28.2.25（214） Seated Female Nude Sketch-28.2.25 (214)

SK0574
坐姿與臥姿裸女速寫-28.2（1） Seated and Reclining Female Nude Sketch-28.2 (1)

SK0600
人物速寫-28.3.15（18） Figure Sketch-28.3.15 (18)

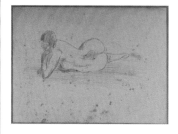
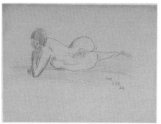

SK0632
臥姿裸女速寫-28.3.23（29） Reclining Female Nude Sketch-28.3.23 (29)

SK0645
立姿裸女速寫-28.3.31（266） Standing Female Nude Sketch-28.3.31 (266)

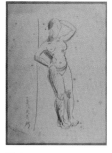
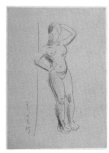

SK0646
立姿裸女速寫-28.3.31（267） Standing Female Nude Sketch-28.3.31 (267)

SK0647
立姿裸女速寫-28.3.31（268） Standing Female Nude Sketch-28.3.31 (268)

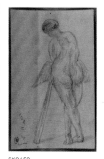
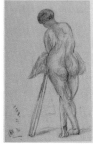

SK0652
立姿裸女速寫-28.11.8（272） Standing Female Nude Sketch-28.11.8 (272)

SK0653
頭像速寫-28.11.8（19） Portrait Sketch-28.11.8 (19)

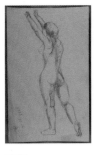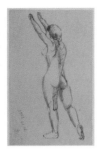

SK0655
立姿裸女速寫-28.11.16（273）Standing Female Nude Sketch-28.11.16 (273)

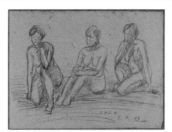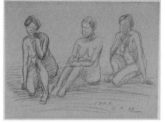

SK0680
坐姿裸女速寫-29.3.9（262）Seated Female Nude Sketch-29.3.9 (262)

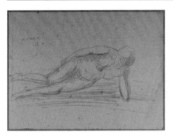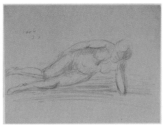

SK0686
臥姿裸女速寫-29.3.9（32）Reclining Female Nude Sketch-29.3.9 (32)

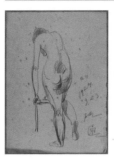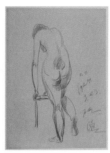

SK0698
立姿裸女速寫-29.3.23（291）Standing Female Nude Sketch-29.3.23 (291)

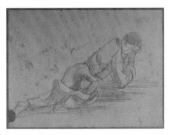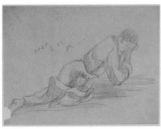

SK0702
人物速寫-29.3.23（20）Figure Sketch-29.3.23 (20)

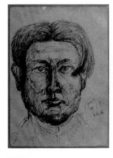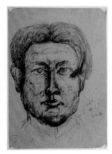

SK0704
頭像速寫-29.4.17（21）Portrait Sketch-29.4.17 (21)

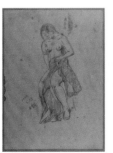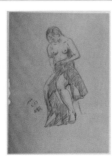

SK0706
坐姿裸女速寫-29.5.13（268）Seated Female Nude Sketch-29.5.13 (268)

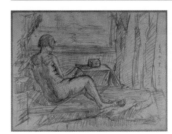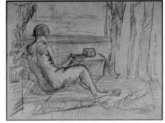

SK0711
坐姿裸女速寫-29.6.27（269）Seated Female Nude Sketch-29.6.27 (269)

*為前一張之背面圖。

SK0712
頭像速寫（22）Portrait Sketch (22)

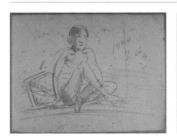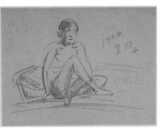

SK0715
坐姿裸女速寫-29.7.13（270）Seated Female Nude Sketch-29.7.13 (270)

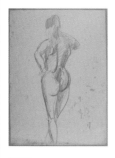
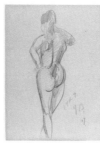

SK0718
立姿裸女速寫-29.7.13（297） Standing Female Nude Sketch-29.7.13 (297)

SK0719
臥姿裸女速寫-29.7.13（39） Reclining Female Nude Sketch-29.7.13 (39)

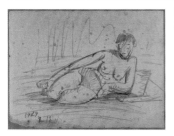
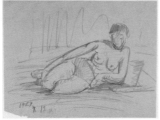

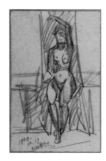
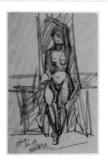

SK0724
臥姿裸女速寫-29.7.13（40） Reclining Female Nude Sketch-29.7.13 (40)

SK0726
立姿裸女速寫-29.12.17（298） Standing Female Nude Sketch-29.12.17 (298)

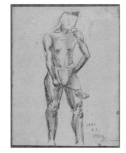
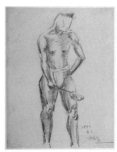

SK0730
畫室速寫（1） Studio Sketch (1)

SK0739
立姿裸男速寫-30.4.2（3） Standing Male Nude Sketch-30.4.2 (3)

SK0741
在九段的舞廳-30.7 A Dance Hall in Kudan-30.7

SK0743
臥姿裸女速寫-30.11.5（41） Reclining Female Nude Sketch-30.11.5 (41)

SK0744
坐姿裸女速寫-30.11.13（281） Seated Female Nude Sketch-30.11.13 (281)

SK0745
立姿裸女速寫-30.11.15（302） Standing Female Nude Sketch-30.11.15 (302)

SK0746
坐姿與臥姿裸女速寫-30.11.15（2）Seated and Reclining Female Nude Sketch-30.11.15 (2)

SK0747
法國公園一隅-30.11.21 A Corner in French Park-30.11.21

SK0748
坐姿裸女速寫-30.11.24（282）Seated Female Nude Sketch-30.11.24 (282)

SK0750
重光-30.12.8 Tsung-kuang-30.12.8

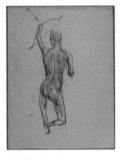
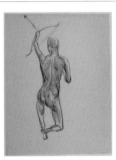

SK0757
跪姿裸男速寫（1）Kneeling Male Nude Sketch (1)

SK0758
頭像速寫（23）Portrait Sketch (23)

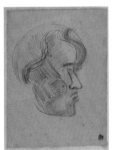
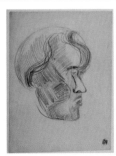

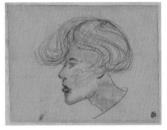
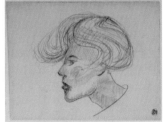

SK0760
頭像速寫（24）Portrait Sketch (24)

SK0761
風景速寫（1）Landscape Sketch (1)

*為前一張之背面圖。

SK0762
教子-31.3.18 Tutoring the Son-31.3.18

SK0763
人物速寫（26）Figure Sketch (26)

SK0768
林蔭小學演劇-31.6.14 Drama Performance of Linyin Elementary School-31.6.14

SK0769
人物速寫（27）Figure Sketch (27)

SK0771
臥姿裸女速寫-31.7.2（43）Reclining Female Nude Sketch-31.7.2 (43)

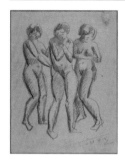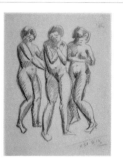

SK0773
立姿裸女速寫-31.8.15（305）Standing Female Nude Sketch-31.8.15 (305)

SK0775
坐姿裸女速寫-31.9.2（285）Seated Female Nude Sketch-31.9.2 (285)

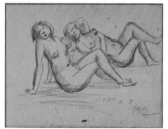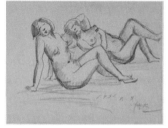

SK0780
坐姿與臥姿裸女速寫-31.9.3（3）Seated and Reclining Female Nude Sketch-31.9.3 (3)

SK0793
坐姿裸女速寫-31.9.8（289）Seated Female Nude Sketch-31.9.8 (289)

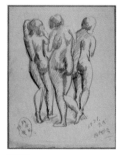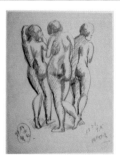

SK0794
群女的快樂-31.9.15 The Joys of Girls-31.9.15

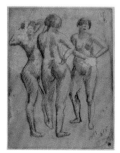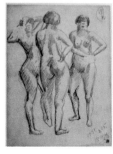

SK0795
休息-31.9.15 Taking a Rest-31.9.15

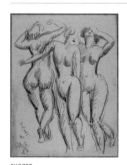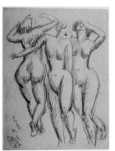

SK0798
立姿裸女速寫-31.9.20（316）Standing Female Nude Sketch-31.9.20 (316)

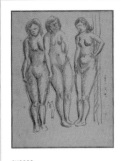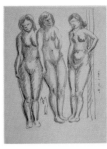

SK0800
立姿裸女速寫-31.10.4（317）Standing Female Nude Sketch-31.10.4 (317)

SK0801
臥姿裸女速寫-31.10.7（44）Reclining Female Nude Sketch-31.10.7 (44)

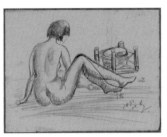

SK0802
坐姿裸女速寫-31.10.8（291）Seated Female Nude Sketch-31.10.8 (291)

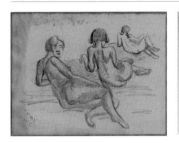

SK0806
臥姿裸女速寫-31.10.8（45）Reclining Female Nude Sketch-31.10.8 (45)

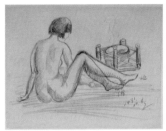

SK0807
跳舞女-31.10.8（1）A Dancer Girl -31.10.8 (1)

*為前一張之背面圖。

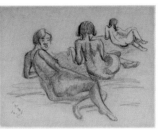

SK0808
跳舞女（2）A Dancer Girl (2)

SK0809
坐姿裸女速寫-31.10.22（294）Seated Female Nude Sketch-31.10.22 (294)

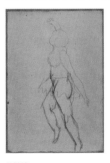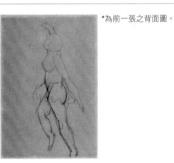

SK0810
立姿裸女速寫-31.10.26（319）Standing Female Nude Sketch-31.10.26 (319)

SK0811
畫家的逍遙-31.10.26 A Carefree Artist-31.10.26

SK0818
人物速寫-31（28）Figure Sketch-31 (28)

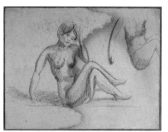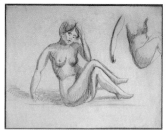

*為前一張之背面圖。

人物速寫（29） Figure Sketch (29)

坐姿裸女速寫（299） Seated Female Nude Sketch (299)

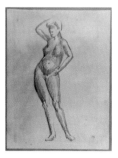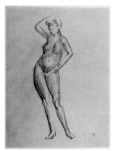

立姿裸女速寫（324） Standing Female Nude Sketch (324)

立姿裸女速寫（325） Standing Female Nude Sketch (325)

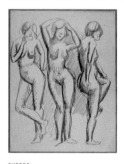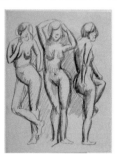

立姿裸女速寫（326） Standing Female Nude Sketch (326)

立姿與坐姿裸女速寫（6） Standing and Seated Female Nude Sketch (6)

坐姿裸女速寫-32.11.26（308） Seated Female Nude Sketch-32.11.26 (308)

坐姿裸女速寫（309） Seated Female Nude Sketch (309)

坐姿裸女速寫-32.11.26（311） Seated Female Nude Sketch-32.11.26 (311)

坐姿裸女速寫（312） Seated Female Nude Sketch (312)

SK0844
坐姿裸女速寫-32.11.26（313）Seated Female Nude Sketch-32.11.26 (313)

SK0845
坐姿裸女速寫-32.11.26（314）Seated Female Nude Sketch-32.11.26 (314)

SK0846
坐姿裸女速寫-32.11.26（315）Seated Female Nude Sketch-32.11.26 (315)

SK0847
坐姿裸女速寫-32.11.26（316）Seated Female Nude Sketch-32.11.26 (316)

*為前一張之背面圖。

SK0848
頭像速寫（25）Portrait Sketch (25)

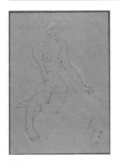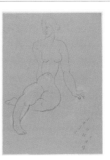

SK0849
坐姿裸女速寫-32.11.26（317）Seated Female Nude Sketch-32.11.26 (317)

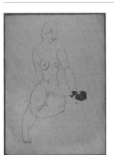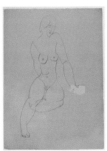

SK0850
坐姿裸女速寫（318）Seated Female Nude Sketch (318)

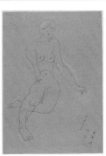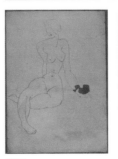

SK0851
坐姿裸女速寫（319）Seated Female Nude Sketch (319)

*為前一張之背面圖。

SK0852
頭像速寫（26）Portrait Sketch (26)

SK0853
立姿裸女速寫-32.11.26（327）Standing Female Nude Sketch-32.11.26 (327)

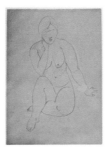

SK0855
坐姿裸女速寫（321）Seated Female Nude Sketch (321)

SK0856
立姿裸女速寫（328）Standing Female Nude Sketch (328)

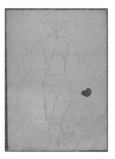
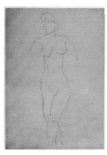

SK0857
立姿裸女速寫（329）Standing Female Nude Sketch (329)

SK0858
臥姿裸女速寫（49）Reclining Female Nude Sketch (49)

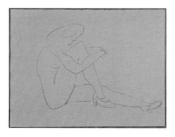

SK0860
坐姿裸女速寫（323）Seated Female Nude Sketch (323)

SK0861
坐姿裸女速寫（324）Seated Female Nude Sketch (324)

SK0862
坐姿裸女速寫（325）Seated Female Nude Sketch (325)

SK0863
坐姿裸女速寫（326）Seated Female Nude Sketch (326)

SK0864
坐姿裸女速寫（327）Seated Female Nude Sketch (327)

SK0865
坐姿裸女速寫（328）Seated Female Nude Sketch (328)

SK0866
坐姿裸女速寫（329）Seated Female Nude Sketch (329)

SK0867
坐姿裸女速寫（330）Seated Female Nude Sketch (330)

*為前一張之背面圖。

SK0868
頭像速寫（27）Portrait Sketch (27)

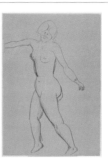

SK0873
立姿裸女速寫（330）Standing Female Nude Sketch (330)

SK0876
立姿裸女速寫（333）Standing Female Nude Sketch (333)

SK0877
立姿裸女速寫（334）Standing Female Nude Sketch (334)

SK0878
立姿裸女速寫（335）Standing Female Nude Sketch (335)

SK0881
立姿裸女速寫（337）Standing Female Nude Sketch (337)

SK0884
臥姿裸女速寫（51）Reclining Female Nude Sketch (51)

SK0885
臥姿裸女速寫（52）Reclining Female Nude Sketch (52)

SK0886
臥姿裸女速寫（53） Reclining Female Nude Sketch (53)

SK0887
臥姿裸女速寫（54） Reclining Female Nude Sketch (54)

SK0889
臥姿裸女速寫（56） Reclining Female Nude Sketch (56)

SK0890
坐姿與臥姿裸女速寫（4） Seated and Reclining Female Nude Sketch (4)

SK0891
人物速寫（30） Figure Sketch (30)

SK0911
風景速寫-45.12.6（4） Landscape Sketch-45.12.6 (4)

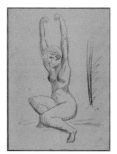
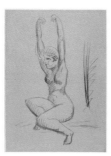

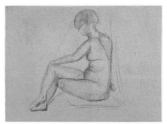

SK0924
坐姿裸女速寫（347） Seated Female Nude Sketch (347)

SK0925
坐姿裸女速寫（348） Seated Female Nude Sketch (348)

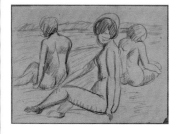
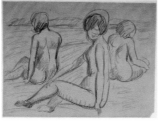

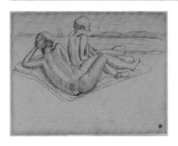
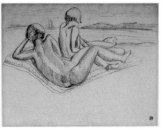

SK0926
坐姿裸女速寫（349） Seated Female Nude Sketch (349)

SK0927
坐姿與臥姿裸女速寫（5） Seated and Reclining Female Nude Sketch (5)

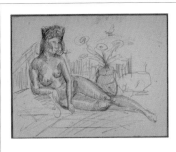
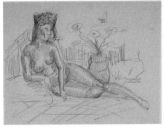

SK0936
坐姿裸女速寫（356）Seated Female Nude Sketch (356)

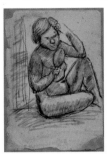
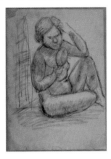

SK0954
坐姿裸女速寫（371）Seated Female Nude Sketch (371)

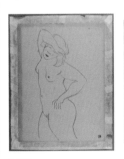
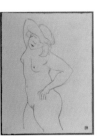

SK0982
立姿裸女速寫（362）Standing Female Nude Sketch (362)

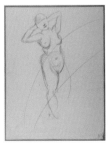
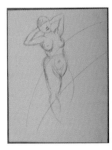

SK0984
立姿裸女速寫（364）Standing Female Nude Sketch (364)

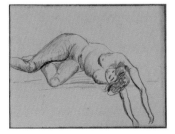
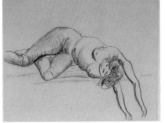

SK0991
臥姿裸女速寫（59）Reclining Female Nude Sketch (59)

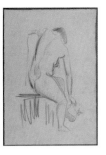

SK0947
坐姿裸女速寫（365）Seated Female Nude Sketch (365)

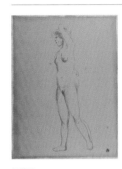
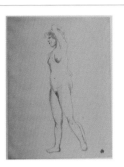

SK0965
立姿裸女速寫（346）Standing Female Nude Sketch (346)

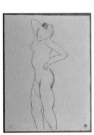

＊為前一張之背面圖，修復前有托裱。

SK0983
立姿裸女速寫（363）Standing Female Nude Sketch (363)

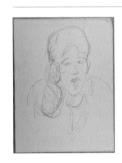

＊為前一張之背面圖。

SK0985
頭像速寫（29）Portrait Sketch (29)

SK0993
臥姿裸女速寫（61）Reclining Female Nude Sketch (61)

SK1001
人物速寫（32）Figure Sketch (32)

SK1007
人物速寫（37）Figure Sketch (37)

SK1008
人物速寫（38）Figure Sketch (38)

SK1010
人物速寫（40）Figure Sketch (40)

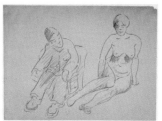

SK1011
坐姿裸女與人物速寫（3）Seated Female Nude and Figure Sketch (3)

SK1012
人物速寫（41）Figure Sketch (41)

*為前一張之背面圖。

SK1013
跪姿裸女速寫（25）Kneeling Female Nude Sketch (25)

SK1017
人物速寫（45）Figure Sketch (45)

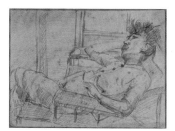
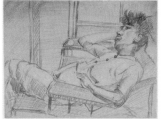

SK1020
人物速寫（48）Figure Sketch (48)

SK1022
人物速寫（49）Figure Sketch (49)

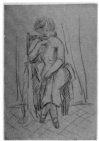

SK1023
人物速寫（50）Figure Sketch (50)

SK1024
人物速寫（51）Figure Sketch (51)

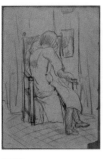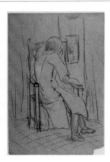

SK1025
人物速寫（52）Figure Sketch (52)

SK1026
人物速寫（53）Figure Sketch (53)

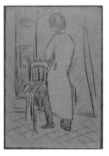

SK1027
人物速寫（54）Figure Sketch (54)

SK1028
人物速寫（55）Figure Sketch (55)

SK1029
人物速寫（56）Figure Sketch (56)

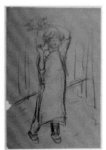

SK1030
人物速寫（57）Figure Sketch (57)

SK1031
人物速寫（58）Figure Sketch (58)

SK1032
人物速寫（59）Figure Sketch (59)

SK1033
人物速寫（60）Figure Sketch (60)

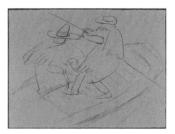

SK1034
人物速寫（61）Figure Sketch (61)

SK1035
人物速寫（62）Figure Sketch (62)

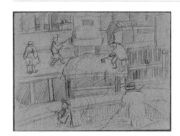

SK1036
人物速寫（63）Figure Sketch (63)

SK1038
人物速寫（65）Figure Sketch (65)

*為前一張之背面圖。

SK1039
頭像速寫（31）Portrait Sketch (31)

SK1040
人物速寫（66）Figure Sketch (66)

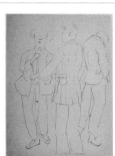

SK1041
人物速寫（67）Figure Sketch (67)

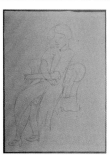

SK1042
人物速寫（68）Figure Sketch (68)

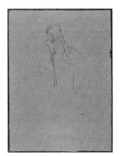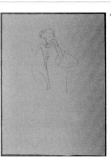

*為前一張之背面圖。

SK1043
人物速寫（69）Figure Sketch (69)

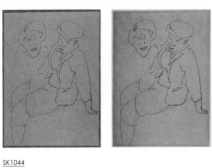

SK1044
人物速寫（70）Figure Sketch (70)

*為前一張之背面圖。

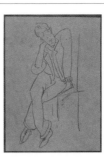
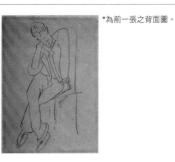

SK1045
人物速寫（71）Figure Sketch (71)

SK1046
人物速寫（72）Figure Sketch (72)

SK1047
人物速寫（73）Figure Sketch (73)

SK1048
人物速寫（74）Figure Sketch (74)

SK1049
人物速寫（75）Figure Sketch (75)

SK1050
人物速寫（76）Figure Sketch (76)

SK1051
人物速寫（77）Figure Sketch (77)

SK1052
人物速寫（78）Figure Sketch (78)

*為前一張之背面圖。

SK1053
人物速寫（79）Figure Sketch (79)

SK1061
人物速寫（86）Figure Sketch (86)

SK1071
狗 Dog

＊為前一張之背面圖，修復前有托裱。

SK1072
雞 Chicken

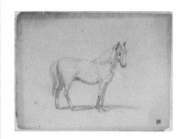

SK1073
馬 Horse

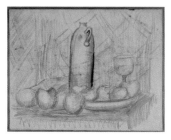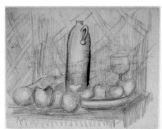

SK1074
靜物速寫（1）Still Life Sketch (1)

SK1077
靜物速寫（4）Still Life Sketch (4)

＊為前一張之背面圖。

SK1078
靜物速寫（5）Still Life Sketch (5)

SK1084
風景速寫（8）Landscape Sketch (8)

SK1085
風景速寫（9）Landscape Sketch (9)

SK1086
風景速寫（10）Landscape Sketch (10)

SK1087
合歡山 Hehuan Mountain

SK1088
風景速寫（11）Landscape Sketch (11)

SK1089
風景速寫（12）Landscape Sketch (12)

SK1090
風景速寫（13）Landscape Sketch (13)

SK1091
風景速寫（14）Landscape Sketch (14)

SK1092
風景速寫（15）Landscape Sketch (15)

SK1097
風景速寫（20）Landscape Sketch (20)

SK1100
風景速寫（23）Landscape Sketch (23)

③ 清潔：377件（5件雙面）
377 works (5 double-sided) - surface cleaned

SK0003
立姿裸女速寫-25.10.5（2）Standing Female Nude Sketch-25.10.5 (2)

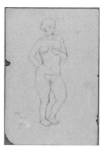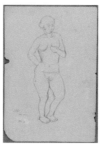

SK0004
立姿裸女速寫-25.10.5（3） Standing Female Nude Sketch-25.10.5 (3)

SK0005
立姿裸女速寫-25.10.10（4） Standing Female Nude Sketch-25.10.10 (4)

SK0006
頭像與人體速寫-25.10.10（1） Portrait and Body Sketch-25.10.10 (1)

SK0007
人物速寫-25.10.16（1） Figure Sketch-25.10.16 (1)

SK0008
頭像速寫-25.10.16（1） Portrait Sketch-25.10.16 (1)

SK0010
人物速寫-25.10.17（2） Figure Sketch-25.10.17 (2)

SK0011
立姿裸女速寫-25.10.17（5） Standing Female Nude Sketch-25.10.17 (5)

SK0012
立姿裸女速寫-25.10.17（6） Standing Female Nude Sketch-25.10.17 (6)

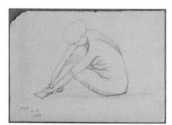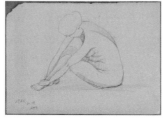

SK0014
坐姿裸女速寫-25.10.17（2） Seated Female Nude Sketch-25.10.17 (2)

SK0015
立姿裸女速寫-25.10.17（7） Standing Female Nude Sketch-25.10.17 (7)

SK0016
臥姿裸女速寫-25.10.17（1） Reclining Female Nude Sketch-25.10.17 (1)

SK0017
立姿裸女速寫-25.10.17（8） Standing Female Nude Sketch-25.10.17 (8)

SK0018
跪姿裸女速寫-25.10.17（1） Kneeling Female Nude Sketch-25.10.17 (1)

SK0019
坐姿裸女速寫-25.10.17（3） Seated Female Nude Sketch-25.10.17 (3)

SK0020
臥姿裸女速寫-25.10.17（2） Reclining Female Nude Sketch-25.10.17 (2)

SK0021
立姿裸女速寫-25.10.24（9） Standing Female Nude Sketch-25.10.24 (9)

SK0022
立姿裸女速寫-25.10.24（10） Standing Female Nude Sketch-25.10.24 (10)

SK0023
立姿裸女速寫-25.10.24（11） Standing Female Nude Sketch-25.10.24 (11)

SK0024
立姿裸女速寫-25.10.24（12） Standing Female Nude Sketch-25.10.24 (12)

SK0025
立姿裸女速寫-25.10.24（13） Standing Female Nude Sketch-25.10.24 (13)

SK0026
立姿裸女速寫-25.10.24（14） Standing Female Nude Sketch-25.10.24 (14)

SK0027
坐姿裸女速寫-25.10.24（4） Seated Female Nude Sketch-25.10.24 (4)

SK0028
立姿裸女速寫-25.10.24（15） Standing Female Nude Sketch-25.10.24 (15)

SK0029
立姿裸女速寫-25.10.24（16） Standing Female Nude Sketch-25.10.24 (16)

SK0030
坐姿裸女速寫-25.10.24（5） Seated Female Nude Sketch-25.10.24 (5)

SK0031
立姿裸女速寫-25.10.24（17） Standing Female Nude Sketch-25.10.24 (17)

SK0032
人物速寫-25.10.24（3） Figure Sketch-25.10.24 (3)

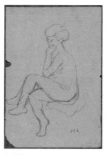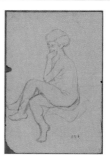

SK0033
坐姿裸女速寫（6） Seated Female Nude Sketch (6)

SK0034
坐姿裸女速寫（7） Seated Female Nude Sketch (7)

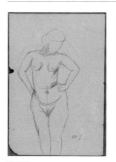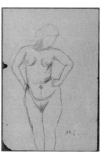

SK0035
立姿裸女速寫（18） Standing Female Nude Sketch (18)

SK0036
立姿裸女速寫（19）Standing Female Nude Sketch (19)

SK0037
立姿裸女速寫（20）Standing Female Nude Sketch (20)

SK0041
坐姿裸女速寫-26.1.30（10）Seated Female Nude Sketch-26.1.30 (10)

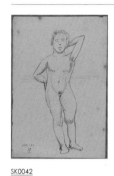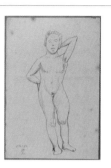

SK0042
立姿裸女速寫-26.1.30（22）Standing Female Nude Sketch-26.1.30 (22)

SK0044
立姿裸女速寫-26.1（24）Standing Female Nude Sketch-26.1 (24)

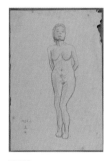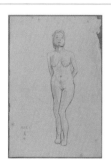

SK0045
立姿裸女速寫-26.1（25）Standing Female Nude Sketch-26.1 (25)

SK0046
蹲姿裸女速寫-26.1（1）Squatting Female Nude Sketch-26.1 (1)

SK0047
蹲姿裸女速寫-26.1（2）Squatting Female Nude Sketch-26.1 (2)

SK0049
立姿裸女速寫-26.2.1（27）Standing Female Nude Sketch-26.2.1 (27)

SK0050
立姿裸女速寫-26.2.1（28）Standing Female Nude Sketch-26.2.1 (28)

SK0051
立姿裸女速寫-26.2.1（29）Standing Female Nude Sketch-26.2.1 (29)

SK0054
立姿裸女速寫-26.2.1（30）Standing Female Nude Sketch-26.2.1 (30)

SK0055
立姿裸女速寫-26.2.1（31）Standing Female Nude Sketch-26.2.1 (31)

SK0056
坐姿裸女速寫（12）Seated Female Nude Sketch (12)

SK0057
坐姿裸女速寫（13）Seated Female Nude Sketch (13)

SK0058
立姿裸女速寫（32）Standing Female Nude Sketch (32)

SK0059
立姿裸女速寫（33）Standing Female Nude Sketch (33)

SK0060
立姿裸女速寫（34）Standing Female Nude Sketch (34)

SK0061
立姿裸女速寫（35）Standing Female Nude Sketch (35)

SK0062
立姿裸女速寫（36）Standing Female Nude Sketch (36)

SK0063
立姿裸女速寫（37）Standing Female Nude Sketch (37)

SK0064
立姿裸女速寫（38）Standing Female Nude Sketch (38)

SK0065
立姿裸女速寫（39）Standing Female Nude Sketch (39)

SK0066
立姿裸女速寫（40）Standing Female Nude Sketch (40)

SK0067
立姿裸女速寫（41）Standing Female Nude Sketch (41)

SK0068
臥姿裸女速寫（3）Reclining Female Nude Sketch (3)

SK0069
蹲姿裸女速寫（3）Squatting Female Nude Sketch (3)

SK0070
女體速寫（1）Female Body Sketch (1)

SK0071
頭像速寫（3）Portrait Sketch (3)

SK0072
人物速寫（4）Figure Sketch (4)

SK0073
人物速寫（5）Figure Sketch (5)

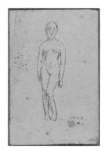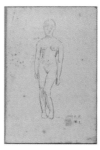

SK0074
立姿裸女速寫-27.2.5（42）Standing Female Nude Sketch-27.2.5 (42)

SK0075
立姿裸女速寫-27.2.5（43）Standing Female Nude Sketch-27.2.5 (43)

SK0076
坐姿裸女速寫-27.2.5（14）Seated Female Nude Sketch-27.2.5 (14)

SK0077
坐姿裸女速寫-27.2.5（15）Seated Female Nude Sketch-27.2.5 (15)

SK0078
坐姿裸女速寫-27.2.5（16）Seated Female Nude Sketch-27.2.5 (16)

SK0079
坐姿裸女速寫-27.2.5（17）Seated Female Nude Sketch-27.2.5 (17)

SK0080
立姿裸女速寫-27.2.5（44）Standing Female Nude Sketch-27.2.5 (44)

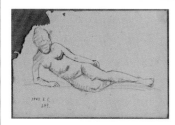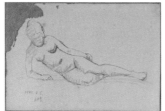

SK0081
臥姿裸女速寫-27.2.5（4）Reclining Female Nude Sketch-27.2.5 (4)

SK0082
坐姿裸女速寫-27.2.5（18）Seated Female Nude Sketch-27.2.5 (18)

SK0084
立姿裸女速寫-27.2.5（46） Standing Female Nude Sketch-27.2.5 (46)

SK0085
立姿裸女速寫-27.2.5（47） Standing Female Nude Sketch-27.2.5 (47)

SK0086
坐姿裸女速寫-27.2.5（19） Seated Female Nude Sketch-27.2.5 (19)

SK0087
坐姿裸女速寫-27.2.5（20） Seated Female Nude Sketch-27.2.5 (20)

SK0088
坐姿裸女速寫-27.2.5（21） Seated Female Nude Sketch-27.2.5 (21)

SK0089
坐姿裸女速寫-27.2.5（22） Seated Female Nude Sketch-27.2.5 (22)

SK0090
臥姿裸女速寫-27.2.5（5） Reclining Female Nude Sketch-27.2.5 (5)

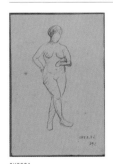 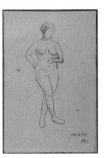

SK0091
立姿裸女速寫-27.2.26（48） Standing Female Nude Sketch-27.2.26 (48)

SK0092
立姿裸女速寫-27.2.26（49） Standing Female Nude Sketch-27.2.26 (49)

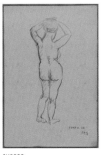 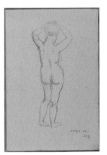

SK0093
立姿裸女速寫-27.2.26（50） Standing Female Nude Sketch-27.2.26 (50)

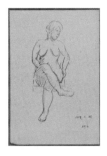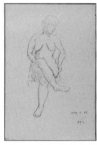

SK0094
坐姿裸女速寫-27.2.26（23） Seated Female Nude Sketch-27.2.26 (23)

SK0095
坐姿裸女速寫-27.2.26（24） Seated Female Nude Sketch-27.2.26 (24)

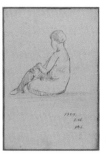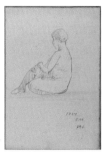

SK0096
坐姿裸女速寫-27.2.26（25） Seated Female Nude Sketch-27.2.26 (25)

SK0097
坐姿裸女速寫-27.2.26（26） Seated Female Nude Sketch-27.2.26 (26)

SK0098
坐姿裸女速寫-27.2.26（27） Seated Female Nude Sketch-27.2.26 (27)

SK0100
坐姿裸女速寫-27.2.26（28） Seated Female Nude Sketch-27.2.26 (28)

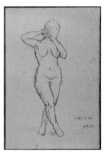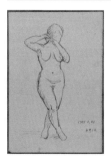

SK0101
立姿裸女速寫-27.2.26（51） Standing Female Nude Sketch-27.2.26 (51)

SK0102
立姿裸女速寫-27.2.26（52） Standing Female Nude Sketch-27.2.26 (52)

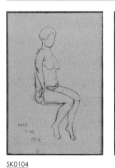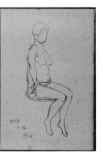

SK0103
立姿裸女速寫-27.2.26（53） Standing Female Nude Sketch-27.2.26 (53)

SK0104
坐姿裸女速寫-27.2.26（29） Seated Female Nude Sketch-27.2.26 (29)

SK0105
坐姿裸女速寫-27.2.26（30）Seated Female Nude Sketch-27.2.26 (30)

SK0106
坐姿裸女速寫-27.2.26（31）Seated Female Nude Sketch-27.2.26 (31)

SK0107
蹲姿裸女速寫-27.2.26（4）Squatting Female Nude Sketch-27.2.26 (4)

SK0108
坐姿裸女速寫-27.2.26（32）Seated Female Nude Sketch-27.2.26 (32)

SK0109
坐姿裸女速寫-27.2.26（33）Seated Female Nude Sketch-27.2.26 (33)

SK0110
坐姿裸女速寫-27.2.26（34）Seated Female Nude Sketch-27.2.26 (34)

SK0111
立姿裸女速寫-27.2.26（54）Standing Female Nude Sketch-27.2.26 (54)

SK0112
立姿裸女速寫-27.2.26（55）Standing Female Nude Sketch-27.2.26 (55)

SK0113
跪姿裸女速寫-27.2.26（3）Kneeling Female Nude Sketch-27.2.26 (3)

SK0115
坐姿裸女速寫-27.3.5（35）Seated Female Nude Sketch-27.3.5 (35)

SK0116
坐姿裸女速寫-27.3.5（36） Seated Female Nude Sketch-27.3.5 (36)

SK0117
立姿裸女速寫-27.3.5（56） Standing Female Nude Sketch-27.3.5 (56)

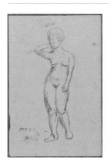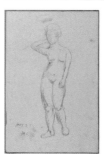

SK0118
立姿裸女速寫-27.3.5（57） Standing Female Nude Sketch-27.3.5 (57)

SK0119
立姿裸女速寫-27.3.5（58） Standing Female Nude Sketch-27.3.5 (58)

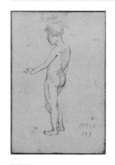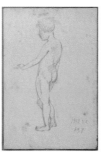

SK0120
立姿裸女速寫-27.3.5（59） Standing Female Nude Sketch-27.3.5 (59)

SK0121
立姿裸女速寫-27.3.5（60） Standing Female Nude Sketch-27.3.5 (60)

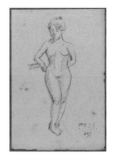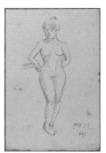

SK0122
立姿裸女速寫-27.3.5（61） Standing Female Nude Sketch-27.3.5 (61)

SK0123
立姿裸女速寫-27.3.5（62） Standing Female Nude Sketch-27.3.5 (62)

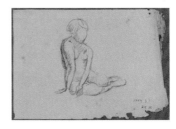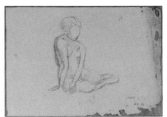

SK0124
坐姿裸女速寫-27.3.5（37） Seated Female Nude Sketch-27.3.5 (37)

SK0125
坐姿裸女速寫-27.3.5（38） Seated Female Nude Sketch-27.3.5 (38)

SK0126
坐姿裸女速寫-27.3.5（39） Seated Female Nude Sketch-27.3.5 (39)

SK0127
坐姿裸女速寫-27.3.5（40） Seated Female Nude Sketch-27.3.5 (40)

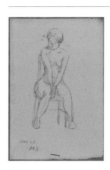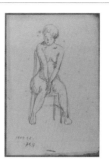

SK0128
坐姿裸女速寫-27.3.5（41） Seated Female Nude Sketch-27.3.5 (41)

SK0129
坐姿裸女速寫-27.3.5（42） Seated Female Nude Sketch-27.3.5 (42)

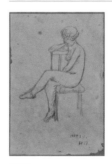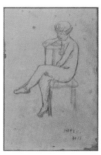

SK0130
坐姿裸女速寫-27.3.5（43） Seated Female Nude Sketch-27.3.5 (43)

SK0131
坐姿裸女速寫-27.3.5（44） Seated Female Nude Sketch-27.3.5 (44)

SK0132
立姿裸女速寫-27.3.12（63） Standing Female Nude Sketch-27.3.12 (63)

SK0133
立姿裸女速寫-27.3.12（64） Standing Female Nude Sketch-27.3.12 (64)

SK0134
跪姿裸女速寫-27.3.12（4） Kneeling Female Nude Sketch-27.3.12 (4)

SK0136
立姿裸女速寫-27.3.12（66） Standing Female Nude Sketch-27.3.12 (66)

SK0137
立姿裸女速寫-27.3.12（67）Standing Female Nude Sketch-27.3.12 (67)

SK0138
坐姿裸女速寫-27.3.12（45）Seated Female Nude Sketch-27.3.12 (45)

SK0139
坐姿裸女速寫-27.3.12（46）Seated Female Nude Sketch-27.3.12 (46)

SK0140
坐姿裸女速寫-27.3.12（47）Seated Female Nude Sketch-27.3.12 (47)

SK0142
坐姿裸女速寫-27.3.12（49）Seated Female Nude Sketch-27.3.12 (49)

SK0362
立姿裸女速寫（166）Standing Female Nude Sketch (166)

SK0470
臥姿裸女速寫（19）Reclining Female Nude Sketch (19)

SK0471
立姿裸女速寫（197）Standing Female Nude Sketch (197)

SK0472
立姿裸女速寫（198）Standing Female Nude Sketch (198)

SK0473
立姿裸女速寫（199）Standing Female Nude Sketch (199)

*為前一張之背面圖。

SK0474
跪姿裸女速寫（17）Kneeling Female Nude Sketch (17)

SK0490
女體速寫（15）Female Body Sketch (15)

SK0510
頭像速寫（9）Portrait Sketch (9)

SK0512
頭像速寫（11）Portrait Sketch (11)

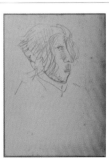

SK0513
頭像速寫（12）Portrait Sketch (12)

SK0514
頭像速寫（13）Portrait Sketch (13)

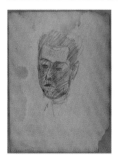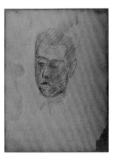

SK0515
頭像速寫（14）Portrait Sketch (14)

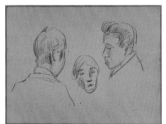

SK0516
頭像速寫（15）Portrait Sketch (15)

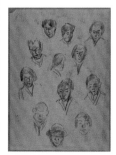

SK0518
頭像速寫（17）Portrait Sketch (17)

SK0519
立姿裸女速寫-28.2.10（213）Standing Female Nude Sketch-28.2.10 (213)

 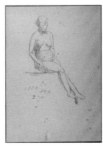

SK0520
坐姿裸女速寫-28.2.10（200） Seated Female Nude Sketch-28.2.10 (200)

SK0521
立姿裸女速寫-28.2.10（214） Standing Female Nude Sketch-28.2.10 (214)

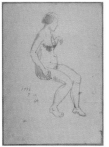 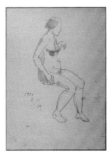

SK0522
坐姿裸女速寫-28.2.10（201） Seated Female Nude Sketch-28.2.10 (201)

 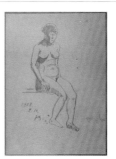

SK0523
坐姿裸女速寫-28.2.10（202） Seated Female Nude Sketch-28.2.10 (202)

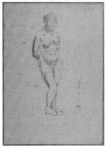 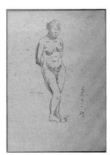

SK0524
立姿裸女速寫-28.2.10（215） Standing Female Nude Sketch-28.2.10 (215)

SK0526
立姿裸女速寫-28.2.10（217） Standing Female Nude Sketch-28.2.10 (217)

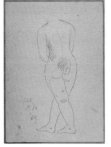 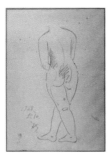

SK0527
女體速寫-28.2.10（17） Female Body Sketch-28.2.10 (17)

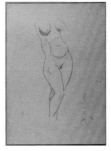 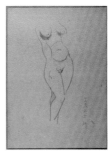

SK0528
女體速寫-28.2.10（18） Female Body Sketch-28.2.10 (18)

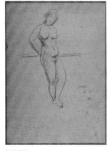 

SK0529
立姿裸女速寫-28.2.17（218） Standing Female Nude Sketch-28.2.17 (218)

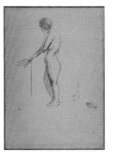 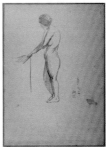

SK0530
立姿裸女速寫-28.2.17（219） Standing Female Nude Sketch-28.2.17 (219)

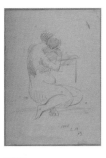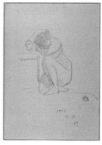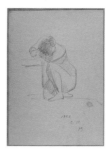

SK0531
坐姿裸女速寫-28.2.17（203） Seated Female Nude Sketch-28.2.17 (203)

SK0532
坐姿裸女速寫-28.2.17（204） Seated Female Nude Sketch-28.2.17 (204)

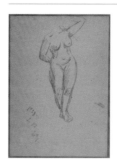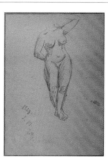

SK0535
女體速寫-28.2.17（20） Female Body Sketch-28.2.17 (20)

SK0536
女體速寫-28.2.17（21） Female Body Sketch-28.2.17 (21)

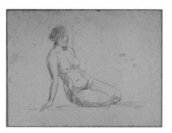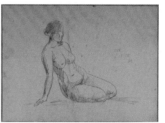

SK0537
女體速寫-28.2.17（22） Female Body Sketch-28.2.17 (22)

SK0538
坐姿裸女速寫-28.2.17（206） Seated Female Nude Sketch-28.2.17 (206)

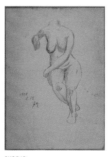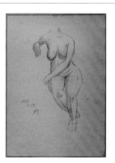

SK0539
女體速寫-28.2.17（23） Female Body Sketch-28.2.17 (23)

SK0540
女體速寫-28.2.17（24） Female Body Sketch-28.2.17 (24)

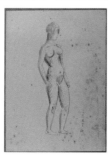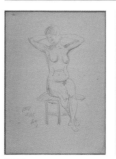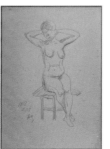

SK0541
立姿裸女速寫-28.2.23（220） Standing Female Nude Sketch-28.2.23 (220)

SK0542
坐姿裸女速寫-28.2.25（207） Seated Female Nude Sketch-28.2.25 (207)

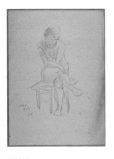

SK0543
坐姿裸女速寫-28.2.25（208） Seated Female Nude Sketch-28.2.25 (208)

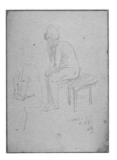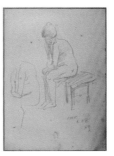

SK0544
坐姿裸女速寫-28.2.25（209） Seated Female Nude Sketch-28.2.25 (209)

SK0545
坐姿裸女速寫-28.2.25（210） Seated Female Nude Sketch-28.2.25 (210)

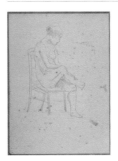

SK0546
坐姿裸女速寫-28.2.25（211） Seated Female Nude Sketch-28.2.25 (211)

SK0547
坐姿裸女速寫-28.2.25（212） Seated Female Nude Sketch-28.2.25 (212)

SK0548
坐姿裸女速寫-28.2.25（213） Seated Female Nude Sketch-28.2.25 (213)

SK0550
坐姿裸女速寫-28.2.25（215） Seated Female Nude Sketch-28.2.25 (215)

SK0551
坐姿裸女速寫-28.2.25（216） Seated Female Nude Sketch-28.2.25 (216)

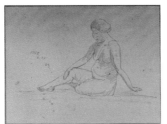

SK0552
坐姿裸女速寫-28.2.25（217） Seated Female Nude Sketch-28.2.25 (217)

SK0553
立姿裸女速寫-28.2.25（221） Standing Female Nude Sketch-28.2.25 (221)

SK0554
立姿裸女速寫-28.2.25（222）Standing Female Nude Sketch-28.2.25 (222)

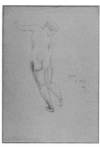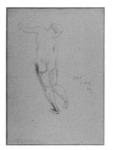

SK0555
立姿裸女速寫-28.2.25（223）Standing Female Nude Sketch-28.2.25 (223)

SK0556
立姿裸女速寫-28.2.25（224）Standing Female Nude Sketch-28.2.25 (224)

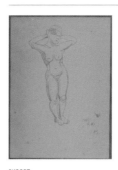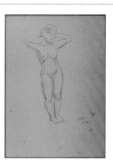

SK0557
立姿裸女速寫-28.2.25（225）Standing Female Nude Sketch-28.2.25 (225)

SK0558
立姿裸女速寫-28.2.25（226）Standing Female Nude Sketch-28.2.25 (226)

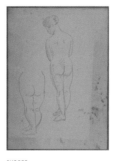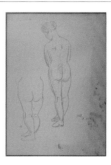

SK0559
立姿裸女速寫-28.2.25（227）Standing Female Nude Sketch-28.2.25 (227)

SK0560
立姿裸女速寫-28.2.25（228）Standing Female Nude Sketch-28.2.25 (228)

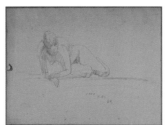

SK0561
臥姿裸女速寫-28.2.25（24）Reclining Female Nude Sketch-28.2.25 (24)

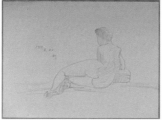

SK0562
臥姿裸女速寫-28.2.25（25）Reclining Female Nude Sketch-28.2.25 (25)

SK0563
臥姿裸女速寫-28.2.25（26）Reclining Female Nude Sketch-28.2.25 (26)

SK0564
臥姿裸女速寫-28.2.25（27） Reclining Female Nude Sketch-28.2.25 (27)

SK0565
立姿裸女速寫-28.2（229） Standing Female Nude Sketch-28.2 (229)

SK0566
立姿裸女速寫-28.2（230） Standing Female Nude Sketch-28.2 (230)

SK0567
立姿裸女速寫-28.2（231） Standing Female Nude Sketch-28.2 (231)

SK0568
坐姿裸女速寫-28.2（218） Seated Female Nude Sketch-28.2 (218)

SK0569
跪姿裸女速寫-28.2（18） Kneeling Female Nude Sketch-28.2 (18)

SK0570
坐姿裸女速寫-28.2（219） Seated Female Nude Sketch-28.2 (219)

SK0571
坐姿裸女速寫-28.2（220） Seated Female Nude Sketch-28.2 (220)

SK0572
坐姿裸女速寫-28.2（221） Seated Female Nude Sketch-28.2 (221)

SK0573
坐姿裸女速寫-28.2（222） Seated Female Nude Sketch-28.2 (222)

SK0575
坐姿裸女速寫-28.2（223）Seated Female Nude Sketch-28.2 (223)

SK0576
立姿裸女速寫-28.3.3（232）Standing Female Nude Sketch-28.3.3 (232)

SK0577
立姿裸女速寫-28.3.3（233）Standing Female Nude Sketch-28.3.3 (233)

SK0578
立姿裸女速寫-28.3.3（234）Standing Female Nude Sketch-28.3.3 (234)

SK0579
立姿裸女速寫-28.3.3（235）Standing Female Nude Sketch-28.3.3 (235)

SK0580
立姿裸女速寫-28.3.3（236）Standing Female Nude Sketch-28.3.3 (236)

SK0581
立姿裸女速寫-28.3.3（237）Standing Female Nude Sketch-28.3.3 (237)

SK0582
立姿裸女速寫-28.3.3（238）Standing Female Nude Sketch-28.3.3 (238)

SK0583
立姿裸女速寫-28.3.3（239）Standing Female Nude Sketch-28.3.3 (239)

SK0586
立姿裸女速寫-28.3.3（242）Standing Female Nude Sketch-28.3.3 (242)

SK0587
坐姿裸女速寫-28.3.3（224） Seated Female Nude Sketch-28.3.3 (224)

SK0588
坐姿裸女速寫-28.3.3（225） Seated Female Nude Sketch-28.3.3 (225)

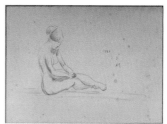

SK0589
坐姿裸女速寫-28.3.3（226） Seated Female Nude Sketch-28.3.3 (226)

SK0590
坐姿裸女速寫-28.3.3（227） Seated Female Nude Sketch-28.3.3 (227)

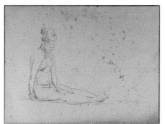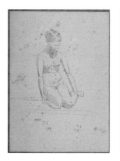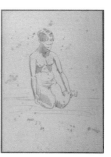

SK0591
坐姿裸女速寫-28.3.3（228） Seated Female Nude Sketch-28.3.3 (228)

SK0592
坐姿裸女速寫-28.3.3（229） Seated Female Nude Sketch-28.3.3 (229)

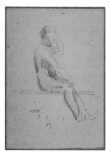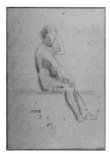

SK0593
坐姿裸女速寫-28.3.3（230） Seated Female Nude Sketch-28.3.3 (230)

SK0596
坐姿裸女速寫-28.3.15（231） Seated Female Nude Sketch-28.3.15 (231)

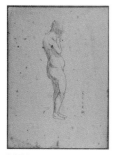

SK0598
立姿裸女速寫-28.3.15（246） Standing Female Nude Sketch-28.3.15 (246)

SK0604
坐姿裸女速寫-28.3.18（235） Seated Female Nude Sketch-28.3.18 (235)

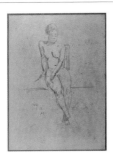

SK0605
坐姿裸女速寫-28.3.18（236）Seated Female Nude Sketch-28.3.18 (236)

SK0607
坐姿裸女速寫-28.3.18（238）Seated Female Nude Sketch-28.3.18 (238)

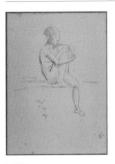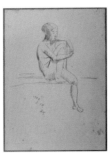

SK0608
坐姿裸女速寫-28.3.18（239）Seated Female Nude Sketch-28.3.18 (239)

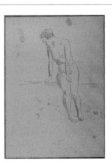

SK0609
坐姿裸女速寫-28.3.18（240）Seated Female Nude Sketch-28.3.18 (240)

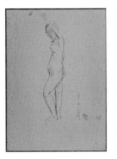

SK0613
立姿裸女速寫-28.3.18（251）Standing Female Nude Sketch-28.3.18 (251)

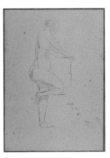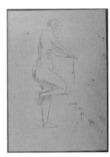

SK0614
立姿裸女速寫-28.3.18（252）Standing Female Nude Sketch-28.3.18 (252)

SK0615
立姿裸女速寫-28.3.18（253）Standing Female Nude Sketch-28.3.18 (253)

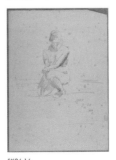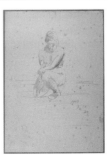

SK06 16
跪姿裸女速寫-28.3.18（19）Kneeling Female Nude Sketch-28.3.18 (19)

SK0620
坐姿裸女速寫-28.3.23（244）Seated Female Nude Sketch-28.3.23 (244)

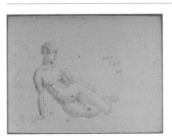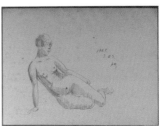

SK0621
坐姿裸女速寫-28.3.23（245）Seated Female Nude Sketch-28.3.23 (245)

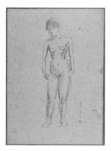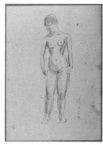

SK0622
立姿裸女速寫-28.3.23（254） Standing Female Nude Sketch-28.3.23 (254)

SK0623
立姿裸女速寫-28.3.23（255） Standing Female Nude Sketch-28.3.23 (255)

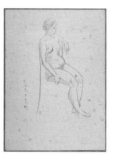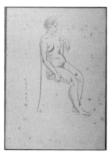

SK0635
坐姿裸女速寫-28.3.31（247） Seated Female Nude Sketch-28.3.31 (247)

SK0636
坐姿裸女速寫-28.3.31（248） Seated Female Nude Sketch-28.3.31 (248)

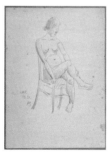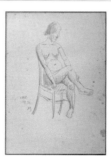

SK0637
坐姿裸女速寫-28.3.31（249） Seated Female Nude Sketch-28.3.31 (249)

SK0638
坐姿裸女速寫-28.3.31（250） Seated Female Nude Sketch-28.3.31 (250)

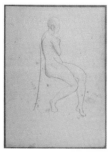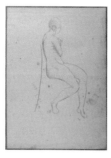

SK0639
坐姿裸女速寫-28.3.31（251） Seated Female Nude Sketch-28.3.31 (251)

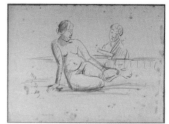

SK0640
坐姿裸女與人物速寫-28.3.31（2） Seated Female Nude and Figure Sketch-28.3.31 (2)

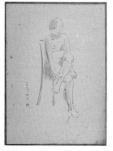

SK0641
坐姿裸女速寫-28.3.31（252） Seated Female Nude Sketch-28.3.31 (252)

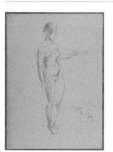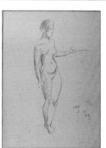

SK0642
立姿裸女速寫-28.3.31（264） Standing Female Nude Sketch-28.3.31 (264)

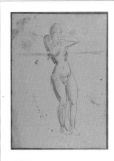
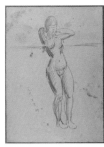

SK0648
立姿裸女速寫-28.3.31（269）Standing Female Nude Sketch-28.3.31 (269)

SK0649
立姿裸女速寫-28.3.31（270）Standing Female Nude Sketch-28.3.31 (270)

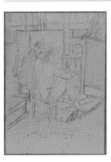
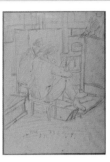

SK0651
人物速寫-28.3.31（19）Figures Sketch-28.3.31 (19)

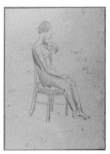

SK0656
坐姿裸女速寫-28.12.7（253）Seated Female Nude Sketch-28.12.7 (253)

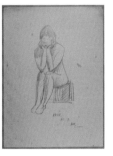
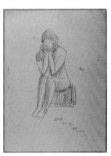

SK0657
坐姿裸女速寫-28.12.7（254）Seated Female Nude Sketch-28.12.7 (254)

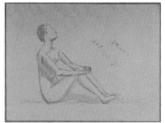
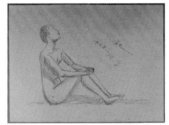

SK0658
坐姿裸女速寫-28.12.7（255）Seated Female Nude Sketch-28.12.7 (255)

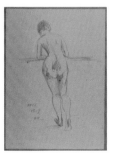
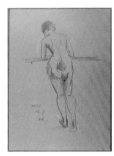

SK0659
立姿裸女速寫-28.12.7（274）Standing Female Nude Sketch-28.12.7 (274)

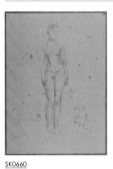
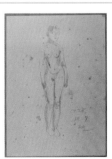

SK0660
立姿裸女速寫-28.12.7（275）Standing Female Nude Sketch-28.12.7 (275)

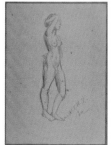

SK0661
立姿裸女速寫-28.12.7（276）Standing Female Nude Sketch-28.12.7 (276)

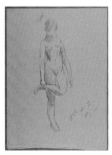
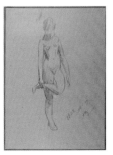

SK0662
立姿裸女速寫-28.12.7（277）Standing Female Nude Sketch-28.12.7 (277)

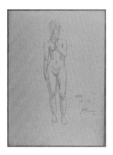 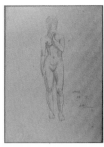

SK0663
立姿裸女速寫-28.12.7（278） Standing Female Nude Sketch-28.12.7 (278)

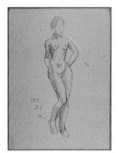 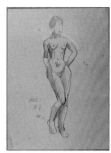

SK0664
立姿裸女速寫-28.12.7（279） Standing Female Nude Sketch-28.12.7 (279)

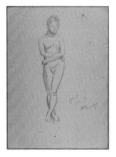 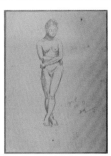

SK0665
立姿裸女速寫-28.12.7（280） Standing Female Nude Sketch-28.12.7 (280)

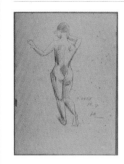 

SK0666
立姿裸女速寫-28.12.7（281） Standing Female Nude Sketch-28.12.7 (281)

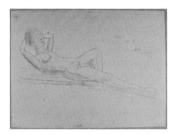 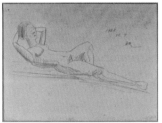

SK0667
臥姿裸女速寫-28.12.7（30） Reclining Female Nude Sketch-28.12.7 (30)

SK0668
臥姿裸女速寫-28.12.7（31） Reclining Female Nude Sketch-28.12.7 (31)

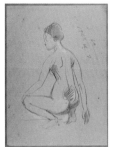 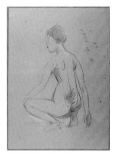

SK0670
蹲姿裸女速寫-28.12.7（16） Squatting Female Nude Sketch-28.12.7 (16)

 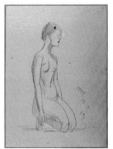

SK0671
跪姿裸女速寫-28.12.7（20） Kneeling Female Nude Sketch-28.12.7 (20)

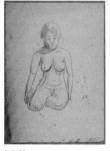 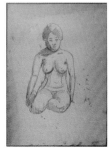

SK0672
坐姿裸女速寫-28（256） Seated Female Nude Sketch-28 (256)

SK0675
立姿裸女速寫-29.2.10（283） Standing Female Nude Sketch-29.2.10 (283)

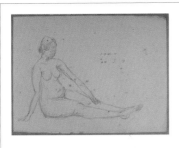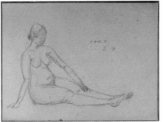

SK0678
坐姿裸女速寫-29.3.9（260）Seated Female Nude Sketch-29.3.9 (260)

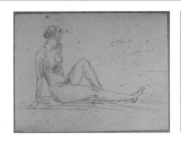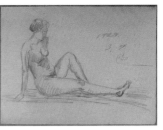

SK0679
坐姿裸女速寫-29.3.9（261）Seated Female Nude Sketch-29.3.9 (261)

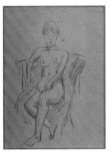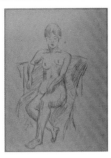

SK0729
坐姿裸女速寫（278）Seated Female Nude Sketch (278)

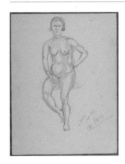

SK0742
坐姿裸女速寫-30.10.23（280）Seated Female Nude Sketch-30.10.23 (280)

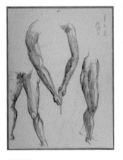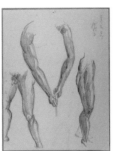

SK0749
手腳速寫-30.11.29（1）Hands and Feet Sketch-30.11.29 (1)

SK0752
立姿裸男速寫（5）Standing Male Nude Sketch (5)

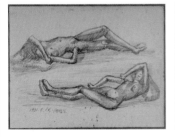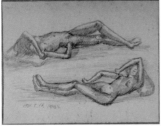

SK0764
臥姿裸女速寫-31.5.16（42）Reclining Female Nude Sketch-31.5.16 (42)

SK0765
立姿與坐姿裸女速寫-31.6.13（1）Standing and Seated Female Nude Sketch-31.6.13 (1)

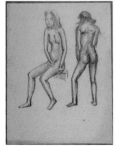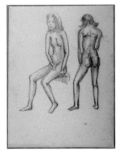

SK0766
立姿與坐姿裸女速寫（2）Standing and Seated Female Nude Sketch (2)

SK0767
坐姿裸女速寫（283）Seated Female Nude Sketch (283)

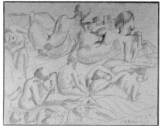

SK0770
洗身群女一見-31.7.2 Bathing Girls-31.7.2

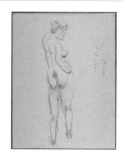
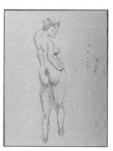

SK0772
立姿裸女速寫-31.7.4（304） Standing Female Nude Sketch-31.7.4 (304)

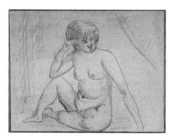
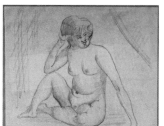

SK0774
坐姿裸女速寫-31.9.2（284） Seated Female Nude Sketch-31.9.2 (284)

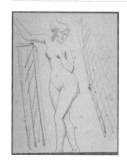
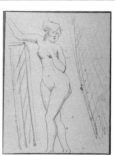

SK0776
立姿裸女速寫-31.9.2（306） Standing Female Nude Sketch-31.9.2 (306)

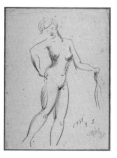
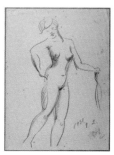

SK0777
立姿裸女速寫-31.9.2（307） Standing Female Nude Sketch-31.9.2 (307)

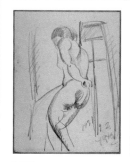
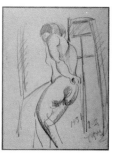

SK0778
立姿裸女速寫-31.9.2（308） Standing Female Nude Sketch-31.9.2 (308)

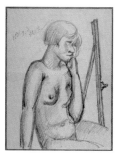
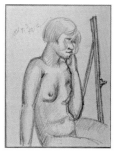

SK0779
坐姿裸女速寫-31.9.3（286） Seated Female Nude Sketch-31.9.3 (286)

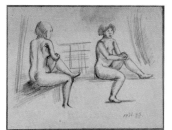
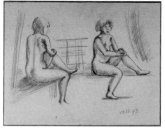

SK0781
坐姿裸女速寫-31.9.3（287） Seated Female Nude Sketch-31.9.3 (287)

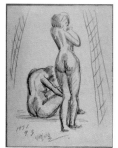
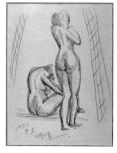

SK0782
立姿與坐姿裸女速寫-31.9.3（3） Standing and Seated Female Nude Sketch-31.9.3 (3)

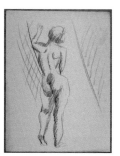
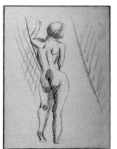

SK0783
立姿裸女速寫（309） Standing Female Nude Sketch (309)

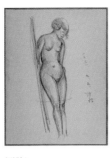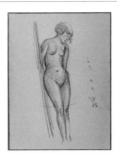

SK0784
立姿裸女速寫-31.9.3（310）Standing Female Nude Sketch-31.9.3 (310)

SK0785
立姿裸女速寫-31.9.3（311）Standing Female Nude Sketch-31.9.3 (311)

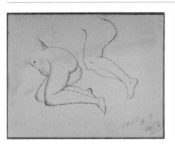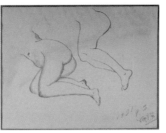

SK0786
女體速寫-31.9.3（25）Female Body Sketch-31.9.3 (25)

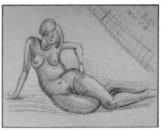

SK0787
坐姿裸女速寫-31.9.4（288）Seated Female Nude Sketch-31.9.4 (288)

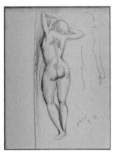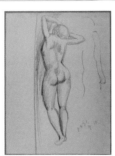

SK0788
立姿裸女速寫-31.9.4（312）Standing Female Nude Sketch-31.9.4 (312)

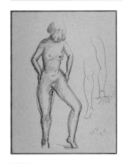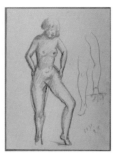

SK0789
立姿裸女速寫-31.9.4（313）Standing Female Nude Sketch-31.9.4 (313)

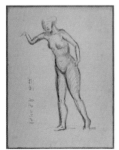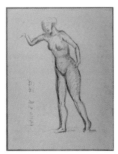

SK0790
立姿裸女速寫-31.9.4（314）Standing Female Nude Sketch-31.9.4 (314)

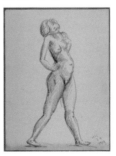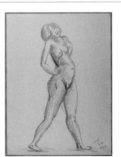

SK0791
立姿裸女速寫-31.9.4（315）Standing Female Nude Sketch-31.9.4 (315)

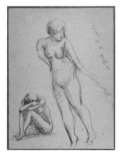

SK0792
立姿與坐姿裸女速寫-31.9.7（4）Standing and Seated Female Nude Sketch-31.9.7 (4)

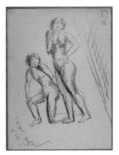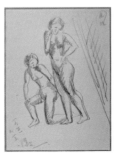

SK0796
追隨-31.9.15 Trailing-31.9.15

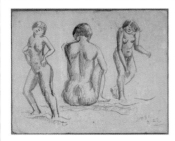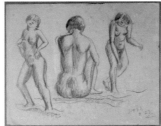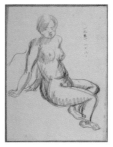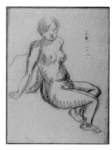

SK0799
立姿與坐姿裸女速寫-31.9.23（5）Standing and Seated Female Nude Sketch-31.9.23 (5)

SK0803
坐姿裸女速寫-31.10.8（292）Seated Female Nude Sketch-31.10.8 (292)

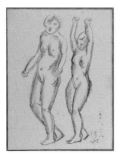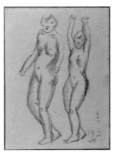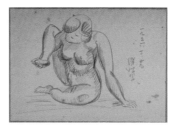

SK0805
立姿裸女速寫-31.10.8（318）Standing Female Nude Sketch-31.10.8 (318)

SK0813
坐姿裸女速寫-31.10.29（295）Seated Female Nude Sketch-31.10.29 (295)

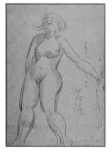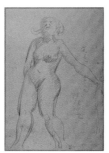

SK0814
立姿裸女速寫-31.10.29（320）Standing Female Nude Sketch-31.10.29 (320)

SK0815
立姿裸女速寫-31.10.29（321）Standing Female Nude Sketch-31.10.29 (321)

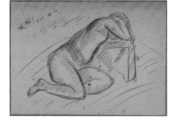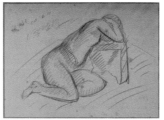

SK0816
臥姿裸女速寫-31.10.29（47）Reclining Female Nude Sketch-31.10.29 (47)

SK0820
坐姿裸女速寫（297）Seated Female Nude Sketch (297)

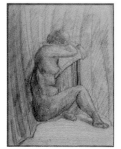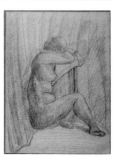

SK0821
坐姿裸女速寫（298）Seated Female Nude Sketch (298)

SK0823
坐姿裸女速寫（300）Seated Female Nude Sketch (300)

SK0824
坐姿裸女速寫（301）Seated Female Nude Sketch (301)

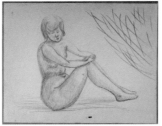

SK0825
坐姿裸女速寫（302）Seated Female Nude Sketch (302)

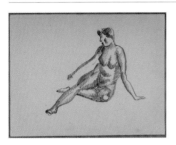
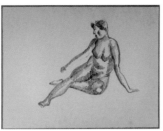

SK0826
坐姿裸女速寫（303）Seated Female Nude Sketch (303)

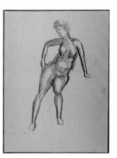

SK0827
坐姿裸女速寫（304）Seated Female Nude Sketch (304)

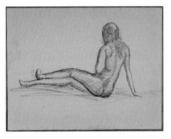
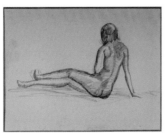

SK0828
坐姿裸女速寫（305）Seated Female Nude Sketch (305)

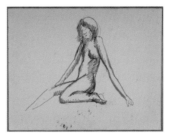
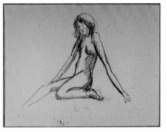

SK0829
坐姿裸女速寫（306）Seated Female Nude Sketch (306)

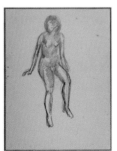
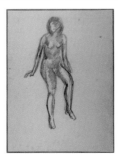

SK0830
坐姿裸女速寫（307）Seated Female Nude Sketch (307)

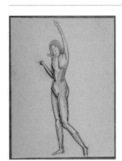
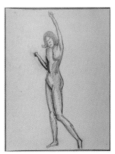

SK0831
立姿裸女速寫（322）Standing Female Nude Sketch (322)

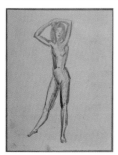

SK0832
立姿裸女速寫（323）Standing Female Nude Sketch (323)

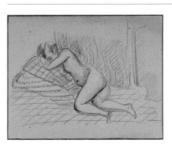
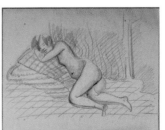

SK0837
臥姿裸女速寫（48）Reclining Female Nude Sketch (48)

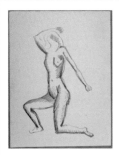 

SK0838
跪姿裸女速寫（24）Kneeling Female Nude Sketch (24)

SK0859
坐姿裸女速寫（322）Seated Female Nude Sketch (322)

SK0869
坐姿裸女速寫（331）Seated Female Nude Sketch (331)

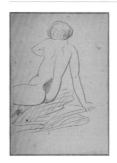 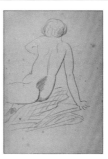

SK0870
坐姿裸女速寫（332）Seated Female Nude Sketch (332)

 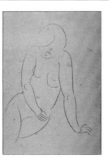

SK0871
坐姿裸女速寫（333）Seated Female Nude Sketch (333)

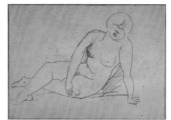 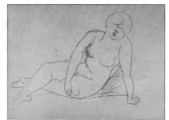

SK0872
坐姿裸女速寫（334）Seated Female Nude Sketch (334)

SK0874
立姿裸女速寫（331）Standing Female Nude Sketch (331)

SK0875
立姿裸女速寫（332）Standing Female Nude Sketch (332)

SK0879
立姿裸女速寫（336）Standing Female Nude Sketch (336)

*為前一張之背面圖。

SK0880
頭像速寫（28）Portrait Sketch (28)

SK0882
立姿裸女速寫（338）Standing Female Nude Sketch (338)

SK0883
臥姿裸女速寫（50）Reclining Female Nude Sketch (50)

SK0888
臥姿裸女速寫（55）Reclining Female Nude Sketch (55)

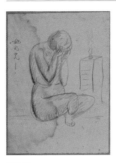

SK0917
坐姿裸女速寫（340）Seated Female Nude Sketch (340)

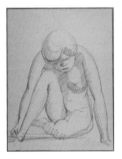
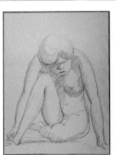

SK0920
坐姿裸女速寫（343）Seated Female Nude Sketch (343)

SK0921
坐姿裸女速寫（344）Seated Female Nude Sketch (344)

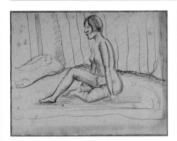
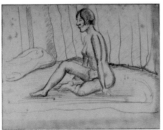

SK0928
坐姿裸女速寫（350）Seated Female Nude Sketch (350)

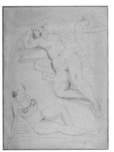

SK0929
坐姿與臥姿裸女速寫（6）Seated and Reclining Female Nude Sketch (6)

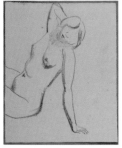
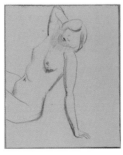

SK0930
坐姿裸女速寫（351）Seated Female Nude Sketch (351)

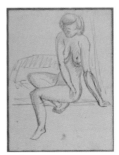
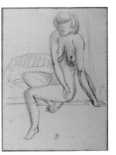

SK0931
坐姿裸女速寫（352）Seated Female Nude Sketch (352)

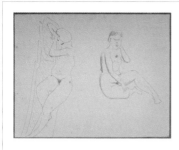

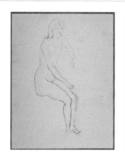

SK0932
坐姿與臥姿裸女速寫（7） Seated and Reclining Female Nude Sketch (7)

SK0933
坐姿裸女速寫（353） Seated Female Nude Sketch (353)

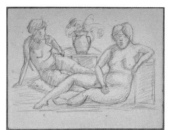

SK0934
坐姿裸女速寫（354） Seated Female Nude Sketch (354)

SK0935
坐姿裸女速寫（355） Seated Female Nude Sketch (355)

SK0937
坐姿裸女速寫（357） Seated Female Nude Sketch (357)

SK0938
坐姿與臥姿裸女速寫（8） Seated and Reclining Female Nude Sketch (8)

SK0939
坐姿與臥姿裸女速寫（9） Seated and Reclining Female Nude Sketch (9)

SK0940
坐姿裸女速寫（358） Seated Female Nude Sketch (358)

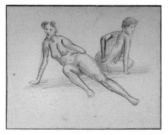

SK0941
坐姿裸女速寫（359） Seated Female Nude Sketch (359)

SK0942
坐姿裸女速寫（360） Seated Female Nude Sketch (360)

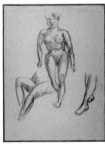

SK0943
坐姿裸女速寫（361） Seated Female Nude Sketch (361)

SK0945
坐姿裸女速寫（363） Seated Female Nude Sketch (363)

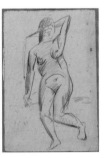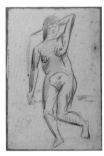

SK0946
坐姿裸女速寫（364） Seated Female Nude Sketch (364)

SK0949
坐姿裸女速寫（367） Seated Female Nude Sketch (367)

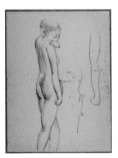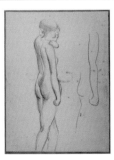

SK0950
坐姿裸女速寫（368） Seated Female Nude Sketch (368)

SK0951
坐姿裸女速寫（369） Seated Female Nude Sketch (369)

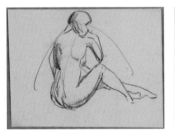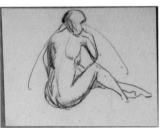

SK0962
立姿裸女速寫（344） Standing Female Nude Sketch (344)

SK0963
立姿裸女速寫（345） Standing Female Nude Sketch (345)

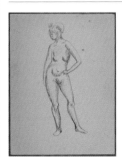

SK0966
立姿裸女速寫（347） Standing Female Nude Sketch (347)

SK0967
立姿裸女速寫（348） Standing Female Nude Sketch (348)

SK0968
立姿裸女速寫（349）Standing Female Nude Sketch (349)

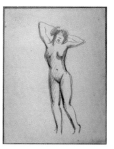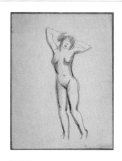

SK0969
立姿裸女速寫（350）Standing Female Nude Sketch (350)

SK0970
立姿裸女速寫（351）Standing Female Nude Sketch (351)

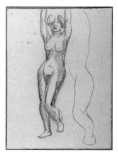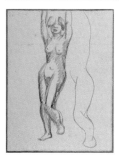

SK0971
立姿裸女速寫（352）Standing Female Nude Sketch (352)

SK0972
立姿裸女速寫（353）Standing Female Nude Sketch (353)

*為前一張之背面圖。

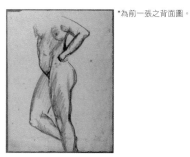

SK0973
女體速寫（26）Female Body Sketch (26)

SK0974
立姿裸女速寫（354）Standing Female Nude Sketch (354)

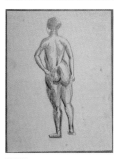

SK0975
立姿裸女速寫（355）Standing Female Nude Sketch (355)

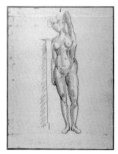

SK0976
立姿裸女速寫（356）Standing Female Nude Sketch (356)

SK0977
立姿裸女速寫（357）Standing Female Nude Sketch (357)

SK0978
立姿裸女速寫（358）Standing Female Nude Sketch (358)

SK0979
立姿裸女速寫（359）Standing Female Nude Sketch (359)

SK0980
立姿裸女速寫（360）Standing Female Nude Sketch (360)

SK0981
立姿裸女速寫（361）Standing Female Nude Sketch (361)

SK0986
立姿裸女速寫（365）Standing Female Nude Sketch (365)

SK0987
立姿裸女速寫（366）Standing Female Nude Sketch (366)

SK0988
立姿裸女速寫（367）Standing Female Nude Sketch (367)

 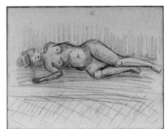

SK0992
臥姿裸女速寫（60）Reclining Female Nude Sketch (60)

SK0995
臥姿裸女速寫（63）Reclining Female Nude Sketch (63)

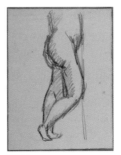 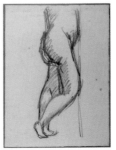

SK0997
女體速寫（28）Female Body Sketch (28)

 *為前一張之背面圖。

SK0998
頭像速寫（30） Portrait Sketch (30)

SK0999
女體速寫（29） Female Body Sketch (29)

SK1000
立姿裸男速寫（10） Standing Male Nude Sketch (10)

SK1009
人物速寫（39） Figure Sketch (39)

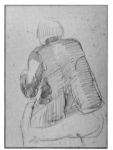

SK1014
人物速寫（42） Figure Sketch (42)

SK1015
人物速寫（43） Figure Sketch (43)

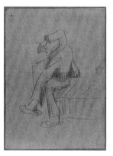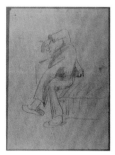

SK1016
人物速寫（44） Figure Sketch (44)

SK1018
人物速寫（46） Figure Sketch (46)

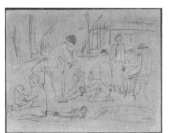

SK1037
人物速寫（64） Figure Sketch (64)

SK1054
人物速寫（80） Figure Sketch (80)

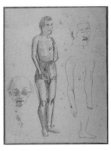

SK1055
人物速寫（81）Figure Sketch (81)

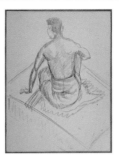
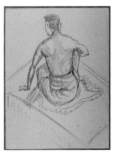

SK1056
人物速寫（82）Figure Sketch (82)

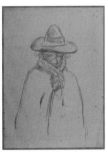
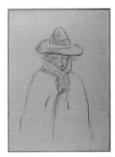

SK1058
人物速寫（84）Figure Sketch (84)

SK1059
人物速寫（85）Figure Sketch (85)

*為前一張之背面圖。

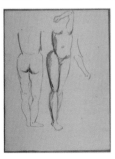

SK1060
女體速寫（30）Female Body Sketch (30)

SK1062
人物速寫（87）Figure Sketch (87)

SK1063
人物速寫（88）Figure Sketch (88)

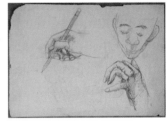

SK1064
頭像與手部速寫（1）Portrait and Hand Sketch (1)

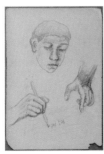

SK1065
頭像與手部速寫（2）Portrait and Hand Sketch (2)

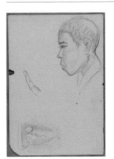
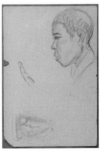

SK1066
頭像與手部速寫（3）Portrait and Hand Sketch (3)

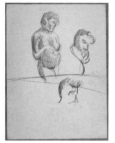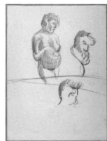

SK1069
頭像速寫（34）Portrait Sketch (34)

# 素描簿 Sketchbooks

每件作品以修復前和修復後做為對照，共兩張圖。
修復前置於左側、修復後置於右側。

## SB02

SB02-001
封面 Front Cover

SB02-002
立姿裸女速寫（28）Standing Female Nude Sketch (28)

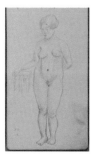

SB02-003
立姿裸女速寫（29）Standing Female Nude Sketch (29)

SB02-004
立姿裸女速寫（30）Standing Female Nude Sketch (30)

SB02-005
立姿裸女速寫（31）Standing Female Nude Sketch (31)

SB02-006
坐姿裸女速寫（25）Seated Female Nude Sketch (25)

SB02-007
立姿裸女速寫（32） Standing Female Nude Sketch (32)

SB02-008
立姿裸女速寫（33） Standing Female Nude Sketch (33)

SB02-009
立姿裸女速寫（34） Standing Female Nude Sketch (34)

SB02-010
立姿裸女速寫（35） Standing Female Nude Sketch (35)

SB02-011
坐姿裸女速寫（26） Seated Female Nude Sketch (26)

SB02-012
人物速寫（4） Figure Sketch (4)

SB02-013
坐姿裸女速寫（27） Seated Female Nude Sketch (27)

SB02-014
坐姿裸女速寫（28） Seated Female Nude Sketch (28)

SB02-015
立姿裸女速寫（36） Standing Female Nude Sketch (36)

SB02-016
立姿裸女速寫（37） Standing Female Nude Sketch (37)

SB02-017
坐姿裸女速寫（29）Seated Female Nude Sketch (29)

SB02-018
坐姿裸女速寫（30）Seated Female Nude Sketch (30)

SB02-019
臥姿裸女速寫（6）Reclining Female Nude Sketch (6)

SB02-020
立姿裸女速寫（38）Standing Female Nude Sketch (38)

SB02-021
人物速寫（5）Figure Sketch (5)

SB02-022
人物速寫（6）Figure Sketch (6)

SB02-023
頭像速寫（2）Portrait Sketch (2)

SB02-024
人物速寫（7）Figure Sketch (7)

SB02-025
日比谷公園（1）Hibiya Park (1)

SB02-026
日比谷公園（2）Hibiya Park (2)

SB02-027
日比谷公園（3）Hibiya Park (3)

SB02-028
人物速寫（8）Figure Sketch (8)

SB02-029
日比谷公園（4）Hibiya Park (4)

SB02-030
人物速寫（9）Figure Sketch (9)

SB02-031
日比谷公園（5）Hibiya Park (5)

SB02-032
人物速寫（10）Figure Sketch (10)

SB02-033
日比谷公園（6）Hibiya Park (6)

SB02-034
人物速寫（11）Figure Sketch (11)

SB02-035
頭像速寫（3）Portrait Sketch (3)

SB02-036
封底 Back Cover

## SB03

SB03-001
封面 Front Cover

SB03-002
坐姿裸女速寫（31） Seated Female Nude Sketch (31)

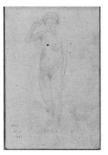

SB03-003
立姿裸女速寫（39） Standing Female Nude Sketch (39)

SB03-004
立姿裸女速寫（40） Standing Female Nude Sketch (40)

SB03-005
坐姿裸女速寫（32） Seated Female Nude Sketch (32)

SB03-006
坐姿裸女速寫（33） Seated Female Nude Sketch (33)

SB03-007
立姿裸女速寫（41） Standing Female Nude Sketch (41)

SB03-008
立姿裸女速寫（42） Standing Female Nude Sketch (42)

SB03-009
坐姿裸女速寫（34） Seated Female Nude Sketch (34)

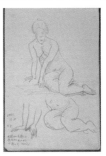

SB03-010
坐姿裸女速寫（35） Seated Female Nude Sketch (35)

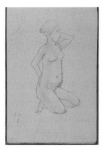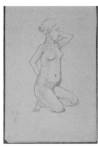

SB03-011
坐姿裸女速寫（36）Seated Female Nude Sketch (36)

SB03-012
坐姿裸女速寫（37）Seated Female Nude Sketch (37)

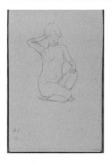

SB03-013
坐姿裸女速寫（38）Seated Female Nude Sketch (38)

SB03-014
坐姿裸女速寫（39）Seated Female Nude Sketch (39)

SB03-015
坐姿裸女速寫（40）Seated Female Nude Sketch (40)

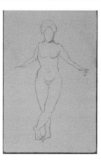

SB03-016
立姿裸女速寫（43）Standing Female Nude Sketch (43)

SB03-017
立姿裸女速寫（44）Standing Female Nude Sketch (44)

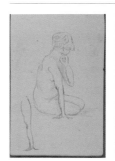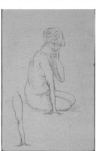

SB03-018
坐姿裸女速寫（41）Seated Female Nude Sketch (41)

SB03-019
立姿裸女速寫（45）Standing Female Nude Sketch (45)

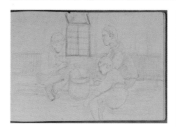

SB03-020
人物速寫（12）Figure Sketch (12)

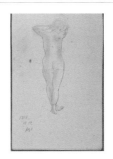

SB03-021
坐姿裸女速寫（42）Seated Female Nude Sketch (42)

SB03-022
立姿裸女速寫（46）Standing Female Nude Sketch (46)

SB03-023
立姿裸女速寫（47）Standing Female Nude Sketch (47)

SB03-024
坐姿裸女速寫（43）Seated Female Nude Sketch (43)

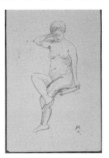

SB03-025
立姿裸女速寫（48）Standing Female Nude Sketch (48)

SB03-026
坐姿裸女速寫（44）Seated Female Nude Sketch (44)

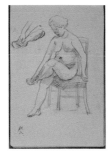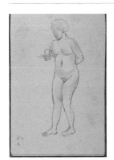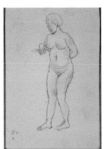

SB03-027
坐姿裸女速寫（45）Seated Female Nude Sketch (45)

SB03-028
立姿裸女速寫（49）Standing Female Nude Sketch (49)

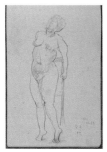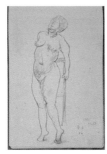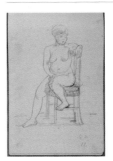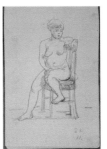

SB03-029
立姿裸女速寫（50）Standing Female Nude Sketch (50)

SB03-030
坐姿裸女速寫（46）Seated Female Nude Sketch (46)

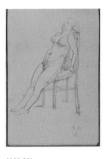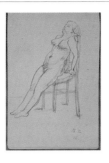

SB03-031
坐姿裸女速寫（47）Seated Female Nude Sketch (47)

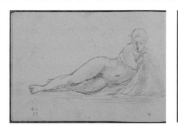

SB03-032
臥姿裸女速寫（7）Reclining Female Nude Sketch (7)

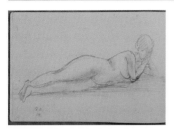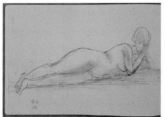

SB03-033
臥姿裸女速寫（8）Reclining Female Nude Sketch (8)

SB03-034
臥姿裸女速寫（9）Reclining Female Nude Sketch (9)

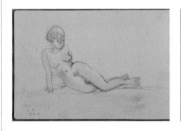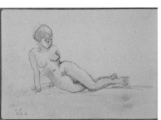

SB03-035
坐姿裸女速寫（48）Seated Female Nude Sketch (48)

SB03-036
立姿裸女速寫（51）Standing Female Nude Sketch (51)

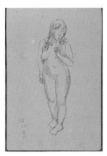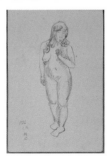

SB03-037
立姿裸女速寫（52）Standing Female Nude Sketch (52)

SB03-038
坐姿裸女速寫（49）Seated Female Nude Sketch (49)

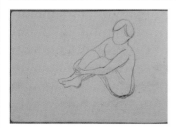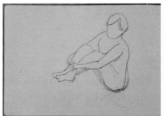

SB03-039
坐姿裸女速寫（50）Seated Female Nude Sketch (50)

SB03-040
立姿裸女速寫（53）Standing Female Nude Sketch (53)

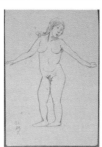

SB03-041
立姿裸女速寫（54）Standing Female Nude Sketch (54)

SB03-042
立姿裸女速寫（55）Standing Female Nude Sketch (55)

SB03-043
地圖（1）Map (1)

SB03-044
立姿裸女速寫（56）Standing Female Nude Sketch (56)

## SB04

SB04-001
封面 Front Cover

SB03-045
封底 Back Cover

SB04-002
頭像速寫（4）Portrait Sketch (4)

SB04-003
立姿裸女速寫（57）Standing Female Nude Sketch (57)

SB04-004
立姿裸女速寫（58）Standing Female Nude Sketch (58)

SB04-005
立姿裸女速寫（59）Standing Female Nude Sketch (59)

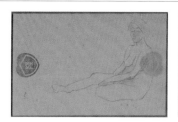

SB04-006
坐姿裸女速寫（51）Seated Female Nude Sketch (51)

SB04-007
坐姿裸女速寫（52）Seated Female Nude Sketch (52)

SB04-008
坐姿裸女速寫（53）Seated Female Nude Sketch (53)

SB04-009
跪姿裸女速寫（1）Kneeling Female Nude Sketch (1)

SB04-010
跪姿裸女速寫（2）Kneeling Female Nude Sketch (2)

SB04-011
坐姿裸女速寫（54）Seated Female Nude Sketch (54)

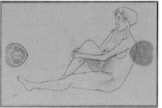

SB04-012
坐姿裸女速寫（55）Seated Female Nude Sketch (55)

SB04-013
立姿裸女速寫（60）Standing Female Nude Sketch (60)

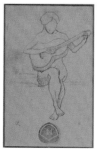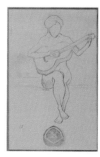

SB04-014
坐姿裸女速寫（56）Seated Female Nude Sketch (56)

SB04-015
坐姿裸女速寫（57）Seated Female Nude Sketch (57)

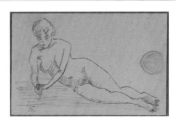

SB04-016
坐姿裸女速寫（58）Seated Female Nude Sketch (58)

SB04-017
臥姿裸女速寫（10）Reclining Female Nude Sketch (10)

SB04-018
坐姿裸女速寫（59）Seated Female Nude Sketch (59)

SB04-019
臥姿裸女速寫（11）Reclining Female Nude Sketch (11)

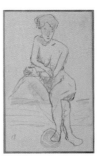

SB04-020
坐姿裸女速寫（60）Seated Female Nude Sketch (60)

SB04-021
坐姿裸女速寫（61）Seated Female Nude Sketch (61)

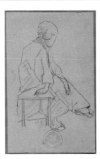

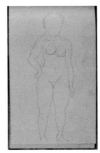

SB04-022
人物速寫（13）Figure Sketch (13)

SB04-023
封底 Back Cover

## SB05

SB05-001
封面 Front Cover

SB05-002
立姿裸女速寫（61）Standing Female Nude Sketch (61)

SB05-003
坐姿裸女速寫（62） Seated Female Nude Sketch (62)

SB05-004
吊飾速寫（1） Decoration Sketch (1)

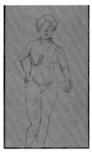

SB05-005
立姿裸女速寫（62） Standing Female Nude Sketch (62)

SB05-006
女體速寫（1） Female Body Sketch (1)

SB05-007
女體速寫（2） Female Body Sketch (2)

SB05-008
大森海岸 Omori Coast

SB05-009
大森 Omori

SB05-010
馬（1） Horse (1)

SB05-011
馬（2） Horse (2)

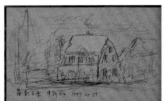

SB05-012
嵐前之景 Before the Storm

SB05-013
中文字（1） Chinese (1)

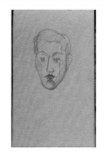

SB05-014
頭像速寫（5） Portrait Sketch (5)

SB05-015
頭像速寫（6） Portrait Sketch (6)

SB05-016
頭像速寫（7） Portrait Sketch (7)

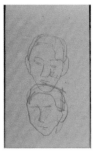

SB05-017
頭像速寫（8） Portrait Sketch (8)

SB05-018
頭像速寫（9） Portrait Sketch (9)

## SB07

SB05-019
封底 Back Cover

SB07-001
封面 Front Cover

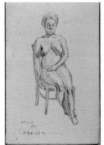

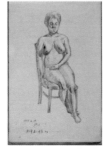

SB07-002
坐姿裸女速寫（65） Seated Female Nude Sketch (65)

SB07-003
坐姿裸女速寫（66） Seated Female Nude Sketch (66)

SB07-004
立姿裸女速寫（63）Standing Female Nude Sketch (63)

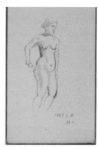

SB07-005
立姿裸女速寫（64）Standing Female Nude Sketch (64)

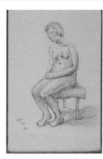

SB07-006
坐姿裸女速寫（67）Seated Female Nude Sketch (67)

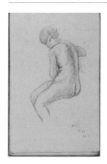
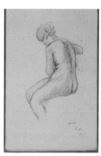

SB07-007
坐姿裸女速寫（68）Seated Female Nude Sketch (68)

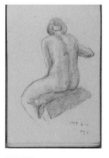
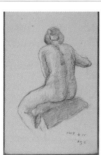

SB07-008
坐姿裸女速寫（69）Seated Female Nude Sketch (69)

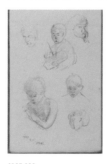
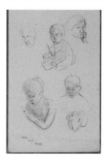

SB07-009
頭像速寫（13）Portrait Sketch (13)

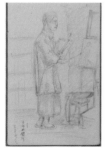

SB07-010
人物速寫（22）Figure Sketch (22)

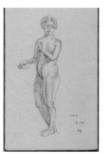
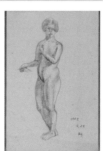

SB07-011
立姿裸女速寫（65）Standing Female Nude Sketch (65)

SB07-012
立姿裸女速寫（66）Standing Female Nude Sketch (66)

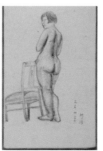

SB07-013
立姿裸女速寫（67）Standing Female Nude Sketch (67)

SB07-014
立姿裸女速寫（68）Standing Female Nude Sketch (68)

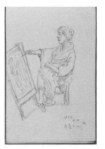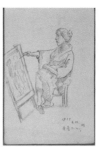

SB07-015
齊藤女士 Ms. Saito

SB07-016
東京帝室博物館 Tokyo National Museum

SB07-018
封底 Back Cover

## SB08

SB08-001
封面 Front Cover

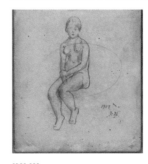

SB08-002
坐姿裸女速寫（70）Seated Female Nude Sketch (70)

SB08-003
中日文字練習 Chinese and Japanese Writing Exercise

SB08-004
坐姿裸女速寫（71）Seated Female Nude Sketch (71)

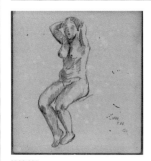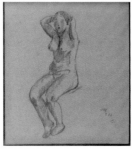

SB08-005
坐姿裸女速寫（72）Seated Female Nude Sketch (72)

SB08-006
坐姿裸女速寫（73）Seated Female Nude Sketch (73)

 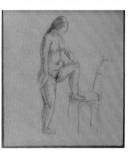

SB08-007
坐姿裸女速寫（74）Seated Female Nude Sketch (74)

SB08-008
立姿裸女速寫（69）Standing Female Nude Sketch (69)

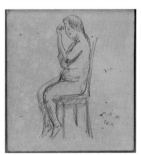 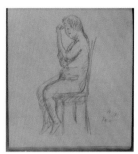

SB08-009
坐姿裸女速寫（75）Seated Female Nude Sketch (75)

SB08-010
坐姿裸女速寫（76）Seated Female Nude Sketch (76)

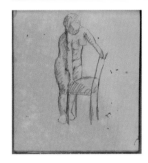 

SB08-011
立姿裸女速寫（70）Standing Female Nude Sketch (70)

SB08-012
立姿裸女速寫（71）Standing Female Nude Sketch (71)

SB08-013
坐姿裸女速寫（77）Seated Female Nude Sketch (77)

SB08-014
坐姿裸女速寫（78）Seated Female Nude Sketch (78)

 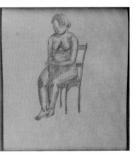

SB08-015
立姿裸女速寫（72）Standing Female Nude Sketch (72)

SB08-016
坐姿裸女速寫（79）Seated Female Nude Sketch (79)

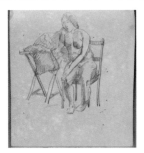 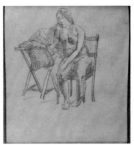

SB08-0 17
坐姿裸女速寫（80）Seated Female Nude Sketch (80)

SB08-018
立姿裸女速寫（73）Standing Female Nude Sketch (73)

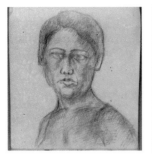 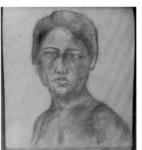

SB08-019
頭像速寫（14）Portrait Sketch (14)

SB08-020
立姿裸女速寫（74）Standing Female Nude Sketch (74)

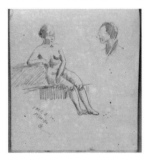 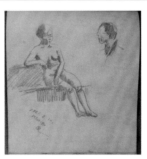

SB08-021
坐姿裸女速寫（81）Seated Female Nude Sketch (81)

 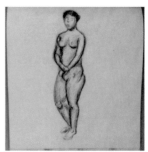

SB08-022
立姿裸女速寫（75）Standing Female Nude Sketch (75)

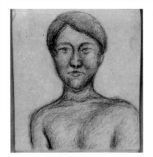 

SB08-023
頭像速寫（15）Portrait Sketch (15)

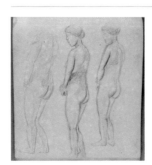 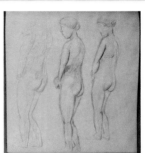

SB08-024
立姿裸女速寫（76）Standing Female Nude Sketch (76)

SB08-025
坐姿裸女速寫（82）Seated Female Nude Sketch (82)

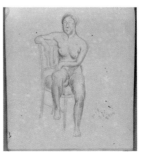 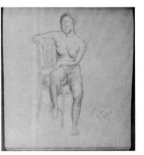

SB08-026
坐姿裸女速寫（83）Seated Female Nude Sketch (83)

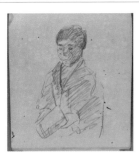

SB08-027
人物速寫（23） Figure Sketch (23)

SB08-028
立姿裸女速寫（77） Standing Female Nude Sketch (77)

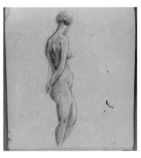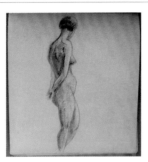

SB08-029
立姿裸女速寫（78） Standing Female Nude Sketch (78)

SB08-030
人物速寫（24） Figure Sketch (24)

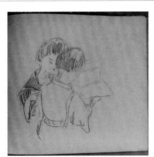

SB08-031
人物速寫（25） Figure Sketch (25)

SB08-032
人物速寫（26） Figures Sketch (26)

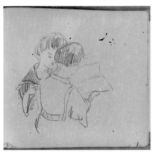

SB08-033
日文字（1） Japanese (1)

SB08-037
封底 Back Cover

## SB09

SB09-001
封面 Front Cover

SB09-002
坐姿裸女速寫（84） Seated Female Nude Sketch (84)

SB09-003
風景速寫（3）Landscape Sketch (3)

SB09-004
頭像速寫（16）Portrait Sketch (16)

SB09-005
風景速寫（4）Landscape Sketch (4)

SB09-006
風景速寫（5）Landscape Sketch (5)

SB09-007
風景速寫（6）Landscape Sketch (6)

SB09-008
風景速寫（7）Landscape Sketch (7)

SB09-009
風景速寫（8）Landscape Sketch (8)

SB09-010
台中市初音橋 Taichung Chuyin Bridge

SB09-011
植物速寫（1）Plant Sketch (1)

SB09-012
台中公園一角 A Corner of the Taichung Park

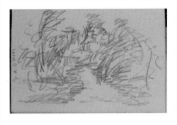 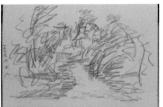

SB09-013
風景速寫（9）Landscape Sketch (9)

SB09-014
橋下 Under the Bridge

SB09-015
嘉義（1）Chiayi (1)

SB09-016
嘉義病室 In Chiayi Ward

SB09-017
遠望虎頭山 Looking Towards Hutou Mountain

SB09-018
風景速寫（10）Landscape Sketch (10)

SB09-019
船上 Aboard

SB09-020
風景速寫（11）Landscape Sketch (11)

SB09-021
廈門港 Xiamen Port

SB09-022
望于廈大 Looking Towards Xiamen University

SB09-023
風景速寫（12）Landscape Sketch (12)

SB09-024
風景速寫（13）Landscape Sketch (13)

SB09-025
鼓浪嶼 Gulangyu Island

SB09-026
人物速寫（27）Figure Sketch (27)

SB09-027
風景速寫（14）Landscape Sketch (14)

SB09-028
風景速寫（15）Landscape Sketch (15)

SB09-029
人物速寫（28）Figure Sketch (28)

SB09-030
線條（1）Lines (1)

 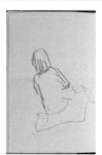  

SB09-031
靜物速寫（1）Still Life Sketch (1)

SB09-032
人物速寫（29）Figure Sketch (29)

SB09-033
人物速寫（30）Figure Sketch (30)

SB09-034
人物速寫（31）Figure Sketch (31)

SB09-035
廈門中山公園（1）Zhongshan Park in Xiamen (1)

SB09-036
人物速寫（32）Figure Sketch (32)

SB09-037
風景速寫（16）Landscape Sketch (16)

SB09-038
風景速寫（17）Landscape Sketch (17)

SB09-039
廈門中山公園（2）Zhongshan Park in Xiamen (2)

SB09-040
風景速寫（18）Landscape Sketch (18)

SB09-041
風景速寫（19）Landscape Sketch (19)

SB09-043
狗 Dog

SB09-044
人物速寫（33）Figure Sketch (33)

SB09-045
人物速寫（34）Figure Sketch (34)

SB09-046
人物速寫（35）Figure Sketch (35)

SB09-047
鉎安船上 On Shengan Boat

SB09-048
風景速寫（20）Landscape Sketch (20)

SB09-049
風景速寫（21）Landscape Sketch (21)

SB09-050
遙望吳淞 Looking Towards Woosung

SB09-051
吳淞（1）Woosung (1)

SB09-052
吳淞（2）Woosung (2)

SB09-053
船過吳淞 Boat Passing Wusong

SB09-054
風景速寫（22）Landscape Sketch (22)

SB09-055
風景速寫（23）Landscape Sketch (23)

SB09-056
風景速寫（24）Landscape Sketch (24)

SB09-057
風景速寫（25）Landscape Sketch (25)

SB09-058
風景速寫（26）Landscape Sketch (26)

SB09-059
寄暢園 Jichang Garden

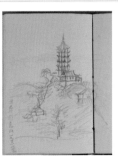

SB09-060
遠望黿頭渚 Looking Towards Yuantouzhu Park

SB09-061
第五次遊惠山 The Fifth Tour to Huishan

SB09-062
風景速寫（27）Landscape Sketch (27)

SB09-063
風景速寫（28）Landscape Sketch (28)

SB09-064
人物速寫（36）Figure Sketch (36)

SB09-065
人物速寫（37）Figure Sketch (37)

SB09-066
頭像速寫（17）Portrait Sketch (17)

SB09-067
離開黿頭渚 LeaveingYuantouzhu Park

SB09-068
蒼山灣 Cangshan Bay

SB09-069
風景速寫（29）Landscape Sketch (29)

SB09-070
黿頭渚 Yuantouzhu Park

SB09-071
風景速寫（30）Landscape Sketch (30)

SB09-072
風景速寫（31）Landscape Sketch (31)

SB09-073
風景速寫（32）Landscape Sketch (32)

SB09-074
風景速寫（33）Landscape Sketch (33)

SB09-075
風景速寫（34）Landscape Sketch (34)

SB09-076
風景速寫（35）Landscape Sketch (35)

SB09-077
風景速寫（36）Landscape Sketch (36)

SB09-078
頭像速寫（18）Portrait Sketch (18)

SB09-079
風景速寫（37）Landscape Sketch (37)

SB09-080
風景速寫（38）Landscape Sketch (38)

SB09-081
風景速寫（39）Landscape Sketch (39)

SB09-082
風景速寫（40）Landscape Sketch (40)

SB09-083
風景速寫（41）Landscape Sketch (41)

SB09-084
風景速寫（42）Landscape Sketch (42)

SB09-085
風景速寫（43）Landscape Sketch (43)

SB09-086
風景速寫（44）Landscape Sketch (44)

SB09-087
風景速寫（45）Landscape Sketch (45)

SB09-088
風景速寫（46）Landscape Sketch (46)

SB09-089
嘉義郊外 Chiayi Countryside

SB09-090
人物速寫（38）Figures Sketch (38)

SB09-091
風景速寫（47）Landscape Sketch (47)

SB09-092
人物速寫（39）Figure Sketch (39)

SB09-093
風景速寫（48）Landscape Sketch (48)

SB09-094
風景速寫（49）Landscape Sketch (49)

SB09-095
風景速寫（50）Landscape Sketch (50)

SB09-096
人物速寫（40）Figure Sketch (40)

SB09-097
人物速寫（41）Figure Sketch (41)

SB09-098
嘉義（2）Chiayi (2)

SB09-099
風景速寫（51）Landscape Sketch (51)

SB09-100
風景速寫（52）Landscape Sketch (52)

SB09-101
風景速寫（53）Landscape Sketch (53)

SB09-102
風景速寫（54）Landscape Sketch (54)

SB09-103
風景速寫（55）Landscape Sketch (55)

SB09-104
風景速寫（56）Landscape Sketch (56)

SB09-105
風景速寫（57）Landscape Sketch (57)

SB09-106
風景速寫（58）Landscape Sketch (58)

SB09-107
風景速寫（59）Landscape Sketch (59)

SB09-108
風景速寫（60）Landscape Sketch (60)

SB09-109
風景速寫（61）Landscape Sketch (61)

SB09-110
風景速寫（62）Landscape Sketch (62)

SB09-111
太湖 Taihu Lake

SB09-112
風景速寫（63）Landscape Sketch (63)

SB09-113
人力車 Rickshaw

SB09-114
頭像速寫（19）Portrait Sketch (19)

SB09-115
人物速寫（42）Figure Sketch (42)

SB09-116
人物速寫（43）Figure Sketch (43)

SB09-117
人物速寫（44）Figure Sketch (44)

SB09-118
人物速寫（45）Figure Sketch (45)

SB09-119
人物速寫（46）Figure Sketch (46)

SB09-120
動物速寫（1）Animal Sketch (1)

SB09-121
法正大學 Fazheng University

SB09-122
人物速寫（47）Figure Sketch (49)

SB09-123
人物速寫（48）Figure Sketch (48)

SB09-124
人物速寫（49）Figure Sketch (49)

SB09-125
人物速寫（50）Figure Sketch (50)

SB09-126
風景速寫（64）Landscape Sketch (64)

SB09-127
人物速寫（51）Figure Sketch (51)

SB09-128
封底　Back Cover

## SB10

SB10-001
封面　Front Cover

SB10-002
人物速寫（52）Figure Sketch (52)

SB10-003
風景速寫（65）Landscape Sketch (65)

SB10-004
台中水心亭　Taichung Water Pavilion

SB10-005
台中公園　Taichung Park

SB10-006
風景速寫（66）Landscape Sketch (66)

SB10-007
風景速寫（67）Landscape Sketch (67)

SB10-008
風景速寫（68）Landscape Sketch (68)

SB10-009
龍井 Longjing

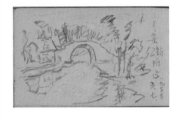

SB10-010
在龍井經西子湖 Longjing by the West Lake

SB10-011
長安站附近 Nearby the Changan Station

SB10-012
紹興 Shaoxing

SB10-013
封底 Back Cover

## SB11

SB11-001
封面 Front Cover

SB11-003
人物速寫（53）Figure Sketch (53)

SB11-004
人物速寫（54）Figures Sketch (54)

SB11-005
人物速寫（55）Figure Sketch (55)

SB11-006
人物與動物 People and Animal

SB11-007
水上庄入口 The Shueishang Village Entrance

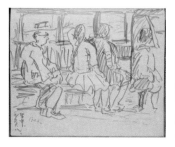 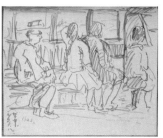  

SB11-008
人物速寫（56）Figures Sketch (56)

SB11-009
風景速寫（69）Landscape Sketch (69)

SB11-010
風景速寫（70）Landscape Sketch (70)

SB11-011
人物速寫（57）Figure Sketch (57)

SB11-012
人物速寫（58）Figure Sketch (58)

SB11-013
風景速寫（71）Landscape Sketch (71)

SB11-014
封底 Back Cover

SB12-001
封面 Front Cover

SB12-002
關子嶺遠望後棟山 Looking Towards Mt. Houdong from Guanziling

SB12-003
關子嶺溫泉遠望于平野 Looking Over an Open Field from Guanziling

SB12-004
關子嶺溫泉瀑布 Guanziling Hot Spring Waterfall

SB12-005
風景速寫（72）Landscape Sketch (72)

SB12-006
風景速寫（73）Landscape Sketch (73)

SB12-007
建物 Building

SB12-008
風景速寫（74）Landscape Sketch (74)

SB12-009
關子嶺途中 On the Way to Guanziling

SB12-010
赴關子嶺途中 On the Way to Guanziling

SB12-011
中文字（2） Chinese (2)

SB12-012
鐘乳洞下 Under the Stalactite Cave

SB12-013
鐘乳石洞遠望關子嶺 Looking Towards Guanziling from Stalactite Cave

SB12-014
人物速寫（59） Figure Sketch (59)

SB12-015
風景速寫（75） Landscape Sketch (75)

SB12-016
風景速寫（76） Landscape Sketch (76)

SB12-017
人物速寫（60） Figure Sketch (60)

SB12-018
人物速寫（61） Figure Sketch (61)

SB12-019
風景速寫（77） Landscape Sketch (77)

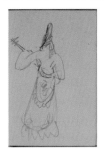
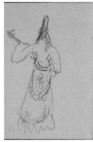

SB12-020
人物速寫（62）Figure Sketch (62)

SB12-021
日文字（2）Japanese (2)

SB12-022
風景速寫（78）Landscape Sketch (78)

SB12-023
中文字（3）Chinese (3)

SB12-024
人物速寫（63）Figure Sketch (63)

SB12-025
人物速寫（64）Figure Sketch (64)

SB12-026
人物速寫（65）Figure Sketch (65)

SB12-027
人物速寫（66）Figure Sketch (66)

SB12-028
人物速寫（67）Figure Sketch (67)

SB12-029
頭像速寫（20）Portrait Sketch (20)

SB12-030
人物速寫（68）Figures Sketch (68)

SB12-031
人物速寫（69）Figure Sketch (69)

SB12-032
頭像速寫（21）Portrait Sketch (21)

SB12-033
人物速寫（70）Figure Sketch (70)

SB12-034
醉月樓對談 Zuiyuelou, Talking

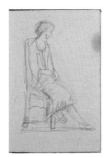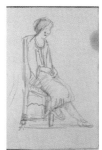

SB12-035
人物速寫（71）Figure Sketch (71)

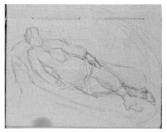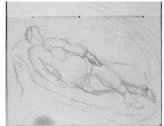

SB12-036
人物速寫（72）Figure Sketch (72)

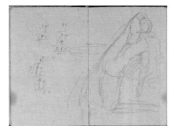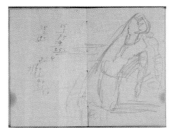

SB12-037
人物速寫（73）Figure Sketch (73)

SB12-038
人物速寫（74）Figure Sketch (74)

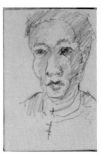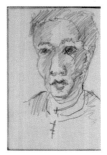

SB12-039
頭像速寫（22）Portrait Sketch (22)

SB12-040
人物速寫（75）Figure Sketch (75)

SB12-041
人物速寫（76）Figure Sketch (76)

SB12-042
人物速寫（77）Figure Sketch (77)

SB12-043
頭像速寫（23）Portrait Sketch (23)

SB12-044
人物速寫（78）Figure Sketch (78)

SB12-045
人物速寫（79）Figure Sketch (79)

SB12-046
人物速寫（80）Figure Sketch (80)

SB12-047
人物速寫（81）Figure Sketch (81)

SB12-048
人物速寫（82）Figure Sketch (82)

SB12-049
人物速寫（83）Figures Sketch (83)

SB12-050
頭像速寫（24） Portrait Sketch (24)

SB12-051
頭像速寫（25） Portrait Sketch (25)

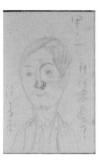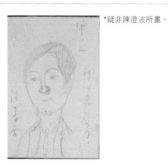

*疑非陳澄波所畫。

SB12-052
頭像速寫（26） Portrait Sketch (26)

SB12-053
石排坑遠望台中市 Looking Towards Taichung from Shipaikeng

SB12-054
中文字（4） Chinese (4)

SB12-055
風景速寫（79） Landscape Sketch (79)

SB12-056
人物速寫（84） Figures Sketch (84)

SB12-057
遠望九十九峯 Looking Towards Mt. Chiuchiu

SB12-058
楊家農場 Yang's Farm

SB12-059
腳白寮 Jiaobailiao

SB12-060
風景速寫（80）Landscape Sketch (80)

SB12-061
風景速寫（81）Landscape Sketch (81)

SB12-062
台中貓鑼溪 Maoluo River

SB12-063
人物速寫（85）Figure Sketch (85)

SB12-064
新高山 Mt. Jade

SB12-065
包車到梧棲 Chartered Car to Wuchi

SB12-066
人物速寫（86）Figure Sketch (86)

SB12-067
關子嶺山岳 Guanziling Mountain

SB12-068
山間小屋 Mountain Hut

SB12-069
數字（1）Numbers (1)

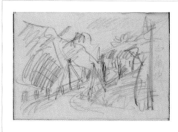 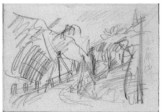

SB12-070
白崩坎 Baibengkan

SB12-071
遠望嘉義平野 Looking Towards Chiayi Plain

SB12-072
公園遠望白崩坎 Looking Towards Baibengkan from Park

SB12-073
風景速寫（82） Landscape Sketch (82)

SB12-074
濁水溪鐵橋 Zhuoshui River Bridge

SB12-075
濁水溪流 Zhuoshui River

SB12-076
二水（1） Erhshuei (1)

SB12-077
二水（2） Erhshuei (2)

SB12-078
二水（3） Erhshuei (3)

SB12-079
封底 Back Cover

SB14

SB14-001
封面 Front Cover

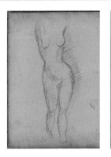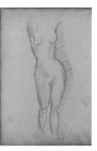

SB14-003
女體速寫（3）Female Body Sketch (3)

SB14-004
坐姿裸女速寫（86）Seated Female Nude Sketch (86)

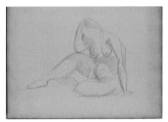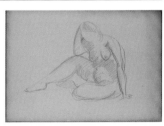

SB14-005
坐姿裸女速寫（87）Seated Female Nude Sketch (87)

SB14-006
跪姿裸女速寫（3）Kneeling Female Nude Sketch (3)

SB14-007
立姿裸女速寫（79）Standing Female Nude Sketch (79)

SB14-008
立姿裸女速寫（80）Standing Female Nude Sketch (80)

SB14-009
坐姿裸女速寫（88）Seated Female Nude Sketch (88)

SB14-010
立姿裸女速寫（81）Standing Female Nude Sketch (81)

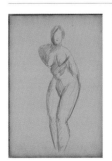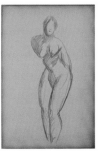

SB14-011
立姿裸女速寫（82）Standing Female Nude Sketch (82)

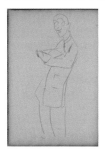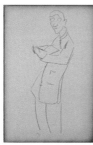

SB14-012
人物速寫（98）Figure Sketch (98)

SB14-013
坐姿裸女速寫（89）Seated Female Nude Sketch (89)

SB14-014
女體速寫（4）Female Body Sketch (4)

SB14-015
坐姿裸女速寫（90）Seated Female Nude Sketch (90)

SB14-016
立姿裸女速寫（83）Standing Female Nude Sketch (83)

SB14-017
臥姿裸女速寫（12）Reclining Female Nude Sketch (12)

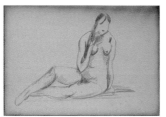

SB14-018
坐姿裸女速寫（91）Seated Female Nude Sketch (91)

SB14-019
立姿裸女速寫（84）Standing Female Nude Sketch (84)

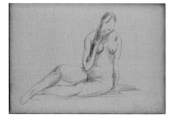

SB14-020
坐姿裸女速寫（92）Seated Female Nude Sketch (92)

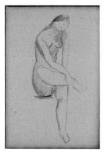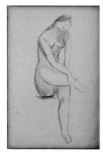

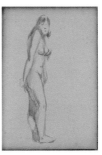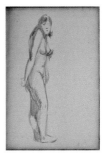

SB14-021
立姿裸女速寫（85）Standing Female Nude Sketch (85)

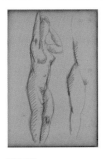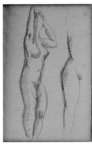

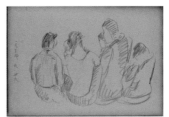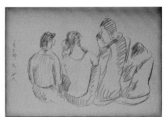

SB14-022
立姿裸女速寫（86）Standing Female Nude Sketch (86)

SB14-023
人物速寫（99）Figures Sketch (99)

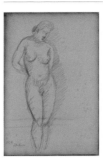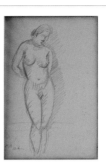

SB14-024
坐姿裸女速寫（93）Seated Female Nude Sketch (93)

SB14-025
立姿裸女速寫（87）Standing Female Nude Sketch (87)

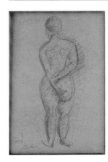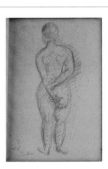

SB14-026
立姿裸女速寫（88）Standing Female Nude Sketch (88)

SB14-028
立姿裸女速寫（89）Standing Female Nude Sketch (89)

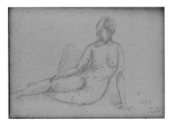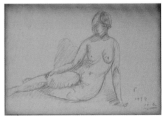

SB14-029
立姿裸女速寫（90）Standing Female Nude Sketch (90)

SB14-030
坐姿裸女速寫（94）Seated Female Nude Sketch (94)

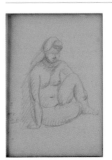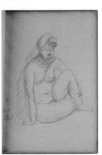

SB14-031
臥姿裸女速寫（13）Reclining Female Nude Sketch (13)

SB14-032
坐姿裸女速寫（95）Seated Female Nude Sketch (95)

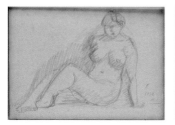

SB14-033
坐姿裸女速寫（96）Seated Female Nude Sketch (96)

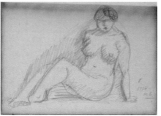

SB14-034
坐姿裸女速寫（97）Seated Female Nude Sketch (97)

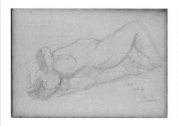

SB14-035
臥姿裸女速寫（14）Reclining Female Nude Sketch (14)

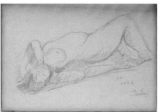

SB14-036
立姿裸女速寫（91）Standing Female Nude Sketch (91)

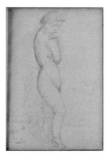

SB14-037
立姿裸女速寫（92）Standing Female Nude Sketch (92)

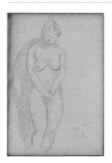

SB14-038
人物速寫（100）Figure Sketch (100)

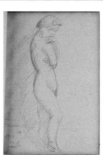

SB14-039
坐姿裸女速寫（98）Seated Female Nude Sketch (98)

SB14-040
坐姿裸女速寫（99）Seated Female Nude Sketch (99)

SB14-041
立姿裸女速寫（93）Standing Female Nude Sketch (93)

SB14-042
坐姿裸女速寫（100）Seated Female Nude Sketch (100)

SB14-043
臥姿裸女速寫（15） Reclining Female Nude Sketch (15)

SB14-044
臥姿裸女速寫（16） Reclining Female Nude Sketch (16)

SB14-045
坐姿裸女速寫（101） Seated Female Nude Sketch (101)

SB14-046
立姿裸女速寫（94） Standing Female Nude Sketch (94)

SB14-047
坐姿裸女速寫（102） Seated Female Nude Sketch (102)

SB14-048
立姿裸女速寫（95） Standing Female Nude Sketch (95)

SB14-049
立姿裸女速寫（96） Standing Female Nude Sketch (96)

SB14-050
坐姿裸女速寫（103） Seated Female Nude Sketch (103)

SB14-051
坐姿裸女速寫（104） Seated Female Nude Sketch (104)

SB14-052
立姿裸女速寫（97） Standing Female Nude Sketch (97)

SB14-053
立姿裸女速寫（98）Standing Female Nude Sketch (98)

SB14-054
封底 Back Cover

## SB15

SB15-001
封面 Front Cover

SB15-002
立姿裸女速寫（99）Standing Female Nude Sketch (99)

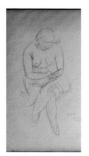

SB15-003
坐姿裸女速寫（105）Seated Female Nude Sketch (105)

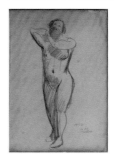

SB15-004
坐姿裸女速寫（106）Seated Female Nude Sketch (106)

SB15-005
立姿裸女速寫（100）Standing Female Nude Sketch (100)

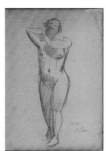

SB15-006
坐姿裸女速寫（107）Seated Female Nude Sketch (107)

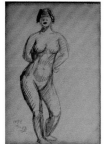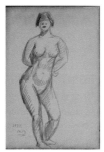

SB15-007
立姿裸女速寫（101）Standing Female Nude Sketch (101)

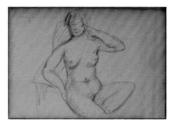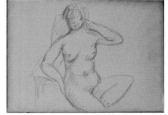

SB15-008
坐姿裸女速寫（108）Seated Female Nude Sketch (108)

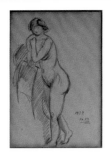
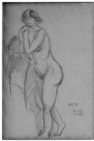

SB15-009
立姿裸女速寫（102）Standing Female Nude Sketch (102)

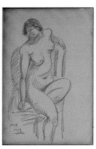
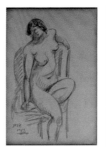

SB15-010
坐姿裸女速寫（109）Seated Female Nude Sketch (109)

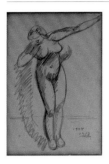
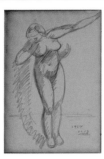

SB15-011
立姿裸女速寫（103）Standing Female Nude Sketch (103)

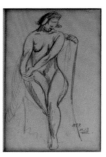
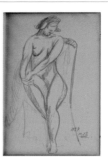

SB15-012
坐姿裸女速寫（110）Seated Female Nude Sketch (110)

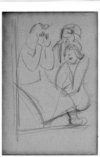

SB15-013
人物速寫（101）Figure Sketch (101)

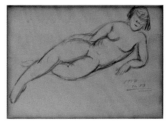
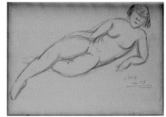

SB15-014
臥姿裸女速寫（17）Reclining Female Nude Sketch (17)

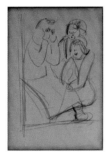

SB15-015
跪姿裸女速寫（4）Kneeling Female Nude Sketch (4)

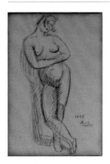
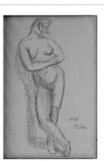

SB15-016
立姿裸女速寫（104）Standing Female Nude Sketch (104)

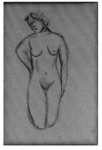
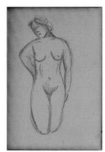

SB15-017
坐姿裸女速寫（111）Seated Female Nude Sketch (111)

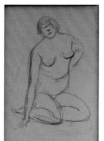
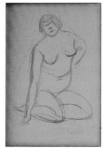
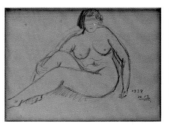
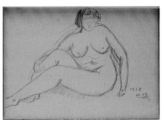

SB15-018
坐姿裸女速寫（112）Seated Female Nude Sketch (112)

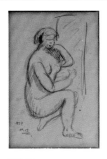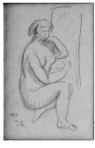

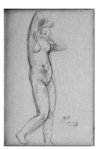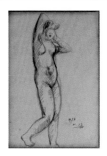

SB15-020
坐姿裸女速寫（114） Seated Female Nude Sketch (114)

SB15-021
立姿裸女速寫（105） Standing Female Nude Sketch (105)

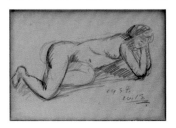

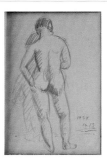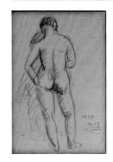

SB15-022
臥姿裸女速寫（18） Reclining Female Nude Sketch (18)

SB15-023
立姿裸女速寫（106） Standing Female Nude Sketch (106)

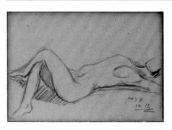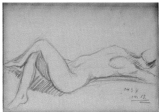

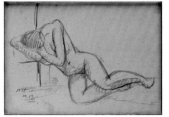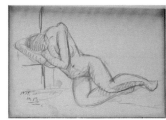

SB15-024
臥姿裸女速寫（19） Reclining Female Nude Sketch (19)

SB15-025
臥姿裸女速寫（20） Reclining Female Nude Sketch (20)

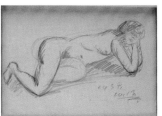

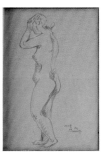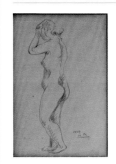

SB15-026
立姿裸女速寫（107） Standing Female Nude Sketch (107)

SB15-027
立姿裸女速寫（108） Standing Female Nude Sketch (108)

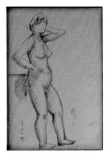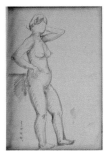

SB15-028
立姿裸女速寫（109） Standing Female Nude Sketch (109)

SB15-029
立姿裸女速寫（110） Standing Female Nude Sketch (110)

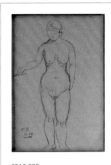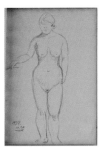

SB15-030
立姿裸女速寫（111） Standing Female Nude Sketch (111)

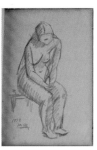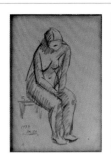

SB15-031
坐姿裸女速寫（115） Seated Female Nude Sketch (115)

SB15-032
坐姿裸女速寫（116） Seated Female Nude Sketch (116)

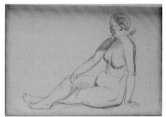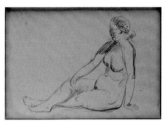

SB15-033
坐姿裸女速寫（117） Seated Female Nude Sketch (117)

SB15-034
臥姿裸女速寫（21） Reclining Female Nude Sketch (21)

SB15-035
坐姿裸女速寫（118） Seated Female Nude Sketch (118)

SB15-036
跪姿裸女速寫（5） Kneeling Female Nude Sketch (5)

SB15-037
立姿裸女速寫（112） Standing Female Nude Sketch (112)

SB15-038
立姿裸女速寫（113） Standing Female Nude Sketch (113)

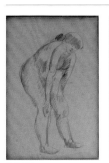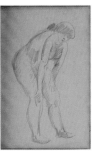

SB15-039
立姿裸女速寫（114） Standing Female Nude Sketch (114)

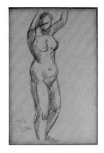 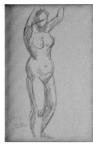

SB15-040
立姿裸女速寫（115） Standing Female Nude Sketch (115)

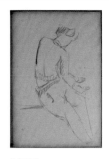 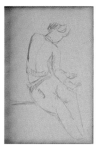

SB15-041
人物速寫（102） Figure Sketch (102)

SB15-042
臥姿裸女速寫（22） Reclining Female Nude Sketch (22)

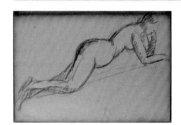 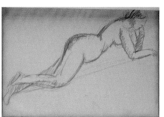

SB15-043
臥姿裸女速寫（23） Reclining Female Nude Sketch (23)

SB15-044
坐姿裸女速寫（119） Seated Female Nude Sketch (119)

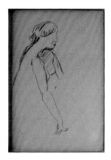 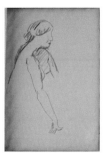

SB15-045
女體速寫（5） Female Body Sketch (5)

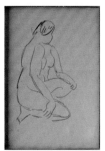 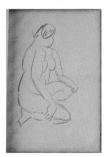

SB15-046
跪姿裸女速寫（6） Kneeling Female Nude Sketch (6)

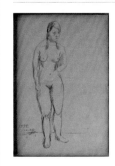 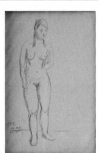

SB15-047
立姿裸女速寫（116） Standing Female Nude Sketch (116)

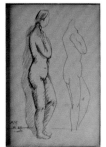 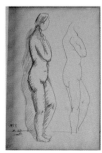

SB15-048
立姿裸女速寫（117） Standing Female Nude Sketch (117)

SB15-049
立姿裸女速寫（118） Standing Female Nude Sketch (118)

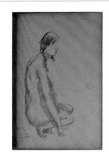
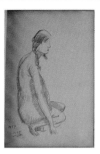

SB15-050
頭像速寫（27）Portrait Sketch (27)

SB15-051
蹲姿裸女速寫（1）Squatting Female Nude Sketch (1)

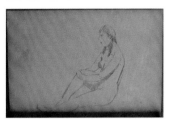
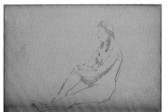

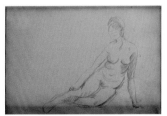
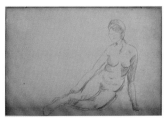

SB15-052
坐姿裸女速寫（120）Seated Female Nude Sketch (120)

SB15-053
坐姿裸女速寫（121）Seated Female Nude Sketch (121)

SB15-054
線條（3）Lines (3)

SB15-055
封底 Back Cover

**SB16**

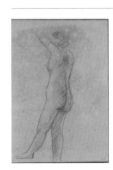

SB16-001
封面 Front Cover

SB16-002
立姿裸女速寫（119）Standing Female Nude Sketch (119)

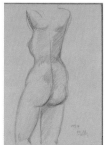
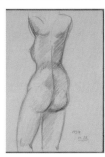

SB16-003
女體速寫（6）Female Body Sketch (6)

SB16-004
人物速寫（103）Figure Sketch (103)

SB16-005
立姿裸女速寫（120）Standing Female Nude Sketch (120)

SB16-006
人物速寫（104）Figure Sketch (104)

SB16-007
立姿裸女速寫（121）Standing Female Nude Sketch (121)

SB16-008
立姿裸女速寫（122）Standing Female Nude Sketch (122)

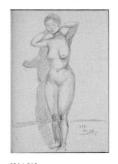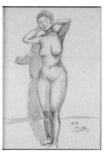

SB16-009
立姿裸女速寫（123）Standing Female Nude Sketch (123)

SB16-010
立姿裸女速寫（124）Standing Female Nude Sketch (124)

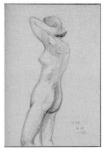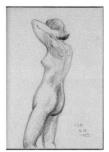

SB16-011
人物速寫（105）Figures Sketch (105)

SB16-012
立姿裸女速寫（125）Standing Female Nude Sketch (125)

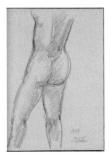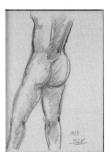

SB16-013
立姿裸女速寫（126）Standing Female Nude Sketch (126)

SB16-014
女體速寫（7）Female Body Sketch (7)

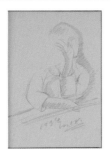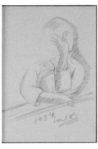

SB16-015
人物速寫（106）Figure Sketch (106)

SB16-016
人物速寫（107）Figures Sketch (107)

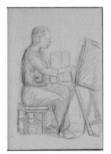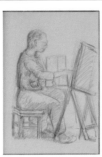

SB16-017
立姿裸女速寫（127）Standing Females Nude Sketch (127)

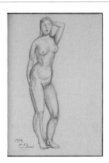

SB16-018
立姿裸女速寫（128）Standing Female Nude Sketch (128)

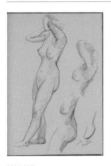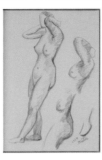

SB16-019
人物速寫（108）Figure Sketch (108)

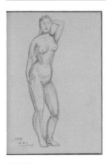

SB16-020
立姿裸女速寫（129）Standing Female Nude Sketch (129)

SB16-021
立姿裸女速寫（130）Standing Female Nude Sketch (130)

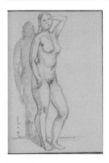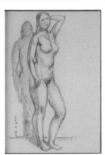

SB16-022
立姿裸女速寫（131）Standing Female Nude Sketch (131)

SB16-023
立姿裸女速寫（132）Standing Female Nude Sketch (132)

SB16-024
立姿裸女速寫（133）Standing Female Nude Sketch (133)

SB16-025
女體速寫（8） Female Body Sketch (8)

SB16-026
人物速寫（109） Figure Sketch (109)

SB16-027
人物速寫（110） Figure Sketch (110)

SB16-028
頭像速寫（28） Portrait Sketch (28)

SB16-029
人物速寫（111） Figure Sketch (111)

SB16-030
人物速寫（112） Figure Sketch (112)

SB16-031
頭像速寫（29） Portrait Sketch (29)

SB16-033
封底 Back Cover

# SB17

SB17-001
封面 Front Cover

SB17-002
坐姿裸女速寫（122） Seated Female Nude Sketch (122)

SB17-003
坐姿裸女速寫（123）Seated Female Nude Sketch (123)

SB17-004
立姿裸女速寫（134）Standing Female Nude Sketch (134)

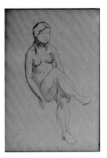
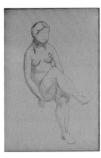

SB17-005
坐姿裸女速寫（124）Seated Female Nude Sketch (124)

SB17-006
坐姿裸女速寫（125）Seated Female Nude Sketch (125)

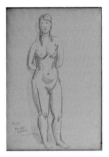
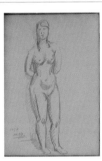

SB17-007
立姿裸女速寫（135）Standing Female Nude Sketch (135)

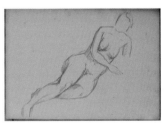
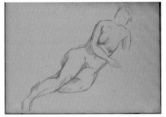

SB17-008
臥姿裸女速寫（24）Reclining Female Nude Sketch (24)

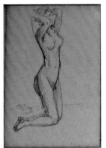
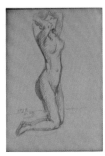

SB17-009
跪姿裸女速寫（6）Kneeling Female Nude Sketch (6)

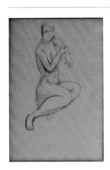
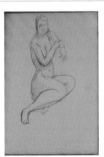

SB17-010
坐姿裸女速寫（126）Seated Female Nude Sketch (126)

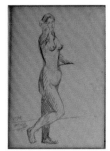
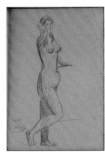

SB17-011
立姿裸女速寫（136）Standing Female Nude Sketch (136)

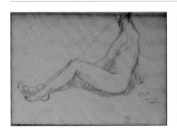
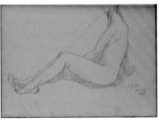

SB17-012
坐姿裸女速寫（127）Seated Female Nude Sketch (127)

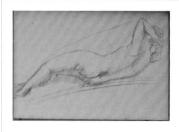
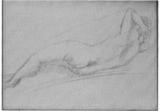
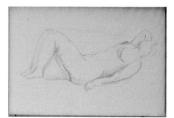
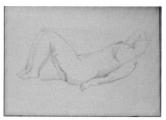

SB17-013
臥姿裸女速寫（25）Reclining Female Nude Sketch (25)

SB17-014
臥姿裸女速寫（26）Reclining Female Nude Sketch (26)

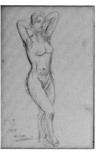
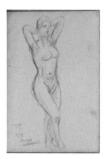
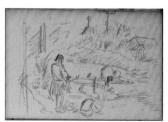
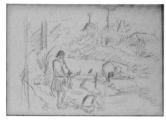

SB17-015
立姿裸女速寫（137）Standing Female Nude Sketch (137)

SB17-016
風景速寫（111）Landscape Sketch (111)

SB17-017
風景速寫（112）Landscape Sketch (112)

SB17-018
動物速寫（2）Animals Sketch (2)

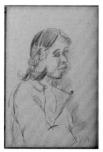
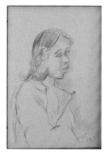

SB17-019
人物速寫（113）Figure Sketch (113)

SB17-020
頭像速寫（30）Portrait Sketch (30)

SB17-021
風景速寫（113）Landscape Sketch (113)
※SB17-022至SB17-029為文字稿。

SB17-030
封底 Back Cover

# SB19

SB19-001
封面 Front Cover

SB19-002
杭州 Hangzhou

SB19-003
塔山展望 Outlook from Ta Mountain

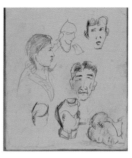 

SB19-004
頭像速寫（31）Portrait Sketch (31)

SB19-005
頭像速寫（32）Portrait Sketch (32)

SB19-006
頭像速寫（33）Portrait Sketch (33)

 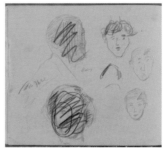

SB19-007
風景速寫（131）Landscape Sketch (131)

SB19-008
人物速寫（140）Figure Sketch (140)

SB19-009
達摩岩 Bodhidharma Rock

SB19-010
拉拉吉社遠望 A View of Rarahi from a Distance

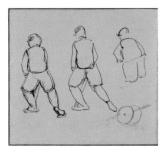 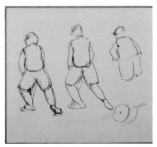

SB19-011
人物速寫（141）Figure Sketch (141)

SB19-012
人物速寫（142）Figure Sketch (142)

SB19-013
風景速寫（132）Landscape Sketch (132)

SB19-014
封底 Back Cover

## SB20

SB20-001
封面 Front Cover

SB20-002
人物速寫（143）Figures Sketch (143)

SB20-003
風景速寫（133）Landscape Sketch (133)

SB20-004
人物速寫（144）Figure Sketch (144)

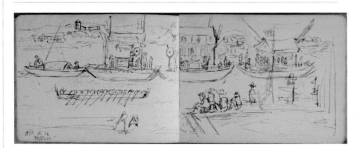 

SB20-006
風景速寫（134）Landscape Sketch (134)

SB20-005
林本源花園 Lin Benyuan Garden

SB20-007
風景速寫（135）Landscape Sketch (135)

SB20-008
人物速寫（145）Figure Sketch (145)

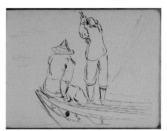

SB20-009
人物速寫（146）Figure Sketch (146)

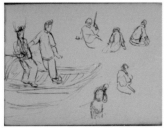
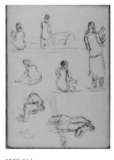
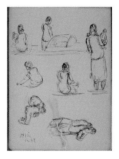

SB20-010
人物速寫（147）Figure Sketch (147)

SB20-011
人物速寫（148）Figure Sketch (148)

SB20-012
人物速寫（149）Figure Sketch (149)

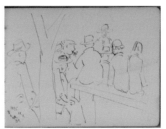

SB20-013
人物速寫（150）Figure Sketch (150)

SB20-014
人物速寫（151）Figure Sketch (151)

SB20-015
人物速寫（152）Figure Sketch (152)

SB20-016
人物速寫（153）Figure Sketch (153)

SB20-018
風景速寫（136）Landscape Sketch (136)

SB20-019
人物速寫（154）Figure Sketch (154)

SB20-020
人物速寫（155）Figure Sketch (155)

SB20-021
頭像速寫（34）Portrait Sketch (34)

SB20-022
人物速寫（156）Figures Sketch (156)

SB20-023
頭像速寫（35）Portrait Sketch (35)

SB20-024
人物與靜物速寫（1）Figures and Still Life Sketch (1)

SB20-025
人物與靜物速寫（2）Figures and Still Life Sketch (2)

SB20-026
風景速寫（137）Landscape Sketch (137)

SB20-027
淡水舊砲台遺跡　Tamsui Old Gun Emplacement Monument

SB20-028
淡水紅毛城　Tamsui Fort San Domingo

SB20-029
觀音山獅子頭展望淡水　Looking Towards Tamsui from Shihzihtou

SB20-030
江頭　Waterhead

SB20-031
風景速寫（138）Landscape Sketch (138)

SB20-032
蛇子形　Shezixing

SB20-033
風景速寫（139）Landscape Sketch (139)

SB20-034
中文字（8）Chinese (8)

# SB21

SB20-036
封底　Back Cover

SB21-001
封面　Front Cover

SB21-002
沙美箕溪口 Shameiji Valley

SB21-003
舉山、馬頭山 Ju Mountain, Matou Mountain

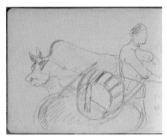

SB21-004
風景速寫（140） Landscape Sketch (140)

SB21-005
風穴 Windhole

SB21-006
人物速寫（157） Figure Sketch (157)

SB21-007
鳥嘴山 Beak Mountain

SB21-008
塔山 Ta Mountain

SB21-009
風景速寫（141） Landscape Sketch (141)

SB21-010
金洞山 Mt. Kondo

SB21-011
杉林 Firs

SB21-012
金鶏山（1）Mt. Kinkei (1)

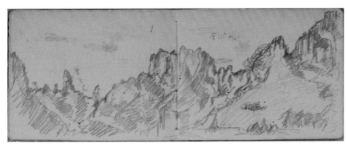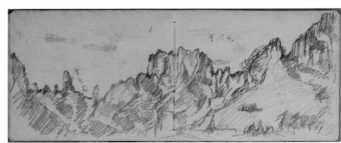

SB21-013
筆頭岩、金洞山 Hitou Rock and Mt. Kondo

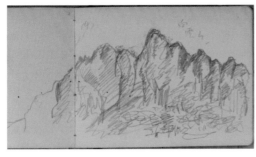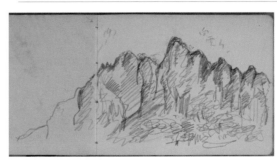

SB21-014
白雲山（1）Mt. Hakuun (1)

SB21-015
線條（4）Lines (4)

SB21-016
風景速寫（142）Landscape Sketch (142)

SB21-017
風景速寫（143）Landscape Sketch (143)

SB21-018
東雲館展望 Outlook from Dongyun Hotel

SB21-019
金鶏山展望 Outlook from Mt. Kinkei

SB21-020
第二石門（1）Second Gate Rock (1)

SB21-021
風景速寫（144）Landscape Sketch (144)

SB21-022
第四石門 Fourth Gate Rock

SB21-023
第二石門（2）Second Gate Rock (2)

SB21-024
第二石門（3）
Second Gate Rock (3)

SB21-025
金鶏山（2）Mt. Kinkei (2)

SB21-026
風景速寫（145）Landscape Sketch (145)

SB21-027
人物速寫（158）Figure Sketch (158)

SB21-028
風景速寫（146）Landscape Sketch (146)

SB21-029
静物速寫（2）Still Life Sketch (2)

SB21-030
風景速寫（147）Landscape Sketch (147)

SB21-031
静物速寫（3）Still Life Sketch (3)

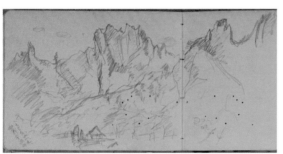

SB21-033
妙義金洞山 Mt. Kondo

SB21-032
静物速寫（4）Still Life Sketch (4)

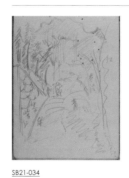 

SB21-034
白雲山（2）Mt. Hakuun (2)

SB21-035
風景速寫（148）Landscape Sketch (148)

 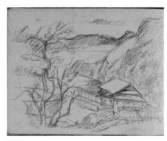

SB21-036
風景速寫（149）Landscape Sketch (149)

SB21-037
東雲閣 Dongyun Hotel

SB21-038
中文字（9） Chinese (9)

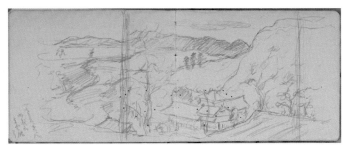 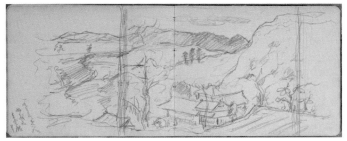

SB21-039
妙義山東雲館展望 Outlook from Dongyun Hotel

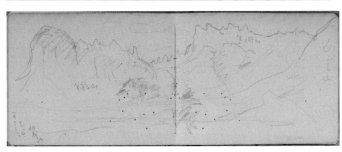 

SB21-040
妙義山 Mt. Myogi

SB21-041
風景速寫（150） Landscape Sketch (150)

 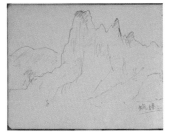  

SB21-042
蠟燭岩 Candle Rock

SB21-043
梅岡 Meigang

SB21-044
風景速寫（151）Landscape Sketch (151)

SB21-045
封底 Back Cover

# SB22

SB22-001
封面 Front Cover

SB22-002
日文字（5）Japanese (5)

SB22-003
人物速寫（159）Figure Sketch (159)

SB22-004
風景速寫（152）Landscape Sketch (152)

SB22-005
女體速寫（9）Female Body Sketch (9)

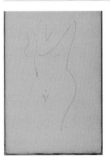

SB22-006
女體速寫（10）Female Body Sketch (10)

SB22-007
頭像速寫（36）Portrait Sketch (36)

SB22-008
立姿裸女速寫（138）Standing Female Nude Sketch (138)

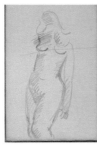

SB22-009
女體速寫（11）Female Body Sketch (11)

SB22-010
女體速寫（12）Female Body Sketch (12)

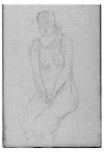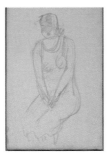

SB22-011
人物速寫（160）Figure Sketch (160)

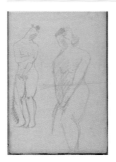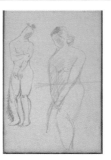

SB22-012
立姿裸女速寫（139）Standing Female Nude Sketch (139)

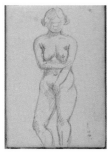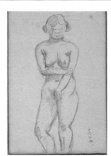

SB22-013
立姿裸女速寫（140）Standing Female Nude Sketch (140)

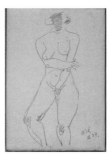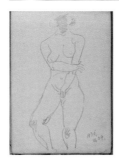

SB22-014
立姿裸女速寫（141）Standing Female Nude Sketch (141)

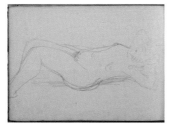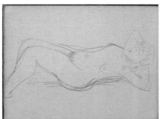

SB22-015
臥姿裸女速寫（27）Reclining Female Nude Sketch (27)

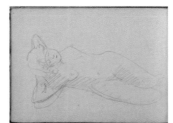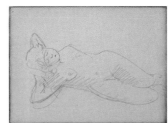

SB22-016
臥姿裸女速寫（28）Reclining Female Nude Sketch (28)

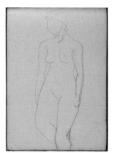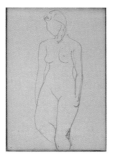

SB22-017
立姿裸女速寫（142）Standing Female Nude Sketch (142)

SB22-018
女體速寫（13）Female Body Sketch (13)

SB22-019
女體速寫（14）Female Body Sketch (14)

SB22-020
対白岳 Duibai Mountain

SB22-021
女體速寫（15）Female Body Sketch (15)

SB22-022
風景速寫（153）Landscape Sketch (153)

SB22-023
女體速寫（16）Female Body Sketch (16)

SB22-024
風景速寫（154）Landscape Sketch (154)

SB22-025
立姿裸女速寫（143）Standing Female Nude Sketch (143)

SB22-026
女體速寫（17）Female Body Sketch (17)

SB22-027
風景速寫（155）Landscape Sketch (155)

SB22-028
風景速寫（156）Landscape Sketch (156)

SB22-029
人物速寫（161）Figure Sketch (161)

SB22-030
風景速寫（157）Landscape Sketch (157)

SB22-031
風景速寫（158）Landscape Sketch (158)

SB22-032
風景速寫（159）Landscape Sketch (159)

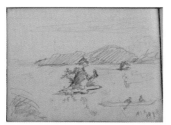

SB22-033
博多灣　Hakata Bay

SB22-034
興野（1）Okino (1)

SB22-035
興野（2）Okino (2)

SB22-036
人物速寫（162）Figure Sketch (162)

SB22-037
風景速寫（160）Landscape Sketch (160)

SB22-038
風景速寫（161）Landscape Sketch (161)

SB22-039
風景速寫（162）Landscape Sketch (162)

SB22-040
封底 Back Cover

SB23-001
封面 Front Cover

SB23-002
鶴（1）Cranes (1)

SB23-003
鶴（2）Cranes (2)

SB23-004
人物速寫（163）Figures Sketch (163)

SB23-005
遊園地一角 Corner of the Playground

SB23-006
鳳凰木 Flame Tree

SB23-007
動物速寫（5）Animal Sketch (5)

SB23-008
人物速寫（164）Figure Sketch (164)

SB23-009
風景速寫（163）Landscape Sketch (163)

SB23-010
人物速寫（165）Figures Sketch (165)

SB23-011
風景速寫（164）Landscape Sketch (164)

SB23-012
風景速寫（165）Landscape Sketch (165)

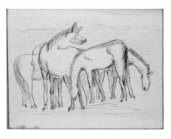

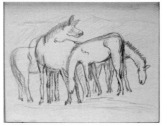

SB23-013
風景速寫（166）Landscape Sketch (166)

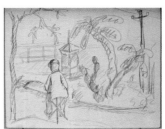

SB23-014
風景速寫（167）Landscape Sketch (167)

SB23-015
動物速寫（6）Animal Sketch (6)

SB23-016
風景速寫（168）Landscape Sketch (168)

## SB24

SB24-001
交力坪 Jiau Li Ping

SB24-002
女子軍材木搬 Female Porter

SB24-003
材木運搬夫 Porter

SB24-004
風景速寫（169）Landscape Sketch (169)

SB24-005
生毛樹公學 Shengmaoshu Public School

SB24-006
風景速寫（170）Landscape Sketch (170)

SB24-007
員潭山 Yuantan Mountain

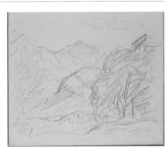

SB24-008
風景速寫（171）Landscape Sketch (171)

SB24-009
風景速寫（172）Landscape Sketch (172)

## SB27

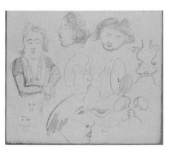
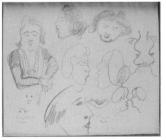

SB24-010
頭像速寫（37）Portraits Sketch (37)

SB27-001
封面 Front Cover

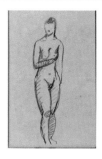

SB27-002
立姿裸女速寫（145）Standing Female Nude Sketch (145)

SB27-003
立姿裸女速寫（146）Standing Female Nude Sketch (146)

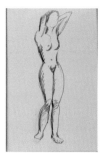
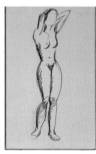

SB27-004
立姿裸女速寫（147）Standing Female Nude Sketch (147)

SB27-005
立姿裸女速寫（148）Standing Female Nude Sketch (148)

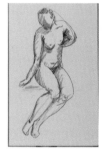
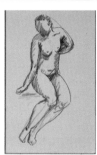

SB27-006
坐姿裸女速寫（129）Seated Female Nude Sketch (129)

SB27-007
坐姿裸女速寫（130）Seated Female Nude Sketch (130)

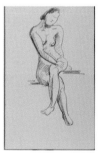
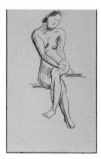

SB27-008
坐姿裸女速寫（131）Seated Female Nude Sketch (131)

SB27-009
坐姿裸女速寫（132）Seated Female Nude Sketch (132)

SB27-010
坐姿裸女速寫（133）Seated Female Nude Sketch (133)

SB27-011
坐姿裸女速寫（134）Seated Female Nude Sketch (134)

SB27-012
坐姿裸女速寫（135）Seated Female Nude Sketch (135)

SB27-013
坐姿裸女速寫（136）Seated Female Nude Sketch (136)

  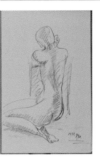 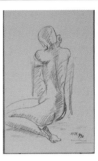

SB27-014
坐姿裸女速寫（137）Seated Female Nude Sketch (137)

SB27-015
坐姿裸女速寫（138）Seated Female Nude Sketch (138)

  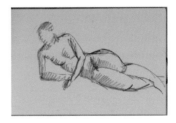 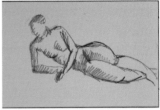

SB27-016
女體速寫（18）Female Body Sketch (18)

SB27-017
臥姿裸女速寫（30）Reclining Female Nude Sketch (30)

SB27-018
坐姿裸女速寫（139）Seated Female Nude Sketch (139)

SB27-019
立姿裸女速寫（149）Standing Female Nude Sketch (149)

SB27-020
立姿裸女速寫（150）Standing Female Nude Sketch (150)

SB27-021
立姿裸女速寫（151）Standing Female Nude Sketch (151)

SB27-023
封底 Back Cover

SB28-001
封面 Front Cover

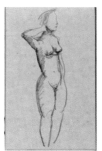
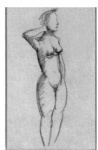

SB28-002
立姿裸女速寫（152）Standing Female Nude Sketch (152)

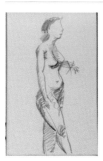
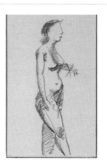

SB28-003
立姿裸女速寫（153）Standing Female Nude Sketch (153)

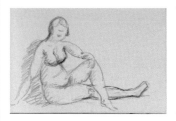

SB28-004
坐姿裸女速寫（140）Seated Female Nude Sketch (140)

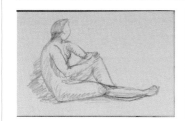

SB28-005
坐姿裸女速寫（141）Seated Female Nude Sketch (141)

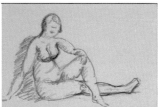

SB28-006
坐姿裸女速寫（142）Seated Female Nude Sketch (142)

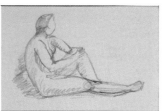

SB28-007
臥姿裸女速寫（31）Reclining Female Nude Sketch (31)

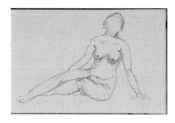

SB28-009
封底 Back Cover

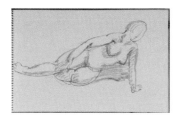
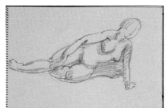

### SB29

SB29-001
封面 Front Cover

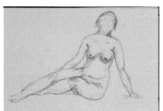

SB29-002
立姿裸女速寫（154）Standing Female Nude Sketch (154)

SB29-003
女體速寫（19）Female Body Sketch (19)

SB29-004
立姿裸女速寫（155）Standing Female Nude Sketch (155)

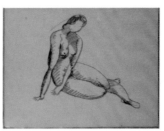
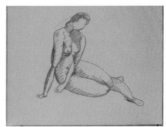

SB29-005
坐姿裸女速寫（143）Seated Female Nude Sketch (143)

SB29-006
坐姿裸女速寫（144）Seated Female Nude Sketch (144)

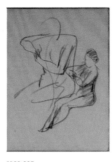
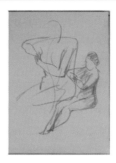

SB29-007
坐姿裸女速寫（145）Seated Female Nude Sketch (145)

SB29-008
坐姿裸女速寫（146）Seated Female Nude Sketch (146)

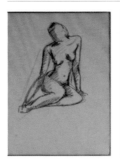
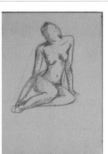

SB29-009
坐姿裸女速寫（147）Seated Female Nude Sketch (147)

SB29-010
頭像速寫（38）Portrait Sketch (38)

SB29-011
女體速寫（20）Female Body Sketch (20)

SB29-012
立姿裸女速寫（156）Standing Female Nude Sketch (156)

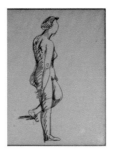 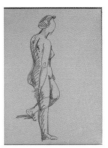

SB29-013
立姿裸女速寫（157）Standing Female Nude Sketch (157)

 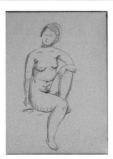

SB29-014
立姿裸女速寫（158）Standing Female Nude Sketch (158)

SB29-015
坐姿裸女速寫（148）Seated Female Nude Sketch (148)

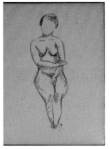 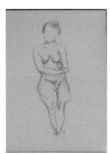

SB29-016
坐姿裸女速寫（149）Seated Female Nude Sketch (149)

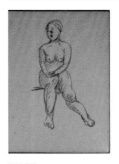 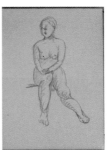

SB29-017
坐姿裸女速寫（150）Seated Female Nude Sketch (150)

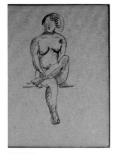 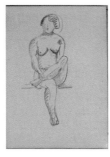

SB29-018
坐姿裸女速寫（151）Seated Female Nude Sketch (151)

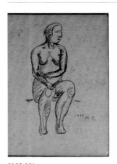 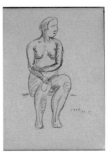

SB29-019
坐姿裸女速寫（152）Seated Female Nude Sketch (152)

SB29-020
坐姿裸女速寫（153）Seated Female Nude Sketch (153)

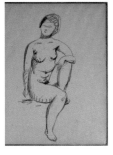 

SB29-021
坐姿裸女速寫（154）Seated Female Nude Sketch (154)

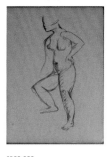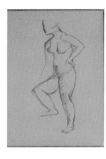

SB29-022
立姿裸女速寫（159）Standing Female Nude Sketch (159)

SB29-023
坐姿裸女速寫（155）Seated Female Nude Sketch (155)

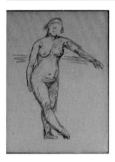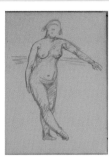

SB29-024
立姿裸女速寫（160）Standing Female Nude Sketch (160)

SB29-025
立姿裸女速寫（161）Standing Female Nude Sketch (161)

SB29-026
風景速寫（184）Landscape Sketch (184)

SB29-027
風景速寫（185）Landscape Sketch (185)

SB29-028
後樂園（1）Korakuen (1)

SB29-029
後樂園所見 Scenery of Korakuen

SB29-030
後樂園（2）Korakuen (2)

SB29-031
風景速寫（186）Landscape Sketch (186)

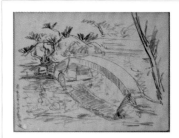
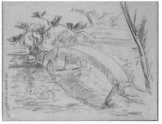

SB29-032
後樂園水戶家內庭 Mito Tokugawa Family Garden of Korakuen

SB29-033
宸苑莊 Chen Yuan Zhuang

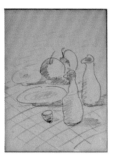
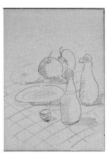

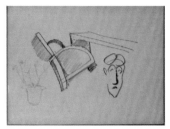

SB29-034
靜物速寫（5） Still Life Sketch (5)

SB29-035
靜物與頭像速寫 Still Life and Portrait Sketch

SB29-036
風景速寫（187） Landscape Sketch (187)

SB29-037
地圖（5） Map (5)

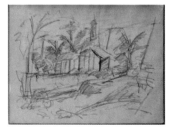
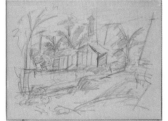

SB29-038
風景速寫（188） Landscape Sketch (188)

SB29-039
風景速寫（189） Landscape Sketch (189)

SB29-040
風景速寫（190） Landscape Sketch (190)

SB29-041
風景速寫（191） Landscape Sketch (191)

SB29-044
封底 Back Cover

SB31-001
封面 Front Cover

SB31-002
鹿港辜家 Koo's Family Old House in Lukang

SB31-003
鹿港 Lukang

SB31-004
風景速寫（204）Landscape Sketch (204)

SB31-005
風景速寫（205）Landscape Sketch (205)

SB31-006
靜物速寫（6）Still Life (6)

SB31-007
綠色山岡 Green Hill

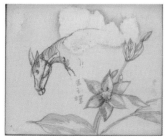
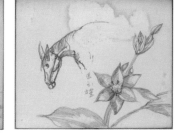

SB31-008
馬玉蝶 Horse and Flowers

SB31-009
人物速寫（177）Figure Sketch (177)

357

SB31-010
封底 Back Cover

SB32-001
封面 Front Cover

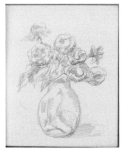

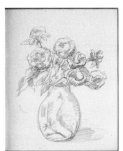

SB32-002
風景速寫（206）Landscape Sketch (206)

SB32-003
赤崁樓 Chikan Tower

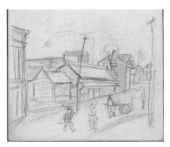

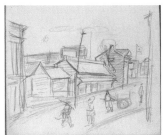

SB32-004
花（2）Flowers (2)

SB32-005
大森山莊 Dasen Villa

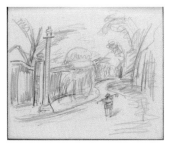

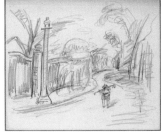

SB32-006
風景速寫（207）Landscape Sketch (207)

SB32-007
人物與動物 Figure and Animal

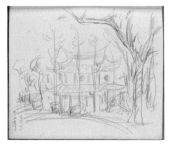

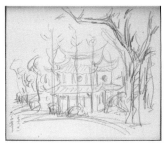

SB32-008
太子亭 Taizi Pavilion

SB32-009
火雞 Turkeys

SB32-010
風景速寫（208）Landscape Sketch (208)

SB32-011
逸園 Yi Garden

SB32-012
風景速寫（209）Landscape Sketch (209)

*疑非陳澄波所畫。

SB32-013
風景速寫（210）Landscape Sketch (210)

SB32-014
設計草圖（3）Design Draft (3)

**SB33**

SB33-001
封面 Front Cover

SB33-002
風景速寫（211）Landscape Sketch (211)

*疑非陳澄波所畫。

SB33-003
風景速寫（212）Landscape Sketch (212)

SB33-004
馬車 Cart

SB33-005
風景速寫（213）Landscape Sketch (213)

SB33-006
風景速寫（214）Landscape Sketch (214)

SB33-007
線條（5）Lines (5)

SB33-008
風景速寫（215）Landscape Sketch (215)

SB33-009
風景速寫（216）Landscape Sketch (216)

SB33-010
風景速寫（217）Landscape Sketch (217)

SB33-011
風景速寫（218）Landscape Sketch (218)

SB33-012
動物速寫（8）Animal Sketch (8)

SB33-013
風景速寫（219）Landscape Sketch (219)

SB33-015
風景速寫（220）Landscape Sketch (220)

SB33-016
風景速寫（221）Landscape Sketch (221)

SB33-017
辨天前 In Front of Biantian Pond

*疑非陳澄波所畫。

SB33-018
動物速寫（9）Animal Sketch (9)

SB33-019
公園 Park

SB33-020
封底 Back Cover

# SB34

SB34-001
封面 Front Cover

SB34-002
嘉義公園（3）Chiayi Park (3)

SB34-003
嘉義神社鳥居（1）The Torii Shrine, Chiayi (1)

SB34-004
嘉義神社鳥居（2）The Torii Shrine, Chiayi (2)

SB34-005
嘉義神社鳥居（3）The Torii Shrine, Chiayi (3)

SB34-006
嘉義公園（4）Chiayi Park (4)

 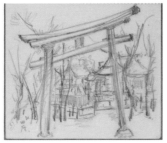

SB34-007
嘉義神社鳥居（4）The Torii Shrine, Chiayi (4)

SB34-008
船 Boats

SB34-009
風景速寫（222）Landscape Sketch (222)

SB34-010
風景速寫（223）Landscape Sketch (223)

SB34-011
風景速寫（224）Landscape Sketch (224)

SB34-012
人物速寫（178）Figure Sketch (178)

SB34-013
風景速寫（225）Landscape Sketch (225)

SB34-014
風景速寫（226）Landscape Sketch (226)

SB34-015
風景速寫（227）Landscape Sketch (227)

SB34-017
封底 Back Cover

# SB37

SB37-001
封面 Front Cover

SB37-002
人物速寫（187）
Figure Sketch (187)

SB37-003
線條（6）Lines (6)

SB37-004
人物速寫（188）Figure Sketch (188)

SB37-005
人物速寫（189）
Figure Sketch (189)

SB37-006
人物速寫（190）Figure Sketch (190)

SB37-007
風景速寫（263）Landscape Sketch (263)

SB37-008
人物速寫（191）Figure Sketch (191)

SB37-009
人物速寫（192）Figure Sketch (192)

SB37-010
人物速寫（193）Figure Sketch (193)

SB37-011
人物速寫（194）Figure Sketch (194)

SB37-012
封底 Back Cover

## SB38

SB38-001
封面 Front Cover

SB38-002
人物速寫（195）Figure Sketch (195)

SB38-003
風景速寫（264）Landscape Sketch (264)

SB38-004
頭像速寫（40）Portrait Sketch (40)

SB38-005
人物速寫（196）Figure Sketch (196)

SB38-006
封底 Back Cover

# 編後語

　　陳澄波因二二八事件罹難，使得他的名字一度成為禁忌；其遺留下來的作品與文物，家屬為避免被政府單位查禁沒收，長期密藏在住家的閣樓裡，由於保存環境不佳，使得作品與文物遭受不同程度的嚴重損壞。因應 2014 年「陳澄波百二誕辰東亞巡迴大展」的展出，這些作品與文物需要被全面修復；由於數量龐大加上時間壓力，因此交付三個主要的單位同步進行，分別是：國立臺灣師範大學文物保存維護研究發展中心（簡稱文保中心）、正修科技大學文物修護中心，與臺北文化財保存研究所。

　　《陳澄波全集》第 15-17 卷，主要就是呈現這三個單位的修復成果。第 15 卷和第 16 卷前半部，為張元鳳老師領導的文保中心的紙質類作品、油畫和文物的修復報告，並搭配專文，深入簡出地介紹修復的理念與過程；第 16 卷下半部為林煥盛老師主持的臺北文化財保存研究所的紙絹類作品修復報告；第 17 卷則是收錄李益成老師領導的正修科技大學文物修護中心的油畫和紙質類作品修復報告，與修復期間所發表的文章。在每個類別的最後，並收入所有作品修復前後的對照圖，將修復作品做一完整之呈現，也讓讀者可以比對修復前後之差異。此外，15-17 卷特以中英文對照呈現，以期能推廣國內優秀的修復技術。

　　由於修復前後對照圖有數千件，當初送修復時的編號也與後來《全集》的編號不同，因此耗費相當多的時間來重新整理圖檔；然而當作品能依序完整呈現，編者亦是感到十分欣慰。而修復前後對照圖大多是修復師所攝，因為不是專業攝影或掃描，有些圖檔品質並不理想，圖檔顏色看起來也會與《全集》第 1 至 5 卷之作品圖錄有些許差異，然均為修復師工作中之紀錄，為完整呈現修復的全貌，編輯時選擇仍將其全部收錄。另有少部分素描簿圖檔，因修復後加強了騎縫處的黏合，導致攝影時靠近騎縫處會有陰影或不平整的狀況產生，實乃無法避免，尚請寬諒。

　　有人把修復師比喻為文物的醫生，而文物就是病人；在面對同一個病人，不同醫師所開的藥方也會不盡相同。同樣的，在面對各式各樣的文物和不一樣的修復需求時，三個單位的修復程序、方法與使用之材料，自然也會有所不同，甚至連修復報告的格式也有所差別。對於這些差異性，編輯者選擇如實保留，不強加統一，藉以呈顯各單位之修復特色。

　　此次陳澄波作品與文物的大量修復，應是國內創舉，目前在臺灣應還沒有其他畫家從事如此大規模的修復；這樣的工程，除需耗費龐大的金錢外，更考驗著三個單位的修復能力，不僅要在有限的時間內完成，以應付展出，最令人感動的是三個單位均嚴格遵循修復倫理，因為修復是為了延長文物的保存壽命，而非讓後人的修復介入反而毀壞了原作。

　　感謝三個單位的主持人與修復師，工作忙碌之餘，還抽空撰寫專文、規劃內容、整理資料，並協助校稿。若要瞭解作品與文物如何被修復，相信讀完這三卷報告書，就會有很清楚的概念。這是國內修復專業一次重大的成果；而美編處理幾千件圖檔的辛勞，在此也一併誌謝。

<div style="text-align:right">

財團法人陳澄波文化基金會<br>
研究專員　賴鈴如

</div>

# Editor's Afterword

The fact that Chen Cheng-po had fallen victim to the "228 Incident" had once made his name a taboo. For fear that his works and cultural objects might be searched for violation of ban and confiscated, his family members had them hidden for a long time in the household attic. Because of the poor conservation conditions, the works and cultural objects had undergone various degrees of serious damages. In order that they could be showcased in the 2014 "Chen Cheng-po's 120th Birthday Touring Exhibition in East Asia", there was a need to conserve these works and cultural objects comprehensively. Considering the large quantity involved and the limited time available, three institutions were charged with carrying out the conservation simultaneously, namely, Research Center for Conservation of Cultural Relics (RCCR), National Taiwan Normal University; Cheng Shiu University Conservation Center; and Taipei Conservation Center.

Volumes 15 to 17 of *Chen Cheng-po Corpus* mainly present the conservation results of these three institutions. Volume 15 and the first half of Volume 16 consist of the reports of conserving respectively paper-based works, oil paintings, and cultural objects by an RCCR team led by Chang Yuan-feng. Also included is a monograph that succinctly presents the concepts and processes of the conservation in depth. The second half of Volume 16 is a report on the conservation of paper or silk based paintings by Taipei Conservation Center run by Lin Huan-sheng. Included in Volume 17 are reports on the conservation of oil paintings and paper-based works carried out by Cheng Shiu University Conservation Center under the leadership of Li I-cheng. It also consists of a number of papers published in the course of the conservation. At the end of each category section, there are comparison photos showing the works before and after treatment. Such a complete presentation of the conserved works allows readers the chance of comparing the differences before and after treatment. Also, Volumes 15 to 17 are published in a Chinese-English bilingual format to better promote the superb conservation techniques available in Taiwan.

Since there are thousands of before and after treatment photos and that the serial numbers at the time of sending out for conservation are different than those given in the *Corpus*, considerable amount of time has been engaged in reorganizing the photo files. Yet, when all the works are finally presented in their sequential order, this editor cannot help but thrilled with satisfaction. Most of the before and after treatment photos have been taken by the conservators concerned. Since no professional photography or scanning is involved, the quality of some of the photo files is less than desirable, with the colors of the files somewhat different than those included in Volumes 1 to 5 of the *Corpus*. Nevertheless, as the entire photo files are the work records of the conservators, in compiling these three volumes, it has been decided to include all of them in order to present a full picture of the conservation efforts. In addition, in some of the sketchbook photo files, since the bonds of the sketchbook seams have been reinforced during conservation, shadows or unevenness may show up near the seams in the photos. This is unavoidable and we hope readers will understand.

Conservators have been likened to doctors of cultural objects and the cultural objects are the patients. When dealing with the same patient, the prescriptions given out by different doctors are not all the same. Likewise, in dealing with a whole range of cultural objects and different conservation needs, the procedures, methods, and materials adopted by the three conservation institutions are naturally not the same; in fact, even the formats of their conservation reports are also different. Faced with these differences, this editor has chosen to retain them as they were and has not enforced uniformity so as to present the conservation features of these institutions.

The current wholesale conservation of Chen Cheng-po's works and cultural objects is a first of its type in Taiwan. As yet, there is no other artist in Taiwan whose works have undergone conservation of such a large scale. Such an undertaking not only incurs a lot of money, it is also very taxing on the conservation capabilities of the three institutions. In addition to having to complete their respective tasks within limited time to be ready for the exhibition, what is touching is that all three of them had to abide by stringent conservation ethics. This is so because, after all, the purpose of conservation is to extend the retention life of the works of art and cultural objects, and is not to allow the intrusion of conservation to damage them.

We extend our gratitude to the directors and conservators of the three institutions for sparing time in their busy schedules to write the papers, plan the contents, and organize the materials as well as to help proofreading. If one wants to understand how art works and cultural objects are conserved, reading these three volumes would be a sure way to get a clear idea. This project is a major achievement on the part of Taiwan's conservation profession. Our thanks is also due to our art editor who had to laboriously handle thousands of photo files.

Researcher,
Judicial Person Chen Cheng-po Cultural Foundation
Lai Ling-ju

國家圖書館出版品預行編目資料

陳澄波全集.第十五卷,修復報告.Ⅰ/蕭瓊瑞總主編.
-- 初版. -- 臺北市：藝術家出版；嘉義市：陳澄波文化基金
會；[臺北市]：中研院臺史所發行, 2018.3
　　368面；22×28.5公分
ISBN 978-986-282-204-3(精裝)

1.書畫 2.文物修復

941.5　　　　　　　　　　　　　　106014676

# 陳澄波全集
## CHEN CHENG-PO CORPUS
### 第十五卷・修復報告（Ⅰ）
Volume 15 · Selected Treatment Reports（Ⅰ）

發　　　行：財團法人陳澄波文化基金會
　　　　　　中央研究院臺灣史研究所
出　　　版：藝術家出版社
發 行 人：陳重光、翁啟惠、何政廣
策　　　劃：財團法人陳澄波文化基金會
總 策 劃：陳立栢
總 主 編：蕭瓊瑞
編輯顧問：王秀雄、吉田千鶴子、李鴻禧、李賢文、林柏亭、林保堯、林釗、張義雄
　　　　　張炎憲、陳重光、黃才郎、黃光男、潘元石、謝里法、謝國興、顏娟英
編輯委員：文貞姬、白適銘、林育淳、邱函妮、許雪姬、陳麗涓、陳水財、張元鳳、張炎憲
　　　　　黃冬富、廖瑾瑗、蔡獻友、蔣伯欣、黃姍姍、謝慧玲、蕭瓊瑞
執行編輯：賴鈴如、何冠儀
美術編輯：柯美麗
翻　　　譯：日文／潘襎（序文）、英文／陳彥名（序文）、陳詩薇、盧藹芹

出 版 者：藝術家出版社
　　　　　台北市金山南路（藝術家路）二段165號6樓
　　　　　TEL：（02）23886715
　　　　　FAX：（02）23965708
　　　　　郵政劃撥：50035145 藝術家出版社帳戶

總 經 銷：時報文化出版企業股份有限公司
　　　　　桃園市龜山區萬壽路二段351號
　　　　　TEL：（02）2306-6842
南區代理：台南市西門路一段223巷10弄26號
　　　　　TEL：（06）261-7268
　　　　　FAX：（06）263-7698

製版印刷：欣佑彩色製版印刷股份有限公司
初　　　版：2018年3月
定　　　價：新臺幣1800元

ISBN　978-986-282-204-3（軟皮精裝）